francesca

Michelangelo's last paintings

Michelangelo's

last paintings

The Conversion of St. Paul and the Crucifixion of
St. Peter in the Cappella Paolina, Vatican Palace

by Leo Steinberg

Phaidon

Phaidon Press Limited, 5 Cromwell Place, London SW7 2JL
First published 1975
© 1975 Phaidon Press Limited
All rights reserved
ISBN 0 7148 1670 1

Printed in Italy by Amilcare Pizzi SpA

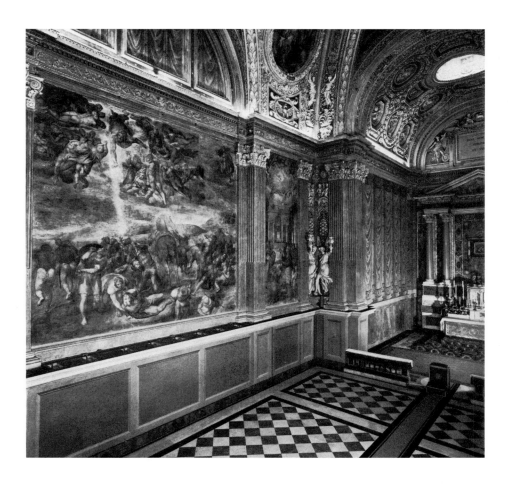

Contents

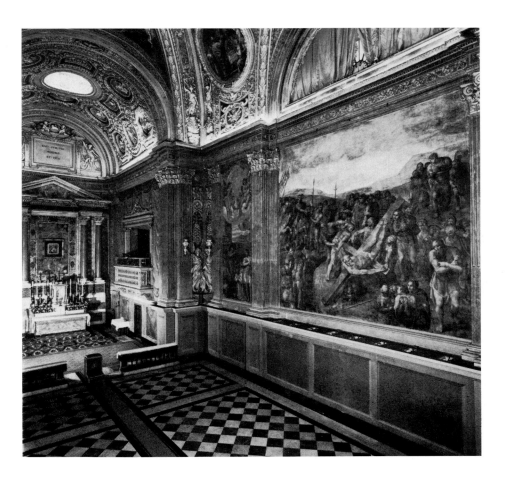

Preface

THE opening chapter of this book tells once again the story of Michelangelo's life—not as we normally trace it, year by year, project by project, giving each season its due—but as though from the artist's septuagenarian vantage, looking back over decades of servitude. The artist's self-image at the time he was painting his final frescoes, the way he evaluated his past, is on record: it emerges from passages such as the following in Condivi's biography. After recounting the tale of the Julius Tomb (the aborted project of Michelangelo's youth), Condivi writes:

'There is no doubt that if he had been allowed to finish it according to the first design, having so large a field in which to show his worth, no other artist, however celebrated, could have wrested from him the high place he would have held.'

The wording here may be Condivi's, but the sentiment of regret—this brooding over the failure of a career that had seemed so promising in its beginning, is Michelangelo's. No other man writing in 1553, least of all the doting Condivi, could have conceived the notion that Michelangelo's place in art was less than the highest, or that the creator of the Sistine *Last Judgment* had been prevented from 'showing his worth'.

Chapter II reviews the critical fortunes of the Paolina frescoes from the day they were unveiled to the recent past. The facts read like a parable: initial disappointment settles into enduring neglect, followed at last by apotheosis. The long oblivion of the Paolina frescoes is not forgettable—any more than the prolonged darkness that hung over the Hieroglyphics before their decipherment. Works of art that seem incomprehensible become mute. And the renewal of interest, the rekindled discussions, the questioning, the attempts to interpret—all these intellectual exercises that attend a major critical revaluation—are comparable to a decoding of runes.

The rest of the book deals with the frescoes themselves. Their 'subject matter' comes to be seen as illimitable, with meanings converging from personal trauma and wide reaches of Christian knowledge. The day is long past when Michelangelo could be defined as Platonist rather than Christian, when only the piety of Fra Angelico seemed consonant with the religion of meekness. It is just over a hundred years since Walter Pater described Michelangelo as wholly alienated from the Roman Church—'too independent to be its subject, yet brought within the neighborhood of its action; consoled and tranquillized, as a traveller might be, resting for one evening in a strange city, by its stately aspect and the sentiment of its many fortunes, just because with those fortunes he has nothing to do.' To sustain this fiction of Michelangelo as a spirit inhabiting regions of ideality 'above the wear and tear of creeds', while serving a church with whose fortunes 'he has nothing to do,' Pater had to suppress (as did most nineteenth-century writers) the Paolina frescoes and the seven years spent in their making. Dedicated to the Apostolic founders of the Roman See, these frescoes lie at, and speak from, the heart of Catholicism.

In my discussions of the two frescoes I have tried not to avoid the responsibilities of interpretation, though my symbolic readings tend to be interfused with what used to be called 'formal analysis'. That term no longer seems helpful. In Michelangelo's pictorial structures, 'form' and 'content' are not to be pried apart. Only in the narrowest sense do his depicted scenes illustrate their pre-given subjects; as the artist's conceptions materialize, they engender new meanings, engage wider, deeper registers of significance. The sweeping curve of a leg—St. Paul's right leg in the *Conversion*—makes a melodious line, but as it aims at the city indicated by Christ, it also foretells, visibly, where Paul is to go. Linear rhythm, dramatic posture, imminent destination and destiny—all collapse together in the unique visual substance.

But a word needs to be said about the limits and license of interpretation. I am aware of the position that frowns on excessively free speculation at the expense of the Masters. But there are, after all, two ways to inflict injustice on a great work of art; by over-interpreting it, or by under-estimating its meaning. If unverifiable interpretations are rightly regarded as dangerous, there is as much danger of misrepresentation in restrictive assertions that feel safe only because they say little. As when we read that the display of nude figures is 'the real point' of the Sistine *Last Judgment*; or that in painting the Doni Tondo Michelangelo was moved, through rivalry with Leonardo, 'to undertake a work [wherein] qualities of form predominate over those of content'; or that Michelangelo's *Crucifixion of St. Peter* is a 'direct illustration of religious content expressed in radically simple form'. Such confident under-interpretations cannot escape the charge of simplistic distortion.

Of the interpretations proposed in this book, I have required three things: that they be probable if not provable; that they make visible what had not previously been apparent; and that, once stated, they so penetrate the visual matter that the picture seems to confess itself and the interpreter disappears. For the rest, the probity of resisting interpretation is not the virtue to which I aspired. Michelangelo's idiom is so highly charged and so impregnated with thought, that nothing would seem to me more foolhardy than to project upon his symbolic structures a personal preference for simplicity. Compared to that kind of projection, the risks I have taken seem slight.

HELP in preparing this book came from several sources. I thank Dott. D. Redig de Campos, Director of the Vatican Museums, for what his own books have taught me, and for enabling me during the past fifteen years to spend many days in the Pauline Chapel. Ruth Campbell placed at my disposal her intimate knowledge of New York's libraries and her fluency in medieval Latin. Francis Naumann, a young art historian with no professional claims in the field of photography, took most of the pictures of the Paolina frescoes *in situ* (Figs. 41, 42, 47, 56 and 61); it was the informality of these pictures and the sense they convey of the frescoes in relation to the architectural setting and to the spectator, that made them especially welcome. Long conversations with Mercedes Matter about the *Conversion* fresco compelled me to test my ideas continually against the viewpoint of an experienced painter. Without the collaboration of my learned assistant, Sheila Schwartz, this book would still be the unfulfilled project it had been for over a decade. To Dr. I. Grafe of Phaidon Press I extend my deepest appreciation for his professional skill and his heroic persistence in patience and tact. I am grateful to the City University of New York, whose Faculty Research Award, 1972–1973, gave me one undisturbed year; and to my students at Hunter College, where I taught for a dozen years, who helped substantially (though they did not know it) by keeping my spirits up. Finally, I salute the valiant Pamela Ilott who, ten years ago, produced an hour-length film on the Cappella Paolina for CBS Television. I wrote the script for it, and some of the ideas incorporated in the present text were first voiced in that program. The fact that Michelangelo's least accessible works were shown in 1965 on popular television is a measure of Pamela Ilott's idealism.

My sister Ada would have enjoyed seeing this book. I dedicate it to her memory.

ADA STEINBERG SIEGEL
Moscow 1917–1956 New York

I. The Artist Grows Old

A MODEST document preserved in the Casa Buonarroti in Florence gives us the master in one of his less awesome moments—Michelangelo jotting down, on the back of a letter, what he expected to eat (Fig. 1). Three menus are itemized. The first lays down the basic diet—two rolls (*pani dua*), a jug of wine (*bochal di vino*), pasta (*tortegli*, spelled *tortelli* seven lines below), and *una aringa*, one herring. There follows a slightly enriched meal with double portions, evidently meant to be shared: beginning with salad, it offers a choice of wines, a plateful of spinach, four anchovies, and pasta. The third menu—back to herring and humble fare— provides for six rolls and substitutes fennel soup for the pasta.

The notation must have been made for an illiterate housekeeper, who needed pictures to illuminate the written instructions; hence the diagrams in pen and ink. But though the diagrams start well-intentioned and in tidy alignment with their corresponding legends, they soon grow unruly. At the third or fourth item, the pressure of pen on paper intensifies; things batten and swell and begin to fall out of line; jugs, loaves and fishes double and treble in size, and the testimony of Michelangelo's frugal living spills down the sheet like a discharged cornucopia.

". . . Carried away by his temperament," writes the scholar who first published this remarkable paper.[1] But a temperament is complex, and so is the impulse to magnify, even on this trivial sheet. We can see that the draughtsman was not merely giving in to carelessness or impatience—the later figures are as firmly drawn as the first. Nor will it do to read the process as but another expression of that irrepressible gigantism which, on a grander scale, leads Michelangelo to create the first colossal sculpture of modern times, or to dream of hewing a titanic effigy into the marble rocks of Carrara, to be seen by mariners from afar. It is true that under Michelangelo's hands, any concatenation of forms wants to expand, to outgrow its beginnings. But look at the menu again. The amplification of its little still-lifes seems arbitrary only when gauged against those written legends. Seen against the full page, the process suggests a coping with another necessity. As the scale of the drawings increases, a new set of determinants—irrelevant to Michelangelo's housekeeper and to the task in hand—comes into play: lines of previous writing and traces coming through from the reverse of the sheet close in on the drawing; they become limits reached, framing borders getting their fill. The whole sheet is invested. To attribute this unexpected development to a "sense of design" misses the psychological shift involved. At some early moment —in the present case it came within seconds—the draughtsman's praiseworthy intention of aligning pictures and legends was overruled by a compulsion to take possession of the entire field.

The impulse to invest the largest possible frame is observable in most of Michelangelo's creative decisions. The aggrandizements he bestows on a form or a task are always correlative. A concept expands against the retentive force of some outer limit contracting upon it. That limit need not be visible, nor relevant to the given project as understood by anyone other than the artist himself. But the artist probes for it and, depending on the assignment, finds and acknowledges it in a paper margin, in the exterior facets of a marble block, in the compressive effect of a niche, the architectural exigencies of a site—or in a fullness of content far beyond the subject matter conceived by the patron.

What happens when this mode of thought collides with the scale of a building; when, regardless of cost, time, or labor, a monumental project is further magnified to encounter maximum pressure? The answer is twofold: the result is either the miracle of the Sistine Ceiling, or else the tragic fiasco of the Julius Tomb.

The commission Michelangelo received in May, 1508, for the Ceiling was large, but not unmanageable. It called for twelve Apostles to be represented in fresco between the windows of the clerestory, leaving the great expanse of ceiling to be patterned with ornament, "according to the usual manner." Had it been executed on these conservative lines, Michelangelo's work would have taken its place, along with the fifteenth-century frescoes on the lower walls, within the Chapel's overall decoration. But in less than two months, arguing that the result "would look poorly," the artist proposed a vastly enlarged scheme, conceived far beyond the conscious needs or dreams of his Papal patron.[2] Michelangelo only found the scale and scope of the project when it was copious enough to command the entire environment. The scheme as executed transformed the Chapel into a supporting

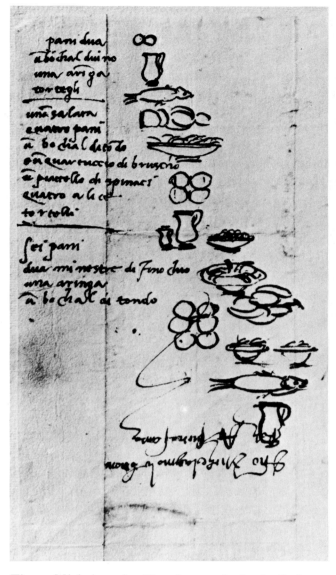

Fig. 1. Michelangelo: Notation on the back of a letter dated March 18, 1518. Florence, Archivio Buonarroti, Cod. 10, no. 578v.

7

substructure for Michelangelo's Ceiling. And on the vaulting itself, the difficult zigzag pattern of penetrations was not merely acknowledged, but so deeply absorbed into the imagery as to seem engendered rather than given (Fig. 2). Gazing up at the finished work, it is difficult to remember that the architecture of the Sistine Ceiling is ill-suited to figurative decoration. One needs to look at an unpainted ceiling of similar structure, such as our Fig. 3, to assess the thanklessness of the task.

But the same impulse that fixed the scale of his most heroic achievement also determined the defeating enormity of the Tomb of Julius II, a project proportioned once more according to an imaginative necessity, but scaled so far beyond reason or manage that it became the overwhelming frustration of his career. The humiliating failure of the Julius Tomb reduced Michelangelo's largest accomplishments, from the Sistine Ceiling to the *Last Judgment*, to the status of interruptions, delaying and thwarting his deliverance from a burden that seemed to turn life into a punishment.

The closing chapter of the "tragedy of the Tomb," as Condivi called it, interpenetrates with the genesis of the Paolina frescoes. We must briefly glance back to its beginnings, since it was the agony of the Julius Tomb that shaped the personality of the artist who, four decades later, confessed himself in the *Conversion of Saul* and the *Crucifixion of Peter*.

MICHELANGELO was turning thirty when he received his first Papal call. Julius II was summoning Italy's foremost artists to Rome, where Michelangelo's reputation was secured by the marble *Pietà*, carved during his early twenties for a chapel off St. Peter's Basilica. Since his return to Florence in 1501, the young sculptor had seen the *David* erected before the Palazzo della Signoria as a civic symbol of Republican Florence. Now the City's chief powers, ecclesiastic and secular, vied for his labor: a contract signed in 1503 bound him to execute, for the interior of the Cathedral, a series of twelve over-lifesize marble Apostles; and for the City he was producing the Bathing Soldiers, or *Battle of Cascina* (Fig. 4), a cartoon for an enormous fresco to decorate the Council Hall of the City Palace. Both projects were dropped when Michelangelo departed for Rome.

He arrived early in 1505, received the commission for the Pope's tomb, and fell to work. The design, which Julius approved with enthusiasm, projected a tomb such as no man since the beginning of Christian history had yet claimed for himself. Not a normal wall tomb, but a free-standing stone mausoleum, three storeys high, 10.80 meters long by 7.20 wide (18 × 12 braccia in Condivi's account[3]) and a spacious burial chamber within (Figs. 5, 6). Its exterior was articulated by a continuous sequence of niches, each niche housing a Victory group flanked by statues of prisoners bound to pilaster herms, all well above natural size. Overhead, the corners of the first platform were to support four enormous statues—the *Moses* as executed sits 2.50 meters high; and from between these four *colossi* a stepped pyramid was to climb to a second platform, upon which were two angels carrying the bier of the Pope.[4] In addition, the project called for a profusion of decorative sculpture and architectural ornament, plus half a dozen bronze reliefs representing the exploits of the Pope. A tomb structure of sovereign grandeur—"surpassing in beauty and richness of ornament all ancient and imperial tombs" (Vasari).

But—as a few sober statistics reveal—it was a utopian vision. The count of statues alone is appalling. Condivi, Michelangelo's disciple and loyal biographer, cautiously puts their number at "more than forty"; modern estimates range from forty-seven to fifty-four.[5] This is well in excess of what Michelangelo's entire professional life would allow him to execute. Yet the agreement, as we learn from the sculptor's letter of May 2, 1506,[6] stipulated a term of five years for the entire work: fifty-odd over-lifesize statues to be carved within sixty months—more than eight of which, Condivi tells us, Michelangelo spent at Carrara, quarrying the blocks. This left less than fifty-two months to complete the assignment. Could even a Michelangelo meet such terms? Consider the comparative figures: the carving of the *Pietà* (1498–99) had taken longer than eighteen months.[7] And Michelangelo's contract of 1503 with the Cathedral Chapter of Florence had allowed a full year for each over-lifesize Apostle. Yet the sculptor was binding himself for five years to produce carvings such as the *Moses* and the Louvre *Slaves* at the rate of one every month. Only he could have conceived so unrealistic a scheme, and persuaded the Pope of its feasibility. But we shall never know whether, in projecting the work, he duly considered the deadline in 1510, or simply repressed the time factor while envisioning for himself one overwhelming

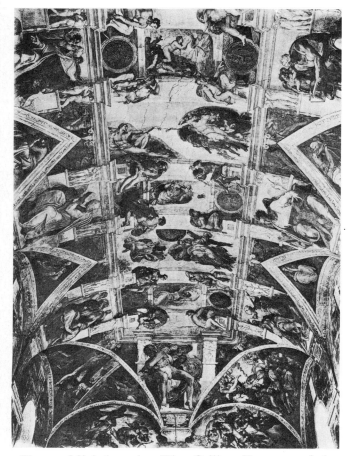

Fig. 2. Michelangelo: The Ceiling Frescoes of the Sistine Chapel. Rome, Vatican

Fig. 3. Ceiling of the church of S. Giuseppe Maggiore, Naples, after World War II bombing

Fig. 4. Aristotile da Sangallo: Copy after Michelangelo's cartoon for *The Battle of Cascina*. Holkham Hall, Earl of Leicester

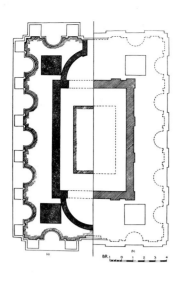

Fig. 5. Reconstructed plan at ground level (left) and at platform level (right) of Michelangelo's 1505 project for the *Tomb of Julius II* (From Weinberger, fig. 1)

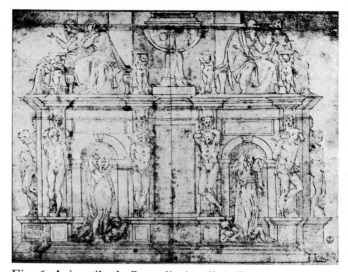

Fig. 6. Aristotile da Sangallo (attrib.): Lower storey of modello for Michelangelo's *Tomb of Julius II*. 1505–13. Florence, Uffizi, Gabinetto dei Disegni, no. 124

creation with which his life should be identified, as Dante's was with the *Divine Comedy*, or Ghiberti's with the *Gates of Paradise*.

But what gave Michelangelo the scale of his project? What determined those grandiose dimensions which in turn dictated the proliferation of statues? Since megalomaniac ambition does not in itself produce precise measurements, there remains only one plausible answer—that the artist's imagination was investing a particular site which necessitated these very proportions. The choice of that site became, in retrospect, the crucial decision of Michelangelo's life, and we must pause to consider it.

The Pope intended, of course, to be buried in St. Peter's. But where in the old Constantinian basilica should the giant mausoleum be placed (Fig. 8)? Condivi tells the story as his master, almost fifty years later, presumably wanted it told. On seeing the artist's design, he writes, "the Pope sent Michelangelo to St. Peter's to see where he could conveniently install the tomb." This suggests that Michelangelo needed prodding to bethink himself of the problem, but he must have pondered it from the beginning. He knew the building, and designing at random was not his way. To continue Condivi's account: "The form of (Old St. Peter's) was at that time a Latin cross, at the head of which Bernardo Rossellino had already begun to erect the new choir for Pope Nicolas V (1447–55), and it was already built to a height of three braccia above the ground when the Pope died. To Michelangelo this place seemed most fitting, and returning to the Pope he set forth his opinion to him; adding that if His Holiness was of the same mind it would be necessary to complete the construction and put a roof on it."[8]

The implications of these innocent words are staggering. The plan of Old St. Peter's (Fig. 7) shows plainly enough that the ancient five-aisled basilica could not accommodate a free-standing pile 23 feet wide and almost 35 feet in length. Accordingly, Michelangelo was informing the Pope that the Tomb should be placed in the projected choir, begun half a century earlier by the Florentine architect Rossellino. The "Rossellino Choir"—laid well outside the old apse and on an enormously enlarged scale—would have extended the ancient structure westward and initiated a far-reaching program of reconstruction. But it had been abandoned, its walls in 1505 rising, according to Condivi, only 1.75 meters above ground. Its massive foundations, however, were sound, and they would determine the new Choir's form and proportions—a vaulted rectangular structure terminating in polygonal outer walls that enclosed an interior hemicycle under a semidome. Completed and joined to the old building, the Rossellino Choir would give the Basilica a new spatial climax, rising high over the altar and baldachin that covered the grave of St. Peter in the old apse.

This, then, was the housing Michelangelo proposed for the Julius Tomb, and a comparison of its dimensions with those of his sculptural project shows such remarkable correspondences as to suggest that, in the artist's mind, Choir and Tomb had from the beginning formed one integrated conception. The width of the Tomb, 7.20 meters, is very nearly one-third of the clear interior width of the Choir—about 23 meters; and its length, proportioned to its width in a ratio of 3 to 2, matches the length of the Choir, excluding its apse. Thus—considering the plan alone—the whole Rossellino Choir would have become an ambulatory for the Pope's Tomb. In elevation, the pyramidal top of the Tomb, where two angels sustained the bier of the deceased Vicar of Christ, would have been seen against the conch of the apse, traditionally a symbol of heaven. And the Tomb's inner burial chamber, its door facing the nave, showed a hemicycle at the far end, so that its interior cavity answered to the curved apse of the Choir. The Tomb, then,

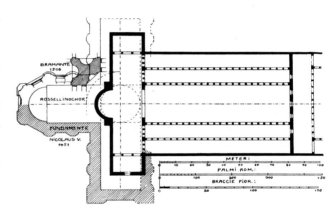

Fig. 7. Plan of Old St. Peter's showing the Constantinian Basilica, the fifteenth-century Rossellino Choir, and the northwestern pier of Bramante's crossing

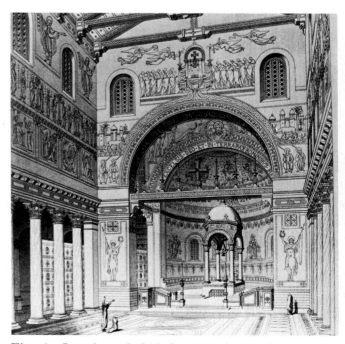

Fig. 8. Interior of Old St. Peter's, Rome, fourth century, looking west towards apse and St. Peter's tomb; as reconstructed by Letarouilly, 1882

9

was planned as if Tomb and Choir conditioned each other; the Tomb's elevation to be canopied by the Choir vault; its flanks to be paralleled at apt distances by the walls; and its inner chamber epitomizing the curve of the outer surround. The correspondences between the Choir foundations and the projected mausoleum explain how the sculptor arrived at his inordinate measurements. The scale of the Tomb, the proportioning of its component units, and the quantity of its sculptures—all were dictated by the imperative to inform a pre-formed spatial environment. The work was to be lodged in its master sphere, its every dimension responsive to its container. Meanwhile, such questions as feasibility, and whether those fifty sculptures could be produced within even a lifetime, were too paltry to weigh against the necessity which the scale of the Rossellino Choir imposed.

The Rossellino Choir would have to be finished and vaulted before the Tomb could be assembled. But once finished and filled, the new choir would become a shell for the Pope's mausoleum and a showcase for the masterwork of his sculptor, commanding the length of the Basilica as a man's head commands the height of his body. An imperial pagan conception, a personal apotheosis, the pride of the artist dragging with it the pride of the Pope and, in the process, dwarfing the Tomb of the Apostle in whose honor St. Peter's Church had been built.

The Pope rejected Michelangelo's scheme, turning instead to a new project: the building of a new Basilica of St. Peter's, to be designed by Bramante. And from the moment the decision to build was taken, the Pope's interest in the Tomb lapsed.[9] By the beginning of 1506, Julius' enthusiasm was wholly diverted to the new St. Peter's, whose foundation stone he laid on April 18, while the sculptor, in hurt and frustration, fled Rome. Michelangelo did not answer the Pope's summons again until eight months later when forced to present himself—in the words of his wounded pride—"with a rope round his neck."[10]

There is documentary indication that Julius' resistance to Michelangelo's scheme arose not so much from superstitious fears about a premature sepulchre,[11] nor from its scale, which the della Rovere Pope had approved with delight, but from its required location at the head of the church, towering over the Tomb of the Apostle. Most significant is Michelangelo's letter of May 2, 1506, written to his friend at court, the Florentine architect Giuliano da Sangallo.[12] Michelangelo, sulking in Florence, requests that Giuliano "inform His Holiness that I am more than ever ready to continue the work. But if it is indeed his wish to execute the Tomb, he should not trouble himself where I do it [i.e. whether in Rome or Florence], provided that at the end of five years, as we agreed, it shall be set up in St. Peter's, *wherever he chooses . . .*" (emphasis added). The words suggest that what Pope Julius resisted was the combination of Michelangelo's imperial project with its proposed location.

Our second document, which refers to an earlier moment, is a passage in Vasari's life of Sangallo, wherein Michelangelo's friend seems at pains to rescue the Tomb project: "When Giuliano da Sangallo returned to Rome, the question of whether the divine Michelangelo should make the Tomb of Julius II was being discussed. Giuliano encouraged the Pope in this enterprise, adding that it seemed to him that they should erect a special chapel for the Tomb, and not place it in Old St. Peter's, since there was no room there, and since this chapel would make the work more perfect."[13] In other words: given the scope of the enterprise on which Michelangelo is embarked, and seeing that Old St. Peter's cannot accommodate it; and (implicitly, by omission), since the proposal to use the Rossellino Choir is not to be entertained, there is no alternative but to erect a separate memorial chapel. It is clear, then, that Julius was still considering the Tomb project after rejecting Michelangelo's proposed site. Vasari continues: "After many architects had executed drawings, the idea was so highly esteemed that, instead of a chapel, the great undertaking of a new St. Peter's was begun."

Condivi's version deviates somewhat from that of Vasari, but he too posits a direct causal connection between Michelangelo's project and the architectural conception of new St. Peter's. Following Michelangelo's proposal to finish the Rossellino Choir for the purpose of housing the Tomb, the Pope consults his two architects—"and sending Sangallo and Bramante to see the place, the desire took the Pope to have the whole church rebuilt, and when he had had several drawings made, he accepted that of Bramante. Thus Michelangelo became the cause of the finishing of that part of the building which had already been begun [Bramante's short-lived choir on the Rossellino foundations], and of the Pope's desire to renew the rest in accord with another finer and more grandiose plan."[14]

According to Michelangelo's two biographers, both writing long after the events described and more or less to the master's dictation, it was the scale of the

projected Tomb, and the consequent need for a major containing structure, that turned the Pope towards the even grander, bolder, purely architectural scheme. For the sculptor, a matter of bitter irony. A vast new choir on the Rossellino foundations was indeed raised—but not to glorify the Pope's sepulcher, and not to display Michelangelo's art, but *ad majorem Dei gloriam*, and to honor the Prince of Apostles. Left unstated by Condivi as well as Vasari is the change of heart implicit in the Pope's change of plans; that his attention turned from his own tomb to the tomb of St. Peter, that is, to a project of reconstruction that would convert the old basilica into a giant martyrium.

ON May 6, 1513, following the completion of the Sistine Ceiling and shortly after the death of Julius II, Michelangelo signed a new contract for the Tomb with the executors of Julius' will—the Pope's nephew, Cardinal Aginensis, residing in Rome, and Francesco Maria della Rovere, Duke of Urbino. The terms of the contract are as utopian as those agreed to eight years before. The Tomb was not to go into St. Peter's and it was to be no longer free-standing, but attached by one short side to a wall in whatever Roman church would be chosen to house it (Fig. 9). The time allotted for its execution was extended to seven years, and the number of marble statues reduced to thirty-eight. Yet the new project was, in some respects, grander than the original: Michelangelo's part of the contract contains an explanatory comment of the kind a professional makes to a layman: five figures rising against the rear wall at the top of the monument, including a Virgin and Child in glory, were to be larger than all the others "as being further from the eye."[15] With these words the artist justified what must have entered the contract at his insistence—a further aggrandizement of the uppermost figures, and consequently a notable increase of the overall height. Apparently, as the design had forfeited the architectural canopy of the projected choir vault of St. Peter's, the work must now incorporate its own celestial apparatus—a glory, or "cappelletta"; the Tomb was to become more visionary, and more stupendous and overwhelming than ever.[16]

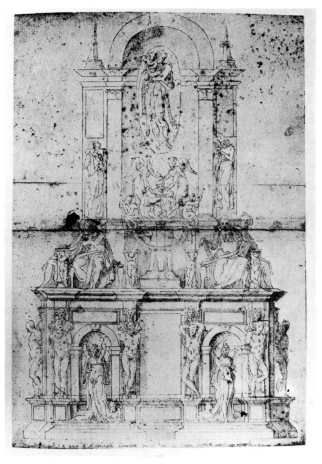

Fig. 9. Jacomo Rocchetti: Copy after Michelangelo's drawing for the 1513 project for the *Tomb of Julius II*. Berlin, Kupferstichkabinett

For the next three years Michelangelo was left in peace to work on the Tomb. Pope Leo X, a Medici whom Michelangelo had known since boyhood, wished to please the Duke of Urbino, and the artistic needs of the Vatican were fully satisfied by the genius and the administrative efficiency of Raphael. And Michelangelo seems at first to have thrown himself into his task in full earnest, designing and overseeing the execution of architectural members and ornaments. The *Moses* and probably the unfinished *Slaves* at the Louvre emerged during these three undisturbed years. But these were three figures out of the thirty-eight called for in the contract, with thirty-four more, including the five colossi, to be delivered in the remaining four years. Michelangelo, now finally having his way, must have realized that his way was impossible. For the first time, he was showing signs of slowing down. Not from exhaustion—for the *Moses* is not the product of flagging energy; but as if in inward alienation from the dream of his youth. Yet, though the impossibility of his undertaking must have become more apparent with each passing month, he did not, like a man of affairs, seek for some compromise or realistic adjustment, but simply wished the problem away and so aggravated his plight. Aged forty-one (with forty-eight years remaining to him), he began to speak of himself as an "old man."

In 1516, Leo X, having made a triumphal entry into his native Florence, decided that San Lorenzo, the family church of the Medici, needed a marble façade commensurate with the dignity of his house. A number of Florentine architects were asked to submit designs, but there is no indication that Michelangelo, not an architect and pre-occupied with the Tomb, was considered eligible. Our evidence for Michelangelo's movements at this juncture is slight, and scholars differ in its interpretation, but it appears that the artist himself offered to design and execute the façade: an architectural screen studded with marble sculpture on a scale comparable to that of the Tomb. Given the hopelessness of his situation, his offer to undertake the San Lorenzo façade may have been made from a longing to escape a defeating predicament and to have his creativity freed and refreshed by a new project. Only a papal commission could extricate him without loss of honor from his obligation to Julius' heirs.

Michelangelo soon regretted his offer and tried in vain to withdraw it. But the Pope, who had made no prior effort to interfere with the sculptor's plans, knew better than to let Michelangelo slip from his grasp, once the offer was made. Michelangelo was to find himself obliged to produce both Tomb and façade at the same time. During the next quarter century, he would live in the crossfire of

irreconcilable, competing claims—those of the Julius heirs seeking their due, and the demands of successive popes, upon whom Michelangelo later laid all blame for the failure of the Tomb project.

In July, 1516, a new contract for the Tomb was negotiated with the della Rovere. The original free-standing mausoleum of 1505, reconceived as a three-sided promontory in 1513, now shrank into a kind of façade, projecting from its retaining wall by only a single bay. The number of statues on it dwindled to twenty. And the time allowed for the completion of this curtailed program was extended —with a due-date in May, 1522, six years away.[17] Michelangelo was to work on the Tomb and the San Lorenzo façade simultaneously.

That he did not is apparent. The next four years were largely lost in quarrying marble for the façade, while a devoted friend in Rome handled the delicate tasks of pacifying the Cardinal Aginensis, and prodding the master to "finish the work, and thus make liars of those who say that you are doing nothing and that it will not be finished."[18]

By the end of 1518, Michelangelo, now wholly caught up in the façade project, had reason to feel persecuted. The Cardinal was growing impatient—"we desire to see this Tomb finished," he writes repeatedly, and, in the spring of 1519, sends an envoy to Florence to see how much had been done. Michelangelo's friend in Rome makes a helpful suggestion—that some of the statues might perhaps be executed by other sculptors.[19]

Meanwhile, Leo X was losing patience over the delayed San Lorenzo façade; without previous warning to Michelangelo, he cancelled the contract (March, 1520). The sculptor was to undertake a more urgent task—the creation of a worthy sepulchre for the deceased of the House of Medici. Six months later, Cardinal Aginensis, who had been the chief goad for the Julius heirs, passed away; and a letter from Sebastiano del Piombo, the painter friend who now became Michelangelo's spokesman in Rome, articulates with libertine insolence what the tormented artist would not have dared say in his own behalf. "Now that Monsignor de Aginensis is dead, you could make a digression with regard to the tomb...", he writes, adding that he had passed the suggestion on to the Pope.[20] Within a month of this letter, Michelangelo accepted the commission for the Medici Chapel, a "digression" that was to engage his energies for the next thirteen years.

Except for one brief interlude: Leo X died on December 6, 1521 and his successor, elected in January, 1522, was the Dutchman Adrian VI, a devout puritan who disdained the pagan worldliness of his predecessors and strove instead to initiate the much-needed reform of the Church. Adrian gave fair hearing to the Duke of Urbino's complaint about the delinquency of the sculptor, whose term for delivery of the Tomb had expired in May, 1522. He ordered the sculptor to fulfill his obligation, and it was probably during Adrian's short-lived Papacy that Michelangelo seriously reconsidered the Tomb design of 1516 and executed several more statues.[21]

But Adrian died in the autumn of 1523, and the wordlings of the Sacred College, terrified by the taste of reform, hastened to elect a successor who would restore the jovial days of Leo X. On November 19, 1523, Leo's nephew Cardinal Giuliano de' Medici, First Citizen of Florence, ascended the Papal throne as Clement VII. And almost immediately, Michelangelo was told to proceed with the Medici Chapel—let the Julius Tomb be executed by others. The heirs of Julius protested, claiming their rights, and what follows is a disheartening tale of see-sawing demands, threats of litigation, enforced concessions, and further erosions of the design.

1525. He had passed fifty. The great rivals, Leonardo, Bramante, and Raphael, had long since died. Pre-occupied with the Medici Chapel and the Laurentian Library, and importuned by new assignments from Clement VII, Michelangelo complained of feeling old and offered full monetary restitution to the della Rovere so as to be rid of all further obligations towards the Tomb; then proposed to have it finished by others, on a scale further reduced. He suggested a simple, old-fashioned wall tomb, so mean in conception that the della Rovere were appalled —in Michelangelo's words, "not without reason"; and hoped that the Pope would allow him to get it done since he wants "to extricate himself from this obligation more than to live."[22]

Michelangelo had, as he put it, become an impostor against his will. But there are strong indications that his predicament was internal. He had lost his artistic faith in the Tomb—not in the individual statues carved for it, but in the Tomb as a containing scheme that lends necessity to the parts. The matrix had crumbled, and so the two early *Slaves* (Louvre), grown too shallow to activate what had

become flat wall decoration, were given away. Other statues (including possibly the *Madonna Medici*) were lifted from the Tomb project and diverted to other uses. In Michelangelo's mind the Tomb was already dismantled.

ALL work for the Medici ceased with the Sack of Rome, June 6, 1527. For eight months the German and Spanish soldiery of Charles V besieged the Pope in the Castel Sant'Angelo. Florence seized the occasion to renounce Medici rule, and for the last time proclaimed herself a Republic. Michelangelo, a staunch Republican, placed himself at the City's disposal. When Pope and Emperor made peace and a combined Papal-Imperial army marched on Florence, he was charged with the City's fortifications.

In Michelangelo's biography this phase forms a poignant chapter, but it has the character of an interlude. Florence was beleaguered and starved, at last betrayed into surrender (August 12, 1530), and proclaimed a hereditary Medici dukedom. The Republican leaders were exiled or executed, and Michelangelo went into hiding. But within two weeks of the City's surrender, the Pope ordered search to be made for him, with promise of full pardon; whereupon Michelangelo gave himself up.[23] Under pressure from Clement VII, he resumed work on the Medici Chapel and the Laurentian Library—exposed as before to the mounting exasperation of the Duke of Urbino.

Negotiations dragged on, driving the aging master into deeper despair, the Pope gradually realizing how much Michelangelo's peace of mind, his working capacity, even his health, depended on reaching a settlement. Clement insisted on his share of Michelangelo's genius, but he also had a genuine warm regard for the man. Determined "to make him younger by twenty-five years," Clement commanded Michelangelo, on pain of excommunication, to work henceforth only on the Julius Tomb and the Medici projects. Then, in April, 1532, he succeeded finally in mediating another contract, the fourth in the series. Financial adjustments were made—the artist to pay 2,000 ducats and return his house in Rome to the della Rovere. The Tomb would be set up in the titular Church of Julius' Cardinalate, S. Pietro in Vincoli. Michelangelo was to furnish a fresh design which must include the long-finished architectural carvings, as well as six statues already existent in Florence and Rome, to be completed by his own hands. Five further figures were to be executed from his designs by other sculptors payable out of Michelangelo's pocket. It was further agreed that during the next three years the Pope would allow the sculptor two months per year in which to work on the Tomb. It was to be finished by 1535.[24]

During the two years following, while the site in S. Pietro in Vincoli was being prepared, Michelangelo moved back and forth between Florence and Rome, working on the Medici projects as well as the Tomb sculptures. Then, early in 1534, and with only a year to go before the new expiration date, Clement VII broached a new project: Michelangelo was to paint a Last Judgment in the clerestory zone of the altar wall of the Sistine Chapel.[25] The artist's immediate response to this assignment is not recorded, but it must have been in connection with it that he moved permanently to Rome. He arrived on September 23, 1534, two days before the Pope's death.

If Michelangelo thought that Pope Clement's passing would enable him at last to unburden himself of his life's debt, he was soon undeceived. The newly elected Vicar of Christ (Fig. 10) declared angrily that he had not waited thirty years to become Pope in order to see Michelangelo work for others. "Where is that contract," cried Paul III, "I want to see it that I may tear it up."[26] Michelangelo was given an official appointment as "Supreme Architect, Sculptor, and Painter to the Apostolic Palace." His duties were to begin with the painting of the *Last Judgment*—a project which expanded in Michelangelo's hands to overspread the entire altar wall, 17 meters high (Fig. 11). Inevitably, the term for completing the Tomb, set in the latest contract for 1535, was again allowed to elapse, but the Pope, in a *motu proprio* of November 17, 1536, let it be known that the artist, "from just and legitimate *impedimenti*," could not fulfill his obligations to Julius' heirs until the great fresco should be completed.[27]

While Michelangelo labored on the *Last Judgment*, Duke Francesco Maria died (October, 1538); and his heir, Guidobaldo, unembittered as yet by delay and frustration, assumed a conciliatory attitude. In a gracious letter to the sixty-three year-old artist, the young Duke wished Michelangelo good health—"that you may honor the sacred bones of him who, in life, honored you."[28] Michelangelo himself intended no less: Julius II had now been dead twenty-five years; the operative design for his Tomb had been finally brought down to manageable

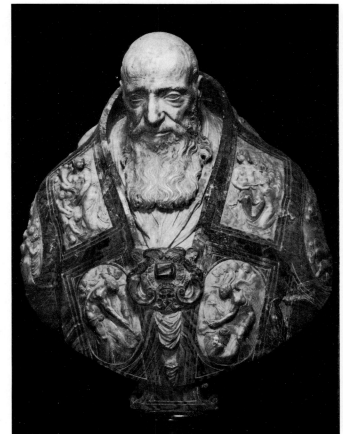

Fig. 10. Guglielmo della Porta: *Pope Paul III*. Marble. Naples, Museo Nazionale di Capodimonte

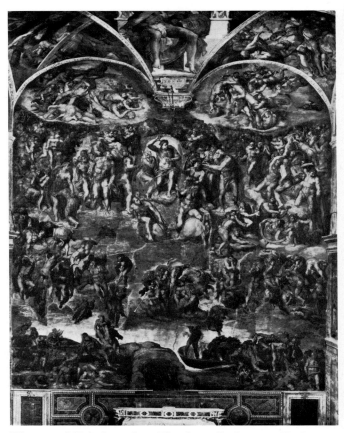

Fig. 11. Michelangelo: *The Last Judgment*. Vatican, Sistine Chapel.

13

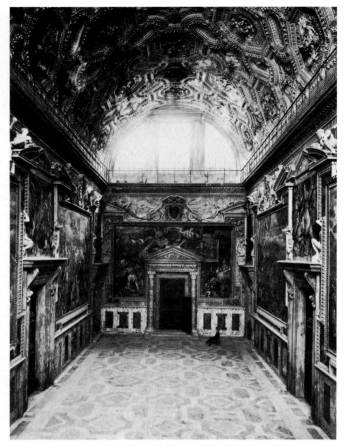

Fig. 12. Rome, Vatican Palace, Sala Regia and entrance to the Cappella Paolina

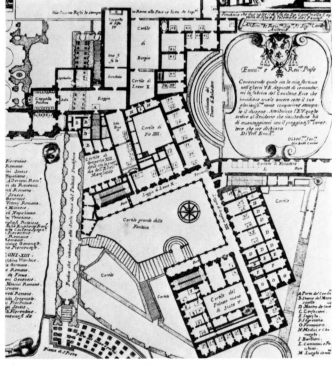

Fig. 13. Plan of the Vatican complex in 1669. The north-eastern angle of St. Peter's is at upper left. The Sistine Chapel is at top, left of center, the Sala Regia and the Cappella Paolina immediately below (Ehrle-Egger, *Die Conclavepläne*, pl. 20)

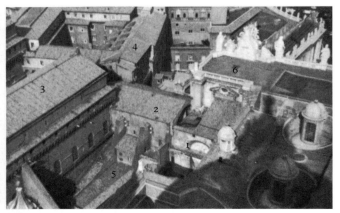

Fig. 14. View to north-east from the dome of St. Peter's: 1. Cappella Paolina; 2. Sala Regia; 3. Sistine Chapel; 4. Sala Ducale; 5. Scala Regia; 6. Portico of St. Peter's

proportions; and the Sistine altar wall was to be positively the last digression. But even before the great fresco was finished, Michelangelo knew that the decision was not in his hands. Nearing completion was the Pope's most cherished architectural project in the Vatican Palace, the Sala Regia and, adjoining it, the Cappella Paolina (Figs. 12–14). Paul III would have none but Michelangelo paint the two frescoes in the new Chapel—let the Tomb wait.

A new Pope in the Chair of St. Peter and a new lord on the ducal throne of Urbino, but the changed cast rehearsing the old written roles. And the logic of these repetitions is inescapable: while the heirs of Julius had no choice but to press for the delivery of the Tomb, if only to save face and recover their large investment, no ruling Pope (unless he was Dutch) could let Michelangelo's energies be diverted by the della Rovere to monumentalize the memory of their ambitious kinsman four papal reigns ago. Paul III, the great Roman patrician, could not, on their account, deprive the Church of Michelangelo's genius, nor himself of the sovereign glory that consists in calling the greatest art into being. The enforced re-deferments, returning inexorably like a fugal theme, and the fresh labors heaped upon Michelangelo, invest the artist's biography with the formal quality of a Herculean myth or a moral parable; from the youthful hubris that promised superhuman performance, down through a fated life of recurring nemesis. We read the data, the factual details, the names and documents and changing particulars of each assignment, all with their superficial stamp of specificity. But underlying all these, and ever more palpable to the victim, is his impotence to escape the cross-fire he had drawn, the futility of his trying to break the chains.

Desperately, Michelangelo pleaded that he was unable. He was in his sixty-sixth year—his health wasting, his eyesight failing; with life running out, his obligation to the heirs of Julius could be staved off no longer. And then, it seems, there occurred an unheard-of event. The seventy-three-year-old Farnese Pope, "bringing with him eight or ten Cardinals," came to visit Michelangelo in his workshop at the old meat market near Trajan's Forum. As Condivi tells it, "He wished to see the statues already carved for the Tomb." It was then that the *Moses* was beheld for the first time, the Cardinal of Mantua observing that "this statue alone was enough to do honor to the Tomb of Pope Julius."

Michelangelo at last consented to undertake the Pope's commission, provided that His Holiness would intercede for him with Duke Guidobaldo, help to settle accounts and free him from the humiliating charge that he had taken great sums of money for the Tomb without keeping his part of the bargain. Under Papal pressure, the Julius heirs yielded to yet another contract;[29] the simple wall tomb was further simplified and the master's personal share in the execution reduced to only three figures, the seated *Moses* to be flanked by statues of Rachel and Leah. Michelangelo, satisfied, agreed to paint the frescoes of the Pauline Chapel, on condition that the new agreement was ratified. But as the ratification was ominously delayed, owing to the continued resentment of the della Rovere, the old artist's anxiety rose again and crippled his will to work.

Two letters survive to record Michelangelo's mood on the eve of setting his hand to the Paolina frescoes. In the fall of 1542 he wrote to the Pope's nephew, Cardinal Alessandro Farnese:

> Monsignore—Your Lordship sends to tell me that I should paint and not worry about anything else. I reply that one paints with the head and not with the hands, and if one cannot concentrate, one brings disgrace upon oneself. Therefore, until my affair is settled, I can do no good work. The ratification of the last contract hasn't come, and on the strength of the other—the one drawn up in Clement's presence—I am stoned every day, as if I had crucified Christ. . . . It is borne in upon me that I lost the whole of my youth, chained to this Tomb, contending, as far as I was able, against the demands of Pope Leo and Clement. . . . But to return to the painting. It is not in my power to refuse Pope Pagolo [Paul] anything. I shall paint ill-content, and shall produce things that are ill-contenting . . .[30]

To his close friend and devoted manager of affairs, Luigi del Riccio, Michelangelo wrote:

> Messer Luigi, dear friend—Messer Pier Giovanni [Master of the Robes to Paul III] is continually urging me to start painting. I don't think I can for another four to six days yet, because, as anyone can see, the *arricciato* [the rough plaster undercoat] isn't dry enough for me to begin. But there is

another thing that worries me more than the *arricciato* and prevents me not only from painting, but from living life at all; namely that the ratification hasn't come. I realize that I'm being put off, so that I'm completely desperate. . . . Painting and sculpture, hard work and fair dealing have been my ruin and things go continually from bad to worse. It would have been better had I been put to making matches in my youth, than to be in such anguish. I'm telling you this . . . because . . . you can apprise the Pope of it, so that he may know that I am unable to live life at all, much less to paint. And if I have given an expectation of starting work, I've given it in the expectation of receiving the ratification, which should have been here a month ago. I will not bear this burden any longer, nor be insulted as a cheat by those who have deprived me of life and honor. Only death or the Pope can release me.[31]

Finally, before the end of November 1542, the signed paper from Urbino arrived, and Michelangelo went to work in the Chapel. The "Tragedy of the Tomb had an end at last," writes Condivi. But the trauma of the Tomb had been too deeply invliscerated to come to an end while Michelangelo lived. His temper was constituted to discount personal triumphs with irony and to feed upon failure with exaggerated self-pity.[32] Though, in his later years, he used all his conscious defenses to clear himself of responsibility, in the final analysis his life's "failure" owed less to the claims made upon him than to the initial surge of his own vision. And his deepening sence of impotency conditioned the image he formed of himself as captive and victim—an image formed perhaps as a needed correlative to the god-like sovereignty he exercised as creator. Thus the "Tragedy of the Tomb" shaped Michelangelo's character as it stylized his destiny. Protracted into the 1540s, it determined the conception of the Pauline frescoes, their emphasis on ordeal and, beneath the manifest universality of their theme, their subjective, confessional aura.

THE Cappella Paolina was built by order of Paul III as part of a major reconstruction of the central staterooms of the Vatican Palace. The work was entrusted to the architect Antonio da Sangallo the Younger, and progressed speedily from 1538 onward (Fig. 15). In January, 1540, Masses were said in the new Chapel. Christoph L. Frommel, in an exemplary study of "Antonio da Sangallos Cappella Paolina" (1964; see Bibliography), has analyzed the history and structure of the Chapel, the place it holds in Sangallo's stylistic development, the role the Chapel was meant to play as the connecting link between the Vatican Palace and St. Peter's Basilica, and the reflection in its design of its dual function—as Chapel of the Sacrament and Chapel of the Conclave.

In 1609 the chancel of the Pauline Chapel was pulled down, while the north wing of the portico of St. Peter's, which grazes the east wall of the Paolina, was being erected (Figs. 13, 14). The chancel was later rebuilt, but to a new design, twice as deep as Sangallo's and with a divergent system of articulation.

The documents concerning the decoration of the Cappella Paolina were assembled and published in 1934 by Baumgart and Biagetti and again, with commentary, by Tolnay (see Bibliography). It appears from letters dated November, 1541 that the Pope had determined—even before the unveiling of the *Last Judgment*—that Michelangelo should paint the walls of the Chapel.[33] Several records of payments refer to the preparation of colors, scaffolding and wall surface during 1542, the actual fresco painting being begun in November.[34] But Michelangelo's pace was now somewhat slower than in his younger years. Interrupted by illness during the summer of 1544, he did not complete the first fresco until July 12, 1545, when Paul III came to inspect it.[35]

None of the documents tells which of the two frescoes was painted first; the priority of the *Conversion* is inferred from its closer stylistic ties to the *Last Judgment*, from the magnified scale of figures in the St. Peter fresco, and from the latter's subject, indicating a change of program after 1546 (see p. 45 below). The wall for the second fresco was being prepared in March, 1546. But in the summer of that year Michelangelo was appointed architect of St. Peter's, and his new responsibilities may have prevented him from starting the second fresco before 1547; the work was completed by December, 1549.

Valuable data on Michelangelo's working procedure and on the present condition of the two frescoes have been published by Baumgart-Biagetti and Tolnay.

Except for the two Michelangelo frescoes, no part of the present decoration of the Chapel corresponds to the intentions of the men who designed it (Fig. 16).

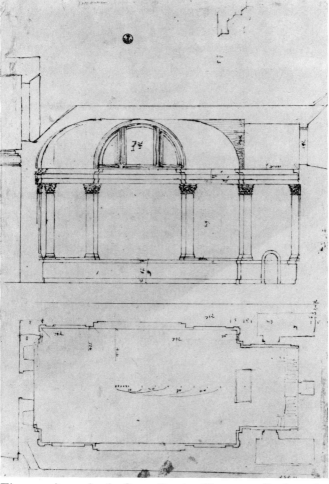

Fig. 15. Antonio da Sangallo the Younger: Projected longitudinal section and plan of the Cappella Paolina. Florence, Uffizi, Gabinetto dei Disegni, no. A1125

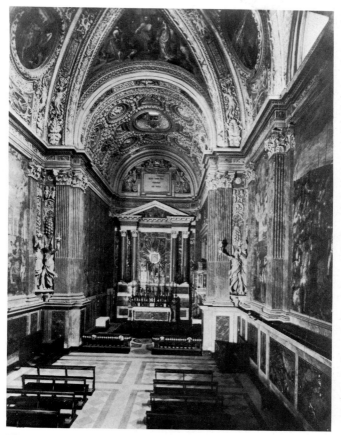

Fig. 16. The Cappella Paolina, Vatican Palace. View towards chancel

According to Vasari, Michelangelo furnished designs for a stucco ceiling to be executed by Perino del Vaga.[36] The work, apparently, was never realized, and Perino died in 1546. Michelangelo also supplied designs for the decoration of the wall panels flanking the frescoes. These and perhaps a lunette over the entrance door representing Christ driving the Moneychangers from the Temple, were to have been executed by Marcello Venusti;[37] but they too remained unrealized, owing perhaps to the Pope's death in 1549. The present additional frescoes by Lorenzo Sabbatini and Federico Zuccari date from the late sixteenth century and misrepresent the setting Michelangelo planned for his frescoes (Fig. 43).

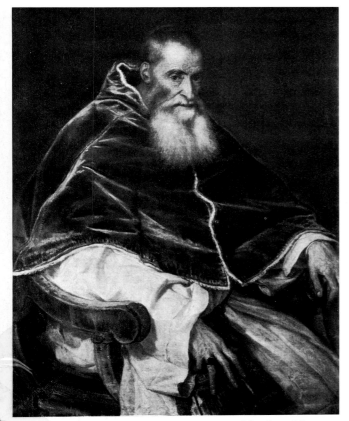

Fig. 17. Titian: *Pope Paul III*, 1543. Naples, Museo Nazionale di Capodimonte

THERE exists no authentic record concerning the meaning of the work to the man who called it into existence—Paul III, the last of the Renaissance Popes (Fig. 17). His beginnings as Cardinal Alessandro Farnese had been clouded in scandal. It was said that the Red Hat had been conferred on him by the Borgia Pope Alexander VI as a favor to Farnese's beautiful sister, Madonna Giulia, the Pope's mistress. But, writes Guicciardini on the closing page of his *History of Italy* (1537–40), "he exercised his office as cardinal with greater skill than that whereby he had acquired it."[38] As Papal legate to the City of Rome, he had shown himself a just and generous ruler. And as member of the Sacred College, he gradually won the respect of all parties, so that, when the death of Pope Clement on September 25, 1534, finally cleared his way, he was elected by acclamation, almost without the formality of a ballot. According to Guicciardini, "the cardinals concurred most voluntarily in electing him because, since he was already almost a septuagenarian and considered to have a weak constitution and not in good health (which opinions were spread by him with considerable skill), they hoped that his reign as Pontiff was bound to be brief."

The Conclave met on the night of Pope Clement's death and against no resistance chose Paul III. "Not for a very long time," writes Pastor, the chronicler of the Popes, "had a Conclave done its work so quickly."[39] The election, in its unanimity and its marvelous suddenness, seemed like the working of Grace. And the new Pontiff, taking the name of the Apostle whom Christ had called his *vas electionis*, may have seen himself as another "vessel of election." (His habitual dilatoriness in making decisions was to earn him the title *vas dilationis*.[40]) Following his elevation, he displayed a special devotion to the Feast of the Conversion of Paul (January 25th), a festival which he celebrated at first in St. Paul's outside-the-Walls, and to which he dedicated the Cappella Paolina.[41]

But the decoration of the new Chapel carried more than a personal meaning. It was conceived when the Reformation was at its height, at a moment of deepest peril for the Papacy and the Catholic cause, before the effects of Paul III's reign —the Reform of the Curia and the Sacred College, the launching of the Jesuit Order, the revival of the Inquisition, and the Council of Trent—restored initiative to the Roman Church.[42] Anticipating the resurgence known to us as the Counter-Reformation, Michelangelo's frescoes of Paul and Peter constituted a passionate reaffirmation of the claims of the Roman See. They belong to a phase of spiritual regeneration—before Catholicism, in reaction to the Protestant challenge, took more rigid forms.

The Cappella Paolina never achieved the importance intended for it. Its location doomed it to minor status. At the end of the century, the eastward extension of the nave and portico of St. Peter's by-passed the Chapel and closed off its connection with the Basilica. The great expansion of the College of Cardinals rendered the interior too small to serve as the chapel of the Conclave.[43] And the style of the frescoes was too forbidding to make the Chapel—like the Cappella Sistina thirty paces away—a center of artistic pilgrimage. Until recently, the very existence of the Cappella Paolina was known to surprisingly few.

II. The Fame of the Frescoes

THE Paolina frescoes are Michelangelo's gift to the twentieth century; no earlier age was willing to have them. Their unveiling in 1550 created no stir, and the literature of the later sixteenth century tries to think them away. Only Vasari and the loyal Condivi describe them; while two younger writers respond with brief censure. The rest is embarrassed silence.

This cold reception seems the more painful when one considers the awe in which Michelangelo was then almost universally held. At the mid-sixteenth century, Michelangelo's fame is such as even religious founders achieve only in retrospect. He is the *uomo divino*, the omnificent artist whose genius surpasses the capacities of the human species. His presence in the world seems to give a discernible shape to time itself—and to his contemporaries a sense of living at its point of climax. So the painter Battista Franco thanks his good fortune to have been born in Michelangelo's day; and Vasari calls Paul III "most happy and fortunate" in that God consented to confer "the marvel of our century"—the fresco of the *Last Judgment*—under his rule.[1] "The world has many kings," writes Aretino, "but only one Michelangelo." For Antonio Francesco Doni of the Florentine Academy, Michelangelo is "the World Oracle." The sculptor Vincenzo Danti proclaims that he is to be "followed eternally." Claudio Tolomei reports that "all painters worship him as master, as prince, even as the god of design."[2]

To men in a worshipful mood a failing god is an embarrassment, and the Paolina frescoes were felt to be failures—void of grace, dissonant in composition and color. Of the two paintings, one seemed too strident, the other too rigid, and both equally uninviting and bleak. Even Vasari, though his account of the frescoes is enthusiastic, betrays ambivalence when he tries to condone their austerities:

> Michelangelo . . . only devoted himself to perfection in art, for we have here no trees, buildings, landscapes, or any variations or charms of art, because he never cared for such things, not wishing, perhaps, to lower his great mind to them.[3]

Twenty years later, the painter-theorist Paolo Lomazzo ascribed to the pictures a "fearsome aspect . . . intimidating to the beholder." He divided Michelangelo's production in fresco into three phases, with the *Conversion of Paul* and the *Crucifixion of Peter* at the nadir of a progressive decline.[4]

During the centuries following, the Paolina frescoes, locked in the Pope's private chapel and darkened by candle smoke, sank into ever deeper neglect. A young Swedish architect, writing home to his parents during a visit in 1673, notes laconically:

> To the right of the Sala Regia [the ceremonial reception hall of the Vatican Palace], is the Cappella Paolina, wherein however, all the painting is wholly spoiled by the smoke from the illuminations that are staged there each year, especially during the Holy Weeks.[5]

No mention even of the painter's name. A hundred years later, Piranesi's representation of a solemn mass held in the Pauline Chapel, carefully crops the space to exclude Michelangelo's frescoes (Fig. 18).

The master's earlier paintings on the ceiling and altar wall of the Sistine Chapel had been endlessly copied and disseminated in drawings and engraved reproductions, so that the afterglow of his inventions is met everywhere in sixteenth-century art. But the prints made of the Pauline frescoes are few; they are crude, hasty products, executed by modest practitioners, printed in small editions, and exerting no influence.[6] Powerless to lend fame to their originals, they could not stay a neglect that extended even to the physical maintenance of the frescoes. Not long after the artist's death, the upper portion of the *Conversion* received spotty corrections—the bare loins and buttocks of some of the angels were draped (Fig. 19).[7] For the rest, the Paolina frescoes escaped the repeated refurbishing generally bestowed on admired things during the eighteenth and nineteenth centuries.[8] Their first full restoration revealed the original surfaces in surprisingly good condition;[9] not "colorless," as had long been thought, but of a delicate coloration and almost untouched by overpainting. There is some advantage in being disdained.

The emergence of systematic art history during the nineteenth century seemed

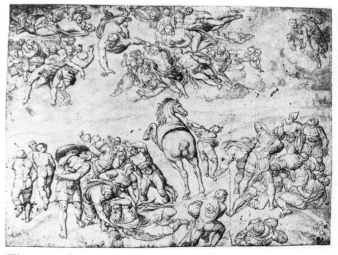

Fig. 18. Piranesi after Louis-Jean Desprez: *Pope Pius VI at the Altar of the Cappella Paolina on Easter Sunday, 1784*. Etching

Fig. 19. Anonymous drawing after Michelangelo's *Conversion of St. Paul*, with indications of loincloths for the nude angels. Paris, Bibliothèque Nationale, Cabinet des Estampes

17

at first to justify the traditional verdict. Writers versed in the documents could now confirm it by invoking (though not without some distortion of context) the master's own words: had not Michelangelo himself, before setting his hand to the work, declared that, "being ill-content, he would produce works ill-contenting"?[10] And after finishing at the age of seventy-five, did he not himself say that fresco painting was no work for an old man?[11] Moved by a genuine love of art, and by respect for the tragic senescence of a great man, nineteenth-century writers continued to shroud the works in charitable oblivion. "In the frescoes of the Pauline Chapel," wrote Charles Perkins, "(Michelangelo) became the mannered shadow of his former self. We shall not pause to search for veins of gold in this lump of quartz, we who have handled wellnigh unalloyed bars of the precious metal as it came forth from the mind of the artist's genius. Better write a volume upon the Prophets and Sibyls of the Sistine Chapel than five lines upon the Conversion of St. Paul—'Guarda e passa'." John Addington Symonds, author of a great Michelangelo *Life*, dismissed the Paolina in a one-line footnote: "they can never have done more than show his style in decadence." Henry Thode, writing in 1912, concluded that the *Last Judgment* had exhausted the master's resources— "even to the annihilation of his artistic will. . . . The two paintings Michelangelo went on to create in the Cappella Paolina show that, in their execution, he merely obeyed an order, not an artistic drive."[12] Such was the universal opinion—and connoisseurship consisted in stating it well. Those who believed that there was objective truth in a lasting consensus of informed judgment—assuming that four centuries last long enough—must have regarded the critical fate of these frescoes as settled.

T H E modern revaluation of Michelangelo's last paintings tells us about ourselves. Aptly enough, the first article to be devoted to them (1929) opens on a note of introspection: "That same psychic wave," wrote Alfred Neumeyer, "which in the plastic arts created the forms of expressionism, also educated the eye and spirit of scholars to penetrate the sphere of the Paolina frescoes."[13] What a strange confession this is: that seekers after objective historical truth needed their spirits washed by a wave of modernity before gaining access to the late Michelangelo. Yet the evidence was incontrovertible. Modern men were approaching these works with different expectations and through other channels of empathy. There is a first hint of this in Wölfflin's comment on the Paolina frescoes delivered in 1899. In a surprising volte-face, he found the *Conversion of Paul* superior to the Vatican tapestry of the same subject designed by Raphael (Fig. 20)—superior in one particular point. In the Raphael, observes the great formalist critic, the prostrate Paul "has too comfortable (*zu bequem*) a view of the wrathful God." And he continues, "Michelangelo knew very well what he was doing when he set the Christ straight above Paul—on his neck, as it were, so that Paul cannot see him."[14] These words give us the first intimation in three-and-a-half centuries that the Raphael masterpiece might be surpassed by Michelangelo's "failure"; and they spring from a new-found ability to empathize with the hero's discomfort.

This ability has had much encouragement in our time. It may be that even such recent experiences as, say, the Dunkirk evacuation in World War II condition us to accept the truth of Michelangelo's vision. Knowing what it means to be dive-bombed on an open beach, we will view the vacant terrain of the *Conversion* in terms more positive than were available to Vasari—who could only plead that the artist's great mind would not stoop to such trifles as houses and trees. Vasari was evidently writing for men who deplored the desolation behind Michelangelo's figures as an offence against art. But Michelangelo, though he did not know about air attacks, could visualize such dire prophecies as are contained in the closing words of Savonarola's first published sermon: "The hand of the Lord is upon you and neither the power of wisdom nor flight may withstand it."[15] He may have heard the fieriest preacher in Rome describe Christ's descent upon Paul on the road to Damascus as an "assault" (see Ochino, quoted on p. 27 below). In the fresco, the human condition evoked by such sermons, the state of defencelessness under the onslaught of Christ, is projected upon a wasteland that offers no cover. To us this barrenness of the land seems so appropriate that we no longer ask whether Michelangelo cared about vegetation or whether the lack of trees is regrettable. The whole compass of modern experience from art to war leads us to pose other questions. These, together with new techniques of analysis, render Michelangelo's last paintings accessible for the first time. Restoring them to their native power and eloquence is our gift to Michelangelo.

The physical restoration of the frescoes in 1934 was less the cause than the consequence of a changed attitude—the earliest critical revaluations had preceded

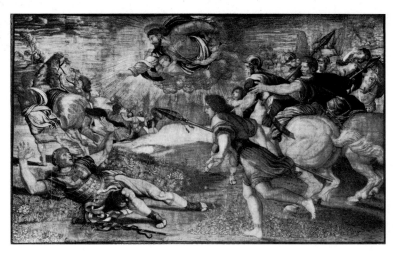

Fig. 20. *The Conversion of St. Paul.*
Tapestry after Raphael's design. Rome,
Pinacoteca Vaticana

the cleaning campaign by some twenty years. Those scholars who first looked at the pictures afresh penetrated the layers of smoke and grime, which for so long had served an averted taste as an excuse for not looking. In 1918–19, Max Dvořak declared the Paolina frescoes to be of "paradigmatic significance." Their space, he wrote, is "the vision of the immeasurable, of an infinity wherein all standards of measurement are annulled, where an earthly-material realm is subsumed in a realm of metaphysical being." Everything in these creations, he concluded, was new. Walter Friedlaender (in a lecture delivered in 1914 but not published until ten years later) described the Paolina frescoes as reaching a "scarcely understood pitch of spiritual abstraction." Finally, Alfred Neumeyer's pioneer article of 1929 celebrated the frescoes with unrestrained admiration: "The melodic harmonies of the fifteenth-century masters have grown into a fugue."[16]

Among the many factors contributing to the revaluation, four may be singled out: first, the recognition of "old-age style" (translating the German *Altersstil*) as a distinct psycho-stylistic phenomenon; second, the definition of "Mannerism" as a willed departure from the ideals of the High Renaissance; third, a reinterpretation of the "abstract" or nonfigurative objectives in Michelangelo's narrative paintings; and, fourth, a changing conception of the nature of representation as symbolic form. The first two terms are familiar enough to be summarized briefly.

At the turn of this century, it was becoming apparent that certain old masters, endowed with genius, long life, and continuing vigor, produced works in old age which could not be judged against those earlier performances that had established their reputations.[17] The formula proposed by Panofsky is admirably succinct—that the life work of such masters falls into three phases: in the first, they take their place within a tradition; in the second, they found a tradition; in the third, they go off incomprehensibly on their own.[18] Whether the late works of men of genius share any common direction or definable feature remains questionable. The constant in old-age works is perhaps no more than an indifference to the criteria which each master's own earlier work had imposed on contemporaries as a critical norm. Yet the mere conceptualizing of *Altersstil*—whatever the real validity of the concept—promoted a change of attitude that necessarily benefited our frescoes. Thoughtful critics began to scan them for signs of renewal, rather than for confirmation that senility had prevented the master from repeating the wonders of the Sistine Ceiling.

On a broader front, the Pauline frescoes gained from the general rehabilitation of mid-sixteenth-century art under the slogan of "Mannerism." The very features that had dismayed earlier critics now appeared as expressions of a psychic shift and a positive stylistic drive. The disturbing irrelation in the Paolina frescoes between figures and landscape environment came to be seen as a determined rejection of the achievements of the High Renaissance. "One strong impulse within Michelangelo's artistic will as it developed in this period was . . . directed towards overcoming Renaissance qualities," wrote Walter Friedlaender.[19] Raphael's exemplary narrative pictures had harmonized depth of space with dramatic action: free-moving figures populate a receptive ambience. But in Michelangelo's frescoes this mutual accommodation is ruptured: in the *Crucifixion of Peter* by a coalescing of space and figures together; in the *Conversion* by an arbitrary discontinuity—men miraged against a waste desert that seems resistant to penetration or occupancy. The *Conversion* achieves a forced neighboring of overcrowding with desolation; there is a sense that the figures, whether earthbound or aloft, interrupt a returning emptiness. And the emotion conveyed, its oppressive disharmony—this, according to the early exegetists of "Mannerism,"

was precisely the mood of the anti-Classical, or Mannerist phase of Italian painting. It was thus no longer necessary to dismiss Michelangelo's final frescoes as personal aberrations; they could now be included in the mainstream.

But the attempt to enlist the Paolina frescoes in the wider stylistic movement of Mannerism never seemed wholly satisfying. The *maniera* style was the creation of younger men, deeply influenced by earlier phases of Michelangelo's art. Though the inventions of these younger painters were in large part "Michelangelizing," they by-passed the master's own late development. The very qualities that constitute Michelangelo's old-age vision preclude his affinity with Mannerist style. It is as though the two phenomena cited—Mannerism and *Altersstil*—cancelled each other out. *Maniera* tends towards a decorative compression of space and a cold, glossing light. Its humanity is overbred—men and women of feline grace, gripped in an absent-minded eroticism, hold cultured poses. Michelangelo's late progeny, by comparison, are rude, stocky frames moving under duress. Of the typical elegance of *maniera*, they show little trace. Friedlaender himself conceded that the Paolina frescoes exist "in a heroic isolation," that their kinship with Mannerist style is definable only in negative terms—as alienation from the rational naturalism of the High Renaissance.[20]

The Paolina frescoes would not have entered the scope of modern appreciation merely for participating in a general supersession of classical norms. That they violated High Renaissance principles was, after all, the long-standing complaint, and the mere declaration that such violations were purposeful and widespread could not have sufficiently altered their aspect to make them acceptable. Yet their appearance in modern eyes did change fundamentally. A declining respect for anatomical drawing, the establishment of formalist criticism, and the emergence of abstract art, induced a shift of focus—away from the things represented to the formal energies that hold things together or drive them apart. In Michelangelo's late frescoes—the *Last Judgment* (Fig. 11) as well as the narratives of the Paolina —the *dramatis personae* began to recede behind forms of organization. The *Conversion* fresco was transfigured into a field of directional forces. Friedlaender's account of the picture recognized "vital tensions which, running through the volumes of the bodies and attaching them to each other, tie them together or separate and isolate them." "All is motion," wrote Dagobert Frey in 1920, "not motion generated by matter, but rather space itself re-interpreted as a phenomenon of mobility. [In the *Conversion of Paul*] the whole aerial space appears filled and saturated by directional rays. . . . The spiritual content is the reign of abstract primordial forces for whose expression the subject is but the pretext." Dvořák detected in the *Last Judgment* and in the Paolina frescoes a "new conception of fate," to which all existence is prone; the figures merely give evidence of "a force whose direction all these giants must follow, as disturbed dust follows the wind." Panofsky thought even the disposition of parts of figures subordinated to larger forces—like iron filings in a magnetic field. Neumeyer saw it as the defining trait of the master's late style that the individual form gives way to "mutually interwoven form-clusters . . . attached to power streams that lie outside themselves."[21]

In retrospect, the generation of scholars writing in the 1920s form a valiant band who sought to reclaim for the twentieth-century sensibility what the settled judgment of four previous centuries had put out of bounds. A specifically modern intuition told them that the Pauline frescoes had been misjudged. To re-instate these works in the corpus of valid artistic expression required new lines of approach. Some proceeded from the supposed psychology of old age; some, by assimilating them to the stylistic definition of Mannerism; others, through a felt affinity with contemporary art forms—Expressionism and Abstraction—converting Michelangelo's last frescoes into figurative equivalents of modern paintings, essentially abstract and secular.

Even the newly discerned inner meaning that emerged from this retro-active modernization of Michelangelo's frescoes was marvelously contemporary. Scholars writing in the 1920s had absorbed the recent insights into the dialectical mechanisms behind visible forms of existence—the workings of evolution, of economic determinants, of unconscious drives; and they responded enthusiastically to a perception of Michelangelo's paintings that made them models of human subjection to uncontrollable forces. This "spiritual content" seemed profound enough to justify the suppression of any merely literary component in Michelangelo's paintings—his specific subject matter and overt religious content, and the poignancy of the human consciousness represented.

Today, it is not hard to see how polemical and exaggerated was the attempt to

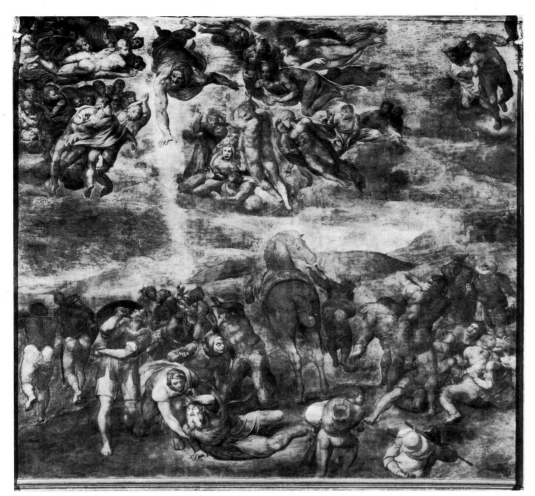

Fig. 21. Michelangelo:
The Conversion of St. Paul.
Vatican Palace, Cappella Paolina

validate Michelangelo's final paintings by defining their true content as the operation of abstract forces. In the process, much was revealed, but much else that had been on Michelangelo's mind was buried. For these frescoes are disguised abstractions only in the sense that all good paintings are. It is true that most of the characters in the *Conversion* lack the self-possession and self-motivation one admired in Renaissance art. And this mortification of freedom may explain some of the discomfort formerly felt at the sight of the fresco, as well as its contemporary appeal. The actions of the figures—the unitive surge of the angels, the *sauve qui peut* impulse among the troop—have become involuntary reflexes. We see not merely so many men stunned or stampeded in panic flight— "in varied attitudes," as Vasari put it—but an explosion in which men scatter like grapeshot. Yet they are not iron filings nor disploded particles, for we see no less clearly that they know, fear, and suffer. The content of subjugation, which is surely there, derives not only from the operation of abstract energies, but from the drama itself, from the gestures and the very anatomies of the actors.

In Michelangelo's earlier works, strength of body could be both exalted and painfully thwarted; in the *Conversion* it appears ironically belittled. Even the power source in the Christ is not unfurled in athletic splendor, but compressed by foreshortening (Plate 2). On the remaining forty-odd figures, the human anatomy undergoes strange revisions: waists thicken while arms shrink and dwindle. Only Christ's right arm is vast, almost a body's length, and its thrust is transmitted to Paul by the embrace of a stooping friend (Fig. 21). Everywhere else, men's arms are hidden or minimized—incapacitated either by cleaving too close to the body or by some gauche, malfunctioning gesture, such as letting a truncheon slip through splayed fingers. The pride of the male physique is aborted and blunted, as in the useless stump of an elbow on the giant at right (Plate 23). One need but compare the manly arms in the *Last Judgment* to perceive how relentlessly the *Conversion* renders the theme of mankind over-powered.[22] The entire scene speaks, in the unison of an emblem, of humbled pride.

But humbled under the hand of God. It is the inner sense of the event that shaped Michelangelo's means. "Gladly will I glory in my infirmities that the power of Christ may dwell in me . . ." wrote St. Paul (2 Cor. 12:9). And the preacher Ochino: "Paul fell unto the ground to note that he must fall from all confidence in himself."[23] Michelangelo was creating neither a literal narrative nor an anachronistic abstraction, but a symbolic structure wherein the whole machinery of Renaissance naturalism, together with all his formal resource, was being diverted to metaphor. On one level of meaning, the picture is as homiletic as the words Thomas More wrote in the Tower in 1534, shortly before his martyrdom: "When we feel us too bold, remember our own feebleness. When we feel us too faint, remember Christ's strength."[24]

21

III. Michelangelo as Narrative Painter

Fig. 22. Lucas van Leyden: *St. Paul being led to Damascus*, with the *Conversion* in the background. Engraving, 1509 (B. VII, 107)

THE story of St. Paul's Conversion is told in the Book of Acts, Chapter 9. Saul (or Paul by his Latin name),[1] a fierce persecutor of the early Church, breathing threats and slaughter against the disciples of the Lord, was journeying towards Damascus. Suddenly a light from Heaven flashed about him. He fell to the ground and heard a voice saying, "Saul, Saul, why persecutest thou me?" Saul's companions stood by amazed, "hearing a voice but seeing no man." They raised him up, found him struck blind, and so led him into Damascus (Fig. 22).

The incident is twice recalled in Paul's own testimonies in Acts, Chapters 22 and 26—with minor discrepancies that might well perplex a painter. Whereas Chapter 9:7 has the companions standing "amazed, hearing a voice," in Chapter 22:9, Paul says explicitly that "they that were with me saw indeed the light, but they heard not the voice"; and adds in Chapter 26:14 that "we were all fallen on the ground." But Paul at that moment cannot have been observing what his companions were doing, and his inconsistencies, taken together, are interpretable as signs of confusion. Michelangelo evidently drew upon all three versions and gained verisimilitude by compounding them: some of his men stand amazed, some fall; some respond to the sudden light, others to a deafening voice. None escape the confusion.

So much for the outward occasion. The painter's problem, if he sought to transcend the raw physical data, was threefold: to convey, if possible, the inward experience—the actual "conversion"; to give form to a theophany manifest to the protagonist but not to his troop; and finally, to pre-indicate the ordained sequel, that is to say, the end of the journey, the restoration of sight, and the Apostolate.

Both the internal event and the historical sequel are woven into the Scriptural narrative as an integral part of the story. To Christ's initial address, Paul responds: "Who art thou, Lord? And he: I am Jesus whom thou persecutest. It is hard for thee to kick against the goad. And he, trembling and astonished, said, Lord what wilt thou have me do? And the Lord said unto him, Arise and go into the city, and there it shall be told thee what thou must do." Three days Paul passed in blindness and prayer. Then, to Ananias, the disciple at Damascus who was to restore Paul's sight, Jesus said in a vision: "This man is to me a chosen vessel, to carry my name before the Gentiles, . . . For I will show him how great things he must suffer for my name's sake." Ananias, doing as he was bidden, sought out the blinded man and, putting his hands upon him, said, "Brother Saul, the Lord Jesus hath sent me, . . . that thou mayest receive thy sight, and be filled with the Holy Ghost. And immediately there fell from his eyes as it were scales" (Fig. 23).

How much of this content can be made visible? How much of it is collapsible in a pictorial instant? There is no delimiting answer, for the volume of content carried by Michelangelo's idiom is not quantifiable, and the channels of meaning are not pre-defined.

Consider the figure of Paul (Fig. 24). His assigned destination is, as it were, postulated in his very body. A catenary runs from Christ through his "chosen vessel" and up to Damascus on the far right. The city indicated by Christ's pointing hand is not only targeted by Paul's right leg, but by his whole frame—a curve in suspension from two fixed points. Or, in another reading: the right angle of Christ's outstretched arms is subtended by a continuous arc traced from Paul to Damascus. Meaning is written into the curvature of Paul's body—not localized in his body, but passing out beyond it as a function in a relational pattern.

Paul's "situation" is prolonged in time as it is projected in space; the grounded hero who bestrode the now-bolting horse is being raised in his very falling, as if to contract in his momentary imbalance the words of the *Golden Legend*, "He was thrown to the ground that he might be lifted up."[2] A collapsed psychic space closes the real distance between Christ and Paul; they are poles apart in the picture, but as termini of a single axis, and the intimacy of their communion is given by their related positions, prone to prone, face-to-face. As for the blinding, it is rendered with a mysterious ambiguity that leaves uncertain whether the man is losing or gaining sight. Paul's lids are closed, but the action of shading the eyes is the ancient familiar sign of a supernatural vision.[3] The figure, in its receptivity to the light, suggests a foreboding of clearer sight, as if this were the instant that inspired the words—"For now we see dimly as through a glass, but then face to face."

Some of the artist's inmost intentions find outlet only in the interaction of

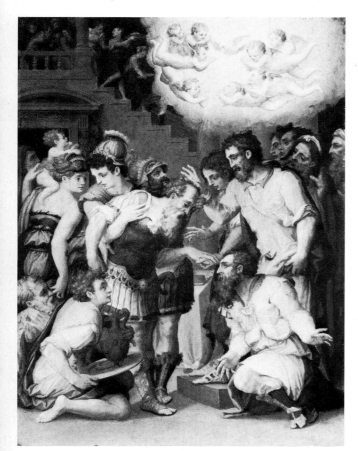

Fig. 23. Giorgio Vasari: *St. Paul being healed of his blindness* (hitherto called *The Meeting of Abraham and Melchizedek*). Greenville, S. C., Bob Jones University Gallery

Fig. 24. Michelangelo: *The Conversion of St. Paul*. Vatican, Cappella Paolina

colors. Two of the figures near Paul—the only two who transcend selfhood in their concern for the chief—wear colors that seem to work as pure metaphor. The first of these is the impulsive helper, whose yellow robe serves visually to convey the radiance of Christ to the Apostle. The second is the armored soldier standing astride behind Paul; he looks down at him, instinctively mimics his gesture—and wears his colors. Does this duplication of Paul's peculiar pale green and lavender, on a figure already so closely engaged, signify a relationship of allegiance? To be assertive on such a point would be hazardous; yet in the context of the Apostle's story and of Michelangelo's storytelling, "allegiance" expressed through assimilation of colors may stand for effective influence. In Acts 26:28–29, Paul hears King Agrippa say, "In a little thou persuadest me to become a Christian"; to which he responds, "I would to God, that both in a little and in much all that hear me should become such as I am." The imitation of Paul, "such as he is"— visualized as a reverberation of color—may foreshadow the force of his ministry.

No one can say with certainty how much of Michelangelo's thought invests and envelops his figures. But one suspects a transcendent conception of narrative that makes every other illustration of the event naively literal.

THE Conversion of Paul had been represented in Christian art both East and West since the ninth century—at first only in cycles of mosaic and manuscript illuminations depicting the life of the Apostle; then, from the fifteenth century onward, with increasing autonomy. Gradually, as the subject gained popularity, several variants emerged, and several constants. In medieval representations, Christ appears in the form of a bust reaching out from the arc of heaven (Fig. 25) —an emblematic protome, expressing the medieval notion that Christ's upper body symbolizes his divine nature.[4] And the tradition persists: though sixteenth-century pictures of the Conversion may expand into a panoramic melée with a Christ amidst clouds and flurries of angels, they retain the convention of suppressing the lower limbs (Fig. 44). Even Michelangelo's Christ figure pays homage to the tradition.

The advanced age Michelangelo assigned to Paul met with official rebuke, though here again a venerable tradition was being honored. But, in fact, the Apostle's age at the time of his conversion presented sixteenth-century artists with an awkward dilemma. How could Paul be old at the beginning of his career; on the other hand, how could he be painted young, yet remain typical? His physical aspect had been more or less codified since the fourth century. In the art of Byzantium, he appears balding, blackbearded and in the prime of life—a

Fig. 25. *The Conversion of St. Paul*. Mosaic, eleventh century. Palermo, Palazzo Reale, Cappella Palatina

23

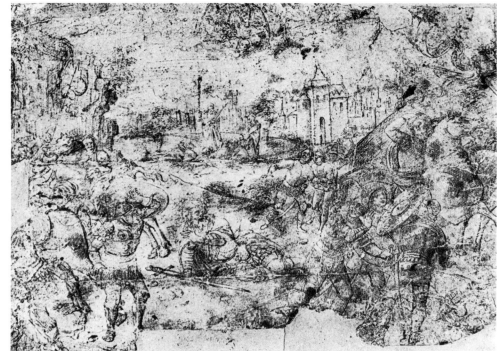

Fig. 26. *The Conversion of St. Paul.* Anonymous woodcut from the *Nuremberg Chronicle*, 1493, fol. 103

Fig. 27. Bartolommeo di Giovanni: *The Conversion of St Paul.* Drawing. Florence, Uffizi, Gabinetto dei Disegni

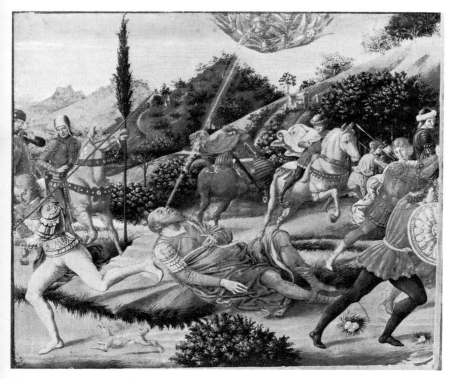

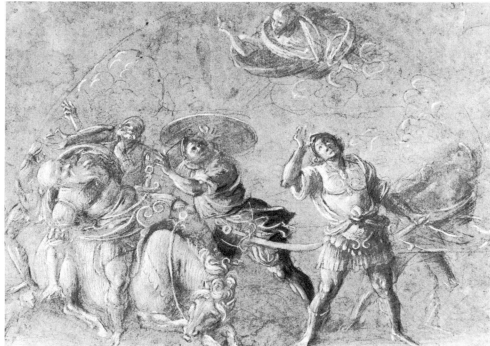

Fig. 28. Benozzo Gozzoli: *The Conversion of St. Paul.* New York, Metropolitan Museum of Art, Rogers Fund 1915

Fig. 29. Gaudenzio Ferrari: *The Conversion of St. Paul.* Drawing. New York, Janos Scholz Collection

Fig. 30. Luca Signorelli: *The Conversion of St. Paul.* Fresco. Loreto, Duomo

recognizable constant maintained through all biographic vicissitudes (Fig. 25). In this form, as a bearded veteran (though not necessarily bald), Paul inhabits most Western representations of the Conversion, whether north or south of the Alps, in high art as in popular imagery (Fig. 26). Fifteenth-century Florentine masters conceived the Saul of the Conversion as an ancient greybeard, a type of King Lear (Figs. 27, 28).[5] And this variant, too, persists through the first half of the sixteenth century (Figs. 23, 29).

The alternative, Saul as a youth, is at first fairly rare; it must have seemed difficult to associate the name, the wisdom and the authority of St. Paul with juvenile features. Exceptional early instances are a fourteenth-century predella panel in Berlin by Lorenzo Veneziano, and Signorelli's fresco of ca. 1480 at Loreto (Fig. 30).[6] But it was Raphael who gave status to the "alternative." The six tapestries for the Sistine Chapel which he devoted to the Apostle's life reveal a calculated concern with biographical sequence. Since Paul's conversion initiates a long ministry, it had clearly to be assigned to his youth.[7] Accordingly, Raphael's Saul appears smooth-cheeked at the Stoning of St. Stephen (where Acts 7:57 actually calls him a "young man") and at his Conversion (Fig. 20); but with a massive black beard thereafter.[8]

Under the influence of the Catholic Reform movement following the accession of Paul III, when all questions of orthodoxy and propriety came under scrutiny, Raphael's historically more correct treatment commended itself to the authorities —to the detriment of the Paolina version. Michelangelo was actually taken to task for putting a beard on St. Paul. The complaint is made in a tract "On the Errors of Painters," written by Gilio da Fabriano, an ecclesiastic better versed in dogmatics than in pictorial tradition.[9] Gilio's diatribe did not appear until 1564, the year of Michelangelo's death, but there is indirect evidence that he was echoing a rebuke voiced in high quarters when the Pauline frescoes were first unveiled (1550). In 1551, when Vasari, on commission from the newly-elected Julius III, painted an altarpiece of the Conversion for the Pope's family chapel in San Pietro in Montorio, he made the protagonist young; and Vasari's autobiography of 1568 justifies the rejection of Michelangelo's model by appealing defensively (though inaccurately) to the authority of St. Paul: "to vary it from that which Buonarroti had executed in the Pauline Chapel, I made the St. Paul young as he himself writes."[10] It is implied that Michelangelo erred; and the incentive to fault the master is not likely to have originated with Vasari.

If Michelangelo erred, it was not in arbitrarily ageing his hero, but in upholding the medieval tradition in a century that knew better. This "better knowledge" asserts itself like a manifesto in Taddeo Zuccaro's *Conversion* altarpiece for S. Marcello, Rome (Fig. 31). The work was produced not long before Zuccaro's death in 1566 and is exceptional in drawing upon Michelangelo's fresco for inspiration; nevertheless, it corrects Michelangelo's "error" by presenting a protagonist about eighteen years old.[11]

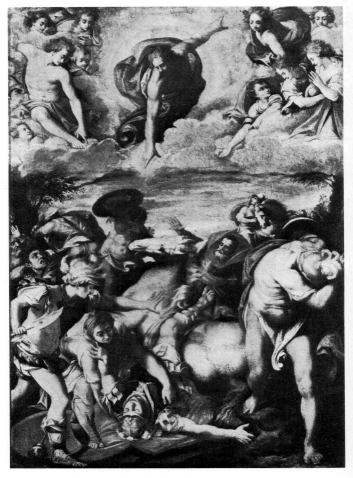

Medieval art depicted Paul in civilian dress, but Renaissance artists put him in armor (Fig. 44). Michelangelo's Paul, being unarmored, seems again to revert to the older mode. Yet he is girt with a sword—perhaps because he had set forth on a murderous mission; or because St. Augustine had called him "a true warrior of Christ"; or else in allusion to his martyr's attribute; or because the combination of sword and civilian garb would relate the figure at once to the modern and the more ancient tradition.[12]

Michelangelo makes no secret of his attachment to precedent. He seems, on the contrary, to make his quotations as conspicuous as possible. Where the impetus of originality threatened to remove his vision too far from the familiar aspect of a Conversion, every usable link with the past became a precious means of holding it down in a recognizable pattern. Michelangelo composed the fresco as though its subject possessed, like an anatomy, a fixed set of features. Hence, the many motifs appropriated from predecessors—the soldier ducking under his shield, as in Signorelli's *Conversion* at Loreto (Fig. 30); the paired fugitives, as in Ghirlandaio's predella at Lucca; the truant charger, as in Raphael's tapestry (Fig. 20); or the similarity of the protagonist to the grey warrior in the fifteenth-century drawing at the Uffizi (Fig. 27). Here and there a motif, such as that of the soldier shielding himself, may directly reflect its antique source in a Niobid sarcophagus. Most other borrowings refer with a truly remarkable loyalty to the popular image of the Conversion. Thus Michelangelo must have lingered with special affection over a Baccio Baldini (?) engraving of ca. 1465. The engraving anticipates the general scatter effect of Michelangelo's composition, with men protecting their ears as they run; and, more important, it incorporates the remote

Fig. 31. Taddeo Zuccaro: *The Conversion of St. Paul.* Rome, Galleria Doria (replica of the altarpiece in S. Marcello, Rome)

25

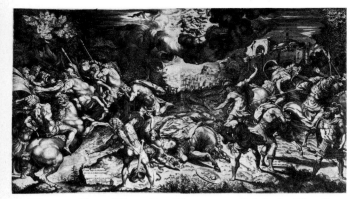

Fig. 32. Enea Vico after Francesco Salviati: *The Conversion of St. Paul.* Engraving (B. xv, 13, as F. Floris)

Fig. 33. Master E.S.: *Inspiration against Despair.* Engraving from the *Ars Moriendi* (Lehrs 178)

consequence of the central moment—in the distance at right, we see St. Paul again, preaching.[13]

One motif, current since the late fourteenth century, assumed overwhelming importance for Michelangelo: the servant or friend bending over to help. In Michelangelo's functional structure, this helper constitutes an indispensable link. Think him away and the figure of Paul lies abandoned; not only because Paul's actual support is withdrawn, but because visually the knot of figures at his back intervenes to divorce him from Christ. It is the helper's presence that mediates the communion between Christ and Paul, even though these are as far distanced as the pictorial dimensions allow. The helper's posture consummates the reach of Christ's arm, and his yellow tunic brings the light of Christ down to the Apostle. Nor can it be accidental that even the foreshortening of this agent of charity resembles the Christ's, so that his trunk, too, forms a whirling corona about his head.

No firm tradition determined the number or character of Saul's other companions. By the sixteenth century, the original pair of Byzantine iconography had grown into a well-armed platoon. The occasion turned into a rout involving both foot and cavalry, the size of the host depending chiefly on the scale of the work (Figs. 32, 44).[14] Considering the dimensions of the Pauline fresco, Michelangelo's detachment of twenty-three men is fairly modest.

As regards Paul's mode of travel, Scripture does not say whether he walked or rode horseback; the Byzantine convention was to depict him on foot. Western art, since the twelfth century, represented him mounted, as befits a great personage visualized in the age of chivalry. At the appearance of Christ, he is thrown, falling headlong over the neck of his mount. It has been shown that this motif, originally antique, was adapted from illustrated manuscripts of the *Psychomachia* of Prudentius—an Early Christian allegorical poem wherein single combats between virtues and vices symbolize the strife for man's soul.[15] In the standardized illuminations of Prudentius (tenth to twelfth centuries), the rider unhorsed —Pride riding before the fall—represents *Superbia*, the first of the mortal sins, overthrown by *Humilitas*. And it was in this form that Paul's Conversion became most familiar to the fifteenth century: an elderly bearded rider, under a shower of hailstones, tumbling head first from his horse. In one of the most popular devotional picture-books of the period, the *Ars Moriendi* (the *Art of Dying Well*), the page illustrating "Inspiration against Despair" shows four forgiven penitents surrounding the dying man's bed: Mary Magdalen with the jar of ointment; the Good Thief on his cross; St. Peter with his conscience personified by the cock; and, in the foreground, proudful Saul in the emblematic pose of come-uppance (Figs. 33, 72).

Pride, penitence, and humility had been associated with Paul's Conversion since the early Church Fathers. "Paul is the name of humility," says St. Augustine, expatiating on the Latin word *paulum*.[16] The Venerable Bede (ca. 700) not only makes the event an exemplum of Pride overcome, but actually alludes to the Prudentian *Superbia-Humilitas* contest in expounding the confrontation of Paul with Christ.[17] Christ, he observes, identified himself to Paul by saying "I am Jesus whom thou persecutest; He did not say: I am God or the Son of God but he said: take on the weakness (*infirma*) of my humility and shake off the scales of pride." As summarized by Jacopo da Voragine in the *Golden Legend*: "Christ overcame Paul's pride by His own humility."[18] And the same author in his *Golden Sermons* on the Conversion, interpreting Paul's given epithet, the *vas electionis*, or chosen vessel, explains that this vessel was "marvelously formed from the clay of humility and the waters of tearful repentance."[19]

The theme of St. Paul's humility is not explicitly Scriptural, but it dominates the exegetical tradition. And it is central to Michelangelo's conception of Paul's Conversion. If he shunned the conventional formula of the toppled horseman, it it was because he had more poignant ways of expressing humiliation—by lowering the protagonist to the trough of the field and through his contact with the bare ground.

The etymologists of the Middle Ages had made much of the derivation of the word *humilitas* from *humus*—earth. Accordingly, from the mid-fourteenth century onward, contact with the earth became a symbolic device, most familiar in the type known as the Madonna of Humility.[20] In these devotional pictures, the Virgin, instead of being enthroned, was seated low on the ground—though fourteenth- and fifteenth-century artists tended to neutralize the abasement by providing the Queen of Heaven with an expensive cushion, or by turning the ground itself into a carpet of flowers. The most uncompromising visualization of

the original thought—the humble spirit cleaving close to the earth—appears in Michelangelo's own early *Doni* tondo, painted in 1506 (Fig. 34).[21] No seated figure ever sat lower than this Madonna, whose lowliness is accentuated by the overtowering of her companions, and whose folded limbs share a single plane with the earth, defining its surface as a lily pad defines a surface of water. Now, forty years later, in the *Conversion* fresco, Michelangelo's Paul hugs the earth along almost the entire length of his body. He is plunged to the nadir of the composition, literally the most abased, his lowliness again emphasized by the friend stooping down to him from above.

Fig. 34. Michelangelo: *The Doni Madonna*. Florence, Uffizi

Paul's Conversion on the road to Damascus is the classic instance of sudden grace. And since the problem of grace greatly agitated the theology of the period, it has been assumed that it also constitutes the primary spiritual content of the Pauline fresco. But as one contemplates the actual structure of Michelangelo's work against the fullness of Christian meditation upon the subject, one begins to suspect wider ranges of inspiration. Michelangelo's Paul is exactly subjacent to the hand of Christ; in staging this correlation, did the painter recall St. Peter's first Epistle (5:6), "Humble yourselves under the mighty hand of God that he may exalt you in due time"? Had he read Erasmus' description of the converted Saul "suddenly cast to the earth by God's right hand"?[22] Michelangelo was an assiduous Bible reader, as we learn from Condivi. Did he remember the verse from the second Penitential Psalm (31:4): "Day and night thy hand was heavy upon me. I am turned (*conversus sum*) in my anguish, whilst the thorn is fastened?" Or was he led to it by Jacopo da Voragine's first *Golden Sermon* where this text is applied to "the blessed Paul thanking God for his conversion"?[23] And in representing the convert's body twisted and turned, did the painter reflect that the Latin *conversus* signifies "turned" in the physical sense as well as "converted"? Or is it fortuitous that Paul's physical turning at his conversion embodies the same two-fold significance as the word which gives the fresco its theme?

Why those clusters of full-grown angels above—they were never part of the iconographic tradition. Were they introduced because St. Gregory had affirmed that Paul, in his conversion, being rapt into the third heaven, "was mingling in contemplation with hosts of angels"?[24]

A sensitive modern scholar, Redig de Campos, has described his impression of the falling Apostle mysteriously drawn up by the light of Christ (Fig. 35).[25] Indeed, as Paul's topheavy chest rolls groundward, the lift of his head and arm gives the impression of obeying an irresistible upward pull. Here too Michelangelo may be seeing a figure of speech. The first of the sermons on the Feast of the Conversion of Paul, preached by Pope Innocent III (1198–1216) and widely used in the sixteenth century, is subtitled "Of the drawing of Paul" (*De tractatione Pauli*).[26] And Michelangelo visualizes the nascent Apostle as if, in Innocent's words, "drawn upward from profound confusion." He may have heard the echo of Innocent's words in the preaching of Bernardino Ochino who, before his apostasy in 1542, was the foremost Catholic orator of his generation: "Christ drew him unto him with great force"; and again, "Paul, illuminated by Christ, was drawn with such violence that he was ravished up even to the third heaven."[27]

Even the fury of Michelangelo's presentation, unprecedented in the pictorial history of the subject, is matched in Ochino's rhetoric: "In the meane while that Paul went, with so great anger, unto Damascus, Christ assaulted him by the way, he used violence with him, and by force converted him."[28] This emphasis on force and assault is neither Biblical nor medieval but, like the fresco, a late fruit of meditation on the Conversion theme.

Pondering the fresco as a narrative structure, one is struck again and again by its deepened responsiveness to the subject. Beyond the Scriptural narrative and beyond any one theological issue, Michelangelo's pictorial conception appears to absorb Patristic commentaries and the homilies of the Middle Ages and the impassioned preachment of his own day. The forms given to the humbling of Paul, to his lying under the hand of Christ, to his being assaulted, deflected, "drawn up," companioned by angels—they are concretions of metaphor. In Michelangelo's imagination, old thoughts and feelings and the figures of speech in which they were vested receive visible substance. Not because he sets out to illustrate what he has heard and read; but because his informed meditation upon the subject penetrates to that same emotional ground whence arise such metaphors as being drawn towards God or turning in anguish under God's heavy hand.

THERE is yet more to his "story-telling." Michelangelo thinks through his eyes, and he charges his narrative structure with meanings that emerge, never verbal-

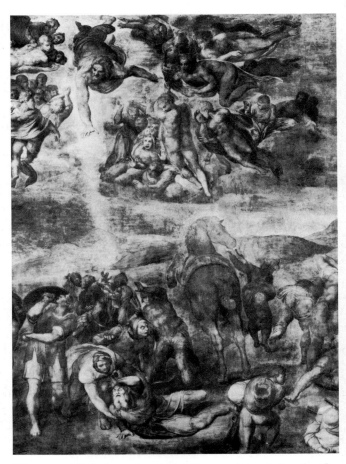

Fig. 35. Michelangelo: *The Conversion of St. Paul*. Detail. Vatican, Cappella Paolina

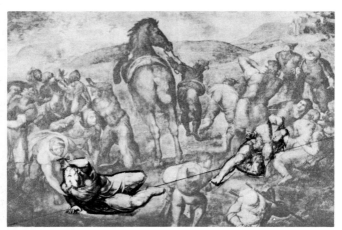

Fig. 36. Diagram showing the correspondence between the two river-god figures in *The Conversion of St. Paul*

Fig. 37. Marten van Heemskerck: *View of the Capitoline Hill towards the old Palazzo dei Conservatori.* Drawing, about 1535–6 (Hülsen-Egger, fol. 72r.)

Fig. 38. Detail of Fig. 37

Fig. 39. Marten van Heemskerck: *The river-gods on the Capitoline Hill.* Drawing, about 1535–6 (Hülsen-Egger, fol. 61r.)

ized, from sight alone. Of these meanings, the most far-reaching is an allusion to the consummation and end of Paul's ministry. The allusion is built large into the picture, but its identification requires an elaborate reconstruction of what in Michelangelo's day was a commonplace.

Consider once more the protagonist's posture. It has long been recognized as a variant of a familiar antique prototype much used in the sixteenth century: the type of the bearded river-god—recumbent, upper body propped on one arm, one leg retracted, the other stretched forth.[29] The derivation is unmistakable, even if the painter has unbalanced the figure to intensify urgency and psychological stress. But then, though the Apostle is central to the event, though Paul is at this moment the unique target of Christ, Michelangelo saw fit to make him one of a pair. Perpendicular to the oblique axis defined by the horse lies another grey-beard, a mirror image, grounded in similar fashion, and even more frankly a river-god (Fig. 36). Paul's counterpart is less conspicuous, being pinned under a giant's legs. And his limbs subtly reverse every one of Paul's actions. But they do so in contrived opposition, like the reclining river-gods Michelangelo had planned for the Medici Tombs. In the *Conversion*, the bearded recumbents share one canted baseline, parallel to the stream of figures and the horizon. Together, as confronted figures flanking a breach, they compose a single bi-partite feature. And the unique model for this arrangement was close at hand: it was to be seen on the Campidoglio, the ancient civic center of Rome on the Capitoline Hill.

Since the early years of the sixteenth century, attempts had been made to re-activate the long-neglected site of the Campidoglio as a focus of the political life of Rome (Fig. 37). To testify to the grandeur of the City's historic past, and to her enduring preeminence, a number of newly-excavated antique sculptures had been assembled in the courtyard of the Palazzo dei Conservatori. (The *Conservatori* were City Fathers elected to exercise such powers as the Pope left to the citizens; their *palazzo* appears in the background of Fig. 37.) Under Pope Leo X the Hill became once again the scene of public ceremonials, performed in the open air. Derelict for a thousand years, unpaved, irregular in its layout and hard of access, the Campidoglio was to be restored to its ancient role as a communal piazza and center of civic pride.[30]

To further this goal the Conservators, in 1517, decided on a grand gesture—casting their eye upon two colossal marble sculptures of river-gods resting on the Monte Cavallo, the ancient Quirinal. Throughout the Middle Ages, these figures had ranked among the marvels of Rome, and had become city symbols, like the Column of Trajan or the Coliseum—except that they were movable. The Conservators, accordingly, ordered them moved to the Hill.[31] The statues were placed before the arcaded loggia of the Conservatori Palace—on the bare ground, without pedestals (Figs. 38, 39). Facing each other symmetrically on either side of the entrance and surmounted by a bronze relief of the She-Wolf suckling the Twins, they composed a heraldic group symbolizing *Roma Aeterna*. Thus, for twenty years (until 1537 when, against Michelangelo's counsel, the equestrian Marcus Aurelius was placed on the piazza), the two river-gods dominated the Campidoglio. They formed the background to those solemn ceremonies in which Roman citizenship was awarded to foreigners—among whom, on December 10, 1537, the Florentine Michelangelo.

During the following decade, the years of his labors in the Cappella Paolina, Michelangelo was entrusted with the task of systematizing the Hill. His design for it was to become a grandiose architectural undertaking. Symbol of continuity with ancient Rome, the Capitoline Hill was at last constituted a worthy counterpart to the Vatican—the two hills together symbolizing Rome in her secular and ecclesiastical primacy.[32]

The *Conversion* fresco shows Paul and his opposite disposed like the Campidoglio group as it appeared in the 1540s. The pattern reveals itself clearly if we temporarily think away the two soldiers intersecting the lower right threshold; though their intrusion masks the directness of the reference, it cannot shake the underlying simplicity of Michelangelo's scheme: two grounded figures of river-god type, facing each other on a straight baseline and flanking an axial opening into depth.

The allusion to the Campidoglio group is unlikely to be gratuitous or inadvertent. And the symmetrical pairing of the protagonist of the sacred drama in his climactic moment with an anonymous supernumerary cannot be purely formal. Michelangelo's decisions are rarely simple and, in the present case, a decision to couple Paul with a similar counterpart would have been frivolous on two counts had it been made with only a structural or decorative intent. Michel-

angelo respected his subject and would not without reason provide St. Paul with a double, nor without reason plant a reference to Rome on the road to Damascus. More probably, he was again thinking on several levels—but one is staggered by what his thinking implies. Was Michelangelo invoking a visual parallel by which to make present to the beholder, along with the moment of Paul's vocation, an image of the political heart of Rome? Was he anticipating the historic sequel to the moment depicted? Paul of Tarsus, proud of his Roman citizenship, is being appointed Apostle unto the Gentiles, and with a specific mission for Rome. In the words of Acts 23:11, "The Lord stood by him, and said . . . as thou hast testified of me in Jerusalem, so must thou bear witness also at Rome." If Michelangelo was not being thoughtless, he was visually linking the converted Paul with his last destination. And, once again, the meaning does not reside in the figure itself, but in its relational context. It is the duplication of Paul's pose that evokes the focus of the immemorial City which his mission would Christianize.

The *Conversion* fresco occupies the east wall of the Pauline Chapel. Its spatial illusion thus opens towards the City, in the direction of the Capitoline; just as the *Crucifixion* fresco on the opposite wall opens in the direction of Peter's tomb under St. Peter's and towards the range of the Vatican Hills. We shall see that the *Crucifixion* makes even more pointed reference to Roman topography. Peter and Paul were both martyred in Rome; it was their blood that consecrated the City and established the Primacy of the Roman See—"doubly apostolic," in Tertullian's phrase. They were the City's twin guardians. As Innocent III stated it:

> Surely not without divine providence was it brought about that where two brothers according to the flesh, Remus and Romulus, who founded that city in the material sense, lie buried in honored tombs, there also two brothers according to the faith, Peter and Paul, who founded the city in the spiritual sense, rest entombed in glorious basilicas. Peter in that part where Romulus was buried, and Paul in that other where Remus was buried. Thus on this side and on that, they guard this state as its patrons.[33]

Michelangelo's frescoes are conceived with regard to a consecrated topography. His Apostles jointly encompass the City in their evocations of the Vatican and the Capitoline. The Chapel—its strong processional axis matched by the range of its broadsides—becomes common ground between two connected realms (Fig. 40): Peter and his rock-based Church on the right complement the Apostle to the Gentiles and his arena, the Roman world. The open-wall illusionism of the two frescoes and the orientation of the Chapel length-wise between City and Vatican Hill—all are absorbed into the structure of meaning.

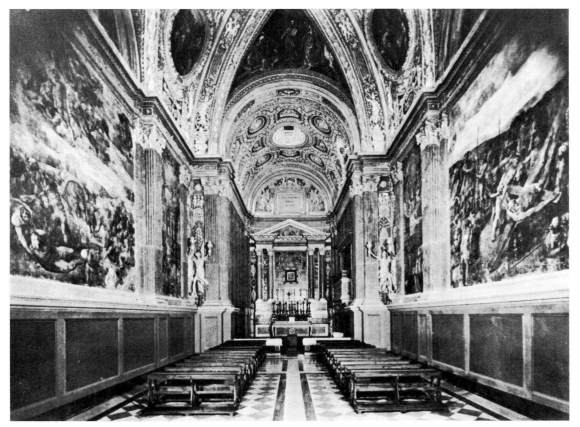

Fig. 40. The Cappella Paolina, Rome, Vatican Palace. Wide-angle view towards the chancel

IV. The Structuring of Disorder

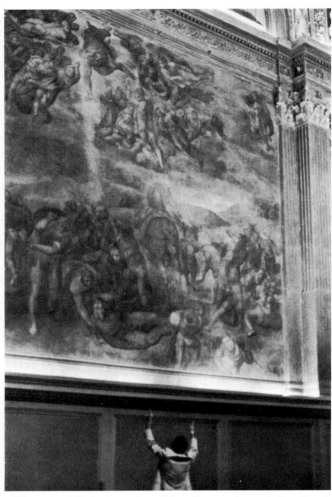

Fig. 41. Michelangelo: *The Conversion of St. Paul.*
Vatican, Cappella Paolina

A conversion of St. Paul (writes Vasari) with Christ in the air and a multitude of naked angels . . . and below, Paul in fear and amazement thrown to the ground by his horse, surrounded by his soldiers engaged in lifting him, while others, stunned by the voice and glory of Christ, flee in varied attitudes, amazed and terrified, and the fleeing horse in the speed of its onrush drags along the man who is seeking to restrain it, the whole scene being executed with extraordinary art and design.[1]

Remarkable in this description is the surprise ending. Between the poles of Vasari's concern—between his random notations and his perception of artfulness—lies the wide gap that most subsequent criticism was unable or unwilling to bridge. The pell-mell of the action was always apparent, but seemed too chaotic to reflect a controlling artistic will. It is as though the depicted disorder overflowed from the fresco to induce a vicarious disorientation in the beholder. Vasari's run-on recital matches the common experience—the getting caught up in the confusion, and the impulse to scan the picture staccato, disjunctively. As in no other work of the period, the viewer's focus is scattered; wherever he looks, his attention is jarred, shunted from side to side, so that, like the depicted characters, he never quite knows where to look.

The *Conversion* must be one of the most difficult paintings in the world to see, to take in as a whole. Its threshold lies well above eye-level; its upper reaches seem to tilt out of sight (Fig. 41). Overwhelming the narrow nave of the chapel, it is scaled too large to permit a convenient viewing distance. The viewer senses that its centrifugal energies elude his grasp and abandons himself to sympathetic confusion. Wölfflin, who respected the picture despite its "shrill dissonances," thought that it "broke away from all symmetry and advanced into formlessness."[2]

Such negative observations are more usefully pondered than brushed aside. Coming from the man who defined the categories of Renaissance and Baroque style, Wölfflin's reaction is profoundly revealing. We need only invoke his famous stylistic alternatives—space organized either as continuous recession, or else as a system of parallel layers in measured progress from frontal plane to horizon—to realize what Michelangelo had done to disappoint Wölfflin's criteria of pictorial form.[3] To say it at once: Michelangelo's fresco escapes the categories of period style through a series of non-alignments that seem to leave the pictorial content centerless and adrift. But, to adopt Wölfflin's phrase, Michelangelo "knew very well what he was doing." His aim was not so much the creation of a wall painting as the transfiguration of the chapel. The two frescoes were to have the effect of obliterating their respective walls. To the longitudinal thrust of the nave they were to oppose a cross-axis. The whole chapel was designed for three poles of attention: the chancel and tabernacle at the focal point of the main north-

Fig. 42. Michelangelo: *The Conversion of St. Paul,*
upper half, with walled-up lunette window above.
Vatican, Cappella Paolina

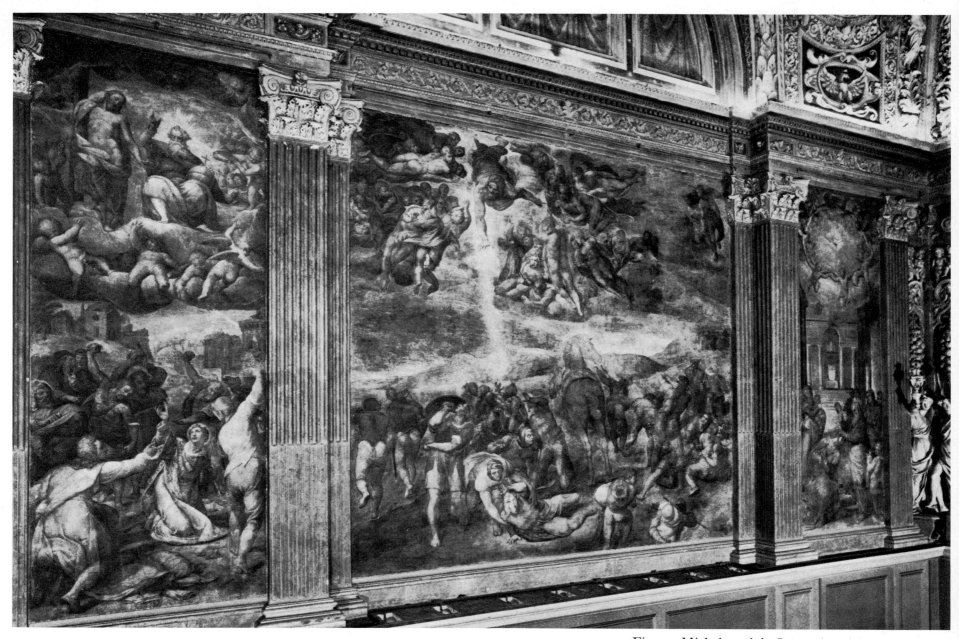

Fig. 43. Michelangelo's *Conversion of St. Paul*, flanked by Lorenzo Sabbatini's *Scenes from the Life of St. Paul*. Vatican, Cappella Paolina

south axis, and the two frescoed spaces opening out like the arms of a transept.

The impression of openness at the sides was originally enhanced by two features that no longer appear as intended. The first involves the window above the *Conversion*. Unlike the westward lunette over the *Crucifixion*, the window that surmounts the *Conversion* was sealed when the portico of St. Peter's was built up against it (Fig. 42; cf. Figs. 13–15). Thus the airiness of Michelangelo's sky is stopped short at the lintel instead of rising through clear window-glass to the crown of the vault. Secondly, in the original project, the narrow wall sections that flank Michelangelo's frescoes cannot have been meant to receive such additional narrative scenes as we now see. Whereas the recessed central fields with their panoramic landscapes and huge overhead windows are without tectonic function, the outer panels pertain to the architectural frame; they are obviously structural in supporting the vault. Contained between their own pairs of pilasters, they project forward from the central squares and define the walls proper. In view of this clear structural differentiation, it is almost certain that the surfaces of these flanking panels would have received a contrasting treatment. Michelangelo considered their decoration and furnished the designs to be executed by Marcello Venusti.[4] No traces of these designs survive, but they must have been of a flat ornamental character, probably simulated reliefs—either figurative or arabesque—like the projected frieze by Perino del Vaga which Michelangelo approved to serve as a dado beneath the fresco of the *Last Judgment*.[5] In both the Sistine and Pauline Chapels, the comparative flatness of the marginal decoration would have stressed the load-bearing role of the surface covered, setting off the open illusionism of the adjacent *istoria*.

Unhappily, after Michelangelo's death, his intentions for the overall mural decoration of the chapel were not respected. Under Pope Gregory XIII (1572–85), a lavish but undiscerning patron of art, the panels flanking the *Conversion* and the *Crucifixion* were frescoed by Lorenzo Sabbatini and Federico Zuccari with further narrative scenes from the lives of Peter and Paul (Fig. 43). As a result, the wide central frescoes are now jostled on either side by competing pictorial spaces, deadening the dramatic contrast between Michelangelo's gaping illusionism and the solidity of the framing flats.

31

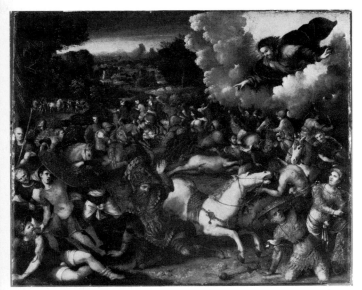

Fig. 44. Anonymous Ferrarese painter: *The Conversion of St. Paul*. London, National Gallery

To rethink Michelangelo's concept, we have to imagine the *Conversion* fresco, not as the central part of a mural triptych, but as a diaphane between opaque panels; a wall removed. Not a mise-en-scène, but open territory expanding unframed in all six directions—beyond the horizon and past the four margins and, as we shall see, hitherward into the chapel. Can such universal extension, such an unboxed, measureless void with its irregular scatter of figures, still be rationalized into form and harmony, let alone symmetry?

Wölfflin's assertion that Michelangelo's picture broke away from formal order and symmetry is neither right nor wrong. Rather, it tells us what *kind* of order the composition lacks; it helps to specify those non-alignments by which the picture escapes conventional categories. To begin with, Michelangelo's fresco rejects the dominant axis of the given field as a scaffolding for its own structure. This becomes clear when we compare another *Conversion of Paul*—a panel by an unidentified Ferrarese master, exactly contemporary with Michelangelo's picture and useful to us as a type precisely because it is undistinguished in quality (Fig. 44).[6] One sees at once that from the viewpoint of what painters call the picture plane— as a surface cohesion of shape, color, and interval—the Ferrarese panel is naive, over-anxious, and muddled. But it is not the integrity of the picture plane that now concerns us; only the way in which the picture's feigned three-dimensional content respects and confirms the format of the rectangular panel.

While the Ferrarese picture represents a tumultuous event in deep space, its groupings obey the given axis and the given rectangular borders; the composition sits firmly locked in its frame. Paul's army deploys in a hemicycle, forming a thinning arch on the plane. The arch, or hemicycle, connects the lower corners of the pictorial field, and its summit falls on the median. Within the hemicycle, Paul and his horse—a single motif exfoliating from the center out—occupy a predictably central position. The lateral margins are buttressed by figures clinging against the sides. Both lower corners are packed, the right angle at left being charged with a right-angled "river-god" figure. And the diagonal is defined by the apparition of Christ, balanced by the tree at the upper left. Thus the design of the drama, positioned in three-dimensional space, confirms what is given; the axial symmetry of the depicted event coincides with the pre-framed symmetry of the panel. And it is this coincidence of symmetries that Michelangelo's *Conversion* is designed to frustrate, making the picture appear "uncomposed."

A second type of non-alignment is the apparent dissociation of Michelangelo's figures from the proscenium plane—the imagined invisible scrim between the flanking pilasters. Michelangelo's composition baffles the Wölfflinian canon by denying both "planarity" and "continuous recession." The figures in the lower zone do indeed form what Wölfflin would call a "row," but a row that equivocates with respect to the frontal plane, being neither quite parallel to it (as are the foreground figures in the Ferrarese panel), nor yet clearly diagonal. The figures drift inward on a ragged oblique that is hard to rationalize. In Wölfflin's "baroque" compositions (Tintoretto included) a diagonal inward recession is referable to the frontal plane of the picture at some cogent angle, somewhere near forty-five or near thirty degrees—a clear segment of the right angle. But Michelangelo's space penetration from left to right resists any conceptualized angulation. And the result, in Wölfflin's terms, is an impression of irregularity, of a formless disorder.

A more disturbing non-alignment in Michelangelo's fresco is the new irrelation between image and frame (Fig. 45). This is difficult to discuss in book form, because we reproduce pictures unframed, whereas Renaissance pictures— frescoes or panel paintings—were painted with the framing surround always present to the mind of the artist. In sixteenth-century painting, the symbiosis of frame and image results in pictorial conceptions whose foreground elements are kept in scale with the articulating elements of the surround, whether this be a carved frame, an ornamental border, or an architectural member. There is a perceptible match between the heads of the largest depicted figures and the capitals of flanking pilasters, between human limbs and the thickness of adjacent moldings. In Raphael's Vatican frescoes, the square divisions of the arched borders are commensurate with the main anatomical units of foreground figures. Thus the frame, which belongs to the membering or the furnishing of the room, is made to pertain as well to the depicted content; it is scaled to mediate between the fictive world and the real.

But the content of Michelangelo's fresco is so proportioned that the traditional correlation breaks down. While the fluting of the framing pilasters is too fine to engage the depicted figures, the pilasters themselves are too overwhelming. And

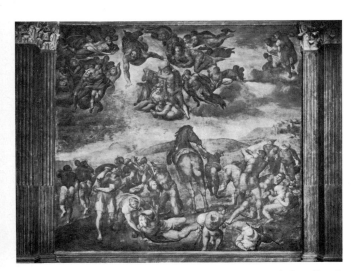

Fig. 45. Michelangelo: *The Conversion of St. Paul.* Vatican, Cappella Paolina

they are neighbored by small huddled forms in place of those large-looming repoussoir figures normally stacked against a pictorial margin to secure the transition. The *Conversion* fresco repudiates its attendant architectural members, so that they, being unclaimed by the picture, will be left to belong to the architecture of the chapel alone. Like no earlier sixteenth-century painting, the picture unframes itself. Cut loose and self-existent, the space that recedes beyond the apparent wall opening seems to have no more alliance with its enframement than a landscape "framed" by the window of a banking airplane.

Finally, the *Conversion* avoids congruence with horizontality and verticality. The closest approximations to horizontals and perpendiculars are fleeting, unstable moments—such as the sprawl of the protagonist in the midst of a fall, or the swaying plummet of light. Everywhere in the fresco, upright lines lean and tilt, while the ground itself heaves and pitches, as if the terrain had yet to settle into definitive contours.

To sum up the four "non-alignments" that would have justified Wölfflin in seeing Michelangelo's picture as a move towards formlessness: the composition renounces the axis of the given format as a determinant for its own structure; the proscenium plane is nowhere paralleled by the pictorial content; the scale of the depicted figures is incommensurate with the enframement; and almost nothing within the representation confirms the geometric coordinates which a narrative picture normally shares with its containing chamber.

Such persistent negations indicate a sustained purpose. And the same formative will, the same insistence on "non-alignment," is at work again in the function assigned to the color. The pigments in the *Conversion* pin nothing down—they unhinge, set afloat and disperse. The slate blues that break up the sky, the green earth blueing to purple on the stacked hills—they are too fitfully stratified to mesh into plane or place. The foreground earth changes color capriciously, adapting itself to the accidental hues of neighboring objects; it brightens about St. Paul, darkens sadly towards the corners; the kind of constancy we expect of the earth is withheld. More perverse still are certain unsettling inversions: despite great stretches of seeming verdure, the grassiest green falls on leggings and armor; the most celestial azure on a horse's saddle, a soldier's shield. Soft whites and greys wrap about hefty buttocks, while the frailest lilacs represent leather. Rarely do color and ponderation agree. The convex role played by recessive hues induces a kind of optical irony about fixed spatial locations; color sparkles across the field in autonomous counterpoint, self-sustained but dissociate from the plane of the wall.

One compositional detail is especially telling—the two soldiers invading the picture at lower right: a brilliant device to disrupt the normal parallelism between the nethermost zone of a representation and its architectural threshold (Fig. 46). There are many precedents in Italian painting for half-length figures climbing into the visual field; but none so oddly paired, so awry.[7] Michelangelo's soldiers, mounting a slope that falls off to the right, enter our field of vision at different levels. Yet they advance neither in tandem nor in echelon, but side by side. Their mutual regard of each other may seem to be a purely illustrational touch, but in the unity of the artist's thought even this motif is integral to his overall purpose. By showing the soldiers in such easy converse, the painter is telling us that they are marching abreast, in a rank oblique to the threshold, so that the solid underprop of the fresco is, as it were, pushed off and distanced from the depicted ground. The soldiers become yet another means of casting the pictorial space off from its moorings.

On the other hand, this apparent autonomy of the space is illusory—an induced dramatic impression. Conceived as a flat rhythmic pattern, the composition not only holds on the picture plane, but contains secretive coordinations even with the framing orders (Fig. 45). If, for instance, one scans the field at the level defined by the lower third of the pilasters, where the cabling stops and the hollow fluting begins, one finds subtle adjustments to anatomic accents, such as waists, leveled arms, shoulders. And if these connections are fragile, there is one figure, that of the Christ, that is conspicuously aligned both with the preformed grid of the field and with its architectural setting. The plumbline of Christ's trunk and right arm prolongs the mullion of the lunette window above—a heroic vertical (Fig. 47). And the horizontal stretch from Christ's right shoulder to his left index marks off the zone of the capitals.[8] It may seem paradoxical that this plunging phantom should be a source of stability to the fresco, yet the effect is unmistakable. The arms of Christ open at a right angle, down and across, like a carpenter's square—coordinates of the plane. And the foreshortened trunk travels inwards,

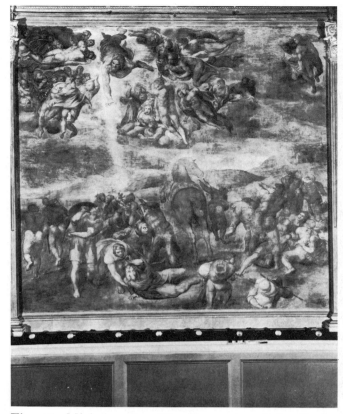

Fig. 46. Michelangelo: *The Conversion of St. Paul.* Vatican, Cappella Paolina

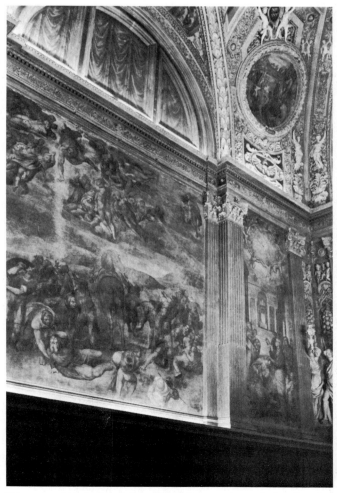

Fig. 47. Michelangelo: *The Conversion of St. Paul.* Detail. Vatican, Cappella Paolina

33

away from both arms, again at ninety degrees, so that body and arms together form a three-pronged figure radiating from the head out. The action of Christ becomes double-natured. Within the dramatic narrative, Christ is understood as the cause of confusion. Yet the form of him is an epitome of spatial order, setting forth, like a diagram, the coordinates of height, width, and depth.[9]

SINCE the tumultuous composition of the *Conversion* rejects any symmetry that unites the architectural frame and the *dramatis personae* in a common visual order, we must search the drama itself for the artist's idea of pictorial structure. But here again the first sensation is bafflement. We see at once that there are three candidates for attention—a horse in the middle, a prostrated hero, and a *deus ex machina*; and that these three scatter our focus and prevent the design from coming to rest. Scanning the picture for a climactic midpoint, we feel misdirected, since the rump of a horse is not what we came to see. But the fresco's physical center is part of a movement in circulation—depleted of interest as if to say, "not here, but keep moving." The surge of the horse's leap leads through a soaring angel up to the Christ, who plunges a beam of light down on the Apostle, who has just slipped from the rampant horse. A pattern disengages itself, a cyclical system recalling convection currents. The three rivals for our attention—Christ as the cause, St. Paul as protagonist, and the horse at the physical center—unite in a circuit passing through animal, man, and God. Linked in a rhythmic continuum, they comprise a hierarchy and a chain of causation. Whether or not the artist thought in precisely these terms, the potential for meaning generated by the interrelatedness of the three "candidates" is remarkable. To adapt a metaphor from Michelangelo's poems: if Christ is the hammer, Paul is his anvil, and the horse, like a flying spark, evidence of the force of the blow. In terms of the drama, Christ, Paul, and runaway horse represent call, responsiveness, mindless flight.

Once the central circuit is isolated, the whole design falls into symmetrical patterns. In the sky, the hurtling Christ figure bisects the angelic school. On the ground, Paul's fleeing horse cuts through the troop, making it fall asunder like parted fruit.

The symmetry principle runs even deeper. It is not hard to imagine the upper and lower throngs as two corporate clusters, two superposed entities whose medians strain away from each other in opposing directions (Fig. 48). Ultimately, the design reveals a profound kinship with Michelangelo's conception of the human torso in action. The trunk of a loose-jointed nude in a characteristic drawing (Fig. 49) shows chest and pelvis rotating respectively to left and right, both centerlines being displaced, yet unmistakably the components of a "symmetric" anatomy. Similarly, in the *Conversion* fresco, the superior body of angels and the body of men below: in the upper region, Christ as the median orients the form to the left; on the ground, the axis defined by the horse swings to the right. The picture, or rather the picture's corporate fill, does indeed acknowledge a single axis, but one that swerves midway as it drops from the Christ down to the fixed hooves of the horse. The swarming anatomies of the narrative—naked and armored, convoked and dispersed—are treated by Michelangelo as though he were articulating the contrapposto of a single physique. Seen together, the entire cast of forty-odd figures exhibits the internal conflict of directions characteristic of Michelangelo's *figura serpentinata*.

The simplicity of the scheme comes as a surprise: parted by a clear swath of hills and sky, the contents of upper and lower zones define themselves as two cognate ellipses, similar in outline and in diametric division. And the two medians—a descending Christ and a rampant horse—perform remarkably similar functions: each separates its proper sphere into odd hemicycles; each shows a foreshortened back; and each sets up a near-perpendicular, excentric with respect to the field. This incongruous congruity serves Michelangelo well; for only by making the celestial and the earthly zones comparable can they be forced into comparison. In other words, their similarity promotes differentiation.

To consider their differentiation is an immediate immersion in symbolism. The two circles are variously engineered—one radial, the other peripheral. On the ground, everything bursts apart as it strains away from Christ—or, more literally, from the point of his impact; the whole lower crater reads centrifugally as an explosion. In the upper orbit, the angelic fleet deploys in spoke fashion, seeking the central light. A contrast is offered between convergence and scatter, between those drawn together volitionally and those breaking up under duress. And they obey distinct laws of physicality. The earth-bound bodies are spaced behind one another, and against a receding three-dimensional plain. The seraphic

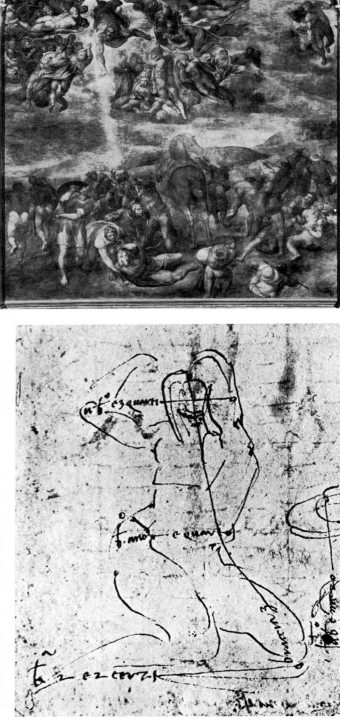

Fig. 48. Michelangelo: *The Conversion of St. Paul.* Vatican, Cappella Paolina

Fig. 49. Michelangelo: *Seated Nude.* Detail from a sheet of studies, about 1525. London, British Museum

formation seems tilted up in a frictionless ether: companions untouched by crowding—like harmonic clusters of voices, immune to displacement, so that their massing creates no congestion; whereas down below, despite the discharge from the center, the congestion remains unrelieved.

The two realms are distinguished in color. The horse, a dun, ashen grey tinged to cold violet, un-colors the lower center, while warmer hues in full saturation fall in dispersed accents about the periphery. The opposite principle reigns in the upper zone, where the strongest coloration is centered on Christ: the three primaries in concentric orbits—red robe, yellow radiance, blue sky.

The distinctness of the two realms extends to their respective holds upon time. Down below we conflate a quick succession of moments. We can tell how each man reached his station and where he may be at the next instant.[10] Our time sense is activated by the felt sequence of impact and dislocation: we see where the bolt has just struck, and see its effect—Paul flung sideways, the horse plunging, a fugitive taking off to the right. But the sky-riders' motion is phaseless, a stationary unrest that perpetually re-inherits its pattern. We can, theoretically, imagine them regrouping like shoals of fish; visually, their confluence spells rest at the center, like the homing of spokes at the hub.

Even the Christ, though he seems to plummet, yet in the abstraction of his radial figure, hinged to the upper edge and the foreshortened torso circling his head, becomes a suspended body, an unmoving constant over a world in commotion. Cause of all perturbation, he looms immovable overhead. It is somewhat like seeing the sun motionless in the sky, while shadows flit and dart on the ground.

Or a sturdier metaphor: the whole upper region prefigures the form of the dome, ancient architectural symbol of heaven. The angelic hosts play a celestial charade. Like the ribs of a cupola bracing a lantern, they converge on an open center through which bursts Christ the light. The image substantiates the artist's conviction that architectural forms derive from the human anatomy; it extends the anatomic analogy from the individual physique to the ways in which human bodies convene.

SEVERAL times in his career, under pressure from Papal patrons, Michelangelo insisted that architecture was not his profession. Yet he developed, decade by decade, into the greatest architect of his age. By the 1540s, even his pictorial imagination was yielding to the principles of the builder.[11]

Michelangelo rarely expressed himself in theoretic terms about his art. A fragment of a letter, datable about 1560 and addressed to an unnamed prelate, is our only direct written record of his architectural principles. The text was apparently written in response to criticism; it is polemical and condescending in tone, but only because the writer takes the truth of what he has to say so much for granted that it vexes him to have to say it. The letter argues that buildings must obey the principle of axial symmetry exemplified in the human body. "When a plan has diverse parts, all those which are alike in quality and quantity must be treated according to the one model, and in one style, and the same applies to the parts which pair with them." On the other hand, central features may and should be unique. Thus "the nose, which stands in the middle of the face, is not dependent upon either eye, although one hand must of necessity correspond with the other, and one eye with the other, because they are placed at the sides and are in pairs. Wherefore it is very certain that architectural members derive from [or ought to follow the same rule as] the members of the human body. He that has not mastered, or does not master, the human figure, and especially its anatomy, can never comprehend it."[12]

As James Ackerman summarizes the argument, Michelangelo here "affirms the relationship of architecture to the human body in the sense that necessary similarity of the eyes and uniqueness of nose implies that architectural elements to the left of a central axis must be mirrored by those on the right, while the central element must be unique . . . It is anatomy, rather than number and geometry, that becomes the basic discipline for the architect."[13]

Michelangelo, then, has strong convictions on the subject of symmetry; but he applies these convictions selectively. They govern his notion of building, but not his approach to the format of the *Conversion* fresco. Here the excentric axes were so dislocated, that Wölfflin could see the *Conversion* only as a total denial of symmetry. Why, then, given the non-symmetrical spacing and staging, should the symmetry principle return to tyrannize the grouping of the persons depicted? Why should a law transferred from anatomy to the design of plans and façades be held equally binding for a multi-figured dramatic event? Would the artist have

35

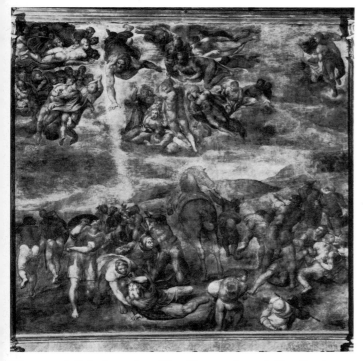

Fig. 50. Michelangelo: *The Conversion of St. Paul.*
Vatican, Cappella Paolina

claimed that groups of men must, even when under stress, behave like an individual anatomy? For the principle laid down in Michelangelo's letter operates throughout the *Conversion* (Fig. 50). A central feature, such as the horse, is unique, but is pressed on each side by similar members: two figures with upraised arms, the soldier above Paul and the groom seen from the back, flank the horse almost like heraldic supporters. The yoking of the two "river-gods" into a single bi-partite motif turns out to be part of a thoroughgoing system of duplications.[14] Paul's helper, bent down to sustain him, has his collateral on the other side: his moral opposite and backside inversion is the foreshortened runaway in the corresponding slot on the right. The brazen giant, whose legs straddle Paul's counterpart, has his own obverse in the giant with the raised shield on our left. Both these figures are overscaled—more effectively so since each is seen against coupled runners, diminished by perspectival recession. These paired running figures, in flight on the left, coming in at far right, are again, like the two giants, inversions of one another; they clearly exemplify the demand for bilateral correspondence. And surely the impulse here is neither dramatic nor narrative nor naturalistic. It is rather an architectural rigor that makes the artist seek repetition at the outer margins, as if he were placing twin columns at the wings of a façade. And in the forward plane, posted like piers, the corresponding giants seem to personify the colossal order Michelangelo loved. One is reminded of the Campidoglio palace façades with their giant pilasters dwarfing attendant paired columns.[15]

As always in Michelangelo's work, structural and illustrational motives coincide. Gestures that express psychic states support the pervasive subordination to tectonic order. If the two foreground giants function as steadying pillars, that effect is dramatically sustained by their panic paralysis. The stalwart at left drags at his sword-hilt in a futile left-handed gesture, straining away from, instead of leaning into, his girded side; and cowers under the rim of his shield as in the shell of a statue niche. His compeer at the right finds no more manly employment for his hands than to protect over-sensitive ears. The strongest are the most arrested. Standing fast in consternation, their urgent gestures serve only to pin them down—for the benefit of the general structure.

The whole cast of characters—once we transcend the illusion of each-man-for-himself—is disposed as if predetermined by symmetric necessities. Left and right echo each other; single figures or doublets of figures answer to mirror images. But each corresponding pair shows, like a pair of hands, variation enough to feign spontaneity and free will. So the two collateral giants may pivot in place and show heads or tails. Paul and his co-recumbent are free to flex this or that leg. Others may exit or enter, so long as they stay in line. Minor shifts and asymmetries are allowed, but as the license of dependent members.

It becomes apparent that the whole earth-bound concatenation of figures, from the coupled runners at left to their incoming opposites at the right, solidifies into one restless parapet of massed bodies. They do not simulate the smooth course of a normal flat wall, but rather the abrupt corrugation of a Michelangesque wall which, in Ackerman's words, is "not a plane cut up into rectangles but an organization of bodies that project and recede . . . The wall is transformed from an inert plane to a vital, many-layered epidermis . . . Unity is enforced by the power of the insistent and continuous alternation of receding and projecting elements."[16] Exactly this "alternation" in restricted depth the fresco achieves by representational means. As the horse at center is checked by its groom, so the escape routes of the fugitive at the right and of the runners at left are blocked by figures approaching. The inroads are forceful, but with no greater prospect of continuing penetration than a recessed element has in a Michelangelesque wall.

Within Michelangelo's human "wall," fierce individual action is reconciled with a close bonding of contours—tangent figures jointed like blocks of ashlar. Surely the tightest seam in the history of painting runs between those two at the right to whom the voice of Christ comes as an ear-splitting din: the brazen giant and, partially overlapped, the turntail with the trailing left leg (Fig. 51). Their interface dovetails continuously from head to heel: the runaway's head is rounded by the giant's armpit, his shoulder is defined by the other's waist, his own waist by the other's hip muscle, and so on down every notch of knee, calf and ankle. A runaway held in place by the seam of a shared contour: it suggests an anatomical back-formation from the subjection of masonry to architectural structure.

In his letter Michelangelo stated it as a truism that "architectural members derive (*dependono*) from human members." And he posited a fairly simple-minded analogy between corresponding parts of a building and such anatomical

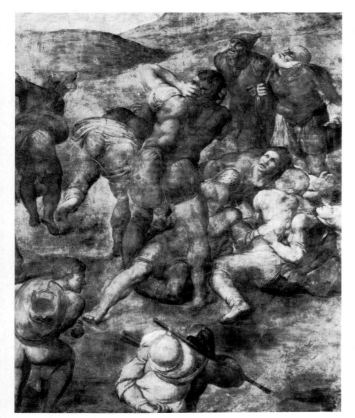

Fig. 51. Michelangelo: *The Conversion of St. Paul.*
Detail. Vatican, Cappella Paolina

double features as hands and eyes. The letter gave no occasion to formulate two related points that emerge from his art: first, that the alleged derivation of architecture from anatomy extends to the ways in which human bodies assemble; crowds and hierarchies and group behavior are no less relevant to Michelangelo's formative notions than the individual physique. Secondly, that the terms of the analogy are reversible, so that modes of human association may follow architectural patterns. Michelangelo's pictorial conceptions project those same ancient "figures" that invest our language—the metaphor of the city, nation, army or church as a superbody with head and members, of corporate entities whose component limbs are individual men. Hence the rebellious runaway in the *Conversion* is really no more than the spasm of a member diseased; he will not run very far. For all their seeming self-will, the actions of the depicted characters are but the convulsions of dependent limbs still incorporated.

In the end, Michelangelo's sense of structure as such is analogical—which helps explain why in his imagery form and symbol cannot be factorized. An athletic physique, a compound building, a body of men—they are reciprocal metaphors of strength under constraint, of individual will overruled. And they bespeak a conception of fate supremely proved in the history of St. Paul.

V. The Included Self

THE structure of the *Conversion* does not leave the viewer alone. It involves him in a system of five interconnected points, four of which lie within the picture. We begin at the Christ.

"Do you think that the Father is satisfied with a foreshortened Son?" asks Jean-Paul Sartre. His rhetorical question expresses a qualm heard ever since Michelangelo's day, a misgiving about the indecorous use of the *scorto*.[1] Gilio's attack on "the Errors of Painters," launched four centuries earlier, makes a special exemplar of our foreshortened Christ:

> Michelangelo (he writes) was much at fault in the Christ who appears to St. Paul in his conversion: who, lacking all gravity and all decorum, precipitates himself from the sky with little dignity; whereas that apparition ought to be rendered with a gravity and majesty befitting the King of heaven and earth and a Son of God. Here, however, he is robbed of devotion and generates something of coarseness in the beholder's heart.[2]

The objection is far from arbitrary, for Michelangelo's *scorto* (foreshortening) represents an astonishing application of perspectival distortion to a sacred figure. Traditionally—roughly since the mid-fifteenth century—*scorti* had been reserved for dead figures; and by the sixteenth century, for the dead and the defeated. Since, normally, a foreshortened diminishing body is tapered into the contractions of perspectival space, it has less room to manoeuvre, hence is felt to be incapacitated, unmanned. Spatial constraint and reduction of stature become legible tokens of deprivation, creating a perfect foil for the heroic figure in commanding possession of space. There is irresistible visual logic in showing a St. Michael, fully and nobly extended, trampling on a grovelling Satan *in scorto*. It follows, then, that the *scorto* of Michelangelo's Christ must be inappropriate.

Modern scholars, however, have shown that Michelangelo was here reverting to a fifteenth-century Florentine tradition, exemplified in those masters who were most alert to the new technology of foreshortening. With magnificent freedom of imagination, both Uccello and Castagno applied the *scorto* to contradictory ends: to the depiction, on the one hand, of lifeless bodies; and, on the other hand, to air-borne divinities—beings endowed with an energy more concentrated than that of human existence.[3] The *scorti* of these great Quattrocentists thus occupy divergent poles, both situated beyond the compass of common experience; they can stand either for victimization or for enhancement.

Michelangelo was fully aware of his forerunners. He knew that a *scorto* can convey puissance or impotence, depending on whether the figure is air-borne or laid low; whether it is seen head or feet foremost; and that you offset the foreshortening of the trunk by giving immensity to the reach of the arms.[4] Finally, he discovered that even a foreshortened trunk can be activated by twisting and spiraling it on its axis. In his Christ figure, Michelangelo strained the anatomical idiom to energize and, at the same time, dematerialize. The fusion of perfect

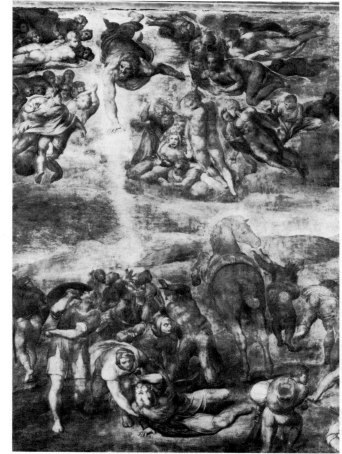

Fig. 52. Michelangelo: *The Conversion of St. Paul*. Detail. Vatican, Cappella Paolina

37

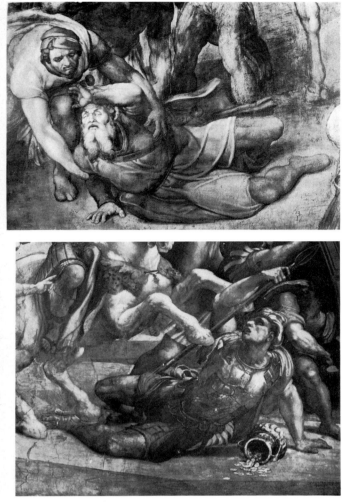

Fig. 53. Michelangelo: *The Conversion of St. Paul.*
Detail. Vatican, Cappella Paolina

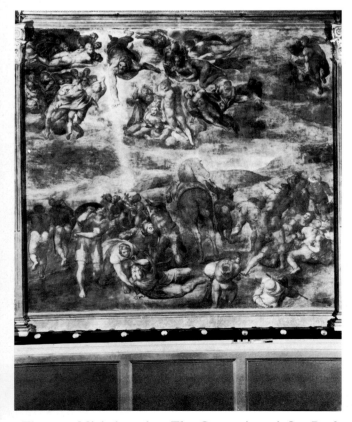

Fig. 54. Raphael: *The Expulsion of Heliodorus.* Detail.
Vatican

Fig. 55. Michelangelo: *The Conversion of St. Paul.*
Detail. Vatican, Cappella Paolina

volition and maximum acceleration empowers the figure as an anatomical body, But as a schema in which the coordinates of height, width, and depth are set forth, it exhibits a quality of geometric abstraction that approaches the incorporeality of a sign: evidently not a figure to be seen as simply one among so many bodies.

Wölfflin observed that the Paul in Raphael's *Conversion* (Fig. 20) has "too comfortable a view" of the Christ, and that Michelangelo's staging is the more effective in that his Christ is poised "so that Paul cannot see him" (Fig. 52; p. 18, above). This is an important half-truth and too fertile to be left where Wölfflin abandoned it. The situation is more complex—even self-contradictory. For if, in a literal sense, the painter seems to be showing us what to Paul is invisible, he is, in another sense, denying us the fullness of Paul's revelation. We see Paul knowing better than we what is overhead. For us, Michelangelo's speeding Christ is too rash and excentric to be held in convenient focus. To anyone on the chapel floor, craning up from so far below, he seems too high up, too compressed; as if he did not wholly submit to observation. We are certain only of this—that the Christ refers to him who lies directly beneath, that his figure is keyed to St. Paul.[5] Paul indeed would see the Christ undiminished, in full, were he not at this moment blinded by this same vision. Christ thus unites with the Apostle in exclusive mutual cognition.

The St. Paul (Fig. 53) is one of Michelangelo's richest creations; a body so activated that its motion fans out all ways—left and right, forward and rearward, to the earth, to the light. Many associations with Michelangelo's earlier works come to mind. The pose remotely suggests the Adam of the Sistine Ceiling, as well as the figure of Dawn in the Medici Chapel—both images of awakening.[6] Closer models have been found in various derivatives of the "river-god" pose, in Michelangelo's own work as well as in Raphael's.[7] But the comparisons are unproductive if they stop at the similarities, for Michelangelo's modifications of the established motif are wide enough to render the St. Paul figure incomparable. All the river-god poses adduced as prototypes are stable structures; even the defensive posture of Raphael's often-cited Heliodorus is nobly balanced (Fig. 54); whereas the pose of Michelangelo's Paul is engineered to collapse. No river-god figure in sixteenth-century painting or sculpture sustains such precarious disequilibrium. Paul's supporting arm is too acutely bent and retracted to steady the toppling mass of the torso. Moreover, the figure turns to us frontally, so that its forward falling, accentuated by the impetuous advance of the helper, is aimed at the spectator. These two distinctions, the sudden imbalance and the frontal address, are without precedent, and they charge the figure with new meaning and urgency. Beyond the two-way relationship between Christ and Apostle there is now an opening outward; beyond the closed binary system of thrust and target, a ricochet: the hitherward plunge of the figure implicates the spectator as a third party. On entering the Cappella Paolina, it is almost the first thing we see—the threatened overflow from the picture space into ours. And this must be why Michelangelo made the Apostle teeter so close to the brink, and on sloping ground pitched towards us: to make us experience the oncoming weight of him as a running over, an imminent forceful invasion of our space. The energy discharged upon the Apostle rebounds and makes us recipients once removed. It is a powerful visualization of the apostolic ordeal, this transmission and mediation of divine energy.

The Christ, then, becomes the first of three interconnected points. From his remote altitude a charge falls upon the Apostle whose posture, facing frontward and beetling over, sends a glancing rebound to the observer. The conscious "I" on the chapel floor is absorbed in a lengthening constellation.

Yet this is but half of a pattern that reverts at once into the picture to engage the intruding pair at bottom right, the two young soldiers plodding along under their kits (Fig. 55). The soldier nearer the center carries his bale akimbo, a blue buckler slung on his back, and a gilded casque upside-down. His comrade supports his bundle with his left hand, a white helmet hung from a pole laid across his right shoulder. Theirs is a strangely anomalous presence. Despite their proximity to the proscenium, they are smaller than the rest of the cast. And although only a few feet separate them from the heart of the uproar, they perceive nothing that might baffle their path. Careless and unheroic, they could be the most vernacular characters in Michelangelo's oeuvre.

They are space-fillers, of course, plugging the intervals left at the lower right between stray feet and hooves. They also round out the lower "crater," and their action of climbing serves to lift the whole scene to the brow of a hill. We have seen, moreover, how their staggered arrival helps emancipate the depicted space. All

of which, and more besides, makes their presence richly functional. Yet the specific character in which the artist has clothed them—their dramatic exclusion, their unconcern and implausible size—remains unexplained. Are they common young soldiers, deaf and blind to the alarm of their elders? Or do they belong to an alternate system, apart from the historic event?

The information we seek is encoded in directional clues. It emerges in answer to two simple questions: where are they going?; whence do they come? Undeviatingly, the two soldiers direct their steps to the goal indicated by Christ's pointing hand. Within the immediate narrative, that goal is Damascus; allegorically, it is where a blindness of spirit is healed. The corollary question touches their point of departure, to be answered again by their homothetic course. Here the directional signal is more complex—like a note on a stave that pertains both to its chord and to its melodic line. In a vertical sense the two soldiers rise from a pit; but horizontally, in prolongation of our sightlines, they form a connecting link between our own station and the city on the horizon—as though they proceeded from that point on the chapel floor where the observer receives from the Apostle the transmitted impact of Christ (Fig. 56). Thus the trail of these common soldiers defines both the aim and the origin of their journey, and these termini declare their identity. External to the depicted historical moment, they become wayfarers, Christian soldiers in perpetual pilgrimage—the *milites christiani*. Space-fillers indeed, for they are relays in a vocational chain. They complete a commanding pattern that runs from the Christ through the Apostle to the spectator's position outside the picture, and thence, in line with their march, to their goal on the horizon: a five-point constellation with its apex in every man.

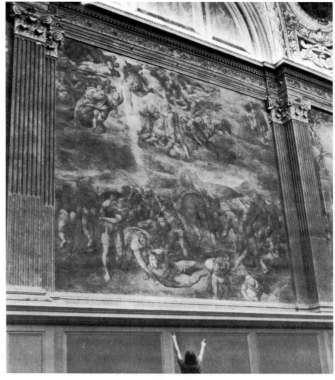

Fig. 56. Michelangelo: *The Conversion of St. Paul*, seen from below. Vatican, Cappella Paolina

PAUL's face, with its flattened nose and forked beard, bears the artist's old, tired features (Figs. 57, 58). But Paul's body is celebrated in floral colors—pale green and lavender, colors of the thin morning light made the more lucent by being relieved against a cloak of deep russet. It is evident that Michelangelo did not assign fixed symbolic values to particular tints; the red of Paul's mantle also colors the leather harness of a soldier in the left background, of another within the huddle at right; and leaps from the Christ to one of the angels. But on Paul's figure the colors act as reciprocal foils, and their juxtaposition in the context of his conversion arouses an intuition of meaning. The fresh vernal tones of Paul's hose and tunic disengage themselves from the autumnal shade of the cloak—as though the contrasted colors conveyed some innermost alteration. As Paul's light-hued body falls free, his opaque outer garment, in which his left foot is still entangled, drops from him—one is tempted to say, like an integument. If indeed the artist imagined a moment of regeneration, no contrast of colors could better symbolize the shedding of an old skin in the emergence of the convert to a new birth.

The sloughed skin as a figure of spiritual renewal following the surrender of pride was familiar to Michelangelo from his lifelong reading of Dante; it occurs in a passage that always held his especial interest (he cites it in Giannotti's First Dialogue)—the description of the First Cornice of the Slope of Purgatory, decorated with flawless white marble sculptures, "besides which Polyclitus' best work would be scorned." The poet's contemplation of these reliefs is interrupted by a procession of men crawling under great slabs of rock. They are the train of the proud, "doubled to the very earth"; at the sight of whom Dante exclaims:

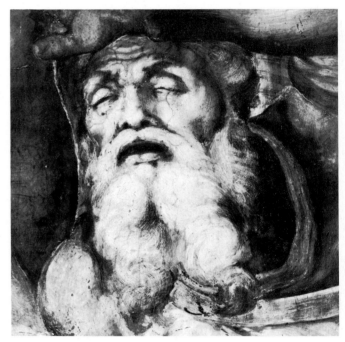

Fig. 57. Michelangelo: *The Conversion of St. Paul*. Detail. Vatican, Cappella Paolina

> O you proud Christians, wretched souls and small,
> . . . can you not see that we are worms, each one
> born to become the Angelic butterfly
> that flies defenceless to the Judgment Throne?
> What have your souls to boast of and be proud?
> You are no more than insects, incomplete
> as any grub until it burst the shroud.[8]

Could it be Dante's image of the cocoon that reacted in Michelangelo's mind as he pondered the state of his hero? Surrendered pride and regeneration are the twin themes that meet again in the *Conversion of Saul*.

But the symbol of the old skin that needs discarding had long before become Michelangelo's own. His poems are haunted by a nightmare fantasy that the skin on his body shrouded his soul in a living death; he felt it dry up and decay upon him. "Here I am, shut in like the pith in its rind." Man, he writes, "sloughs his skin like a serpent . . .". He speaks of his "mortal epidermis" and his "dried husk." And again, "man lives in a sack of leather."[9]

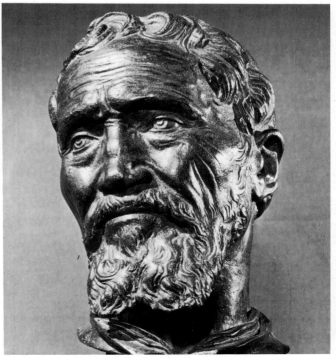

Fig. 58. Daniele da Volterra: *Michelangelo*. Bronze. Paris, Louvre

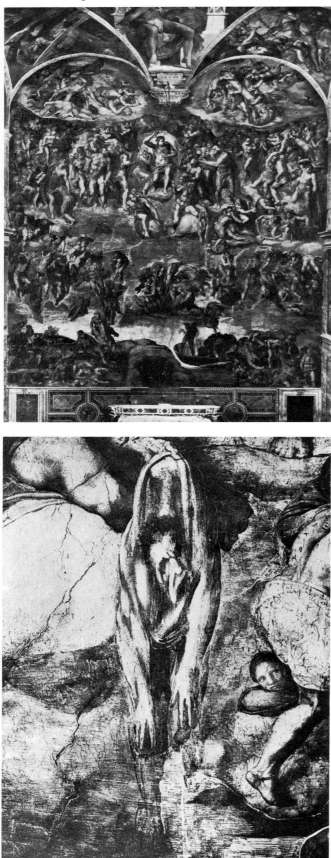

Fig. 59. Michelangelo: *The Last Judgment*. Vatican, Sistine Chapel

Fig. 60. Michelangelo: Detail from *The Last Judgment*. The flayed skin held up by St. Bartholomew with Michelangelo's self-portrait. Vatican, Sistine Chapel

Out of this same obsession—sublimated to the level of an existential theology—emerged one of Michelangelo's most formidable personal symbols, his self-portrait as a flayed human skin hung under the gaze of Christ in the *Last Judgment* (Figs. 59, 60). The artist's presence at the focal point of the action usurps Christ's immediate attention. Christ's glance and suspended gesture, whether to damn or save, direct themselves pointblank at the rag in St. Bartholomew's hand, the limp sheath stamped with Michelangelo's features. And the line that descends from the Judge through the martyred Apostle to the skin he holds up as Michelangelo's intercessor, becomes the main artery of the design. A verdict is about to be handed down, and the first arraigned is the wretched likeness of Michelangelo's self. The whole cosmic drama—the giant fresco with more than three-hundred figures—collapses upon a single destiny. Not because the artist thinks himself foremost amongst mankind, but because the reality of the Last Judgment, as he rethinks it, requires it: for if the *dies irae* is more than a fable, and more than a warning to others; if the certainty of divine judgment is real and serious, then it is so only to the extent that the man who tells of it knows himself to be the first on trial.

What was being tried was a past life which the ageing artist came to regard as perilously misdirected to the worship of art—

> That passionate fantasy
> Which once made art idol and king to me.[10]

Even now, nearing seventy—"so near to death, so far from God"[11]—he felt not yet wholly released from the idolatry of his youth. The artist of whom Condivi wrote—"He loved not only human beauty, but universally every beautiful thing . . . choosing the beauty in nature as the bees gather honey from flowers . . ."—this same man exclaims in a sonnet, "Teach me to hate the world."[12]

The sonnets Michelangelo wrote during the years devoted to the *Last Judgment* and the Cappella Paolina dwell continually on his mounting guilt, his need for regeneration, his anxious craving for grace. They reflect the religious upheaval then overtaking Western Christendom, and the general intensification of Christian consciousness in an age characterized by conversions. But they express, above all, Michelangelo's own conversion to a more urgent Christianity. During the latter 1530s in Rome, he had been drawn into a circle of devout Catholic Reformers gathered about the poetess Vittoria Colonna, the group known as the *spirituali*. And the depth of his change of heart is attested by the changing character of his work. Not only is there a withdrawal from pagan themes; not only does his body image increasingly distance all sensuous appeal; but there is, beginning with the *Last Judgment*, a new directness of address to the viewer, a concept almost apostolic of the role his art must now play in the world.

Up to this moment, Michelangelo had striven to create art of surpassing perfection. In his early twenties, entering upon the contract for the Roman *Pietà*, he had proudly bound himself to deliver "the finest work in marble which Rome today can show, and that no master of our day shall be able to produce a better."[13] In a letter of May 2, 1506, he had given a similar undertaking to Julius II concerning the Pope's Tomb: "It shall be a work of art such as I have promised; for I am certain that if it is carried out, there will be nothing to equal it the world over." In the Sistine Ceiling—here we have only his echo in the words of Vasari—Michelangelo was resolved "to show modern artists the true way to design and paint." And the master himself reaffirmed his pride and ambition when, in 1517, he promised to make the façade of S. Lorenzo "a mirror of architecture and of sculpture to all Italy."[14] An introverted aestheticism had ruled Michelangelo's art. His figures tended to turn in on themselves—in the sufficiency of their beauty, in their cyclical structure and their emotional self-absorption. The Medici Chapel, Michelangelo's last work in Florence before he finally moved to Rome, still presented itself as a sealed aesthetic domain.

Not so the *Last Judgment*. Though Vasari's description tries to aestheticize it into a virtuoso display of athletic nudes and difficult *scorti*, the *Last Judgment* is rhetorical, outer-directed, and limitless—not a contained system so much as an act of aggression, assaulting both mind and body. It assaults the mind by flooding it in excess, by the urgency of the subject, even by shocks of obscenity;[15] and the body, by disturbing the sense of safety which one derives from abiding indoors. By its seeming obliteration of the altar wall (Fig. 61), Michelangelo's frameless fresco converts the Chapel into a huge open shed, or hangar, its protective screen melted away to reveal the perpetual imminence of the Last Day. At the sight of it, Pope Paul is said to have dropped on his knees and fallen to prayer.

The *Conversion* fresco is conceived in a like spirit: less an object of contempla-

tion, than a bid to manipulate our response, to reach out, to persuade, to involve. In the aggressiveness of its Christian summons, in its predatory encroachment on the spectator's space, it again transcends Michelangelo's former aestheticism. The work is rhetorical in the sense that it engages the viewer; and it is, like the *Last Judgment,* confessional in that the artist projects himself passionately into his subject, even to the point of portraying himself in its hero. The painting becomes a synthesis of private penance, apostolic fervor, and art.

Some ten years after completing the Paolina frescoes, Michelangelo revealed something of his final self-image in the device and motto he chose for a medal struck in his honor (Figs. 62, 63).[16] The medal was made by the sculptor Leone Leoni. Its obverse displays the rutted profile of Michelangelo octogenarian; the reverse represents him as a blind pilgrim led by a dog. The inscription, taken from the fourth Penitential Psalm (50: 15), reads: *Docebo iniquos vias tuas et impii ad te convertentur* ("I will teach the unjust thy ways: and the wicked shall be converted unto thee").

It is important to recall the mood of the Psalm to which Michelangelo's chosen motto is the conclusion; for the Psalmist is not glorying in having something to teach, but confessing himself in contrition.

> Have mercy on me, O God, according to thy great mercy . . . Blot out my iniquity . . . and cleanse me from my sin. For I know my iniquity, and my sin is always before me. To thee only have I sinned, and have done evil before thee . . . Cast me not away from thy face; and take not thy holy spirit from me. Restore unto me the joy of thy salvation, and strengthen me with a perfect spirit. I will teach the unjust thy ways: and the wicked shall be converted unto thee.

Between the penultimate verse and the pledge contained in the closing line, a conjunction is wanting—an accident of style that led earlier Michelangelo scholars to read the lifted motto in isolation. More recently, Philipp Fehl, in a thoughtful essay on Michelangelo's *Crucifixion* fresco, has expounded what must surely have been Michelangelo's meaning: "'Cleanse me from my sin,' prays the blind pilgrim guided by faith, *and then* (emphasis added) will I 'teach the unjust thy ways and the wicked shall be converted unto thee'."[17]

The context of the Psalm from which the motto was drawn may help to illuminate the spirit that would have allowed the painter of the *Conversion* to identify himself with the saint. Saul, in the instant of his election, is marked for suffering as an instrument of divine will;[18] and is cleansed of selfhood and sin of pride, being regenerated by an act of sudden, unmerited grace. The artist is like the protagonist of his picture in past pride and selfhood, and in longing to undergo the Apostolic ordeal—wanting only the assurance of grace. "Lord, in my latest hours," he writes, "around me let thy pitying arms be thrown! Teach me thy will: defend me from mine own."[19] His self-projection into the role of Saul is a petition.

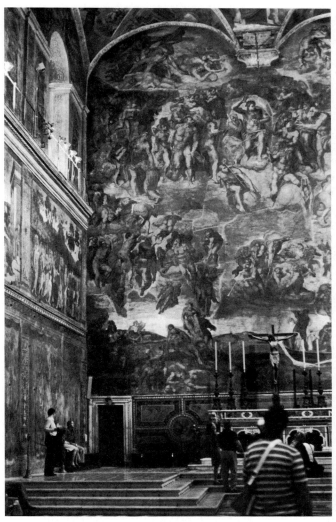

Fig. 61. Michelangelo: *The Last Judgment.* Vatican, Sistine Chapel

Figs. 62–63. Leone Leoni: Portrait medal of Michelangelo

Fig. 64. Fra Bartolommeo: *Portrait of Michelangelo.* Drawing. Rotterdam, Museum Boymans—Van Beuningen

MICHELANGELO'S humor rarely admitted contentment, but the three years spent on the first Pauline fresco must be counted among the happiest of his life. He was surrounded by friends who loved him, who worshipped his genius, hung on his words, put up with his carking, and stocked his kitchen.[1] When the old master (Fig. 64) took ill in the summer of 1544, the devoted Luigi del Riccio (the representative of the Strozzi bank in Rome, who also managed the artist's financial affairs) moved him into the Strozzi Palace and nursed him back to health.[2] The following year brought the most wished-for relief: the Julius Tomb, which had "empoisoned his manhood" (Symonds), was finally finished and put away in S. Pietro in Vincoli. And now the first of the Pauline frescoes was done. It was inspected by the Pope on July 12, 1545, and there is no reason to doubt that it gave satisfaction.[3] Papa Pagolo, as Michelangelo called him, seems to have felt real affection for his chosen artist, approving whatever he did; when Michelangelo sent him thirty-three pears out of a shipment of eighty-six he had just received from his brother, His Holiness "found them excellent and was very grateful."[4]

Meanwhile, on March 6, 1545, Michelangelo had turned seventy, an event celebrated by his admirers with the publication of the master's portrait, engraved by Giulio Bonasone (re-issued 1546; Fig. 65). Donato Giannotti's *Dialogues with Michelangelo* were printed in the same year. But Michelangelo, Bible reader and lifelong student of Dante, can have found little cause for self-congratulation in the attainment of seventy. The opening line of the *Divine Comedy* fixes the poet's thirty-five years at the mid-point of the journey of life—in accord with the familiar ninetieth Psalm: "The days of our years are threescore and ten, and if by reason of strength they be fourscore years, yet is their strength labor and sorrow; for it is soon cut off . . .".

For the old artist not soon enough. Though nineteen productive years lay ahead, Michelangelo trembled lest the protraction of life add to his guilt and make it harder for Grace to effect his salvation. Having outstayed man's allotted season, he began to speak of himself as one living on borrowed time, or, as he put it, "on credit."[5] The first of Giannotti's *Dialoghi* concludes with the artist's madrigal on the necessity of thinking death—"the only thought which makes us recognize ourselves."[6] "I am an old man and death has robbed me of the dreams of my youth," he writes to a friend in 1547. To another, in 1549, "I wrestle with death." And to Vasari in 1555, ". . . I am at the eleventh hour and I conceive no thought in which Death is not engraved."[7]

The passing of threescore-and-ten is a symbolic event.[8] For Michelangelo its import was soon confirmed by a hail of calamities. In August 1545, he began to suffer acute financial anxiety as the revenues from the Po Ferry above Piacenza, assigned to him by the Pope, were suspended, cutting his income by half.[9] And in December 1545, he contracted another fever, graver than that of the preceding year. It has been surmised that this illness was brought on, or aggravated, by an especially cruel visitation of the previous month: Aretino's letter to Michelangelo professing outrage over the obscenities of the *Last Judgment.*

Objection to certain details in the giant fresco had been rife for some time, but their expression was checked by the painter's renown and the protective hand of the Pope. Now, in Aretino's eloquent *auto da fé,* the muted mutterings were gathered up and delivered in one stinging attack.

> As a Christian who has received Holy Baptism (writes Aretino), I feel nothing but shame at your unbridled license. . . . Why even the Heathen . . . when carving a nude Venus allowed her, by means of stance and gesture, to appear as if draped. But you, who are a Christian, so subordinate your faith to your art, that the violation of the shame of martyrs and holy virgins is turned into a spectacle such as in a bawdy house one would behold only with eyes half averted. In some voluptuous bagnio, not in the first Chapel of the World, should such a thing have been painted. Truly it were better for you to be an infidel, than as a member of the faithful so to offend the faith of others.[10]

Aretino's motive for circulating the letter is usually ascribed to personal spite, Michelangelo having disdained to honor him with the gift of a drawing. But the incentive is more likely to have been political. Power in Italy was reverting to the

MICHAEL ANGELVS BONAROTVS PATRITIVS
FLORENTINVS AN AGENS LXXII

QVANTVM IN NATVRA ARS NATVRAQVE POSSIT IN ARTE
HIC QVI NATVRÆ PAR FVIT ARTE DOCET

M D XLVI

Fig. 65. Giulio Bonasone: *Portrait of Michelangelo.* Engraving, 1546. (B. xv, 345)

religious. The Inquisition had been revived in 1542; the Society of Jesus, confirmed in 1540, was extending its influence; and the long-delayed Council of Trent was preparing its opening session (December, 1545). The acute Aretino (Fig. 66), whose nimble pen compassed the scurrilous and the sacred, libels and Bible commentaries, dialogues of courtesans and lives of saints, handling each genre with unerring precision—this laughing philosopher now seized the occasion to put himself on the side of the angels, the injured, the innocent. As John Addington Symonds commented, "the malignancy of his letter is only equalled by its ingenuity. Aretino used every means he could devise to wound and irritate a sensitive nature."[11]

Michelangelo's fever lasted until January, 1546. Recovering, he was plunged into the most bereaved period of his life—five of his friends, colleagues, and relatives passing away during an eighteen-month spell. Luigi del Riccio died in the autumn of 1546, leaving the old artist deprived of his main worldly support and stunned with grief. February 25, 1547, brought the death of Vittoria Colonna, the agent of his religious conversion and the only woman with whom Michelangelo had been able to form an attachment. "Recalling her death," writes Condivi, "he often remained dazed as one bereft of sense."[12] Then—June, 1547—the death at sixty-two of Sebastiano del Piombo, for many years Michelangelo's most intimate friend among painters. November, 1547: death at forty-six of Perino del Vaga, the brilliant painter and stuccoist who was to have been Michelangelo's collaborator in the decoration of the Pauline Chapel. And Michelangelo's brother, Giovan Simone, died on January 9, 1548. Envious of the dead, the artist began to see himself as a forgotten survivor. It was then that he fell to work on the Florentine *Pietà* (1547–54), destined for his own tomb, with his self-portrait in the figure of the hooded mourner supporting the Christ (cf. Fig. 85).

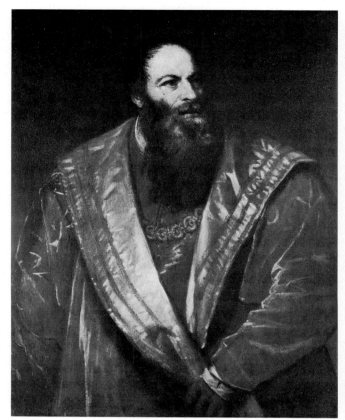

Fig. 66. Titian: *Portrait of Pietro Aretino*, 1545. Florence, Palazzo Pitti

One other death intruded on Michelangelo's life—that of Antonio da Sangallo the Younger (August 3, 1546), for the past twenty-six years architect of St. Peter's. Condivi tells the immediate sequel: "When at last Antonio da Sangallo died, and Pope Paul wished to put Michelangelo in his place, he refused the post, saying that architecture was not his profession. He refused it so earnestly that the Pope had to command him to take it."[13] But of course he did take it, and maintained the position through three subsequent papacies. No wonder Michelangelo appeared to his contemporaries as an immortal. About to embark on the second of the Pauline frescoes, while carving the four-figure *Pietà*, his most ambitious sculptural group, at night by the light of a candle which he sticks in a paper cap on his head, the weary gaffer, who seeks "day and night to make friends with death so that at the end he may not treat me worse than other old folk,"[14] turns professional architect, taking charge of the Campidoglio and the Farnese Palace, and the largest architectural undertaking in Europe, St. Peter's Basilica.

Michelangelo's most momentous decision as architect of St. Peter's is not unrelated to his meditations on the St. Peter fresco: in the Church, as in the Chapel, he wrought a change of program that shifted emphasis to the death of the Apostle. In both instances, he was commemorating the fact that the Church's mission had been consecrated by martyrdom. "Non vi si pensa quanto sangue costa"—"They consider not [there on earth] how much blood it cost"—he had written on the stem of Christ's Cross in his *Pietà for Vittoria Colonna*.[15] The words take their primary meaning from their original context: they are spoken in Heaven by Dante's Beatrice as she denounces those self-willed men who go about preaching novel interpretations of Scripture, not thinking what it had cost in blood to disseminate the true doctrine (*Paradiso*, Canto XXIX, 91). In Michelangelo's *Pietà* drawing, the words are ascribed to Mary-Ecclesia, the Virgin Mother as figure of the true Church; they are her credentials as teacher, a memento that the religion founded in Christ's sacrificial death had been perpetually re-affirmed by the blood of martyrs. And it is in the spirit of these affirmations that the artist now makes his decisions.

To begin with St. Peter's. Bramante's original project had condemned the old longitudinal structure to be replaced by a central plan—four equal arms radiating from the domed crossing. A change of such magnitude unites many motives, but one of these must have been the symbolic status assigned to centralized churches in sixteenth-century architectural thought. Whereas a longitudinal plan was understood to be essentially congregational, a centralized building, such as a domed Greek cross, presented the Church as a monument, the marker and canopy of a hallowed site.[16] In the Renaissance, this conception of a domed, centralized church as a mausoleum or memorial structure found encouragement

43

in Roman funerary monuments. But it harked back continually to the tomb of Christ, the Rotunda of the Holy Sepulcher in Jerusalem, and to its derivatives in churches erected as martyr shrines.[17] St. Peter's, the old occidented Basilica, was such a shrine in fact, though not in appearance or structure; for it located the tomb of St. Peter beneath its apse at the western end of a Latin cross plan. That tomb Pope Julius refused to have moved;[18] it was to become instead the fixed pivot of his vast new construction. The Bramante plan to which Julius gave approval not only proposed a domed central structure, but located the cupola of that structure so that the immovable tomb of the Prince of Apostles fell under its apex. By re-deploying the parts of the building about that fixed point, Bramante succeeded in shifting the tomb's relative situation from apse to center. Surely the Pope's architect understood the implications of this momentous shift. Whatever other considerations co-determined his plan, St. Peter's under his charge was being converted into a giant martyrium.[19]

But Pope Julius died early in 1513—Bramante in the year following. And their successors, Leo X and Raphael, reconverted the project into an axial, Latin cross structure, which offered important advantages from the point of view of the liturgy. From 1514 to 1538, the operative plans for St. Peter's appended a nave to the initial design. Only in 1539, after nineteen years as incumbent architect, did Sangallo, yielding to various pressures, try to combine the axial and the centralized systems. But in his ingenious compromise the clarity of Bramante's centralization and the immediacy of its message remained vitiated.[20] This compromise Michelangelo swept away. Against sharp opposition from the building administrators, he discarded Sangallo's model to reinstate unequivocally the central plan of Bramante. "Anyone who has departed from Bramante's arrangement, as Sangallo has done, has departed from the truth," wrote Michelangelo— and reverted to the centering stress on Peter's martyrdom.[21]

The poles of Michelangelo's life cohere like the terms of a parable. Forty years had passed since Bramante's artistic will had prevailed against his. Then, in the lustihood of his youth, he had dreamt of seeing his masterwork rise three storeys high under the vault of a new choir, overlooking St. Peter's tomb and giving the Church a spatial climax that would have prolonged and commanded its longitudinal axis. "Once I had hoped to raise me by thy height," he had written in a sonnet to Julius II.[22] Counting on the omnipotence of the Pope, he had meant to use St. Peter's as an exalting frame for his art. Now, after a life of punished hubris, he would use his art to exalt St. Peter's. As its new architect-in-chief, he insists on doing the work without pay—partly to enhance his authority, but no less as an offering, perhaps as an expiation. He begins by enforcing the central plan that honors the sepulchre of the martyred Apostle—and in the very year of that crucial decision, diverts the subject of the second Pauline fresco from Christ's charge to St. Peter to the consummation of Peter's mission in crucifixion. We shall see that this change of subject must have come about at Michelangelo's prompting.

Pope Paul's intentions for the fresco decoration of the Pauline Chapel are not documented. But they may be inferred from certain considerations, beginning with the purpose for which the Chapel was built. Its function was twofold. The first was the preservation and exposition of the Sacrament. The second directly concerned the Apostolic claims of the Bishop of Rome: the Cappella Paolina was designed as the meeting place of the Conclave that creates Popes; here the links in the chain of Apostolic succession were to be forged; here the votes of the Sacred College were to be cast and counted; here the name of St. Peter's latest successor would be announced; and here was to be staged the enthroning of the newly-invested Pope on the altar, to receive the homage of the assembled Cardinals.[23] The Roman See, as Tertullian had phrased it, was "doubly Apostolic." Appropriately, therefore, the two giant murals in the Chapel of the Conclave would have represented the moments in which the twin founders of the Roman Church received their respective commissions from Christ: the Delivery of the Keys to St. Peter, which prefigures the foundation of the Church and the primacy of the Roman See; and the Conversion of Paul, which initiates the Church's apostolate to the Gentiles. The two subjects are significantly related, while the Crucifixion of Peter is normally paired with the Beheading of Paul.[24]

The subject of Christ's charge to St. Peter had been prominently displayed in the Sistine Chapel half a century earlier in Perugino's fresco. It was then the expression of the doctrine of Papal supremacy over the claims of Church Councils. The theologians of Sixtus IV had based their arguments largely on the pre-

44

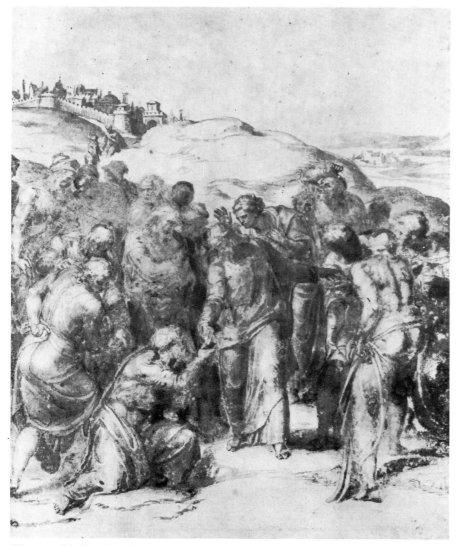

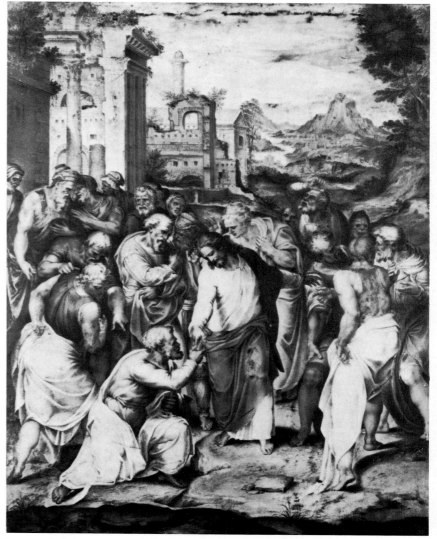

Fig. 67. Giulio Clovio: *Christ Giving the Keys to St. Peter*. Drawing. Windsor Castle, Royal Collection

Fig. 68. Giulio Clovio: *Christ Giving the Keys to St. Peter*. Drawing. Paris, Louvre

eminence of St. Peter, and they invariably interpreted the Donation of the Keys as proof that Peter, the first Bishop of Rome, had been singled out above the other Apostles.[25] If this issue was vital in the 1480s, when the opponents of Papal supremacy were the Conciliarists, it was infinitely more pressing in 1540, when half of Europe was branding the Roman Pontiff the Antichrist and calling his power a usurpation. At such a moment, then, the obvious counterpart to the *Conversion* fresco in the Paolina should have been Christ's Charge to St. Peter.

Certain clues indicate that the Delivery of the Keys was indeed the subject originally planned for the second mural. Michelangelo may actually have sketched such a composition, for there exist two drawings of the subject that seem to imply a lost design by the master (Figs. 67, 68). Both are attributed to Giulio Clovio, the famous miniaturist who repeatedly copied Michelangelo's drawings. Composition and figure style of these sheets reflect Michelangelo's manner of the 1540s. And if one projects the Windsor drawing upon the right-hand wall of the Pauline Chapel, correspondences with the *Conversion* fresco on the opposite wall suggest themselves—in the general format, the tilted terrain, the agitation and massing of figures. Alerted by Clovio's drawing, one is led to suspect that the subject proposed to Michelangelo for the second fresco had not always been the Crucifixion.

Weightier evidence comes from Vasari. The first edition of the *Lives* (printed in Florence in 1550 but from a manuscript completed just before Vasari left Rome in the fall of 1546) contains this brief reference to the Paolina: "He (Michelangelo) was assigned another chapel, where the Sacrament is to be kept, called the Paolina, in which he is painting two histories, one of St. Peter, the other of St. Paul; one, wherein Christ gives the keys to Peter, the other, the awesome (*terribile*) Conversion of St. Paul."[26]

Vasari's mention of the Keys instead of the Crucifixion could be a slip of the pen or a lapse of memory; but this is a feeble hypothesis in view of the climactic role his book assigns to Michelangelo's final period. More probably, Vasari left Rome before gaining knowledge of Michelangelo's final design; and his "erroneous" statement correctly records the program for the Paolina as it stood before the second fresco was started—a *Crucifixion of Peter* too extraordinary to slip the mind.

But why was the subject changed and can the change be attributed to the

45

Fig. 69. Domenico Taselli(?): *The Crucifixion of St. Peter*. Copy of a destroyed wall painting in the portico of Old St. Peter's. Rome, Archivio San Pietro, Album Jacopo Grimaldi, fol. 39

Fig. 70. Cimabue (?): *The Crucifixion of St. Peter*. Fresco. Assisi, S. Francesco, Upper Church

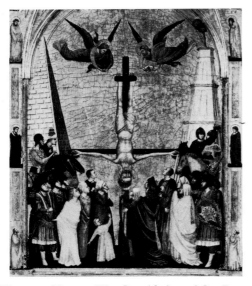

Fig. 71. Giotto: *The Crucifixion of St. Peter*. Detail from the Stefaneschi Triptych. Rome, Pinacoteca Vaticana

artist? Normally, such a suggestion would be preposterous. We may not know the name of the person who drew up the program, but we assume that either the patron or his advisor dictated to the artist what he should paint. In the present case, however, this assumption would be unjustified—not only because Michelangelo is involved, but because the subject forbids it. A St. Peter crucified heels over head could not have been proposed initially for the Pauline Chapel, because the scene, in its established, familiar aspect, was as inappropriate to the role of the Chapel as to the scale of its walls.

It had never been a popular martyrdom, considering the eminence of the victim. Representations in Italy of the Crucifixion of Peter were comparatively uncommon.[27] Its canonic statement, probably based on an Early Christian prototype, was a thirteenth-century fresco in the portico of Old St. Peter's—part of a fresco cycle that perished in 1609–10 when that last surviving portion of the Constantinian building was razed. But the composition of the lost fresco is preserved in a seventeenth-century drawing (Fig. 69): it shows the Apostle head down, nailed to the cross in rigid vertical posture. Subsequent fresco cycles depicting the life of Peter—in the Upper Church at Assisi (Fig. 70), at S. Piero a Grado near Pisa, in the Brancacci Chapel at the Carmine in Florence—repeat the same scheme.[28] Frontality and inflexibility of the victim are constant features, regardless of medium or scale, style or chronology—in altar wings and predella panels from Giotto (Fig. 71) to Giovanni Bellini; in sculptured reliefs from diminutive Gothic ivories (Fig. 72) to Filarete's bronze doors at St. Peter's (Fig. 73); in Carolingian illuminations and in designs almost contemporaneous with the Pauline Chapel (Fig. 74).[29] A millenial tradition confirms time and again that the crucified Peter, fastened feet skyward to the inverted cross, is only conceivable as rigid, frontal, and perpendicular.

One other feature characterizes nearly all of these images: they are frames in a sequence. Whereas the beautiful martyrdoms of St. John, St. Catherine, St. Sebastian or St. Lawrence lent themselves to separate treatment, the sight of the Prince of Apostles turned topsy-turvy was too dispiriting to be left unaccompanied by some image of restored majesty. Patrons, painters, and public alike understood that a man upside down was not only tormented, but that his humanity was impaired; that an inverted face became incommunicative, no longer readable for expression. Therefore—except in those special cases where the dedication of the church demanded a fresco cycle in which the Crucifixion must needs be included—pictorial representations of Peter's death were usually small in size, intended more as visual mementos than as affective images in their own right. It seems to have been generally acknowledged that his death as a heroic exemplum had little to gain by being depicted. Nor can it be accidental that Peter is the only Apostle whose attribute is not derived from his martyrdom.[30]

The story of Peter's martyrdom is post-Biblical. St. Jerome refers to it briefly in the first of his *Lives of Illustrious Men*:

> (Peter) pushed on to Rome in the second year of Claudius to overthrow Simon Magus, and held the sacerdotal chair there for twenty-five years until the last, that is the fourteenth, year of Nero. At his hands he received the crown of martyrdom being nailed to the cross with his head downwards to the ground and his feet raised on high, asserting that he was unworthy to be crucified in the same manner as his Lord.[31]

It is the crux of the story that what the ancients regarded as an aggravation of punishment was incurred voluntarily. "For so he had demanded to suffer," writes Origen.[32]

From simple humility—according to these reticent Fathers. But in the Apocryphal *Acts of Peter* (originated in the late second century), Peter's motives become more complex, and more preacherly and improbable. With elaborate reasoning, the Apostle, already nailed head down to the cross, expounds his preference for that posture. Arguing that the cross "is not this thing that is visible," he proceeds to its mystical exegesis:

> The Word is this upright tree on which I am crucified; but . . . the crosspiece (is) the nature of man; and the nail that holds the cross-piece to the upright in the middle is the conversion (or turning point) and repentance of man. . . .[33]

We learn, furthermore, that Peter chose the inverted posture as a similitude of the manner of human birth:

46

The first man whose likeness I have in my appearance, in falling head-downwards showed a manner of birth that was not so before; . . . and the form in which you see me hanging is a representation of that man who first came to birth.[34]

In another version of the Apocryphal text, the hoisting of Peter's feet indicates their eventual goal:

> And Peter, having come to the cross, said: Since my Lord Jesus Christ, who came down from the Heaven upon the earth, was raised upon the Cross upright, and He has deigned to call to Heaven me, who am of the earth, my Cross ought to be fixed head down-most, so as to direct my feet towards Heaven. . . .[35]

Finally, in Voragine's *Golden Legend* (thirteenth century), the received elements are compounded. Since this is the text that was most familiar to Renaissance readers, it deserves to be quoted at length:

> And when Peter came in sight of the cross, he said: "My Master came down from Heaven to earth, and so was lifted up on the Cross. But I, whom He has deigned to call from earth to Heaven, wish to be crucified with my head toward the earth and my feet pointing to heaven. Crucify me head down-wards, for I am not worthy to die as my Master died." And so it was done: the cross was turned, so that he was fixed to it head downwards. At this the crowd was enraged, and wished to kill Nero and the prefect, and deliver the Apostle; but he besought them not to hinder his martyrdom. Then God opened the eyes of those who wept, and they saw angels standing with crowns of roses and lilies, and Peter standing in their midst, and . . . he began to speak from the cross: "Lord, I have desired to follow Thee, but I did not wish to be crucified upright. Thou alone art erect, upright, and high. We are children of Adam, whose head was bowed to the ground: his fall denotes the manner in which men are born, for we are born in such wise that we are let fall prone upon the ground."[36]

The speeches which these medieval accounts impute to St. Peter are typical of the non-visual, word-bound imagination. That Peter in his predicament is made to expatiate on the symbolism of the cross is unlikely enough. The analogy with the posture of human birth is an infelicitous verbal conceit. And the notion that feet pointing skyward imply a destination in heaven may be rhetorically effective, but it remains an unrealized image. In the corpus of Christian imagery, no one ascends to heaven feet first. Visually, an upside-down figure heads for the ground, and no representation of Peter crucified succeeds in suggesting a heaven-bent course half so well as does one pair of eyes glancing upward. Visualizations of Peter's inverted posture are thus necessarily at odds with the spiritual significance claimed for it.

Beyond the unrealized verbalisms of the *Acts* and the *Legend* lies a graver discrepancy. What the literary accounts project most insistently is the commanding will of the victim. It is Peter's wish to be hoisted feet uppermost, and the henchmen turn the cross at his bidding. And when the friendly crowd moves to intervene on his behalf, it is he who orders them to desist. Throughout the story he has his will. But in the pictures—though they may dignify the Apostle by making him large, by centering him in the field, and by endowing him with the imperturbability of a pillar—Peter remains inert. Steadfastness the painters could let him have; but none thought it possible to show the inverted man manipulating his situation or willing the motions of his executioners. Nor could such a conception arise except in the mind of that artist who habitually conceived of suffering as a state of being, a resource of energy and test of effective strength. Only Michelangelo could have envisioned the crucifixion of Peter as sufficient to a vast mural painting. Only as he re-invented it did the subject become feasible and acceptable.

Of course, the change of program required approval from Paul III; and the sense the Roman Church then had of struggling against peril and persecution must have lent a welcome symbolic dimension to the image of the martyred St. Peter. But Michelangelo must first have assured the Pope that he could rescue the theme; that he could render St. Peter crucified upside down, yet indomitable and dominant.

Instead of presenting the cross already planted, Michelangelo's *istoria* recedes to the moment of preparation (Fig. 75).[37] By activating the event into an elevation

Fig. 72. *Scenes from the lives of St. Peter and St. Paul.* French ivory diptych, 1320–30. Paris, Musée de Cluny

Fig. 73. Filarete: *The Crucifixion of St. Peter.* Detail from the bronze portals of St. Peter's, Rome

Fig. 74. Polidoro da Caravaggio: *The Crucifixion of St. Peter.* Wash drawing. Paris, Louvre

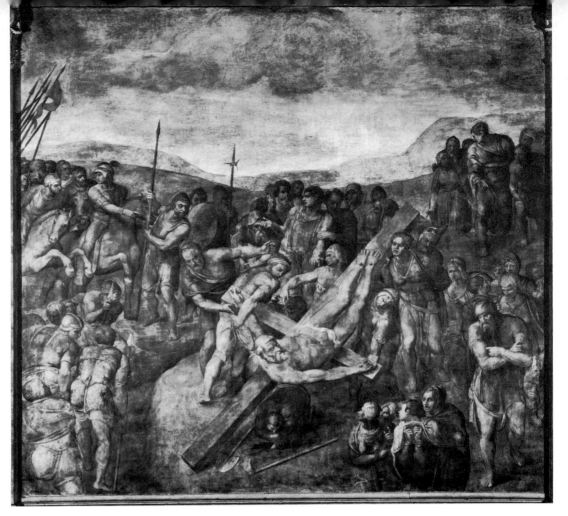

Fig. 75. Michelangelo: *The Crucifixion of St. Peter.*
Vatican, Cappella Paolina

of the cross; by making the powerful wrench and the foreshortening of Peter's torso disguise a gigantic aggrandizement of proportions; by letting the center revolve in obedience to the vigorous clockwise turn of Peter's head and extended arms; and by giving the victim such fierce alertness of gesture that all other motions in the vast fresco seem by comparison dazed and half-hearted, Michelangelo could, for the first time in a thousand years, verify what those Apocryphal words had been claiming—the Apostle's agony as the triumph of a superior will. And through this unique realization the two Pauline frescoes together attained a richer coherence; they became one yoked symbol of the Church founded in vocation and martyrdom.

ONE shudders as one turns from the *Conversion* to the *Crucifixion*. In this second fresco, begun in his seventy-third year, the strength of Michelangelo's drawing is undiminished, but almost everything else has changed: the uproar, the fever, and the violence of the first fresco have given way to stillness and oppressive slow motion. Perfectly centered, constrained to symmetry, fifty figures of magnified stature bestride a contracting space. Almost incomprehensible is the landscape that now serves as setting: wastelands and barren rocks, yet with carved steps in them—intimations of long-trodden tracks.[38] The sky fills with rolling clouds, but they collide at the lintel with the regularity of an architectural gable. The horizon hangs high, which normally indicates an elevated eye level. Yet everything in the fresco looms overhead, and St. Peter's glance nails us where we stand under him on the Chapel floor (Pl. 29).

St. Peter's glance: is it aimed at the viewer? Or perhaps at the apparition of Christ on the wall opposite? Or at the purple dignitaries of the Sacred College, of whom one will pass into the apostolic succession under his gaze?[39] On that stern glance at the center the whole picture seems to converge as a cone converges upon its point. Peter himself, by a fanatic contraction of the abdominal muscles, lifts and projects his trunk towards the beholder, rousing and twisting his upper body in order to see; never has human body summoned such strength for the exertion of looking—not to fix his executioners, nor to regard his friends, but to engage every newcomer, every approach.[40] The rich historical narrative of the crucifixion condenses into the single-mindedness of an icon.

Two remarkable books, separated by half a millennium, open—by unhappy coincidence—with descriptions of the same type of image, the frontal aspect of a face whose eyes, focused directly forward, hold every spectator in focus. The more recent of these books is George Orwell's *1984*, written in 1948. In Orwell's futuristic nightmare, the city displays at every turn "one of those pictures which are so contrived that the eyes follow you about when you move. BIG BROTHER IS WATCHING YOU, the captions beneath it ran." The ubiquitous poster with its

48

all-seeing visage symbolizes the pervasive surveillance of the totalitarian state.

The other book that begins by referring to this pictorial device was written in 1453 by one of the profoundest religious thinkers of his age, Nicolas of Cusa, Cardinal of San Pietro in Vincoli. Michelangelo passed his tomb whenever, during the 1540s, he entered the Cardinal's titular church to oversee the installation of the Tomb of Julius II. Cusanus' book, the most popular of his writings, is entitled *The Vision of God*. It was composed for a community of Benedictine monks, to whom the author explained in a covering letter that he was sending them a picture and a little book which together would teach them to realize the presence of God. In fact, Cusanus' whole treatise has been called a commentary upon that icon, or image of the Omnivoyant—"for God is in very truth an Unlimited Sight. The Absolute Glance falls equally, simultaneously, and unflickeringly on all."[41] Cusanus begins his preface as follows:

> If I strive in human fashion to transport you to things divine, I must needs use a comparison of some kind. Now among men's works I have found no image better suited to our purpose than that of an image which is omnivoyant —its face, by the painter's cunning art, being made to appear as though looking on all around it. There are many excellent pictures of such faces. . . . Yet, lest ye should fail in the exercise, which requireth a figure of this description to be looked upon, I send for your indulgence such a picture as I have been able to procure, setting forth the figure of an omnivoyant, and this I call the icon of God.
>
> This picture, brethren, ye shall set up in some place, . . . and shall stand round it, . . . and look upon it. And each of you shall find that, from whatsoever quarter he regardeth it, it looketh upon him as if it looked on none other. . . . And, as he knoweth the icon to be fixed and unmoved, he will marvel at the motion of its immoveable gaze.[42]

The device of the forthright glance, common to icons and, in the fifteenth century, adopted in portraiture, had been recommended by Alberti for use in *istorie*. His *Della Pittura* of 1435 advised painters to include in their compositions "someone who admonishes and points out to us what is happening there; or beckons with his hand to see; . . . or invites us to weep or to laugh together with them. Thus whatever the painted persons do among themselves or with the beholder, all is pointed toward ornamenting or teaching the *istoria*."[43] The angel in Leonardo's first *Virgin of the Rocks* (Louvre) is such an Albertian figure, "pointing out to us what is happening there."

But Michelangelo's figures tend to shy from the direct glance. Self-absorbed, sometimes entangled in groups, they do not seek to address or transfix the beholder. The forthright exhorting glance as a central motif occurs only in two of Michelangelo's pictorial compositions, in his last and his first; in the *Crucifixion of Peter* and in the Cascina Cartoon of 1504, known as the *Bathing Soldiers* (Fig. 76). Michelangelo's "Battle of Cascina"—once again not the battle itself but a moment of preparation—was destined for the City Hall of Republican Florence. It represented the City's militia rising to arms to meet the professional cavalry of the enemy; and two clamorous central figures, one of whom is the bugler, look straight out as though to rouse the patriots of the City.

Fig. 76. Aristotile da Sangallo: Copy after Michelangelo's cartoon for *The Battle of Cascina*. Holkham Hall, Earl of Leicester

During the forty years that separate *Cascina* from the Paolina *Crucifixion*, the outright glance is avoided; among the thousand creatures of Michelangelo's sculpture and painting, a bare half dozen acknowledge the viewer's presence.[44] All the more significant that the motif regains its centrality in his last painting. Michelangelo has changed citizenship—from Republican Florence to *Roma aeterna*—and moved his center from patriotism to religious faith. Now the all-seeing, all-summoning power is not the state but the Church, here personified in its founder.

The symbolic equation of St. Peter and Church (an ancient topos in Christian symbolism) is implicit in the very design of the fresco, above all in the relationship of the protagonist to the terrain. Peter is being crucified on a rock, a high, roughly cylindrical knoll, which his executioners bestride in force because they are small, but which Peter's titanic body alone seems to span length- and crosswise. As in diagrams of the "Vitruvian Man," the outspread arms of the figure touch the circumscribed circle, so that the ambit of Peter's extended limbs coincides with his rock. In an almost hallucinatory effect of illusionism, his figure becomes co-extensive with the rock of his martyrdom. The rock may allude to the *mons crucifissionis*, which for long centuries had marked the site of Peter's crucifixion in Rome.[45] But it brings to mind more than that. The prominent isolation of

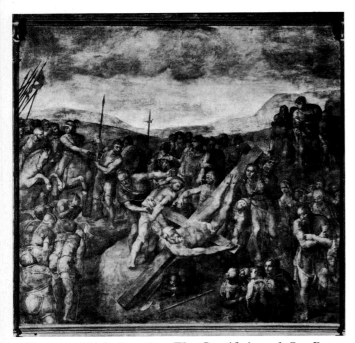

Fig. 77. Michelangelo: *The Crucifixion of St. Peter.* Vatican, Cappella Paolina

Fig. 78. Bramante: *Tempietto.* Rome, S. Pietro in Montorio. Engraving from Sirigatti, *La pratica di prospettiva*, Venice, 1596, lib. 2, pl. 52

Peter's rock, and its scale so nearly congruent with the reach of his body, compels us to *see* what we know—that Peter's name signifies rock, and that he had heard Jesus say to him: "Tu es Petrus, et super hanc petram aedificabo Ecclesiam meam"—"Thou art Peter and on this rock I will build my Church" (Matt. 16:18). Michelangelo puns with Christ. The rock at the core of the fresco associates itself with St. Peter in the entirety of his Christian signification—with his name, his ministry, his martyrdom as first Bishop of Rome, and, ultimately, with the Church's foundation.[46]

If Peter's rock symbolizes the Church, how many should gather about it? We see Peter attended by executioners and watched by sympathetic bystanders above and below; all the rest are arriving. The humanity that builds up the solid sides of Michelangelo's composition is formed of three incoming streams, each open-ended as though indefinitely prolonged; each one revealed only as the vanguard of a host whose origin and extent remain hidden. At lower left, the soldiers come to the scene with leaden tread, wearied men finishing a long trek. One of them turns, slowed perhaps by indecision, but is pushed on by a collective momentum, as if there were more behind mounting the slope. On the plateau above are the horsemen: but what we see is no more than the van of a cavalcade broaching the field. Then, on the right, the procession from behind the hill—generations of witnesses filing past. We see their passing but not the length of their train; it is their defining trait to belong to a march without limits. The three groups spiral inward like the vanes of a pinwheel—a confluence of processions from deep, wide, and far—each bringing endlessness to the site of the rock.

At the center, seven men busy themselves with the cross. On the literal, narrative level their work is mechanical. The far end of the cross has just been raised off the ground. A bearded foreman in a red leather cap directs the proceedings: he lends a hand and indicates with his left that all hands together be ready to lift the great weight diagonally so that it may be planted—inserted into the hole being dug for it at bottom center. But this functional reading is contradicted by a circular motion—we are shown that the cross is being rotated rather than raised. The rotation seems generated by the powerful swerve of the Apostle. It is confirmed by the two young henchmen at the cross-beam—one of them striding inward, the other bent over towards us. It is stressed again by the foreman's arms and sustained by all the rest of the group. There is no doubting the visual evidence that all these motions revolve together on a circular track.

How strangely they move, these executioners. They are doing the job well enough, and their foreman seems competent. And yet, not one of the men grips firmly, or takes hold of the heavy cross with both hands. These strong men submit to their tasks with expressions and motions that are either over-detached or over-emphatic. They participate in rounding the circle as much as in raising the cross. Each one of them lends only one hand while reserving the other, as if they were turning a mill-wheel, or rehearsing a ritual, or performing a dance. The formalized round of their motion suggests perpetuity more than efficiency in doing the moment's work.

In the context of Peter's martyrdom under Nero in Rome, the circular motion at center calls up a precise and concrete association: it reminds us that, in Michelangelo's day, the crucifixion of Peter was believed to have taken place on the Janiculum—on one of the crests of that Western range that comprised the ancient *mons vaticanus*. And there, on the Montorio, or "golden hill," enclosed by the court of S. Pietro in Montorio, the supposed site of the Martyrdom was marked by a small, round, free-standing monument, Bramante's Tempietto (Fig. 78). At the mid-sixteenth century, Bramante's memorial Chapel would have leapt to the mind of any Roman whenever he thought of the locale of St. Peter's death. And this ineluctable association turns the strange wheeling motion of the executioners into a topographical clue. It is as though these men, acting under a superior compulsion, were tracing the circular plan of the monument that would commemorate the site of the crucifixion.

Philipp Fehl's recent study, "identifying the locale of the action," explores further connections between the staging of the event in the fresco and the topographical situation of the Tempietto—"a place which Michelangelo knew intimately."[47] The fresco, Fehl argues, is neither a "no-man's land," nor a stylistic reversion to Gothic verticalism, nor an "abstract scaffolding (for an) array of figures"; it is rather an evocation of the steep climb required to reach the Montorio. Fehl suggests that Michelangelo's coloring of the ground alludes to the golden sands for which the hill, the *monte-aureo*, was named. And he brings an important insight to his discussion of the youth at the lower center, who

reaches into the hole he has dug for the insertion of the cross. Earlier writers, responding to a hint of wistfulness in the pose, saw it as an expression of yearning and sought to relate it to Michelangelo's nostalgia for death—the aged artist, like Tennyson's superannuated Tithonus, longing to be released and restored to the ground. Fehl interposes a more immediate association: Bramante's Tempietto, he points out, consists of an upper and a lower chapel (Fig. 79). The latter's pavement has an opening in the middle—"suggesting to the imagination the place of the insertion of the cross, that is, the hole into which, in Michelangelo's painting, the young man inserts his hand (Fig. 80). Worshippers at the site are, to this day, enjoined to bend down and touch with their hands . . . some of the gold-colored sand of Montorio which fills the enclosure."[48]

The present arrangement of the lower chapel dates from the seventeenth century, but the Tempietto's substructure had been hallowed ground long before. The original *mons crucifissionis* rose over an ancient cave, which by 1500 was equipped with an altar. Ancient, too, was the custom of touching, or taking home, sand from the floor of the cave. Thus the earlier interpreters who responded to an expression of longing in the youth's action—seeing more in it than the effort of digging or removing a rock—were not wholly misled. The youth's action alludes, beyond its immediate narrative function, to what would become timeless practice.[49]

Finally, Fehl observes that the place of St. Peter's martyrdom had been singled out from time immemorial for Christian meditation; which suggests that the figures on the right of the fresco, as "they walk past the cross and down the hill, . . . are the first in the never-ending procession of pilgrims and worshippers who come to the site at S. Pietro in Montorio."[50] The fresco, then, is "the likeness of Michelangelo's own visual meditation at the site"; and the locale of the action connects the historic event with the viewer's present.

What does this tell us of Michelangelo's conception of historical narrative? While the locale of the action is specified with topographic precision, the *form* of the action anticipates its own future commemoration; the witnesses of the event become unwitting initiators of enduring ritual practice. The *istoria*, then, represents a finite, delimited place, but a place infinitely projected through time. Timeflow is expressed in procession, and the disparity of remote moments, in simultaneity. Duration and simultaneity continually stamp the same ground, a ground whose definition, for Michelangelo, includes its survival—its capacity to retain accretions of thought and devotion.

ON the deepest level of Michelangelo's visual thinking, the meaning of the historic occasion as a rite of foundation and an affirmation of faith is expressed in the tectonic character of the design: it has the foursquare solemnity composers give to the *Credo*. The *Crucifixion* fresco (Fig 77) is more blatantly architectural than the *Conversion* had been. Not only have the figures increased in size; along the right edge they seem almost too large for the space to contain them; they constitute space, like figures in the stacked registers of a Roman sarcophagus, or like statues in tiers on a sculptured façade. Throughout the field, the *dramatis personae* seem to build the space into a solid front. The component groups—the soldiers at the lower left, the horsemen, the friendly chorus at upper center, the marchers in echelon descending at right, and the huddle of women below—all form compact rectangular units.[51] The groups touch and bond like huge building blocks, consolidating the sides into two massive piers with the rotation of Peter's cross enarched between them, as if the crucifixion were set within a triumphal gate. Hence the stony austerity of the composition; the entire scene petrifies in the shape of a monument.

The motions within the fresco—the rise and fall at the sides and the revolution at center—these, too, are prefigured in Michelangelo's architectural thinking. They recall his staircase designs for the vestibule of the Laurentian Library in Florence (Fig. 81): lateral flights of steps frame a curved central element—the straight flanks (as the artist explained in a letter of 1555 to Vasari) for the servants, the centerpiece for the master.[52] Something of the hierarchical structure and the congealed dynamism of Michelangelo's staircase projects inheres again in the fresco.

But the picture departs from the abstract symmetry of those projects by its humane differentiation of left and right. On one side, all the men are on duty, variously involved in the action. On the other, untouched by the action, the marchers proceed as though the external event were an occasion only of inward experience. Left and right side thus unbalance the outward symmetry of the

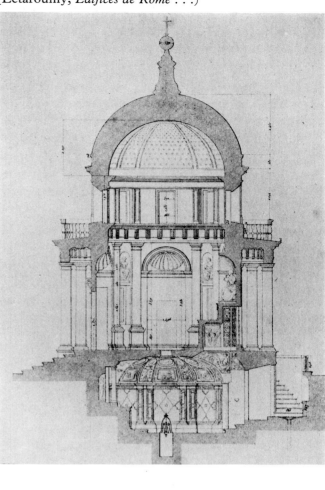

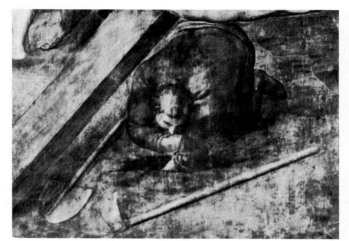

Fig. 80. Michelangelo: *The Crucifixion of St. Peter.* Detail. Vatican, Cappella Paolina

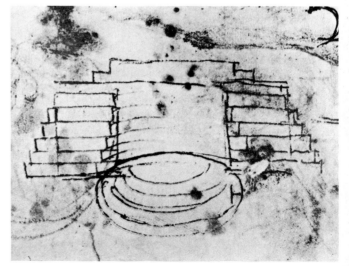

Fig. 81. Michelangelo: Sketch for the stairway to the Laurentian Library. Detail from a sheet of studies. Florence, Casa Buonarroti, no. 92v.

design by setting forth the old Christian distinction between activity and contemplation. Yet even here we are reminded of an architectural precedent: Michelangelo's final design for the Julius Tomb, composed as a monumentalized triptych. On the Tomb, the central figure of Moses—like St. Peter a ruler, founder and seer—is flanked by the statues of Leah and Rachel, symbolizing the active and the contemplative life.

One penetrates the picture by stages, in a series of spiritual exercises. Seen as a stable structure, the massed figures present themselves as two lateral piers buttressing a connecting arch. If one follows the processional movements within the structure, they read, like Michelangelo's visions of stairs, as ascents and descents enclosing a rotary motion. And if one looks at the dramatic occasion, it becomes a projection of moral choice between action and abstention from action. Into the historical episode, and suffusing its architectural structure, Michelangelo injected his own moral dilemma.

The confrontation of action and contemplation had always been part of his symbolism. According to Vasari, the original Julius Tomb project of 1505 was to have mounted colossal allegorical statues of *vita activa* and *vita contemplativa*. And during the 1520s, the dualism was subtly embodied in the two seated Princes of the Medici Chapel. But on the Julius Tomb in its final form—in the two Old Testament sisters Michelangelo adjoined to the figure of Moses—the old conventional personifications became acutely personal. Rather than symbolizing the traditional teaming of Faith and Charity, love of God and love of neighbor, they express a melancholy dichotomy between labor and vision—mournful fertility beggared by the exaltation of divine knowledge.[53]

Here Michelangelo located the central conflict of his moral life. He had reluctantly taken charge of St. Peter's Basilica to become, like Martha, "anxious and troubled about many things." But he had done so, he says, "*per amor di Dio*" —for love of God. Yet the artist and the religious convert remained at odds in his soul. His lifelong artistic activity became in retrospect a wasteful expenditure, a neglect of what Christ, speaking to Martha and Mary, had called "the better part" and "the one thing needful." Four years after finishing the Pauline frescoes, his most famous sonnet weighs his life's habit against the direct contemplation of God and finds it wanting:

> To paint and carve no longer calms
> the soul turned to that Love divine
> Who to embrace us on the cross opens his arms.[54]

But Michelangelo's avowed nostalgia for a life of visionary inaction is retardataire, harking back to the eremitic religiosity of the Middle Ages; it is as discordant with his own irrepressible creativity as with the spirit of the times. A modern scholar has argued that the distinguishing characteristics of the age of the Counter-Reformation were individualism and activism, and that the genius and the success of St. Ignatius Loyola consisted in his "embracing rather than fighting the general tendencies of his age. . . . An intuition of the power of human action, and anxiety to release this power for the pursuit of divine enterprises, were surely . . . the most distinctive features of Ignatius' spirituality."[55]

In this sense, Michelangelo's working life, as opposed to his protestations, is as contemporary a phenomenon as the working life of Loyola. Paul III, who befriended Loyola and confirmed and encouraged the Jesuit Order, similarly "confirmed" and encouraged Michelangelo and kept him unceasingly occupied. Nor did the artist's energy slacken, so that invention continued to pour from him in abundance, and he would still be carving the *Rondanini Pietà* in his ninetieth year, fourteen years later. In his last decade, "devotion" and divine contemplation became for Michelangelo, as for St. Ignatius, not a distinct form of activity but the tone of all his activity, including all drawing, designing and carving.

But the *Crucifixion* fresco—and this may account for its chilling effect—projects a painful detachment from action, and not in the right-hand marchers alone: the henchmen about the cross revolve like somnambulists; the soldiers at the lower left come unwillingly; and the horsemen are too marginal in the design to activate a humanity given over to resignation.

Most remarkable in its stillness is the "chorus" of men at top center behind the cross. Can they be meant to represent "the people" spoken of in the *Golden Legend*? There we read that after Peter's cross had been turned, "the people were angry" and that only Peter's command restrained them from slaying his executioner. But Michelangelo's fresco represents them unarmed and outnumbered, and with no inclination to move. Their leader, a gargantuan, square-shouldered

Fig. 82. Michelangelo: *The Crucifixion of St. Peter.* Vatican, Cappella Paolina

youth in pale green, stands near the apex of the figural composition. He seems wanting to speak, points with one hand to the mounted captain, with the other to the man crucified. The momentum of his robust body issues in the work of two pointing fingers, so that one feels a disparity between given strength and performance. On either side of him, the two old men cowled in identical blue may represent the brothers Marcellus and Apuleius who, in the *Legend*, will take the crucified from the cross and give him burial.[56] But in Michelangelo's depicted present, the ancient, bare-shouldered Marcellus, folding his hands away, peers out from under his hood through a grid of intruding arms, as would a man looking through prison bars. He suggests again, as all these bystanders do, a concentrated withdrawal from action. No one stirs; no one cries out, nor lifts a hand to influence the course of events. As Michelangelo conceives the occasion, these friends were never tempted to intervene. Stilled and alert, they institute the timeless discipline of meditating on Peter's martyrdom. The painter, as he meditates on his subject, becomes their successor.

THERE are no certain self-portraits in the *Crucifixion* fresco. Yet, among the fifty-odd faces depicted, there are two that repeatedly and insistently strike observers as likenesses of the artist; not perfect resemblances in the sense of personalized portraits, but facial types into which a self-conscious artist would inevitably project a symbolic self-image. One of these is the ancient man in the Phrygian cap at the lower right, stepping down with arms folded (Fig. 83). This moving solitary approaching his exit has long been recognized as the master's spiritual self-portrait.[57] The identification is indeed irresistible, even though this patriarchal type occurs early in Michelangelo's iconography. It is as though Michelangelo, having the type, had aged into it.

The figure is evocative on many levels. In dress, gait, and mood of regret, it recalls Roman statues of Barbarian captives (Fig. 84). And its cornering in the field reminds one of antique sarcophagi, the type that shows teeming battle scenes with bound, over-sized prisoners at the sides. Though the heroic solitude and finality of Michelangelo's figure separates it from these antique prototypes, its formal associations betray an elective affinity with the captive state. The captive as symbol of his human condition came readily to Michelangelo.[58]

Some have seen a significant similarity between the old man in the fresco and the Michelangelo-pilgrim on the reverse of the Leoni medal (Fig. 63).[59] But the closest connection is surely to the ideal self-portrait Michelangelo carved upon the face of the aged mourner of the *Pietà* (Fig. 85). This is the work that occupied his nights at home while he was painting the fresco. It is not likely that the psychic resemblance between the carved and the painted figure would have escaped him.

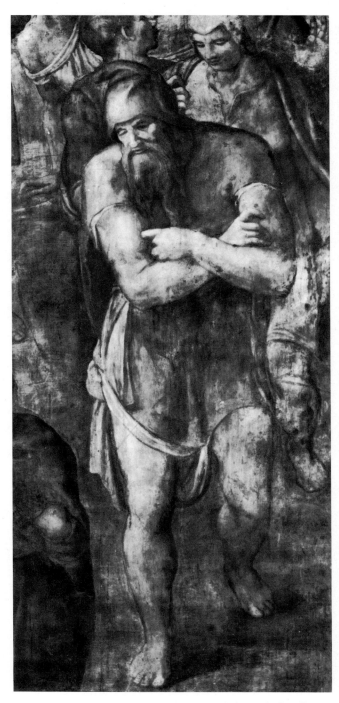

Fig. 83. Michelangelo: *The Crucifixion of St. Peter.* Detail. Vatican, Cappella Paolina

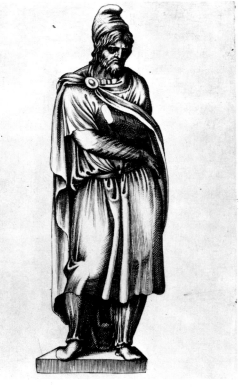

Fig. 84. *A Parthian King in Roman Captivity.* Drawing of an ancient statue from G.-B. Cavalieri, *Antiquarum statuarum urbis Romae . . .*, first ed., 1566, pl. 14

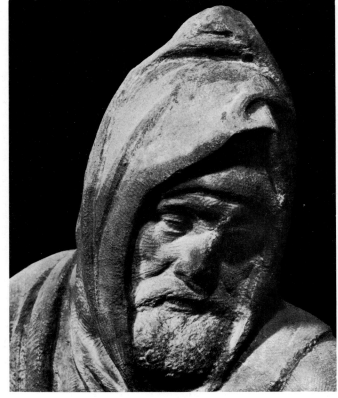

Fig. 85. Michelangelo: Detail from the Florentine *Pietà.* Florence, Duomo

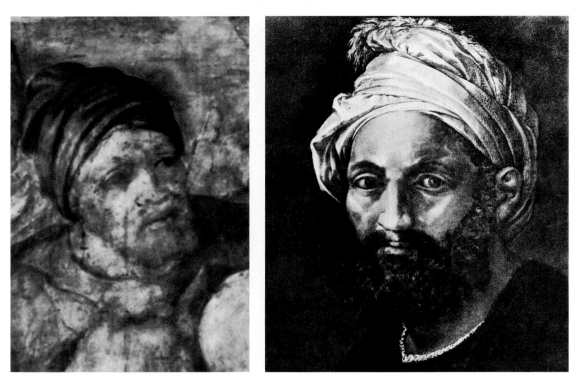

Fig. 86. Michelangelo: *The Crucifixion of St. Peter*. Detail. Vatican, Cappella Paolina

Fig. 87. Copy after Bugiardini's *Portrait of Michelangelo*. Paris, Louvre

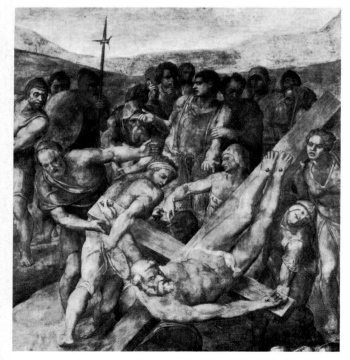

Fig. 88. Michelangelo: *The Crucifixion of St. Peter*. Detail. Vatican, Cappella Paolina

The other head in which Michelangelo's features are recognizable is that of the horseman immediately behind the commanding officer at the upper left (Fig. 86). He seems about forty years old and his beard is red—not Michelangelo's coloring. Yet the likeness of this head, dressed in the artist's characteristic turban, comes too close to authentic Michelangelo portraits to be discounted (Fig. 87).[60]

But this gives us two Michelangelos. And as no man can be in two places at once, scholars have tended to accept only one or the other as representing Michelangelo's self; or else have dismissed both, since the case for either head as a self-portrait seems compromised by the fact that another claimant exists. But such arguments proceed from misplaced rationality. Suppose we consider the "irrational" alternative that both identifications are right. As the fresco in its entirety embodies simultaneities of then and now—the Crucifixion as a historic moment, the meditation upon it and the presage of its commemoration in the Tempietto—so the artist, too, if he is indeed present, may be portrayed in the full span of his moral history. The turbaned rider then stands for a younger Michelangelo, or for Michelangelo's youth, and we shall find it significant that his place is under the Roman captain's command.

This Roman is not anonymous. In the *Acts of Peter* he is named the Prefect Agrippa and appears in a fairly good light: the Emperor Nero complained that he had not put Peter to death with greater torment.[61] And his face too is familiar. It is the clear-cut, square-jawed antique profile that suggests some idealized head carved on a gem, or in marble. It is kindred to the ideal face which Michelangelo in his youth had bestowed on his *David*, the Biblical hero to whom he gave all he knew of young masculine beauty (Figs. 89 and 90). The Perfect Agrippa, painted almost half a century later, bears the same sovereign pagan face, matured and hardened, but still the face of Michelangelo's early idolatry.

The Prefect now assumes a twofold role. On the narrative level, and in relation to Peter, he is still the cool man of action, the officer in charge of the execution. But for the anxious rider behind him, whom we identify with Michelangelo, he is an embodiment of pagan antiquity, perfect in masculine grace. And the painter has taken care to ensure that the two heads, crested and turbaned, are seen as a pair; for the interval between them is closed by the hand of another man, serving as a visual hyphen. The Prefect, then, not only commands Michelangelo, but stands between him and the Church.

Our musing is worth pursuing a while longer, because it deepens the sense of at least one other action within the picture, that of the chorus leader (Fig. 88). Again, at a literal level of interpretation, he is protesting the Apostle's ignominious execution to the Prefect; hence his pointing both ways. But for whose benefit is he pointing? He is not that Albertian herald catching our eye and showing us "what is happening there." And to the Captain in charge of the operation, the victim protagonist of the scene hardly needs to be pointed out. The artist has even

54

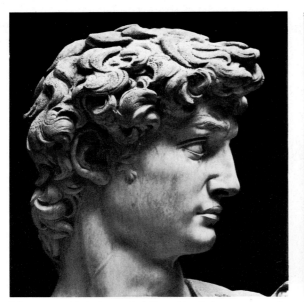

Fig. 89. Michelangeloi Detail of the statue of *David*. Florence, Accademia

Fig. 90. Michelangelo: *The Crucifixion of St. Peter*. Detail. Vatican, Cappella Paolina

averted the Captain's head, clear signal that not he is being addressed. Aimed at the Prefect, the gesture of the chorus leader would remain timid, functionless, inadequate to the occasion. Yet the thrust of his fingers, his collected shoulders and the glare of his eye indicate a fierce intensity. They suggest a more terrible possibility—that the chorus leader directs his protest to the Michelangelo figure. For he points both to St. Peter and to where Michelangelo is spending his youth, as if to say, "They are crucifying the Apostle of Christ, and you keep their company?" The indictment that was haunting the artist's conscience is personified in the chorus leader. Behind him, a man puts up a silencing finger; and he too must have mattered to Michelangelo, for the entire compositional pyramid culminates in his plea.

If this reading is true—though beyond proof or disproof—then the whole fresco turns into a chart of the artist's personal trial; like the *Last Judgment*. It is the descending graph of Michelangelo's destiny that runs, from his early idolization of pagan beauty and art, from the vigorous upper left corner, down the imperious diagonal that begins in the Prefect's commanding arm and flows through the transverse beam of the cross, down to his own self again—himself in deepest old age. Arrived at the lower right, he meditates on the death of the Apostle who had denied Christ and repented. And the arms of St. Peter's cross reach to connect the poles of Michelangelo's life—from his own denial of Christ to his present contrition. The work's ultimate meaning flows in the geometry of its structure.

THE last day Michelangelo gave to the fresco created those four eerie women above the threshold (Fig. 91). Technical examination conducted in 1934 revealed that these abruptly underscaled half-length figures were the last portion of surface covered, and that they constitute a day's work.[62] What meaning they had for Michelangelo may never be known, but it is evident that they were executed in haste. Pope Paul, aged 82, paid his second and final visit to the Chapel on October 13, 1549. The occasion is recorded in a letter written by the Florentine Ambassador to his Duke: "His Holiness is so hardy that this morning he climbed a ladder of ten or twelve rungs to see the paintings which Buonarroti made in the Chapel." Less than a month later, on November 10, Paul III died. And on the 29th of that month, the Conclave that would elect Julius III held its opening session in the Cappella Paolina.[63] The reference to the ladder in the document of October 13 indicates that the scaffolding was then still up and the fresco not yet completed. A month later, when the Chapel was being prepared for the Conclave, the scaffolding must have been down. The sequence of events suggests that Michelangelo may have been told to make haste and clear out.

Hence perhaps the hurried handling of that group of women—the last of the eighty-seven work-days that make up the fresco surface, and the last time that Michelangelo wielded a brush. Or it may be that the death of his dear "papa Pagolo" made him want to have done. Or that he hurried those final touches because he had so much more work in hand.

Fig. 91. Michelangelo: *The Crucifixion of St. Peter*. Detail. Vatican, Cappella Paolina

SELECTED BIBLIOGRAPHY

James S. Ackerman, *The Architecture of Michelangelo*, New York, London, 1961.

Lettere sull' Arte di Pietro Aretino, ed. E. Camesasca, Milan, 1967.

Paola Barocchi, ed., Giorgio Vasari, *La Vita di Michelangelo nelle redazioni del 1550 e del 1568*, Milan, Naples, 1962.

Paola Barocchi, ed., *Trattati d'Arte del Cinquecento*, Bari, 1960–1962.

F. Baumgart, B. Biagetti, *Gli Affreschi di Michelangelo e L. Sabbatini e F. Zuccari nella Cappella Paolina in Vaticano*, Vatican City, 1934.

Kenneth Clark, *The Artist Grows Old*, Cambridge, 1972 (The Rede Lecture, 1970).

Ascanio Condivi, *Vita di Michelangelo Buonarroti pittore, scultore, architetto* (1553), ed. Rome, 1853 (in *Storia di Michelangelo Buonarroti . . . narrata per diversi autori*).

E. von Dobschütz, "Die Bekehrung des Paulus," *Repertorium für Kunstwissenschaft* 50 (1929), 87–111.

Luitpold Dussler, "Die Spätwerke des Michelangelo," in *Michelangelo Buonarroti*, Würzburg, 1964 (*Persönlichkeit und Werk* I).

Max Dvořák, *Geschichte der italienischen Kunst im Zeitalter der Renaissance*, II, Munich, 1929 (based on lectures delivered 1918–1919).

Herbert von Einem, *Michelangelo*, Stuttgart, 1959; revised English edition, London, 1973. (See also "Michelangelos Fresken in der Cappella Paolina," *Festschrift Kurt Bauch*, Berlin, Munich, 1957, 193–204.

H. Outram Evennett, *The Spirit of the Counter-Reformation*, ed. John Bossy, Notre-Dame, London, 1970.

Philipp Fehl, "Michelangelo's *Crucifixion of St. Peter*: Notes on the Identification of the Locale of the Action," *The Art Bulletin* 53 (1971), 327–343.

Dagobert Frey, *Michelangelo-Studien*, Vienna, 1920.

Walter Friedlaender, *Mannerism and Anti-Mannerism in Italian Painting*, New York, 1957 (based on an inaugural lecture at the University of Freiburg, 1914).

Christoph L. Frommel, "Antonio da Sangallos Cappella Paolina. Ein Beitrag zur Baugeschichte des Vatikanischen Palastes," *Zeitschrift für Kunstgeschichte* 27 (1964), 1–42.

Giovanni Gaye, *Carteggio inedito d'artisti dei secoli XIV. XV. XVI.*, Florence, 1840 (reprint, Turin, 1961).

Enzo Noè Girardi, *Michelangelo Buonarroti. Rime*, Bari, 1960.

Herman Grimm, *Leben Michelangelos* (1860), ed. Vienna, Leipzig, n.d.

Charles Holroyd, *Michael Angelo Buonarroti . . . with Translations of the Life of the Master by his Scholar, Ascanio Condivi . . .*, London, New York, 1903.

Valerio Mariani, *Gli affreschi di Michelangelo nella Cappella Paolina*, Rome, 1932.

G. Milanesi, *Le lettere di Michelangelo Buonarroti edite ed inedite coi ricordi ed i contratti artistici*, Florence, 1875.

Alfred Neumeyer, "Michelangelos Fresken in der Cappella Paolina des Vatikan," *Zeitschrift der bildenden Kunst* 63 (1929–30), 173–182.

Bernardino Ochino (1487–1564), *Certaine Godly and very profitable sermons of Faith, Hope, and Charitie . . .*, London, 1580.

John C. Olin, *The Catholic Reformation: Savonarola to Ignatius Loyola. Reform in the Church 1495–1540*, New York, Evanston, London, 1969.

Erwin Panofsky, "The first two projects of Michelangelo's Tomb of Julius II," *The Art Bulletin* 19 (1937), 561–579.

Ludwig Pastor, *The History of the Popes from the Close of the Middle Ages* 3rd ed., London, St. Louis, 1950.

G. Poggi, P. Barocchi, R. Ristori, eds., *Il Carteggio di Michelangelo*, Florence, 1965 ff.

John Pope-Hennessy, *Italian High Renaissance and Baroque Sculpture*, 2nd ed., New York, London, 1970.

E. H. Ramsden, *The Letters of Michelangelo*, Stanford, 1963.

D. Redig de Campos, *Affreschi della Cappella Paolina in Vaticano*, Milan, 1950.

D. Redig de Campos, *Itinerario pittorico dei Musei Vaticani*, Rome, 1954.

L. Steinberg, "The Metaphors of Love and Birth in Michelangelo's *Pietàs*," in *Studies in Erotic Art*, ed. Th. Bowie, New York, 1970, 231–285.

John Addington Symonds, *The Renaissance in Italy. The Fine Arts* (1877), ed. London, 1909.

John Addington Symonds, *The Sonnets of Michelangelo Buonarroti* (1878), ed. London, 1926.

John Addington Symonds, *The Life of Michelangelo Buonarroti* (1893), Modern Library Edition, New York, n.d.

Charles de Tolnay, *Michelangelo. I. The Youth of Michelangelo*, 2nd ed. Princeton, 1947. II. *The Sistine Ceiling*, 2nd ed. Princeton, 1949. III. *The Medici Chapel*, Princeton, 1948. IV. *The Tomb of Julius II*, Princeton, 1954. V. *The Final Period*, Princeton, 1960.

Henriette Van Dam Van Isselt, "Sulla iconografia della 'Conversione di Saulo' di Michelangelo," *Bolletino d'Arte* 37 (1952), 315–319.

Le Vite de' più eccellenti pittori scultori ed architettori scritte da Giorgio Vasari, ed. G. Milanesi, Florence, 1906.

Giorgio Vasari: see also under Barocchi.

Jacopo da Voragine, *The Golden Legend* (Lives of the Saints), ca. 1275, eds. G. Ryan, H. Ripperger, New York, 1941.

Jacopo da Voragine, *Sermones pulcherrimi . . . de sanctis . . .* (The "Golden Sermons"), ed. Paris, 1510? Unpaginated.

Martin Weinberger, *Michelangelo the Sculptor*, London, New York, 1967.

Heinrich Wölfflin, *Die Klassische Kunst* (1899), 7th ed., Munich, 1924.

NOTES TO CHAPTER I

1. The menu was first published by Charles de Tolnay, "Le Menu de Michel-Ange," *The Art Quarterly* 3 (1940), 240–242. For more recent literature see Luitpold Dussler, *Die Zeichnungen des Michelangelo*, Berlin, 1959, no. 35; Paola Barocchi, *Michelangelo e la sua scuola. I Disegni dell'Archivio Buonarroti*, Florence, 1964, III, no. 341. The paper Michelangelo used was a letter, dated March 18, 1518, received from Bernardo Niccolini; its text is transcribed in Poggi, *Carteggio* I, no. CCLXII. (A Bibliography of frequently cited sources precedes the notes.)

2. Michelangelo describes the original contract for the Sistine Ceiling and his reasons for expanding the project in a letter of December 1523 to Giovan Francesco Fattucci (Ramsden I, no. 157).

3. Condivi, 30 (Holroyd transl., 32).

4. For modern reconstructions of the Tomb project and the disputed interpretations of the original evidence, see Panofsky, 561 ff.; Tolnay IV, 9 ff.; Weinberger, 129 ff.

5. See Panofsky, 571, and Weinberger, 135, respectively.

6. Ramsden I, no. 8.

7. Vasari marvels that so miraculous a creation had been produced in so short a time—*in pochissimo tempo*.

8. Condivi, 31 f. (Holroyd transl., 33 f.)

9. The hypothesis, proposed by Tolnay and von Einem, that the Pope's tomb was at one time intended to go under the dome of St. Peter's is untenable. Metternich's thesis suggesting that the Julius Tomb was to be accommodated under one of the lesser domes of the new structure seems to be unconvincing but falls outside the scope of the present discussion. (Herbert von Einem, "Michelangelos Juliusgrab im Entwurf von 1505 und die Frage seiner ursprünglichen Bestimmung," *Festschrift für H. Jantzen*, Berlin, 1955, 152 ff.; and *Michelangelo*, Stuttgart, 1959, 45; Tolnay IV, 87, 167; Franz Wolff Metternich, "Le Premier Projet pour St.-Pierre de Rome, Bramante et Michel-Ange," *Acts of the 20th Congress of the History of Art*, ed. M. Meiss, Princeton, 1963, II, 79 f.)

10. Ramsden I, no. 157.

11. Condivi, 29 (Holroyd transl., 31): ". . . Bramante . . . made him [the Pope] change his mind as to the monument by telling him, as is said by the vulgar, that it is unlucky to build one's tomb in one's lifetime."

12. Ramsden I, no. 8.

13. Vasari-Milanesi IV, 282.

14. Condivi, 32 (Holroyd transl., 34).

15. ". . . per essere più lontane dall'occhio." The contract is transcribed in Milanesi, *Lettere*, 636 f., and Pope-Hennessy, 315.

16. For Michelangelo's further enlargements as he entered upon the 1513 project, see Paul Joannides, "A Note on the Julius Tomb 1513," *The Burlington Magazine* 113 (1971), 149 f.

 One significant document has yet to receive full attention. After the completion of the Sistine Ceiling and shortly before his death in February, 1513, Pope Julius issued an official statement concerning his personal tomb (see Pastor VI, 480): He wished to be buried in the "Cappella Giulia"—evidently Bramante's Choir raised on the Rossellino foundations. The Pope thus accepted the site Michelangelo had proposed eight years before—but without Michelangelo's monument, of which no mention is made. An important study of Julius' final intentions for his burial chapel is to be published shortly by Christoph L. Frommel.

17. The contract is published in Milanesi, *Lettere*, 644 ff., and Pope-Hennessy, 317.

18. Leonardo Sellaio in Rome to Michelangelo in Florence, letter dated August 9, 1516 (Poggi, *Carteggio* I, no. CXLVIII).

19. For a full account of these events, see Tolnay IV, 46.

20. Poggi, *Carteggio* II, no. CDLXXVII.

21. The statues assigned to the post-1516 phase of the Tomb include the *Victory* group, now in the Palazzo Vecchio; possibly the four unfinished *Slaves* in the Accademia (though their dating is still disputed, ranging from 1519 to 1534); and perhaps the *Madonna Medici* which, as Pope-Hennessy (p. 334) has sugges-

ted, may have been intended originally for the Julius Tomb.

22. Letter to Giovan Francesco Fattucci, November 1, 1526 (Ramsden I, no. 178).

23. There is a poignant contrast between the treatment here accorded to Michelangelo and that meted out to the great German sculptor Tilman Riemenschneider under similar circumstances. As mayor of Würzburg, Riemenschneider had joined the cause of the peasants in their revolt against the Prince-Bishop, 1525. When the Peasant Revolt was crushed, the sculptor was incarcerated and tortured. He could produce no more work during the remaining six years of his life.

24. Tolnay IV, 54 ff. describes these developments in detail. The identification of the six already-existent statues remains uncertain: the most likely candidates are the *Moses*, the four Accademia *Slaves*, and the *Victory* group.

25. The commission was received some time before February 20, 1534; see Tolnay IV, 57, citing Pastor IV, 2, 567.

26. Condivi, 66 (Holroyd transl., 66); "Egli son già trent'anni ch'io ho questa voglia: ed ora, ch'io son papa, no me la posso cavare? Dove è questo contratto? Io lo voglio stracciare." And cf. Vasari (Milanesi VII, 206; Barocchi, I, 71): "Io ho avuto trent'anni questo desiderio, et ora che son papa no me lo caverò? Io straccerò il contratto e son disposto che tu mi serva a ogni modo."

27. Tolnay IV, 64.

28. Quoted in Tolnay IV, 65.

29. The new contract of 1542 is described in a petition to Paul III (written in Luigi del Riccio's hand for Michelangelo) dated July 20th of that year (Ramsden II, no. 219 and App. 28).

30. Ramsden II, no. 227.

31. Ramsden II, no. 226.

32. Cf. Michelangelo's sole recorded comment upon completion of the Sistine Ceiling: "I have finished the chapel I have been painting; the Pope is very well satisfied. But other things [the Julius Tomb project?] have not turned out for me as I had hoped" (letter to his father, October 1512, Ramsden I, no. 83). Within the same month, to the same addressee, he writes (Ramsden I, no. 82): "I lead a miserable existence and reck not of life nor honour—that is of this world; I live wearied by stupendous labours and beset by a thousand anxieties. And thus have I lived for some fifteen years now and never an hour's happiness have I had . . ."

33. The letter, written to the Duke of Urbino by Cardinal Ascanio Parisani, is dated November 23, 1541. It begins: "Desiderando Nostro Signore ed essendo risoluto che Michelagnolo metta mano a dipingere la sua cappella nuova di Palazzo . . ." (Gaye II, 290). See also, in Pastor XII, 631 and App. 9, a letter of November 19, 1541, from Nino Sernini to Cardinal Ercole Gonzaga in which reference is again made to the Pope's desire to have Michelangelo paint the frescoes in the Cappella Paolina.

34. Baumgart-Biagetti, 69 f.

35. The Pope's visit is recorded in the diary of Francesco Firmano, Baumgart-Biagetti, no. 29, 76 f.

36. Vasari-Milanesi VII, 216. Payments for the stucco work are recorded on August 27, 1542 (Pastor XII, 631 and n. 4). Tolnay (V, 136) assumes that the stucco work was destroyed by fire in 1545. But Frommel (p. 42) has convincingly argued that the damage in the "Cappella" mentioned by Michelangelo in a letter to Luigi del Riccio referred to the Sistine and not the Pauline Chapel.

37. The suggestion that Michelangelo's drawings for the *Cleansing of the Temple* may have been intended for the lunette over the entrance door was made by Tolnay (V, 78) and was developed by Frommel, 41 f. Cf. the Michelangelo drawings, Tolnay V, figs. 241–247 and Marcello Venusti's painted copy in London, Tolnay, fig. 317.

38. Francesco Guicciardini, *The History of Italy*, trans. Sidney Alexander, New York–London, 1969, 442.

39. Pastor XI, 14.

40. Pastor XI, 32 and n. 3.

41. See Pastor XII, 633 and n. 1. In 1535, 1536, and 1537, the Pope made annual visits to St. Paul's outside-the-

Walls on the Feast of the Conversion. Bad weather prevented his visit in 1539. In the year following, the Feast was celebrated in the newly-dedicated Cappella Paolina.

42. The conception of the Cappella Paolina is not an expression of Counter-Reformatory success, but rather coincides with the moment when, in Pastor's words, "the reputation and power of the Papacy were shaken well-nigh to the ground; a great portion of the clergy was defiled by greed and unchastity; many convents were deserted or disorganized; the influence of the Church over schools had, for the most part, vanished" (Pastor XII, 122).

 Of the inroads of Protestantism in Italy, Pastor observes: "nothing shows more forcibly the strength of the movement of secession, which shook the Catholic Church to the foundations, than the fact that the impact was felt in Italy itself . . . So woeful was the condition of the Church that in numerous quarters only too favourable a reception was given to the missionaries of error. This was especially the case in Northern Italy, where . . . Protestantism found a conspicuous foothold" (XII, 490 f.). On January 18, 1540, Luther wrote to the Elector of Saxony: "It is all up with the Pope, as it is with his god, the devil. They are both . . . beyond prayers and hope" (M. de Wette, *M. Luthers Briefe*, Berlin, 1825–56, V, 258).

 Events throughout Europe seemed to confirm Luther's prognosis. By the late 1530s, all Scandinavia had apostatized, and there were serious fears of a schism in France. In the England of Henry VIII, dissident Catholics were being martyred, the mother of Cardinal Pole being put to death in the Tower in her eightieth year on May 27, 1541. "At the beginning of 1542, Papal relations with Portugal were so embittered that the Kingdom was on the point of breaking off communication with the Holy See" (Pastor XII, 47). In Germany the Diet of Ratisbon met in October, 1541, to discuss Christian doctrine and, to the consternation of the Papal Legate, did not even make reference to the Pope. Since the fall of 1541, Calvin had established himself in Geneva, his influence beginning to radiate throughout Europe.

 Meanwhile, the threat of the Ottoman Empire (allied with France) was increasing. In August, 1541 the Turks seized the capital of Hungary and annexed almost the entire country. To procure the help of the German Protestant princes against the Turks, Charles V sought continually to placate them in religious affairs—a policy which led to unremitting conflict between Emperor and Pope. In October, 1541, Charles V failed in his campaign against Algiers, and in the following year a Christian army of 55,000, including Papal levies, was disastrously routed in Hungary. Many thought that all Europe would soon be subjugated; the city of Rome went so far as to fortify itself against a Turkish landing and siege (Pastor XII, 124).

43. At the accession of Paul III in 1534, the strength of the College of Cardinals was 42. The number of Cardinals appointed during Pope Paul's incumbency was 71. On the significance of Paul's transformation of the College, see Evennett, 112.

NOTES TO CHAPTER II

1. Vasari-Milanesi VII, 215.

2. The conventional epithet "divine" had been affixed to Michelangelo's name as early as 1516 in Ariosto's famous pun (*Orlando Furioso*, canto xxiii): "Michel più che mortal angel divino" (Michael, more than mortal, angel divine). In a letter written in 1561 by the sculptor Leone Leoni, Michelangelo is more seriously addressed as "uomo divino" (cited in Barocchi IV, 1736). For the quotation from Aretino, see his *Lettere* I, 64 (letter of 1537 to Michelangelo). Antonio Francesco Doni, secretary of the Florentine Academy of Design, described Michelangelo as the "World Oracle" in a letter of January 12, 1543 (published 1544), quoted in Ernst Steinmann, *Michelangelo im Spiegel seiner Zeit*, Leipzig, 1930, 14. Vincenzo Danti's

paean appears in the preface to his *Trattato delle perfette proporzioni* (1567) in Barocchi, *Trattati* I, 211. For Claudio Tolomei's letter of ca. 1540 to Apollonio Filareto, see Barocchi (Vasari) IV, 1881. Cf. also Bronzino's praises of Michelangelo as "wonder of nature," "angel elect," etc., in a letter and two sonnets dedicated to the master (published in E. Baccheschi, *L'Opera completa di Bronzino*, Milan, 1973, 8 f.

3. Vasari-Milanesi VII, 216.

4. G. Paolo Lomazzo, *Idea del Tempio della Pittura*, Milan, 1590, 53.

5. Nikodemus Tessin, *Studieresor i Danmark, Tyskland, Holland, Frankrike och Italien*, ed. Osvald Sirén, Stockholm, 1914, 157.

6. The first list of prints after the Pauline frescoes was compiled by Alfred Neumeyer, who commented (180 f.): "It is certain that such prints were always few in number." Most of the prints were cited again, with corrections, in Baumgart-Biagetti, 17, n. 1. Following is an updated list:

Nicolas Beatrizet, *Conversion of Paul* (Fig. 92; R.D. 29; Pas. VI, 33; published by Antonio Salamanca.)

Giovanni Battista Cavalieri. *Conversion of Paul*. This print is cited by Neumeyer and his citation is quoted by Baumgart-Biagetti and Tolnay (V, 142), even though it has never been seen. Neumeyer may have found the print listed in an old catalogue where it was confused with Cavalieri's engraving after the *Crucifixion of Peter*.

Giovanni Battista Cavalieri. *Crucifixion of Peter* (Fig. 93; Le Bl. I. 27). There exists an unrecorded second state after the plate was cut down on all four sides from the original 57·5 × 43·3 cm. to 54·1/54.3 × 41·5/42 cm.

Michele Lucchese. *Crucifixion of Peter* (Fig. 94; Pass. VI. 6). In Lucchese's etching the format has been uprighted and the proportions of St. Peter and of his cross are substantially reduced. In the Cavalieri engraving, the format has been deliberately widened. Evidently the square shape of the original fresco was felt to be unsatisfactory.

Nicolas Beatrizet. Engraving after the bearded figure with folded arms at the lower right of the *Crucifixion of Peter* (Fig. 95). Known since 1874, but not reproduced until 1965, when an impression appeared on the London market (Craddock & Barnard, 1965 Catalogue, No. 9). The figure inspired William Blake's engraving of *Joseph of Arimathea among the rocks of Albion* (Fig. 96). The Beatrizet engraving was first listed in 1874 in the catalogue of the Dyce Collection, London, as a "figure with folded arms from the martyrdom of St. Peter. After Michelangelo." In the following year, L. Passerini (*La bibliografia di Michelangelo Buonarroti e gli incisori delle sue opere*, Florence, 1875, 168), misreading the English "arms" as "weapons," described the figure as "vestito di armi." As a result, a non-existent engraving of a "gewaffneter Krieger" appeared as no. 3 in Neumeyer's list. The confusion was cleared up by Baumgart-Biagetti, 17, n. 1.

Cherubino Alberti. Engraving after the soldier shielding his eyes, second from left (reversed), in the *Conversion* (Fig. 97; B. XVII. 143). Neumeyer and Baumgart-Biagetti incorrectly describe this figure as taken from the *Crucifixion of Peter*.

An engraving of St. Peter alone by Michele Lucchese was cited by Passerini, 211; thereafter quoted by Neumeyer, Baumgart-Biagetti, and Tolnay (V, 145), though no impression has been located.

Neumeyer lists an engraving of the *Crucifixion of Peter* by Francesco Bartolozzi (1728–1815), but this seems to be a confusion with Bartolozzi's engraving after the *Last Judgment*.

Line engravings of both frescoes based on drawings made in the Chapel by Richard Duppa, appeared in R. Duppa, *The Life of Michel Angelo Buonarroti*, London, 1806, pls. V and VI (33 × 26.5 cm). The book, with its cold, Flaxman-style reproductions, passed through five editions during the nineteenth century.

A handful of sixteenth-century drawings after the Pauline frescoes have come to light, most of them copying figures from the *Conversion*. Only one

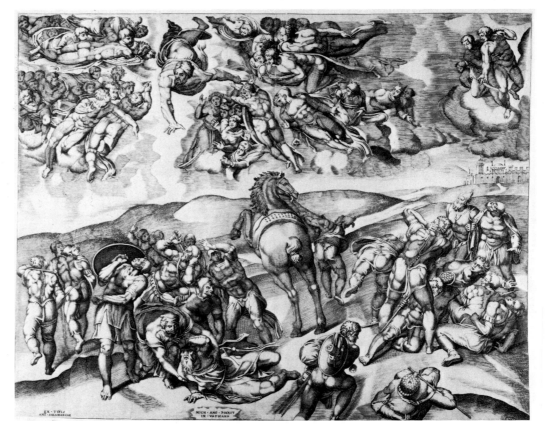

Fig. 92. Nicolas Beatrizet after Michelangelo: *The Conversion of St. Paul*. Engraving. (R.D.29; Pass. vi, 33)

involves the whole composition (our Fig. 19 and n. 7).

A previously unknown mid-sixteenth-century drawing after the angel at upper right in the *Conversion* (Fig. 98) was published in the catalogue *Disegni italiani e stranieri del Cinquecento e del Seicento*, Edizioni "Stampa della Stanza del Borgo," Milan, 1969, no. 53.

Tolnay V, 142 and fig. 305, reproduces a drawing after the soldier to the left of the horse in the *Conversion* (Amsterdam, Rijksmuseum).

Lelio Orsi produced two unusual variations of figures from the *Conversion*, both in the British Museum (A. E. Popham, *Italian Drawings . . . in the British Museum. Sixteenth-Century School of Parma*, London, 1967, pls. 45, 46). The first is a reverse adaptation of the group of St. Paul and the soldier aiding him; the second, an imaginative projection of the rearing horse and its groom as though seen from the front.

A drawing in Princeton (Tolnay V, fig. 304), possibly by Giulio Clovio, copies one of the soldiers ascending at the extreme left in the *Crucifixion of Peter*.

7. The drawing (Paris, Bibl. Nat., Ba. 6, IV, fol. 2) was discovered and published by Tolnay V, 142 and fig. 299 with the following comments: "This drawing, representing the composition of Michelangelo's *Conversion of Saul*, was probably done to show the Pope the loincloths which were to be painted on the nudes and which are distinguished in this drawing by a darker wash. Since these loincloths are not identical with those finally executed, the drawing cannot be a copy from the fresco but rather a project for the corrections."

8. Tolnay V, 138 mentions without further reference "an earlier cleaning recorded in 1842." It was apparently this cleaning campaign that led Grimm in 1860 to deplore a recent restoration, so crudely handled "that perhaps not a single authentic brush-stroke of Michelangelo remains to be recognized" (Grimm, 627).

9. The restoration was followed in 1934 by a full report in the monograph by Baumgart-Biagetti. For further discussion of the condition of the frescoes, see also Tolnay V, 138, and 73, where the author takes issue with the results of a renewed restoration in 1953. In this latter campaign, the head of the horse in the *Conversion* was removed to reveal another version beneath. Tolnay believes that the "more fiery" head removed in this cleaning (see our Fig. 45) was Michelangelo's own final version.

10. "Io dipingerò malcontento, et farò cose malcon-

tente." For the full context of this remark see Michelangelo's letter, p. 14, above. The artist is saying that, if his mind is troubled by an unsettled external anxiety, he will not be able to produce good work. Lifting it from its original context, Berenson takes the remark as proof that in Michelangelo's later years "painting, drawing, and indeed even writing were gradually becoming painful to him" (*The Drawings of the Florentine Painters* (1903), 2nd ed. Chicago, 1939, I, 231. Enzo Carli relates the words to the "funereal and disconsolate *poesia* emanating from the Pauline frescoes" (*Michelangelo*, 2nd ed., Bergamo, 1946, 42). Kenneth Clark reads the quotation as evidence that Michelangelo had undertaken the Pauline frescoes reluctantly and with a growing pessimism about his creative powers (*The Artist Grows Old*, 10).

11. See Vasari-Milanesi VII, 216: "Queste furono l'ultime pitture condotte da lui d'età d'anni settanta-cinque, e, secondo che egli mi diceva, con molta sua gran fatica; avvengachè la pittura, passato una certa età, e massimamente il lavorare in fresco, non è arte da vecchi." Paolo d'Ancona still cites these words to explain the comparative failure of the Paolina's "muddled and forced compositions" (*Michelangelo: Architettura, Pittura, Scultura*, Milan, 1964, 36).

12. The quotations above are from the following: Charles C. Perkins, *Raphael and Michelangelo: A Critical and Biographical Essay*, Boston, 1878, 237; Symonds, *Renaissance*, 313. Even in Symonds' exhaustive *Life of Michelangelo*, the Paolina frescoes are mentioned only in passing and without comment (pp. 345, 369). Henry Thode, *Michelangelo und das Ende der Renaissance*, Berlin, 1912, III/2, 610.

An extensive collection of generally adverse comments on the Pauline frescoes from the eighteenth and nineteenth centuries appears in Barocchi III, 1410–1433, nos. 598–602; see also Ludwig Schudt, *Italienreisen im 17. und 18. Jahrhundert*, Vienna, Munich, 1959, 346, n. 17. Among the rare nineteenth-century writers cited in Barocchi who find good words for the frescoes are Quatremère de Quincy (1835), Jacob Burckhardt (1855) and É. Montégut (1870).

13. Neumeyer, 173: "Dieselbe Geisteswelle, die in der bildenden Kunst die Ausdrucksform des 'Expressionismus' geschaffen hat, sie hat auch Blick und Geist der Forscher für ein Eindringen in die Sphäre der Paolina-Fresken erzogen."

14. Wölfflin, 198. See text p. 38 for further discussion of this passage.

15. Savonarola's sermon "On the Renovation of the

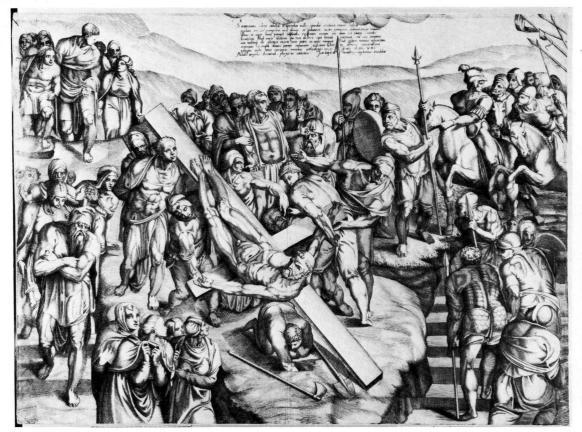

Fig. 93. Giovanni Battista Cavalieri after Michelangelo: *The Crucifixion of St. Peter*. Engraving (Le Bl. i, 27)

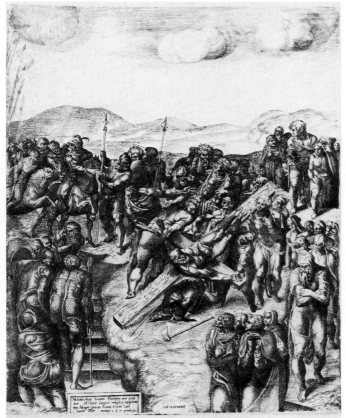

Fig. 94. Michele Lucchese after Michelangelo: *The Crucifixion of St. Peter*. Etching (Pass. vi, 6)

Fig. 95. Nicolas Beatrizet after Michelangelo: Engraving after the figure at the lower right in *The Crucifixion of St. Peter*

Fig. 96. William Blake: *Joseph of Arimathea among the Rocks of Albion*. Engraving, 1773

Fig. 97. Cherubino Alberti after Michelangelo: Engraving (reversed) after a soldier in *The Conversion of St. Paul*. (B. xvii, 143)

Fig. 98. Anonymous Italian, ca. 1550: Drawing after an angel in *The Conversion of St. Paul*. Art Market

Church" was delivered in Florence Cathedral on January 13, 1495, and immediately printed in pamphlet form. See Olin, 4–15, for the full text of the sermon in translation.

16. Dvořak, 129, 131; Friedlaender, 18; Neumeyer, 174. Other pioneers in the positive revaluation of the Paolina frescoes are Dagobert Frey; and Valerio Mariani, *Gli Affreschi di Michelangelo nella Cappella Paolina*, Rome, 1932.

17. The notion of old-age art as a distinct stylistic phenomenon has been discussed (inconclusively, it seems to this writer) from A. E. Brinckmann, *Spätwerke grosser Meister*, Frankfurt, 1925, to K. Clark, *The Artist Grows Old*. Many authors of the 1920s referred to the characteristics of old-age style as though these had in fact been successfully isolated (e.g. Frey's reference, 140, to "die immer mehr überhandnehmende Neigung des Alters zum Raisonnement und zur Abstraktion."

18. From a lecture on Titian delivered at the Institute of Fine Arts, New York University, September 27, 1963. Panofsky called the third phase "splendid, as opposed to melancholy, isolation."

19. Friedlaender, 14.

20. Cf. also Panofsky's observation that Michelangelo's late works were more remote from Mannerism than those of his middle period, or even the Sistine Ceiling. The latter's spandrels, he writes, are "more mannerist than the Last Judgment—to say nothing of the Pauline frescoes" ("Die Pietà von Ubeda. Ein kleiner Beitrag zur Lösung der Sebastianofrage," *Festschrift für Julius Schlosser*, Vienna, 1927, 158).

21. Friedlaender, 18; Frey, 143; Dvořak, 128; Panofsky, unpublished lectures on Michelangelo, Institute of Fine Arts, New York University, 1938; Neumeyer, 173.

22. Michelangelo habitually modified anatomical norms. In several early works, the extremities of the male figure are amplified, most notoriously in the overscaled hands of the *David*. The disproportions here cannot be, as has been suggested, optical adjustments to a low point of sight, since the hands fall at different levels and the head and feet are equally overscaled. But Michelangelo may have drawn inspiration from the traditional etymology given to David's name: "David, which is to say, strong of hand." (See St. Augustine, *Pat. Lat.* 36, 302.) Cf. Cassiodorus (*Pat. Lat.* 70, 35): "The interpretation of names . . . is shown to indicate hidden things, even as interpreters of Hebrew names have wished to transmit them: David signifies strong of hand . . ." ["Interpretatio nominum . . . res nobis secretiores indicare monstratur, sicut interpretes Hebraeorum nominum tradere maluerunt: David significat manu fortis . . .".] Isidore of Seville writes "David, strong of hand, because assuredly most strong in battles" (*Pat. Lat.* 82, 279). Michelangelo would have heard the (erroneous) translation of David's name from Savonarola: "David id est manu fortis," and again, "David vuol dire pulcher aspectu et fortis manu"; see *Prediche Italiane ai Fiorentini*, ed. F. Cognasso, Perugia, Venice, 1930, II, 280, 295. I am indebted to Pamela Askew of Vassar College for drawing my attention to the quotations from Savonarola and St. Augustine. Having assigned a magnified scale to the hands of the *David*, the rest had to follow, so that head, hands and feet alike

became magnified. The result is a figure whose posture is stilled, but whose puissant extremities suggest imminent action. The anatomy is imaginatively kinetic rather than ontological.

An even more striking instance of re-proportioning is the Child of the *Bruges Madonna*. Here the enlargement of arms and legs relative to the trunk is so drastic that Raphael, adopting the Child for his *Belle Jardinière* (Louvre), felt the need to correct it, restoring the fullness of torso and reducing the limbs to conform to the proportions of normal infant anatomy.

The mature Michelangelo tends to treat the male body as a centered structure from which arms and legs—comparable in size and mobility—issue as equivalent radiations. Even in the *Last Judgment*, where the figures seem swayed or tossed by impersonal forces, the male nudes wield enormous athletic arms. Only in the *Conversion* are these relative disproportions inverted, so that arms become reduced and enfeebled.

23. For Ochino's sermon on the Conversion of Saint Paul, see p. 30 and n. 27.

24. Sir Thomas More, *A Dialogue of Comfort* (1534), Book III ("Against Tribulation"), ed., New York, London, 1951, 421.

NOTES TO CHAPTER III

1. Saul's change of name is explained as follows by St. Jerome: "As Sergius Paulus Proconsul of Cyprus was the first to believe in his preaching, he took his name from him because he had subdued him to faith in Christ" (St. Jerome, *Lives of Illustrious Men*, Chapter V, in *A Select Library of Nicene and Post-Nicene Fathers of the Christian Church*, eds. P. Schaff, H. Wace, Grand Rapids, n.d., III, 362). Cf. also below, n. 16, for St. Augustine's commentary on the names. Dobschütz, 87, n. 1, is incorrect in maintaining that Paul is a Roman equivalent for Saul.

2. Voragine, *Golden Legend*, 127.

3. For the symbolism of this gesture, and its persistence from antiquity to the Renaissance, see Ines Zucker, *Der Gestus des Aposkopein*, Zurich, 1956. Examples of St. Paul at his Conversion shielding his eyes in sign of a supernatural vision are common in Northern art—e.g. H. S. Beham, woodcut (Pauli, App. 898), and Pieter Coeck van Aelst, drawing (New York, The Metropolitan Museum of Art, 63.76.7). Both these works are of interest also for the "river-god" pose assigned to the protagonist (see below, p. 28).

4. See Leo Steinberg, "Leonardo's *Last Supper*," *The Art Quarterly* 36 (1973), 388, n. 32 on the tradition of relating the two natures of Christ to his upper and lower body respectively.

5. The Bartolommeo di Giovanni drawing of ca. 1488 (Fig. 28) was first published by Van Isselt, fig. 3, there attributed to a Ghirlandaio pupil.

6. Lorenzo Veneziano's *Conversion* (Berlin; dated 1370) forms one of five predella panels to an altarpiece of *Christ Giving the Keys to St. Peter*; reprod. in B. Berenson, *Italian Pictures of the Renaissance. Venetian School*, London, 1957, figs. 15–17. For recent literature, see R. Pallucchini, *La Pittura Veneziana del Trecento*, Venice, Rome, 1964, 174 ff.

Other early instances of Conversions showing a youthful Saul are a predella panel in the Seattle Art Museum by a Follower of Spinello Aretino (d. 1410), and a predella panel of Giovanni Bellini's Pesaro Altarpiece (1471–74).

7. The chronology of the historical Paul has remained a matter of some conjecture. The difficulties are summarized in C. Tresmontant, *Paulus in Selbstzeugnissen und Bilddokumenten*, Hamburg, 1959. Paul was born in the earliest years of the Christian era and was somewhat younger than Christ. At the time of the Stoning of St. Stephen (ca. 36 A.D.) he is described as a "young man" (Acts 7:57). But we do not know how much time elapsed between that event and the Conversion; nor between the Conversion and his first visit to Jerusalem, a period which includes at least three years spent in Arabia (Gal. 1:17–18). Paul's

arrest in Jerusalem (Acts 22:22 ff.) is datable in 58–59 A.D. In I Cor. 15:8, Paul refers to himself as "one born out of due time"—which may refer to his being too young to have met the Master in person.

8. Raphael's portrayal of the "older" St. Paul eliminates his traditional baldness, as do most subsequent Renaissance representations of the Apostle. Raphael's authority for the type of Paul with close-cropped hair and long dark beard was an ancient cameo with obverse and reverse busts allegedly of Christ and Paul, which had been sent by the Sultan to Innocent VIII in 1492. Copies of the medal, made in Rome, ca. 1500, were widely disseminated. (J. Fischer, *Sculpture in Miniature. The Andrew S. Ciechanowiecki Collection of Gilt and Gold Medals and Plaquettes*, exh. cat., The J. B. Speed Museum, Louisville, Ky., 1969, no. 233; G. F. Hill, *A Corpus of Italian Medals of the Renaissance before Cellini*, London, 1930, no. 900.) A further instance of Raphael's historicism is the youthful Saul in the tapestry of the *Stoning of St. Stephen*—closely modelled on the corresponding figure in the Early Christian fresco formerly at S. Paolo fuori le mura (see the seventeenth-century drawing after the destroyed fresco reproduced in Stephan Waetzoldt, *Die Kopien des 17. Jahrhunderts nach Mosaiken und Wandmalereien in Rom*, Vienna, Munich, 1964, fig. 368).

9. The complete text of Gilio's *Degli Errori de' Pittori circa l'istorie* is published in Barocchi, *Trattati* II; see p. 45 for Gilio's criticism of Michelangelo's Paul: "Mi pare ancora che Michelagnolo mancasse in quel san Paolo abbarbagliato ne la nova Capella, che, essendo egli di 18 o 20 anni, l'abbia fatto di 60; e molto più notabile mi pare in lui uno erroruccio, tenendo il principato di quanti pittori ha 'l mondo, che in altri uno erroraccio, che non sono in quel grado ne in quella somma consideratione che è esso: conciossia che egli ha data e dà la norma a tutti i pittori che sono ora e che saranno." Gilio's criticism of Michelangelo's bearded St. Paul, combined with the authority of Raphael's beardless version, has misled scholars into believing that a youthful St. Paul in representations of the Conversion was a norm from which Michelangelo had departed.

10. Vasari-Milanesi VII, 893.

11. A later example of a *Conversion* replete with references to Michelangelo's fresco, but with a youthful hero, is Pier Francesco Mola's fresco in the Gesù, Rome, first chapel, left (R. Cocke, *Pier Francesco Mola*, Oxford, 1972, pl. 74).

12. Paul does not usually wear the sword of his martyrdom, but he is so represented in Rembrandt's *Self-Portrait as St. Paul* (1661; Amsterdam, Rijksmuseum).

13. For the Ghirlandaio predella at Lucca, see Van Isselt, fig. 2. For the antique type of the soldier ducking under his shield on a Niobid sarcophagus, see the Girolamo da Carpi drawing at the British Museum (reproduced in Cornelius C. Vermeule, "The Dal Pozzo-Albani Drawings of Classical Antiquities," *The Art Bulletin* 38 (1956), fig. 7). The Florentine engraving of the *Conversion* (Hind, A. II. 10) is attributed to Baccio Baldini by Konrad Oberhuber in *Early Italian Engravings from the National Gallery of Art*, Washington, D.C., 1973, 16 and fig. 2–6. Closely related is a Florentine niello print of ca. 1470–80 attributed to Matteo di Giovanni Dei (Dutuit 235; Duchesne 139; reprod. in M. Knoedler & Co., *Engravings and Etchings . . .*, 7th Annual Exhibition, New York, 1931, p. 20. The plate is preserved in the Bargello, Florence). Of all the fifteenth-century Florentine examples cited, this niello offers the closest prototype for Michelangelo's figure of Paul.

14. An outstanding example of Paul's retinue as a full-scale army is Pieter Bruegel's *Conversion of St. Paul* (1567; Vienna, Kunsthistorisches Museum).

15. See Dobschütz, 95, for the introduction of the horse in twelfth-century Conversions, and 108 ff., for the relevance of the Prudentius manuscripts, suggested to Dobschütz by Dr. Geisau.

16. *Paulus humilitatis nomen est.* St. Augustine, *Sermones ad populum*, Sermo 279 (*De Paulo apostolo. Pro solemnitate conversionis ejusdem*), *Pat. Lat.* 38, 1278.

17. Bedae Venerabilis *super Acta Apostolorum Expositio*,

cap. ix, *Pat. Lat.* 92, 963.

18. Voragine, *Golden Legend*, 126.

19. Voragine, *Sermons*, Sermo 74, *De conversione sancti Pauli*, sermo ii. Cf. Sermo 76, iiii: "He was converted from pride to profound humility." (Voragine's *Golden Sermons* had passed through sixteen printed editions by 1533; I would like to thank Mr. Thomas Martone for bringing this important source to my attention.)

Modern writers on Michelangelo's fresco connect its subject with the problem of Grace, of which the Conversion of Paul is the classic instance, and which in the sixteenth century had become a most urgent theological issue. But the observation usually stops at the mere statement of the connection. What has been ignored, though more fertile when applied to the fresco, is the traditional emphasis upon Paul's humility. Thus Peter Abelard (*Sermones et Opuscula Ascetica*, Sermo 24, *Pat. Lat.* 178, 530): "Ille ergo ex hoc populo et primus in superbia, et postmodum praecipuus testis in humilitate nobis ad medium [Paulus] deducatur . . . per humilitatem postmodum inclinans dicit." And Ochino (*Sermons of Hope*, Sermon 8, fol. 76ᵛ), echoing St. Augustine: "And for all this he [Paul] was so humble that he called himself the least of the Apostles, unworthy of the name of an Apostle . . . yea, the chiefest sinner of the world."

20. On the Madonna of Humility see M. Meiss, "The Madonna of Humility" (1936), in *Painting in Florence and Siena after the Black Death*, Princeton, 1951, 132–156, and 149 for the symbolic exploitation of the etymology of *humilitas* in Isidore of Seville and St. Thomas Aquinas.

21. Of the two dates proposed for the *Doni* tondo, 1504 and 1506, the latter is by far the more probable, as I hope to demonstrate in a forthcoming essay.

22. Erasmus, *The Immense Mercy of God (De Immensa Misericordia Dei*, 1524), ed. P. Radin, San Francisco, 1940, 34.

23. Voragine, *Sermons*, Sermo 73, i. The above text follows the Vulgate's reading as rendered in the Douay Bible. Though the divergent translation of the Hebrew in the King James version is the more correct, it is obviously not relevant to our subject.

24. St. Gregory the Great, *Dialogorum*, Lib. III, xvii, *Pat. Lat.* 78, 265 (English translation from *The Fathers of the Church* XXXIX, trans. O. J. Zimmerman, New York, 1959, 148). In the Florentine tradition, the Christ of the Conversion sometimes appears surrounded by winged putti-heads (e.g. Figs. 27, 28)—clearly too young to sustain the notion of fellowship in contemplation. It is worth observing that Salviati's *Conversion of Saul* (see Fig. 32 for Enea Vico's engraving) uses the group of God the Father surrounded by angels in the Sistine *Creation of Adam* fresco for the role of Christ.

25. Redig de Campos, *Paolina*, 13; reprinted in his *Itinerario pittorico dei Musei Vaticani*, Rome, 1954, 301.

26. Pope Innocent III, *Sermones de Sanctis*, Sermo 9, *In Festo Conversionis Divi Pauli Apostoli : De tractatione Pauli, et magna Dei misericordia erga peccatores, et ut nemo desperet*; *Pat. Lat.* 217, 489–494.

27. Ochino, *Sermons of Hope*, Sermon 8: Of the Wonderful Conversion of Saint Paul, fol. 75ʳ; *Sermons of Charity*, Sermon 9: How Christ upon the Cross draweth every thing unto him, fol. 93ᵛ. In the 1530s, Ochino preached "before distinguished congregations, including many Cardinals," from the pulpit of S. Lorenzo in Damaso. He was the "ideal of the spiritual orator." A contemporary reports in 1539, "we have among us many eminent preachers; but none can be compared to Ochino" (Pastor XI, 486, 489). Among his warmest admirers, supporting him for as long as possible against the charge of heresy, was Vittoria Colonna, Michelangelo's religious guide. See Pastor XI, 486–495 for the vicissitudes of Ochino's career and an account of his friendship with the Marchesa.

28. Ochino, *Sermons of Hope*, Sermon 8, fol. 74ᵛ. Cf. also St. Jerome, who describes Paul on the road to Damascus as "constrained to faith by a revelation" (*Lives of Illustrious Men*, v; see note 1). The violence of Paul's Conversion is rendered graphically in a woodcut by the Monogrammist A (B. VII. 1; cf. the

copy by Lambert Hopfer, B. VIII. 21), where Christ thrusts his cross at Paul like a weapon, in a posture reminiscent of Pluto plying his trident.

29. See Tolnay V, 141, with references to earlier scholars: "The motif of the outstretched body of Saul reverts to ancient River Gods . . . Raphael in his Heliodorus and Marcantonio in his Judgment of Paris also reverted to the same ancient prototype." Michelangelo's significant departures from the river-god tradition are discussed on p. 38.

30. For a history of the Campidoglio and its role in Roman civic life see Siebenhüner (below, n. 31), and Ackerman, 49 f. See also Livy I. 55 for that ancient discovery of a relic on the Capitol which "announced in unambiguous fashion that this place would be the seat of empire and the capital of the world."

31. Since the attributes of these river-gods were subsequently found to refer to the Nile and the Tigris, it was decided to convert the latter into the Tiber by changing its tiger into the She-Wolf and Twins (1565–66). The two statues remained in front of the Conservatori Palace through the 1540s; thereafter they were placed back to back by Michelangelo against the staircase of the Senatori Palace. See Herbert Siebenhüner, *Das Kapitol in Rom. Idee und Gestalt*, Munich, 1954, 49 f.

32. Cf. G. Pecchiai, *Il Campidoglio nel Cinquecento sulla scorta dei documenti*, Rome, 1950, 66 f., describing the Capitoline as ". . . il colle che divideva col Vaticano la gloria e la nobilità dell'Urbe."

33. Pope Innocent III, *Sermones de Sanctis*, Sermo 22, *In solemnitate D. Apostolorum Petri et Pauli, Pat. Lat.* 217, 557. An earlier association of Peter and Paul with Romulus and Remus was made by Peter Abelard: ". . . this state, which was first built by two brothers, Remus and Romulus, was later founded much more felicitously in Christ by the greater brothers, Peter and Paul. From these two all the grace was distributed which would suffice for the confession of the whole world, since Peter was eminent in miracles, Paul in words" (*Sermones et Opuscula Ascetica*, Sermo 23, *Pat. Lat.* 178, 528).

The "honored tombs" of Remus and Romulus to which Innocent III refers are the so-called *Meta Remi* (Pyramid of Cestius) and the *Meta Romuli* (the no longer extant pyramidal Tomb of Numa, near St. Peter's), regarded in the Middle Ages as the sepulchers of the Twins.

NOTES TO CHAPTER IV

1. Vasari-Milanesi VII, 215 f.
2. Wölfflin, 197—restating the traditional view of the fresco as unintelligible confusion. Cf. Grimm's brief remarks on the Paolina frescoes, 627: "They are comprehensive compositions, remarkable in that many groups, widely separated from each other, fail to cohere in a proper unity. The figures are very numerous, not lacking even among the clouds." See also Fritz Knapp (*Michelangelo*, Stuttgart, Leipzig, 1924, xlvi): "The wild, senseless confusion of the figures is driven to the utmost. Michelangelo here forgets that composition needs scaffolding, and that increase of effect requires contrast. With him, everything is wild passion, and the eye, the soul, searches in vain for a point of departure."
3. Wölfflin's stylistic criteria of Renaissance and Baroque art were first expounded in his *Renaissance und Barock* (1888; English translation by Kathrin Simon, London, 1964), and were set forth systematically in his famous five categories in *Kunstgeschichtliche Grundbegriffe* (1915), translated as *Principles of Art History*.
4. For the commission to Marcello Venusti (called Il Mantovano in the documents), see Baumgart-Biagetti, 80, n. 2 (Doc. 33), and Frommel, 41, n. 83.
5. Perino del Vaga's design for the *basamento* of the altar wall of the Sistine Chapel was identified by Hermann Voss from a preliminary painting on canvas now in the Palazzo Spada, Rome (*Die Malerei der Spätrenaissance in Rom und Florenz*, Berlin, 1920, I,

72 and figs. 2–4). See also Tolnay V, 128 and fig. 290. The composition displays winged genii, termini, putti, festoons and strapwork against a flat ground.
6. For the attribution of this panel to an anonymous Ferrarese master (formerly given to Dosso Dossi), see Cecil Gould, *National Gallery Catalogues. The Sixteenth-Century Italian Schools*, London, 1962, no. 73, 55 f.
7. Outstanding examples are: Mantegna's *Crucifixion* panel (Louvre) from the San Zeno Altarpiece; Ghirlandaio's *St. Francis Receiving the Rule* (fresco, Florence, Sta. Trinita); the *Coronation of Charlemagne* (Raphael School; Vatican, Stanza dell'Incendio); Salviati's fresco of the *Visitation* (1538; Rome, S.

Fig. 99. Albrecht Altdorfer: *The Holy Family at the Fountain*. Woodcut, 1512–15 (B. VIII. 59)

Giovanni Decollato). Half-length soldiers seen in back view above the threshold appear in Pontormo's fresco of *Christ before Pilate* at the Certosa del Galuzzo, near Florence. But in all these instances, either the figures themselves or the stairwells in which they ascend parallel and confirm the pictorial base. For a particularly clear instance of this procedure in Northern art, cf. the foreground figure of Joseph and the ledge upon which he places his foot in Altdorfer's *Holy Family at the Fountain* (Fig. 99).
8. Michelangelo's desire to establish the action of Christ as a significant horizontal may explain why Christ's left arm breaks so curiously at the elbow. The arm has two things to do: to point to the city on the horizon—as the arm surely does from the elbow down; and to maintain horizontality, as it does in the level stretch from the shoulders out.
9. The surface shape created by the foreshortening of the Christ figure has led a number of scholars (e.g. Redig de Campos, *Itinerario*, 299) to compare it to the three-legged or three-pronged sign known as *triskelion* or *trinacria*, implying perhaps a Trinitarian allusion.
10. In the rendering of figures in action, Pomponius Gauricus, writing in 1504, had distinguished between energy, emphasis, and ambiguity. The "energy" of a figure indicates whence it came; its "emphasis" indicates where it is tending: "ambiguity" leaves it readable either way (Pomponius Gauricus, *De Sculptura*, eds. André Chastel, Robert Klein, Geneva, Paris, 1969, 198 f.). In the 1530s and '40s Pomponius turned astrologer, was enjoying the special favor of Paul III (Pastor XI, 39 n.; XII, 537). He was probably known to Michelangelo.
11. Cf. Frey, 140, describing the Pauline frescoes: "Es vollzieht sich hier eine Umdeutung des Gegenständlichen, wie wir sie parallel in der Architektur Michelangelos finden; wie die tektonischen Formen bei ihm ihre primäre Bedeutung verlieren und zu plastischen Bewegungssymbolen werden, so hier in der imitativen

Kunst der menschliche Körper. In diesem Sinne nähert sich die Malerei der Baukunst und wird zur anthropomorphen Architektur."
12. Quoted in Ackerman, I f. The unnamed prelate is probably Cardinal Rodolfo Pio da Carpi. The translation used here is from Elizabeth Holt, ed., *A Documentary History of Art* II, Garden City, 1958, 20 f. See also David Summers, "Michelangelo on Architecture," *Art Bulletin* 54 (1972), 146, n. 2. For the original text, see Milanesi, *Lettere*, 554.
13. Ackerman, 2 and 59.
14. The persistence of these duplications does not diminish the incongruity of duplicating the figure of the protagonist. Michelangelo could have avoided it by making Paul the unique central element.
15. The similarity between Michelangelo's grouping of human figures and of architectural members, noted in a general sense by D. Frey (above, n. 11), was observed by Wölfflin, 197, in his discussion of Michelangelo's *Last Judgment* fresco (Fig. 11): "The figure of the Virgin is completely dependent, attached to that of Christ, just as in architecture at this time the single pilaster was accompanied by a strengthening half- or quarter-pilaster." Cf. also the placement of the Virgin in the Doni Tondo (Fig. 34), recessed between the embracing thighs of the Joseph figure, recalling the principle of the *colonna alveolata*.
16. Ackerman, 20, 31, 42.

NOTES TO CHAPTER V

1. Jean-Paul Sartre, "Man at Bay," in *Essays in Aesthetics*, trans. W. Baskin, New York, 1956, 56. Sartre, referring to Mantegna's *Dead Christ*, is convinced that "perspective is profane; sometimes even, a profanation."
2. Gilio da Fabriano, *Degli Errori de' Pittori circa l'istorie* in Barocchi, *Trattati* II, 44.
3. E.g. the dead body of the prone soldier in Uccello's *Battle of San Romano* (London, National Gallery), or Castagno's Madonna in his lost *Death of the Virgin*. Examples of foreshortened divinities are the figure of the Almighty in Uccello's *Sacrifice of Noah* and Castagno's God and Christ in his *Vision of St. Jerome*.
4. Instances of such compensation in the Quattrocento are found in the arms' spread of Castagno's foreshortened Christ in the *Vision of St. Jerome* and in Mantegna's martyred St. Christopher in the Eremitani, Padua.
5. That the foreshortened Christ is not immediately related to the beholder, but rather represents the saint's vision, is an observation anticipated by Ursula Schlegel with respect to Castagno's *Vision of St. Jerome*, where the image of the Trinity "is less immediately keyed to the beholder . . . since it is characterized as a vision appearing to the saints in the lower part of the picture" ("Observations on Masaccio's Trinity Fresco in S.M. Novella," *The Art Bulletin* 45 [1963], 30).
6. The idea that Paul's Conversion is a kind of birth may be implicit in Salviati's design for Enea Vico's engraving (Fig. 32). Here the figure of Christ surrounded by angels duplicates the group of the life-giving God in Michelangelo's fresco, the *Creation of Adam*.
7. Tolnay, V, 141, tries to derive the pose from Michelangelo's own earlier work: "The necessity of using curving bodies in the composition led Michelangelo to search out models in certain of his sketches executed earlier for the Medici Chapel: thus in the pose of Saul, the artist takes up with a slight modification the motif of the River Gods which he had projected for the Medici Chapel—a pose which he had also used for his composition of Venus and Cupid." The author here seeks to counter the common assertion that the pose of Michelangelo's Paul was directly adapted from the figure of the eponymous villain in Raphael's *Expulsion of Heliodorus* (Fig. 54). It is undeniable that the legwork in the Raphael figure is almost identical—as it is again in the river-god in Marcantonio's *Judgment of Paris* engraving, or in the Michelangelo *Venus*

cited by Tolnay, or, subsequently, in Bronzino's *Martyrdom of St. Lawrence*. The type, in brief, had become a familiar formula.

8. Purgatory, Canto X, 118–126; translation by John Ciardi, Mentor Books, New York, 1957, 116.

9. For the quotations in the above paragraph, see R. J. Clements, *Michelangelo's Theory of Art*, New York, 1961, 355 f., and 363.
 Cf. also Vasari's account of Michelangelo's peculiarity in the matter of dress (Vasari-Milanesi VII, 285): "he wore, when old, dog skins next to the skin of his legs during the winter, and when he wished to remove them, the skin often came with it."

10. Girardi 285: "Onde l'affettuosa fantasia/che l'arte mi fece idol' e monarca"; translation Symonds, *Sonnets*, LXV.

11. Girardi 66: "Si presso a morte, e sì lontan di Dio"; translation Symonds, *Sonnets*, LXXI.

12. Condivi, 93 (Holroyd transl. 87); Girardi 288: "Mettimi in odio quante 'l mondo vale"; translation Symonds, *Sonnets*, LXVI.

13. Tolnay I, 147; Milanesi, *Lettere*, 613 f. The contract was drawn up by Jacopo Gallo on behalf of the young Michelangelo.

14. For the letter of 1506, see Ramsden I, no. 8, and for the reference to the San Lorenzo façade, Ramsden I, no. 116.

15. It is a euphemism to refer only to the "nudities" of the *Last Judgment* fresco as having given offense. Along the right edge of the fresco, Michelangelo placed three overt sexual allusions, the like of which had not been seen since the representations of Hell in Romanesque art.

16. A summary of contemporary sources and modern literature on the Leoni medal appears in Barocchi IV, 1735 ff.

17. Fehl, 340.

18. Cf. I Cor. 9:16: ". . . a necessity lieth upon me; for woe is unto me if I preach not the gospel."

19. Girardi 161: "Stendi ver me le tue pietose braccia,/Tômm'a me stesso, e fammi un che ti piaccia"; translation in R. J. Clements, *Michelangelo: A Self-Portrait*, Englewood Cliffs, N.J., 1963, no. 588.)

NOTES TO CHAPTER VI

1. Michelangelo thanks his friends with elegant sonnets for gifts of cheese, wine, and sugar; e.g. Girardi, 299 ("Al zucchero, a la mula . . .").

2. Michelangelo's letter of October 22, 1547 (Ramsden II, no. 291) recalls his stay at the Strozzi Palace in 1544 and Luigi del Riccio's devotion. See also Ramsden's Appendix 27, "Michelangelo and Luigi del Riccio," II, 244 ff. and especially 245, for an account of the master's illness.

3. The Pope's visit to the Pauline Chapel was recorded in the diary of Francesco Firmano; Baumgart-Biagetti, 76 f., Tolnay V, 136.

4. Ramsden II, no. 306 (May 2, 1548).

5. Girardi, 267: ". . . l'osteria è morte, dov' io viv' e mangio a scotto."

6. Donato Giannotti, *Dialogi*, ed. D. Redig de Campos, Florence, 1939, 69.

7. References in order of citation: Ramsden II, no. 279; Tolnay V, 15; Ramsden II, no. 402.

8. Numerical symbolism certainly figured in Michelangelo's habits of thought. If he selected exactly thirty-three pears to send to the Pope, his motive was surely the same as determined the number of buttons on the priest's cassock, or the number of Cantos in the *Paradiso*.

9. Michelangelo was a rich man, but such a gold hoarder and energetic investor that, being perennially short of liquid assets, he lived in comparative penury and contrived to think of himself as a pauper. In January, 1506, he begged his family, "Pray God my affairs go well; and see, in any case, that up to a thousand ducats are invested for me in land, as we agreed." A month later he writes from Rome, "I haven't a *quattrino*" (Ramsden I, nos. 6 and 7).
 When Michelangelo's income from the Po Ferry

was suspended (between August, 1545 and February, 1546), he wrote to Luigi del Riccio: "having lost the ferry at Piacenza, and being unable to remain in Rome without an income, I'm thinking of using up the little I have on hostelries, rather than stay cooped up like a beggar in Rome" (Ramsden II, no. 259). Although the revenues were subsequently restored, and though Michelangelo had other substantial sources of income, his complaining continued. In 1548 he asked his brother to find some property near Florence in which he could invest three or four thousand *scudi* "because, having lost the ferry, I am in need of providing myself with an income that cannot be taken away from me" (Ramsden II, no. 311; see her Appendix 33 for a detailed account of the Po Ferry income).

10. Gaye II, 332 f.

11. Symonds, *Michelangelo*, 336. For a subtle analysis of Aretino's motives, see Hans Tietze's important essay, "Michelangelos Jüngstes Gericht und die Nachwelt," *Festschrift zum sechzigsten Geburtstag von Paul Clemen*, Düsseldorf, Bonn, 1926, 429 f. Edgar Wind ("The Ark of Noah," *Measure* [1950], 411) calls Aretino's letter "a brazenly truthful and very irreverent letter in which he held up a vexing mirror to Michelangelo's face. This caricature is one of the most accomplished in its genre. Aretino declined to publish; and it would not have reached and shocked the nineteenth century had not Michelangelo himself, who had a marked taste for the bizarre, chosen to preserve and circulate this unflattering portrait which its author had asked him to destroy." Wind is correct insofar as Aretino did not include the letter in the Marcolini anthology; but he forgets that Aretino sent out at least one other copy—to Alessandro Corvino (Aretino, *Lettere* II, 176; July, 1547).

12. Condivi, 91 (Holroyd trans., 85).

13. Condivi, 87 (Holroyd trans., 83).

14. Ramsden II, no. 433 (May, 1557).

15. Art historians tend to refer this quotation to Michelangelo's sense of the creative ordeal, to the blood it costs to produce works of art (e.g. Tietze, 434, cited above, n. 11; and Clark, *The Artist Grows Old*, 9). But the context of the drawing and of the Dante passage rule out such a reading. See Steinberg, "Metaphors," 269.

16. See Wolfgang Lotz, "Notizen zum kirchlichen Zentralbau der Renaissance," in *Studien zur toskanischen Kunst. Festschrift Ludwig H. Heydenreich*, Munich, 1964, 157–165; Staale Sinding-Larsen, "Some functional and iconographical aspects of the centralized church in the Italian Renaissance," *Acta ad Archaeologiam et Artium Historiam Pertinentia* 2 (1965), 236 ff.

17. Richard Krautheimer, "Santo Stefano Rotondo in Rome and the Rotunda of the Holy Sepulchre in Jerusalem" (1935), *Studies in Early Christian, Medieval, and Renaissance Art*, New York, 1969, 91 ff., 97.

18. According to the account of Aegidius da Viterbo (discovered by Pastor), Bramante had originally proposed to reorient the Church at right angles, so as to have the obelisk on its southern flank front the main entrance. Such a shift would have required moving the Tomb of St. Peter if it was not to be relegated to the end of a transept. Julius, however, would not have the shrine tampered with. See Pastor VI, 479 f. and App. 89, 655 f. for the transcription of Aegidius' report.

19. Cf. Lotz, 164: "Die Konzeption des Sakralbaus als Denkmal äussert sich in der grossartigsten Weise in den Neubauprojekten für St. Peter. Bramante zerstört die traditionsbeladene konstantinische Basilika und gibt der neuen Memoria über dem Apostelgrab die Form des Zentralbaus." The above is hard to reconcile with the author's subsequent statement (p. 165): "nur aus künstlerischen Erwägungen kann es erklärt werden, dass Bramante für den von Julius II befohlenen Neubau die Zentralform anstelle des für einen solchen Bau zu erwartenden Longitudinalschemas wählte." But "artistic considerations" and symbolic significance need not be in mutual conflict; in most major works of the Renaissance they are coincident.
 The slight westward displacement of the Apostle's Tomb with respect to the geometric centerpoint of the dome has, I believe, little bearing on the present argument. The excentricity was dictated by the

situation of the Rossellino foundations which predetermined the siting of the great piers. And it commended itself on functional grounds, for the displacement of the Martyr's Tomb towards the west, with the High Altar beyond it, allowed greater assembly room for the congregation. At the same time, the shift was not large enough to disturb the visual sense of the centrality of the Martyr's Tomb under the dome.

20. See Frommel, 18–22, who argues convincingly that the central plan does not reflect Sangallo's own architectural thinking and that it was Paul III who urged its resumption.

21. ". . . in mode che chiunque s'è discostato da detto ordine di Bramante, come a fatto il Sangallo, s'è discostato dalla verità" (Milanesi, *Lettere*, no. CDLXXIV; cf. Ackerman, Catalogue, 88 f., and Ramsden II, no. 274). Needless to say, Michelangelo had more than one reason for preferring Bramante's design to Sangallo's.

22. Girardi, 6: "Già sperai ascender per la tua altezza."

23. From the altar of the Paolina, the Pope, seated on the *Sedia Gestatoria*, was borne in procession to St. Peter's, and there enthroned on the high altar, whence he gave blessing to the assembled populace. Frommel, 40, n. 83, thanks Dr. Heinrich Thelen for first drawing his attention to the intended function of the Paolina as Chapel of the Conclave. Both its sacramental and its electoral functions were inherited from an earlier Chapel of the Sacrament, which fell victim to the reconstructions of Paul III (Frommel, 11–13).

24. Cf. Voragine, *Golden Legend*, 341, quoting two Latin verses which parallel the martyrdoms of Peter and Paul. The Crucifixion of Peter and the Conversion of Paul occasionally appear together along with additional scenes—in ivory panels (e.g. Fig. 73) or within a predella (e.g. Lorenzo Veneziano's two panels, cited above, Chap. III, n. 6; or Giovanni Bellini's predella to the Pesaro *Coronation of the Virgin*). But they do not seem to have been exclusively paired before Michelangelo.

25. See L. D. Ettlinger, *The Sistine Chapel Before Michelangelo*, Oxford, 1965, 111 f. In 1541, when Paul III dispatched Contarini as Legate to the Diet of Ratisbon, the "divine institution of the Primacy" was listed as the first of the fundamental matters of principle on which there could be no compromise (Pastor XI, 429).

26. Barocchi I, 123; Tolnay V, 135.

27. The event is not often represented in Italian art until the thirteenth century. Earlier Northern examples show an inverted, rigidly vertical cross, usually with two men nailing down Peter's hands. They include no specific allusions to the Roman site of the martyrdom. (Cf. the list compiled by Louis Réau, *Iconographie de l'Art Chrétien*, III/3, Paris, 1959, 1098, citing, among others, the ninth-century miniature from the Homilies of Gregory of Nazianzus; the *Crucifixion of Peter* in an illuminated initial in the Sacramentary of Drogo; the tenth-century illumination in the Gradual of Prüm; the tympanum in the Church of Aulnay-de-Saintonge and the capital at Duravel, both of the twelfth century. All the above are reproduced in T. Sauvel, "Le Crucifiement de Saint Pierre," *Bulletin Monumental de la Société Française d'Archéologie* 97 (1938), 337 ff. For eleventh-century representations, see Paris, BN, Ms. Nouv. Acq. lat. 2390, fol. 32, reprod. in Meyer Schapiro, *The Parma Ildefonsus . . .*, College Art Association of America, 1964, fig. 63; and—a rare Italian example—the destroyed fresco, known from a seventeenth-century copy, from S. Andrea Catabarbara, Rome; reprod. in S. Waetzoldt, *Die Kopien des 17. Jahrhunderts nach Mosaiken und Wandmalereien in Rom*, Vienna—Munich, 1964, fig. 16.)

28. The thirteenth-century frescoes on the portico of St. Peter's depicted five scenes from the story of Peter, including his Crucifixion and burial. The cycle, known only from seventeenth-century drawings, has been attributed, inconclusively, to both Cimabue and Cavallini. (See R. van Marle, *The Development of the Italian Schools of Painting*, The Hague, 1923, I, 457 with citation of previous literature.) The Assisi fresco (Fig. 70) was given to Cavallini by Strzygowski and to

Cimabue by A. Venturi and is now attributed to a master of the Roman School (Strzygowski, *Cimabue und Rom*, Vienna, 1888; Adolfo Venturi, *Storia dell'Arte Italiana*, v, Milan, 1907, 195 ff.; Eugenio Battisti, *Cimabue*, University Park, London, 1967, 105). The fresco cycle on the portico of St. Peter's inspired an anonymous *Crucifixion* at S. Piero a Grado near Pisa, dating ca. 1300 (P. d'Achiardi, *Gli Affreschi di S. Piero a Grado presso Pisa . . .*, Rome, 1905, fig. 17); and, more important, the *Crucifixion of Peter* on the Stefaneschi Triptych (Fig. 71), commissioned for Old St. Peter's. The interrelations of these four images, and their inclusion of the "two metae" between which Peter was crucified, are discussed in J. M. Huskinson, "The Crucifixion of Peter: A Fifteenth-Century Topographical Problem," *Journal of the Warburg and Courtauld Institutes* 32 (1969), 140–142.

29. The Polidoro da Caravaggio drawing probably records his destroyed *Crucifixion of Peter* which formed part of the decoration of the façade of S. Pietro in Vincoli, ca. 1520–25. See A. Marabottini, *Polidoro da Caravaggio*, Rome, 1969, 122, 301, 353.

30. The other exception is St. John, depicted before the sixteenth century with book and quill, attributes which characterize him as Evangelist rather than as Apostle.

31. St. Jerome, *Lives of Illustrious Men* (see Chap. III, n. 1), 361.

32. From Origen's lost commentary on Genesis, Book III; quoted in Eusebius, *Ecclesiastical History*, III, 1.

33. *Acts of Peter*, Chapter 39, as translated in E. Heenecke, *New Testament Apocrypha*, ed. W. Schneemelcher, Philadelphia, 1965, II, 320. See Schneemelcher's introduction to the *Acts*, II, 259–271 for their late second-century origin.

34. Idem, 319 (Chapter 38).

35. This recension is found in *The Ante-Nicene Fathers*, VIII, eds. A. Roberts, J. Donaldson, Grand Rapids, 1951, 484.

36. Voragine, *Golden Legend*, 337.

37. The idea of representing a crucifixion at the moment of raising the cross seems to arise tentatively after the mid-fifteenth century. The first instance of it known to me occurs in the central panel of Roger van der Weyden's Miraflores Altarpiece (Granada, Capilla Real) in one of the simulated reliefs forming the voussoirs of the painted frame. It is possible that already here the composition alludes to the Roman type of the raising of a standard, or of a god of boundaries, with attendant connotations of triumph. Further fifteenth-century images of the theme remain rare (a Venetian drawing attributed to Carpaccio at Christ Church, Oxford; a panel by a Nuremberg Master at the Staedel Institute, Frankfurt, SG 448; another South German work of ca. 1490, in the same museum, HM 43). The theme became most popular in Germany in the first two decades of the sixteenth century (works by Sigmund Holbein, Dürer, Baldung, Schäufelein, Altdorfer, Wolf Huber) and was disseminated by means of woodcuts. The crucified may be the Christ, or the Good Thief, or (as in Dürer's drawing of 1507 in Vienna, Winkler II, 438) one of the 10,000 martyrs. An unusual Netherlandish *Raising of the Cross* (of Christ) occurs in one of the frames of Simon Bening's quadriptych of miniatures, ca. 1520, in the Walters Art Gallery, Baltimore.

The earliest monumental treatment of a Raising of the Cross appears to be Filippino Lippi's *Crucifixion of St. Philip*, Strozzi Chapel, S. Maria Novella, completed 1502. A later Italian example, clearly influenced by German prints, is an *Elevation of the Cross of*

Christ given to the School of Luini, in the Poldi-Pezzoli Museum, Milan. A survey of these infrequent precedents indicates the startling novelty of Michelangelo's conception. He seized upon a rare modern motif, raised it to monumental power and applied it for the first time to the Crucifixion of Peter. And whereas all the previous elevations, including Filippino's, show the cross in nearly upright position so that it appears visually as an only slightly modified Crucifixion, Michelangelo's cross of St. Peter is still close enough to the ground to dramatize the physical action of lifting and to maintain the Apostle in a pose not yet fully inverted.

38. The steps are more clearly visible in the engravings after the fresco, Figs. 93 and 94.

39. The intense connection with the beholder established by Peter's glance is described by von Einem, 149. Philip Fehl, 340, recognizing further possibilities of interpretation, speaks of: ". . . the piercing look of St Peter, which is directed perhaps at the figure of Christ in the painting on the opposite side of the Chapel . . ." He adds (n. 65) that "in responding to the intense look of St. Peter we should, perhaps, recall his last words, as they are recited in the first Vespers on the feast day of St. Peter: 'Beatus Petrus, dum penderet in Cruce, alacri vultu ad Dominum deprecabatur, dicens: Domine Iesu commendo tibi oves, quas tradisti mihi.' Michelangelo, in turning the head of Peter so that it affects every step taken in the Pauline Chapel, may perhaps also have been conscious of the immensity of the affairs affecting the future of the church which were to be transacted in the Chapel."

40. The direct implicating glance of the Crucified at the moment of being nailed to the cross or during the Elevation, appears to be a Northern motif. See Gerard David's *Christ Nailed to the Cross* in the London National Gallery (a work of Italian provenance) and Rubens' *Raising of the Cross* (Grasse; painted in 1602 for S. Croce in Gerusalemme, Rome).

41. Evelyn Underhill, paraphrasing Cusanus, in the introduction to *The Vision of God*, trans. Emma G. Salter, New York, 1960, xii.

42. Cusanus, preface to *The Vision of God*, ed. cit., 3 f. On the effect of the outright glance, see also Dagobert Frey, *Dämonie des Blickes*, Wiesbaden, 1953; and, most recently, on the "image as miraculously observant and addressing the viewer . . . as a model of the ubiquitous, all-seeing God," see Meyer Schapiro, *Words and Pictures*, The Hague, Paris, 1973, 39.

43. Leon Battista Alberti, *On Painting*, trans. John Spencer, New Haven, 1956, 78.

44. Among the hundred-odd figures on the Sistine Ceiling, only three look straight out: one of the twelve naked youths (to the left above Daniel); one of the ancestors in the lunettes; and, more meaningfully, the figure of the Child under the reserved hand of God in the *Creation of Adam*. As God's right forefinger animates the first man, the other, with equivalent power, designates the new Adam of the Incarnation to come. The Child is the only figure in the *istorie* of the Ceiling who sends his direct gaze down upon every man. In the Medici Chapel it is significantly the figure of *Day* that looks at the viewer. And no less significant are the two exceptional outright glances observable in the lowermost zone of the *Last Judgment*: a caverned devil and a personification of death.

45. See B. Pesci, E. Lavagnino, *S. Pietro in Montorio* (*Le Chiese di Roma Illustrate*, no. 42), Rome, n.d., 10 and n. 40.

46. The symbolism of Peter's rock was dramatically reaffirmed by Paul III in 1547 during an altercation with Charles V; the Pope observing to the Imperial

Ambassador that Christ had addressed to St. Peter and not to the Emperor the words "Upon this rock will I build my church" (Pastor XII, 362).
Callot's etching of the *Martyrdom of St. Peter* (Lieure 1387) sets the Crucifixion on a rock remarkably like Michelangelo's, and with the dome of St. Peter's in the background.

47. Fehl, 329 and n. 18, for Michelangelo's repeated connections with San Pietro in Montorio.

48. Fehl, 330.

49. But cf. Clark's comment on "the young man who, with mindless concentration, digs the hole in which the cross will be placed. He is innocent, the air-force pilot who releases the bomb" (*The Artist Grows Old*, 13).

50. Fehl, 339, n. 63 and 340.

51. The clustering of figures into solid blocks as a characteristic of Michelangelo's late compositional style was observed by Panofsky as appearing first in the *Children's Bacchanal* drawing at Windsor Castle (unpublished lecture, Spring, 1938, Institute of Fine Arts, New York University). Cf. also the hexagonal assembly of figures in the *Pietà for Vittoria Colonna* (Steinberg, "Metaphors," 265–270).

52. Ramsden II, no. 406; cf. p. 213, for the draft of the letter.

53. One is reminded of St. Gregory, the reluctant Pope, who first paralleled the Old Testament sisters with Martha and Mary and translated both pairs into allegory: "I have loved the beauty of the contemplative life as a Rachel, barren, but keen of sight and fair, who, though in her quietude she is less fertile, yet sees the light more keenly. But, by what judgment I know not, Leah has been coupled with me in the night, to wit, the active life, fruitful but tender-eyed, seeing less, but bringing forth more. I have longed to sit at the feet of the Lord with Mary to take in the words of his mouth. And lo, I am compelled to serve with Martha in external affairs, to be anxious and troubled about many things" (*Epistles*, I, v, as translated in *A Select Library of The Nicene and Post-Nicene Fathers . . .*, XII, eds. P. Schaff, H. Wace, Grand Rapids, 1964, 75).

54. Girardi, 285: "Nè pinger nè scolpir fia più che quieti/L'anima volta a quell'Amor divino/Ch' aperse, a prender noi, in croce le braccia." The poem was sent to Vasari in 1554.

55. John Bossy, postscript to Evennett, 128.

56. The brothers—later canonized with October 7th as their Saints' day—are also present in Filarete's relief (Fig. 73); see Fehl, 334 and n. 51.

57. Fehl, 340. The likeness had been discussed previously by F. Magi, H. von Einem, Tolnay, and others.

58. In one of his poems of the 1530s, Michelangelo speaks of himself as "love's prisoner." In his *Victory* group at the Palazzo Vecchio, he seems to project his own self into the old man crushed by the victor's knee. Recalling his reconciliation with Julius II, the artist remembers "a halter around his neck" (Ramsden I, no. 157). And in his letter of 1542 to Cardinal Alessandro Farnese (above, Chap. I, p. 14), he writes that he has "lost the whole of his youth, chained to the Julius Tomb"—as if Michelangelo saw himself figured in one of his own bound *Slaves*.

59. Fehl, 340.

60. The self-portrait quality of this head was first pointed out by L. Goldscheider. It is dismissed by von Einem and by Fehl, 340, n. 66.

61. *Acts of Peter*, Chapter 41, ed. cit. (above, n. 33), 321.

62. Baumgart-Biagetti, 54.

63. Idem, 77 f., Documents 31, 32, and Frommel, nn. 42 and 83.

THE Cappella Paolina forms part of the central staterooms of the Vatican Palace. It was erected under Pope Paul III by the architect Antonio da Sangallo the Younger. Building was begun in 1537–1538, the raw structure being completed by January, 1540, when Mass was read in the new Chapel. Its walls remained bare until the fresco of the *Last Judgment* in the neighbouring Sistine Chapel was finished; Michelangelo was then ordered to fresco the large recessed central panels of the lateral walls of the Paolina (6·25 m. × 6·61 m.). It is probable that the first work undertaken was the *Conversion of St. Paul* on the east wall (November, 1542 to July, 1545). Interrupted by illness, and commanded by Paul III to take charge of the building of St. Peter's Basilica, Michelangelo did not set his hand to the second fresco until well into 1546 or even the following year. In November, 1549, shortly after the death of the Pope, the scaffolding before the completed fresco of the *Crucifixion of St. Peter* was taken down.

The colour and monochrome photographs reproduced on Plates 1–64 were taken by Ronald Sheridan, London. The extensive photography was carried out by a grant from the Samuel H. Kress Foundation, New York, to which the author and the publishers express their gratitude.

SELECTED INDEX OF PROPER NAMES

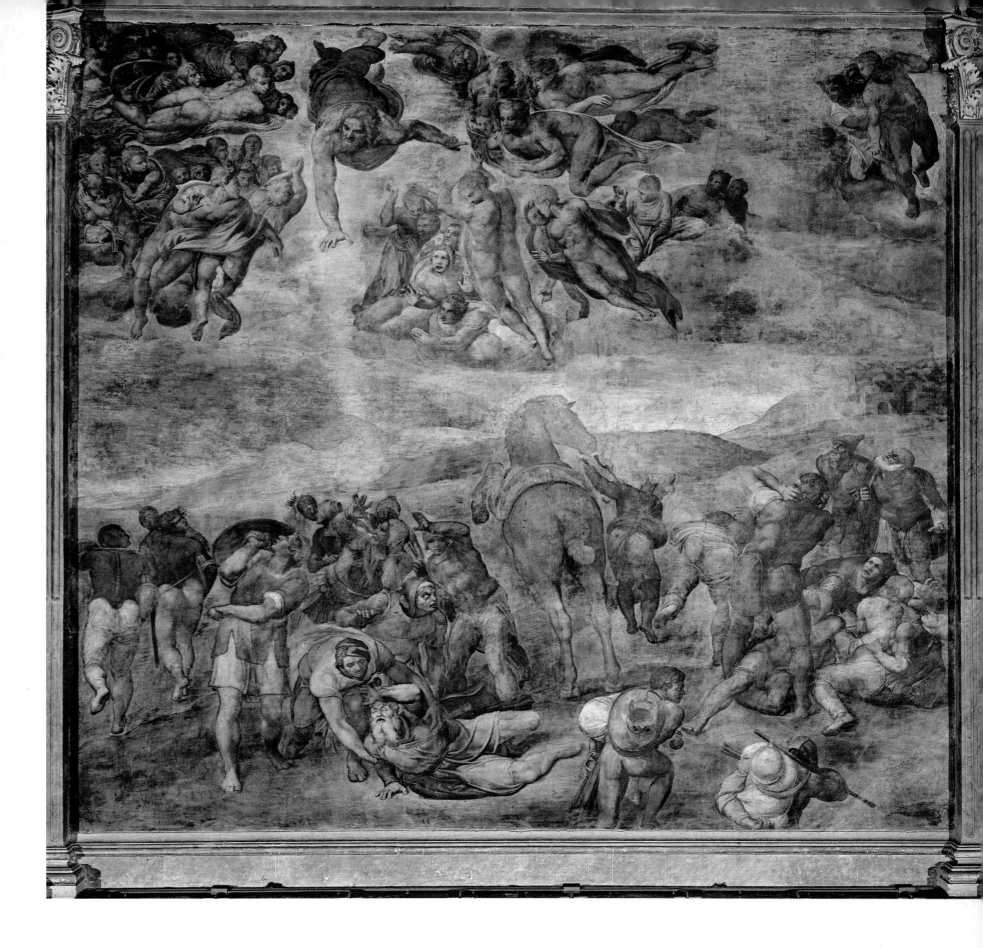

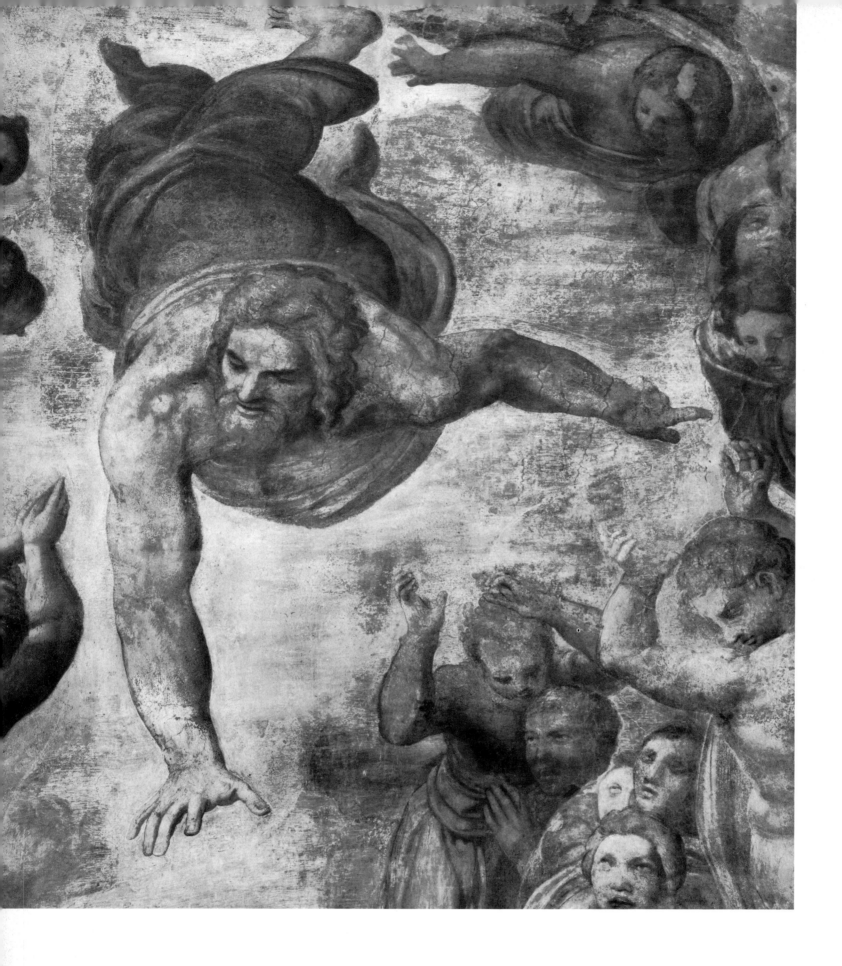

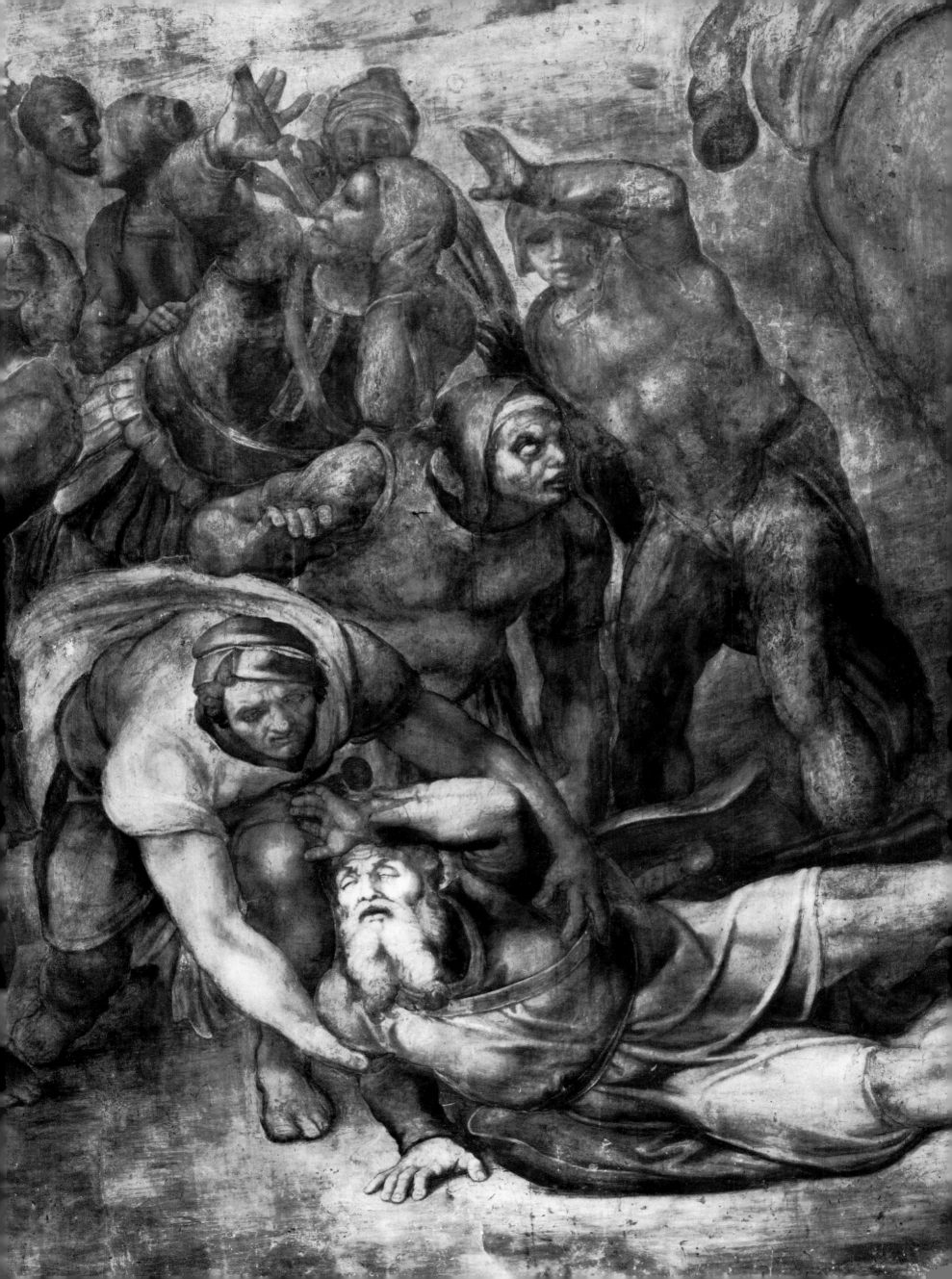

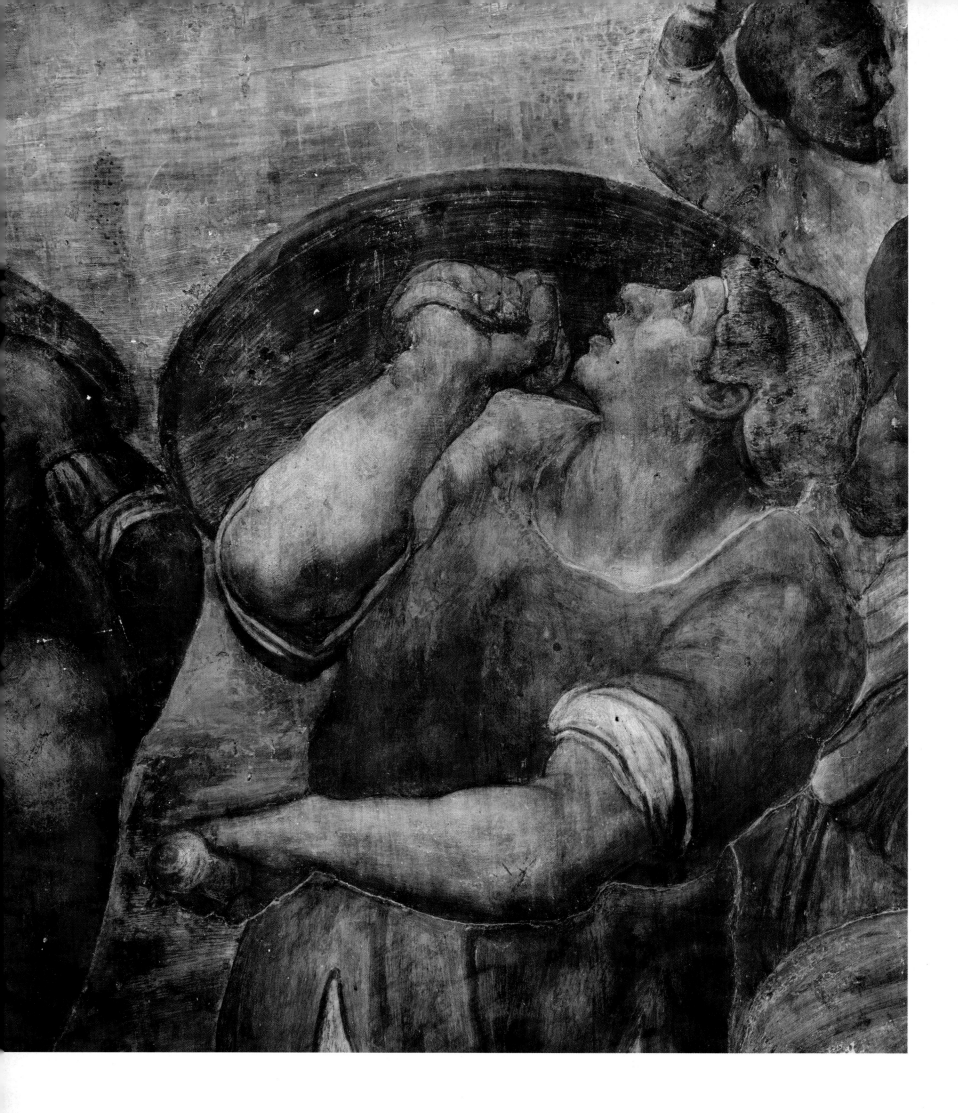

4

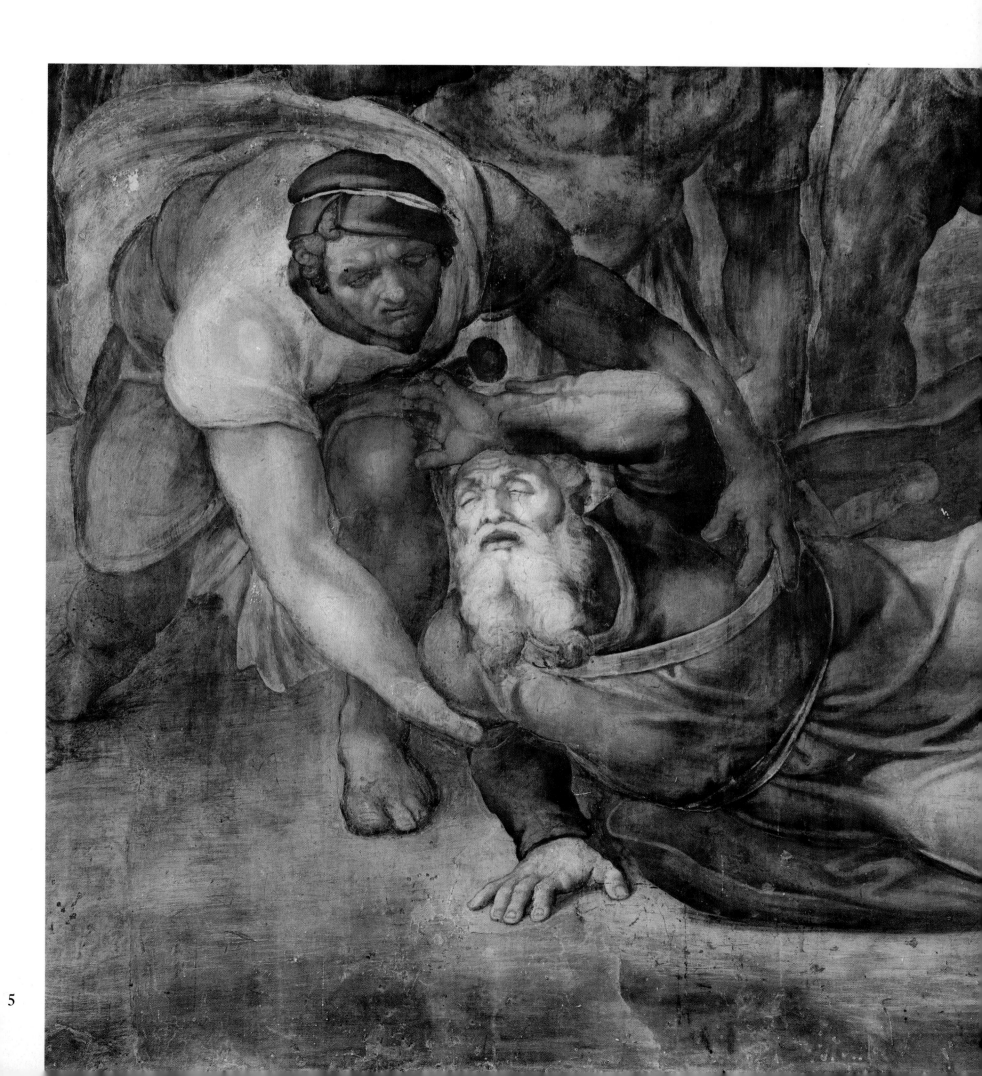

5

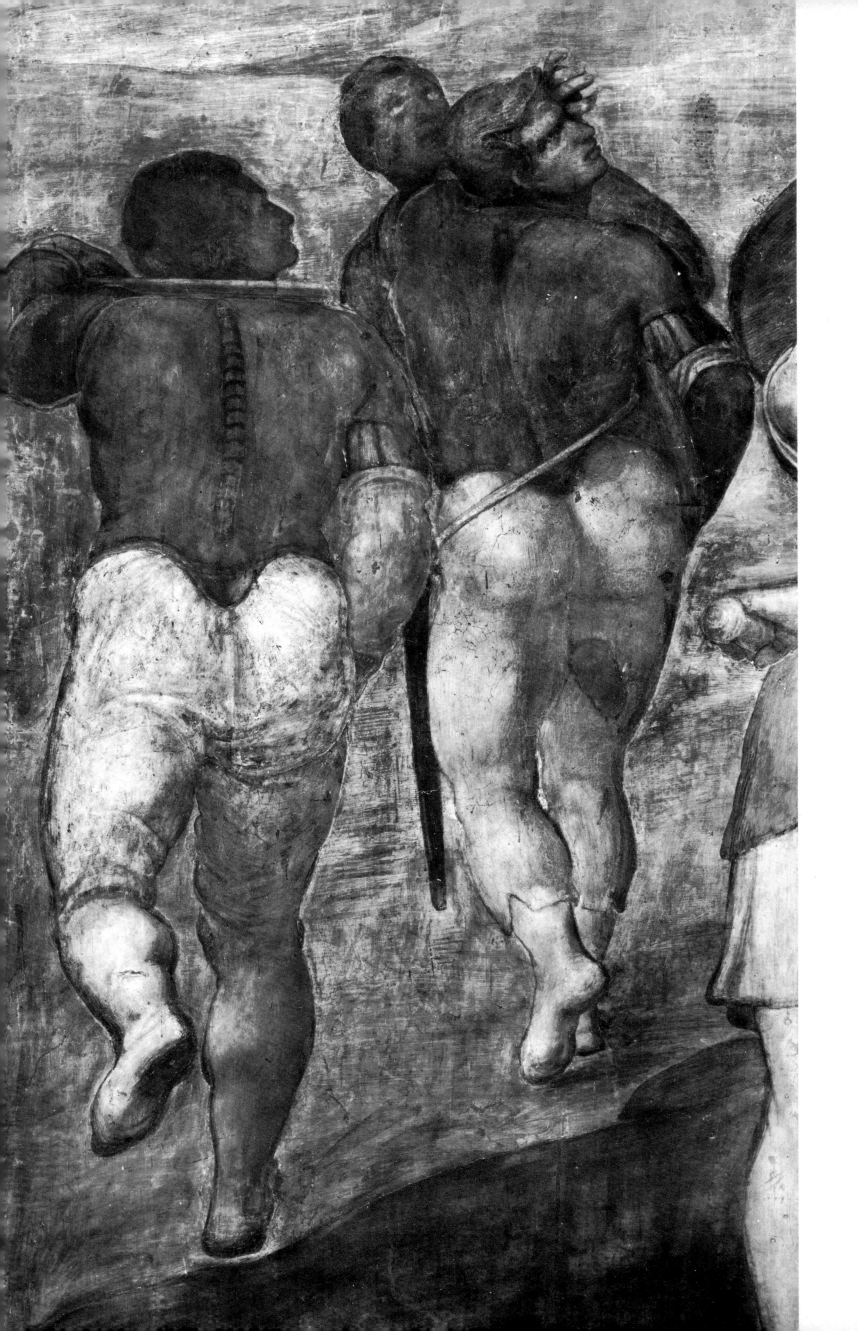

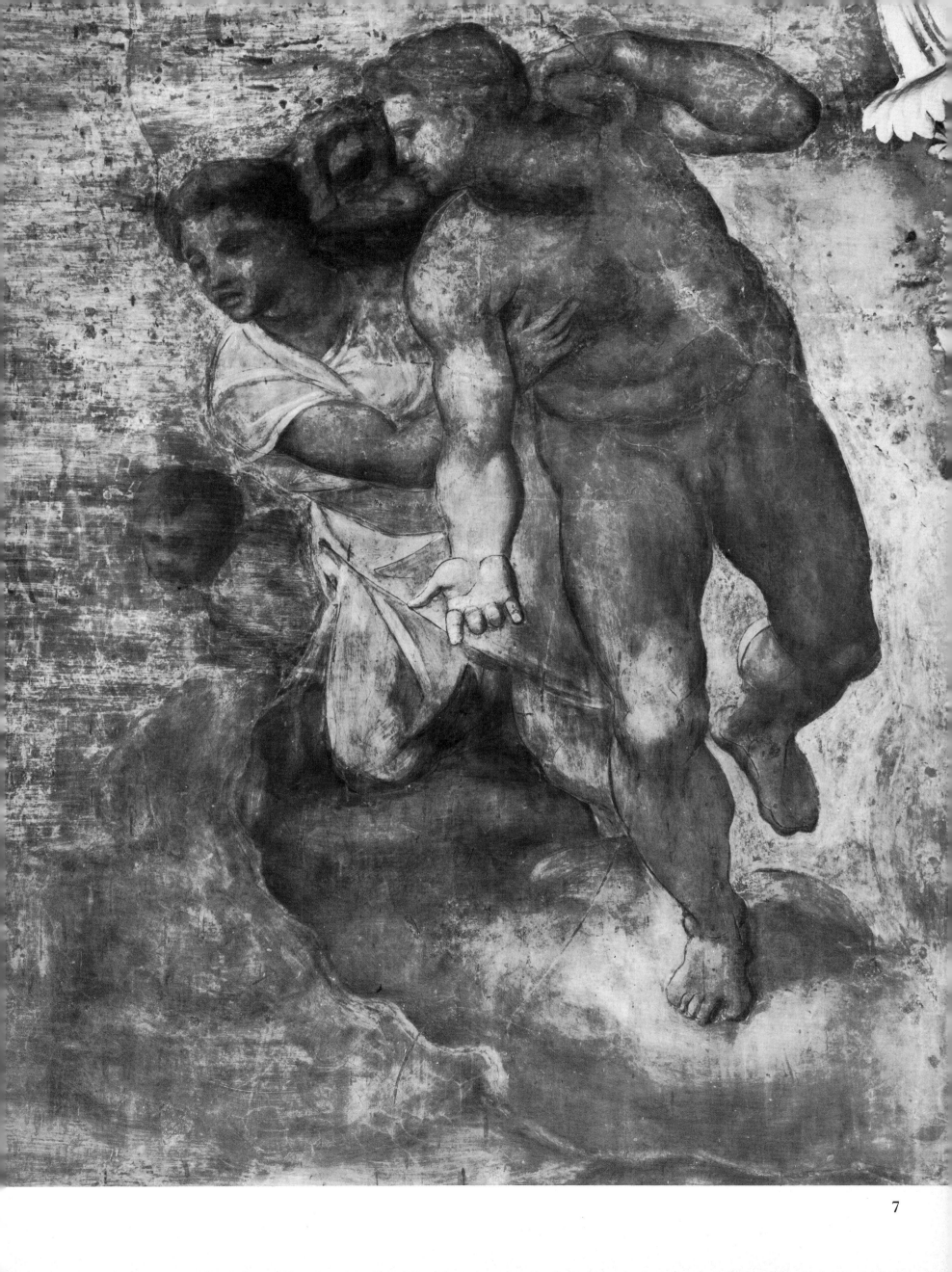

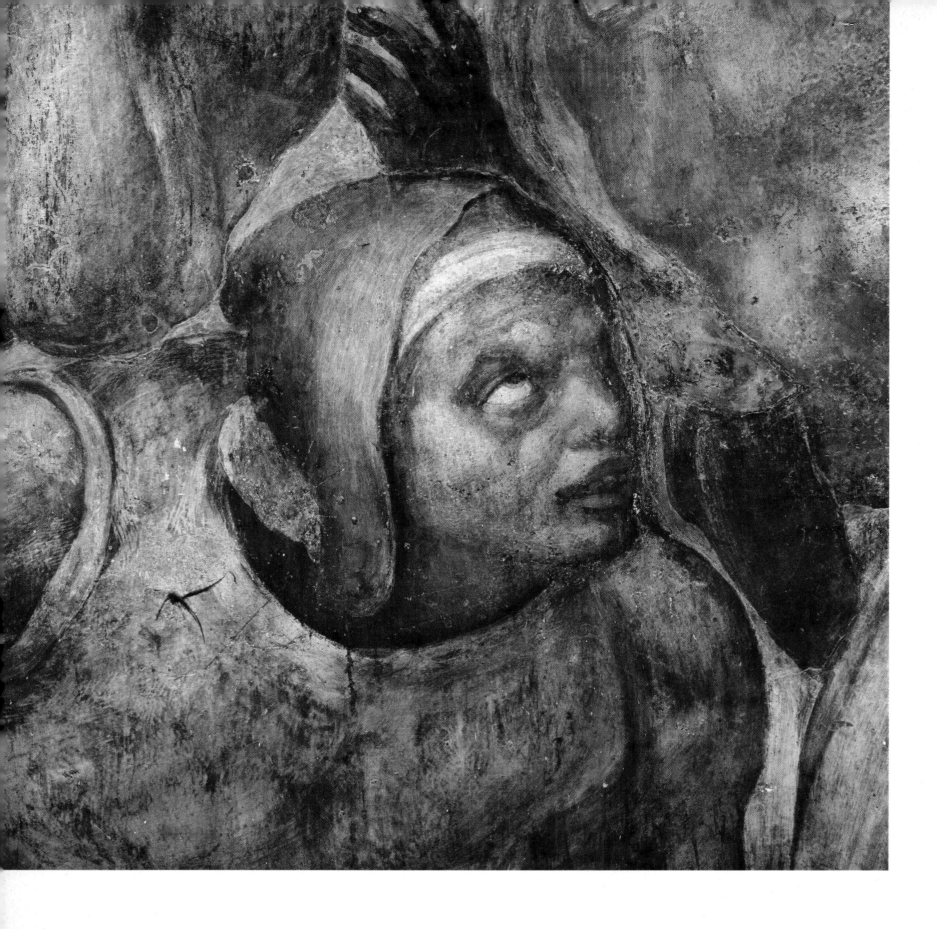

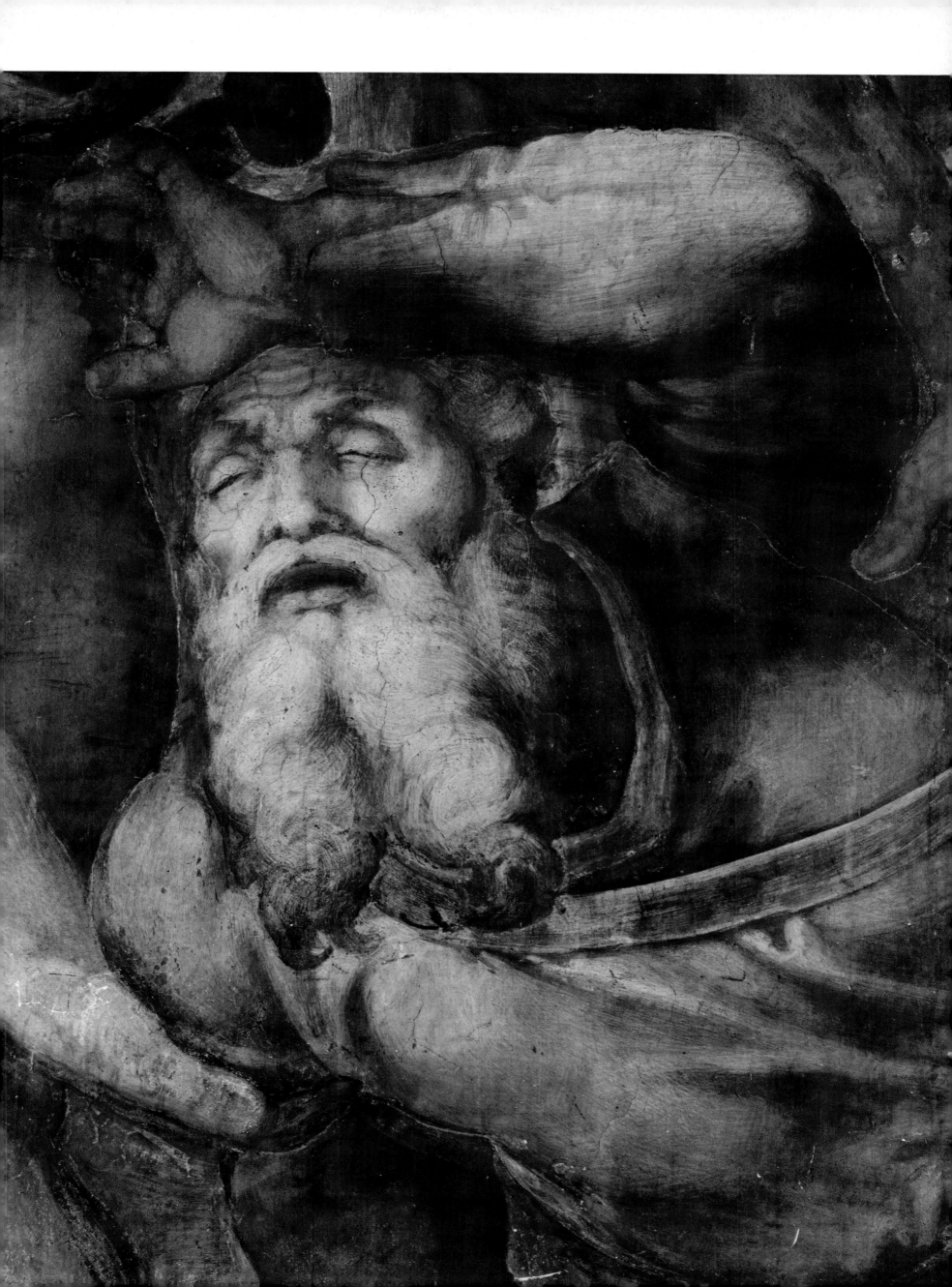

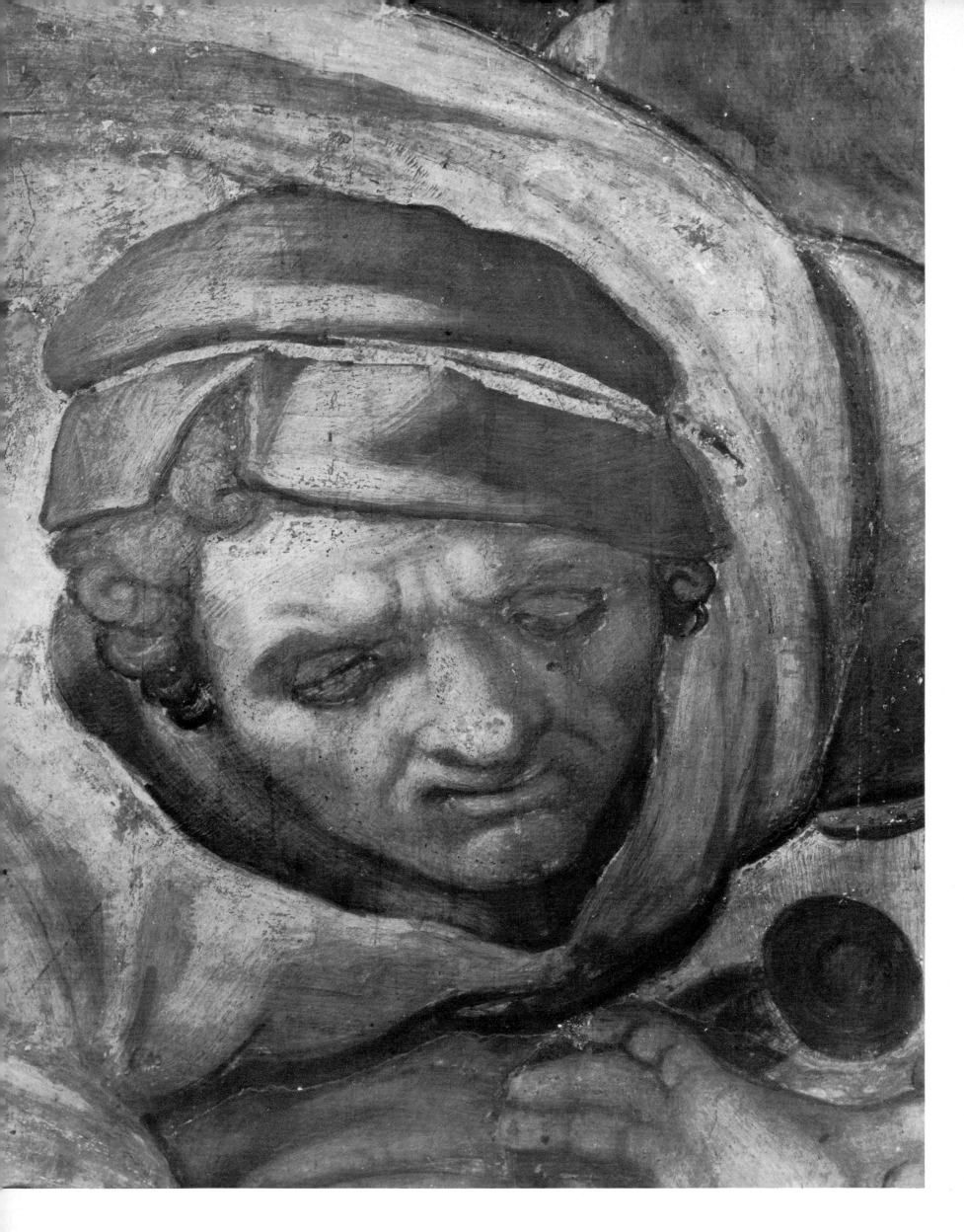

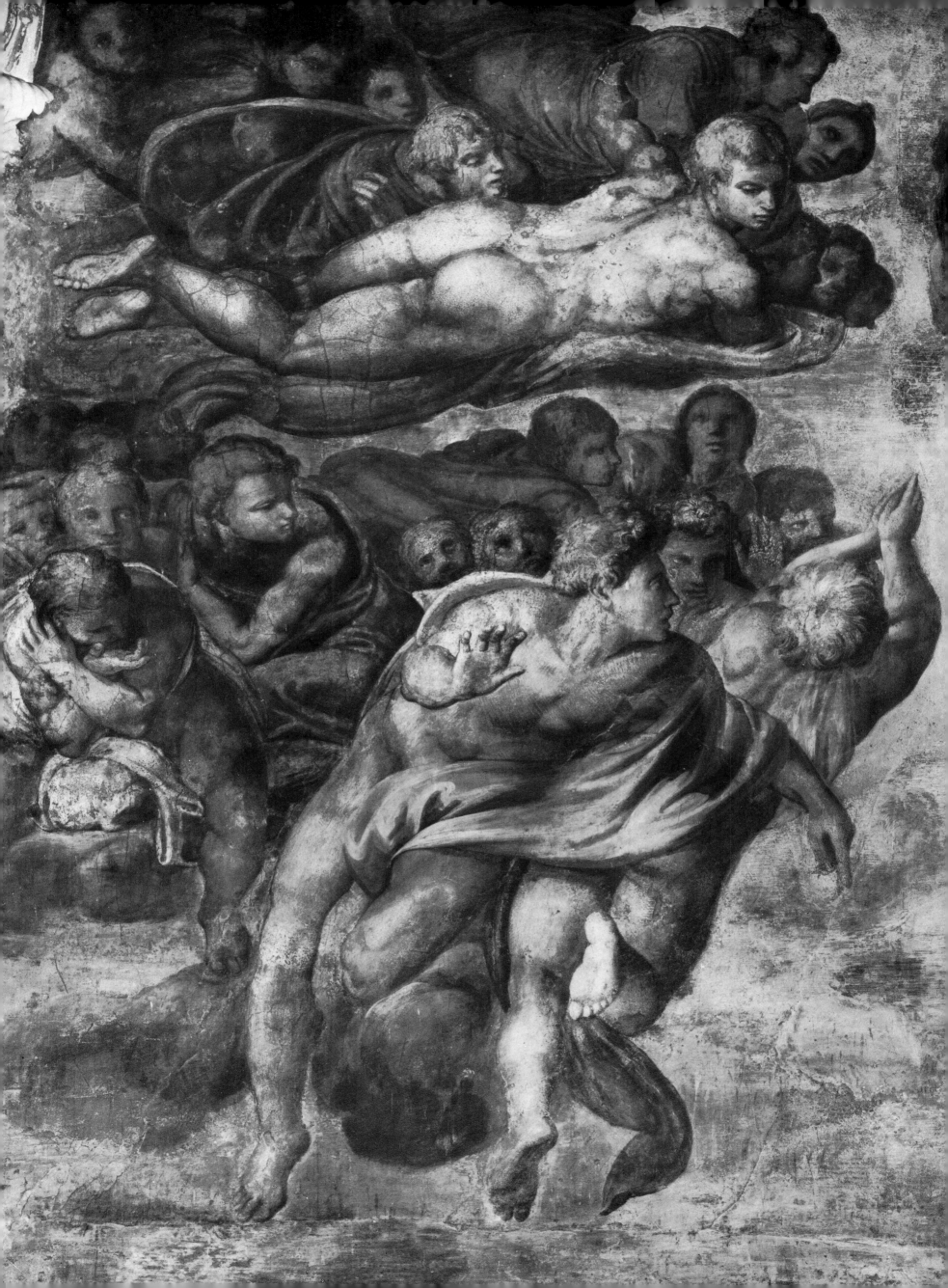

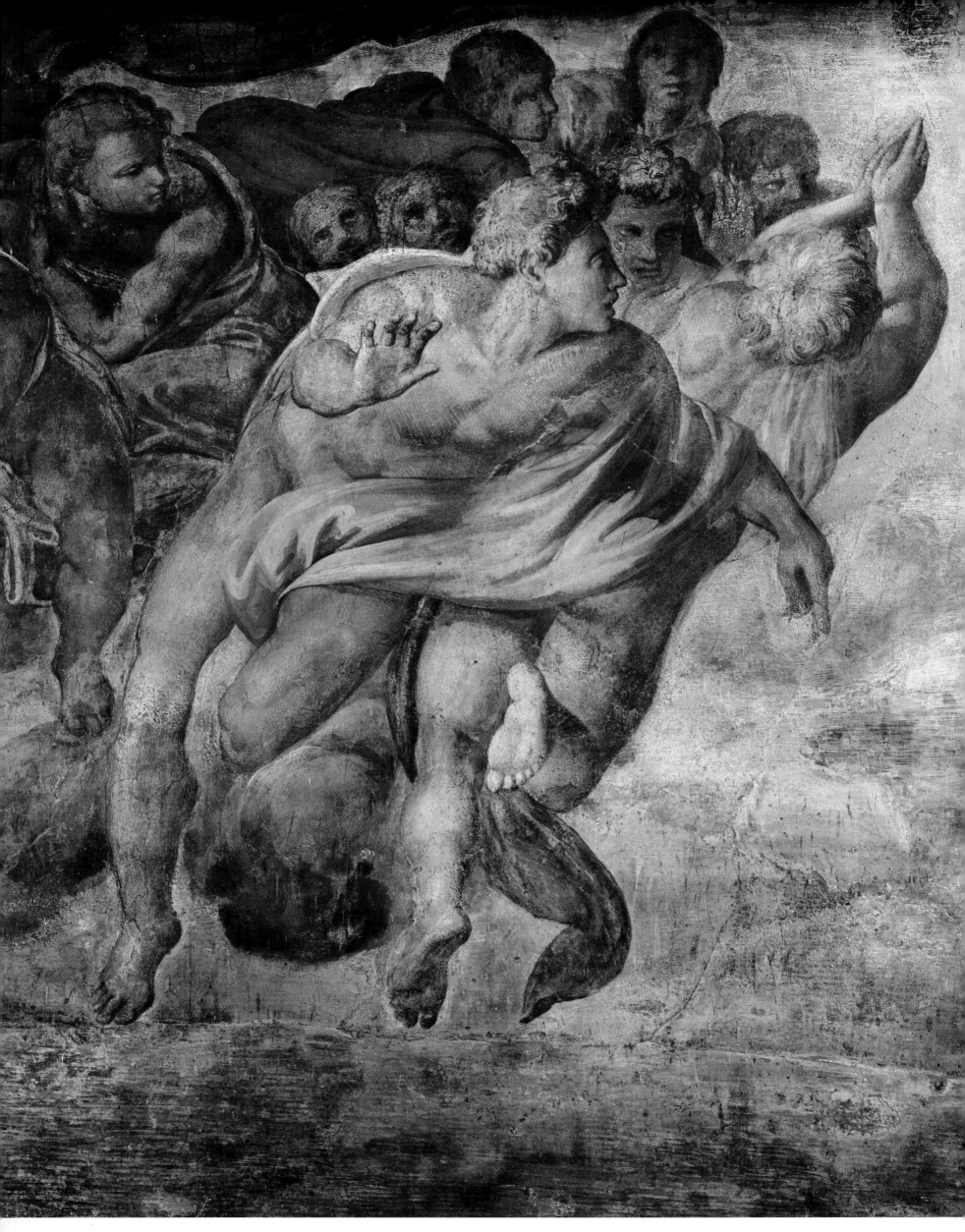

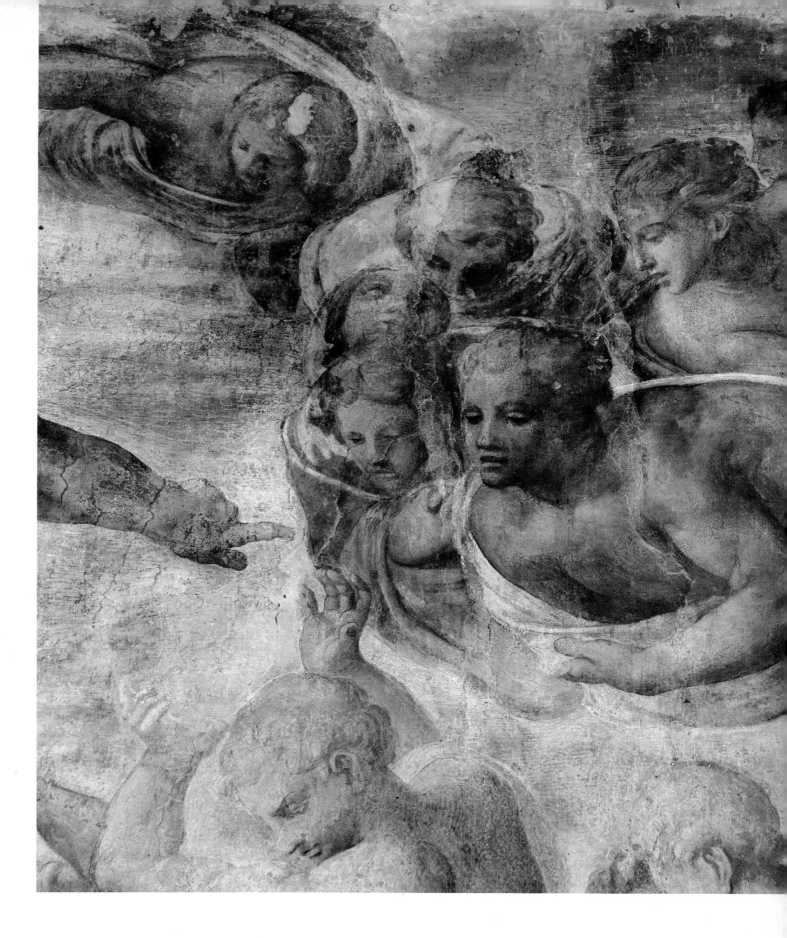

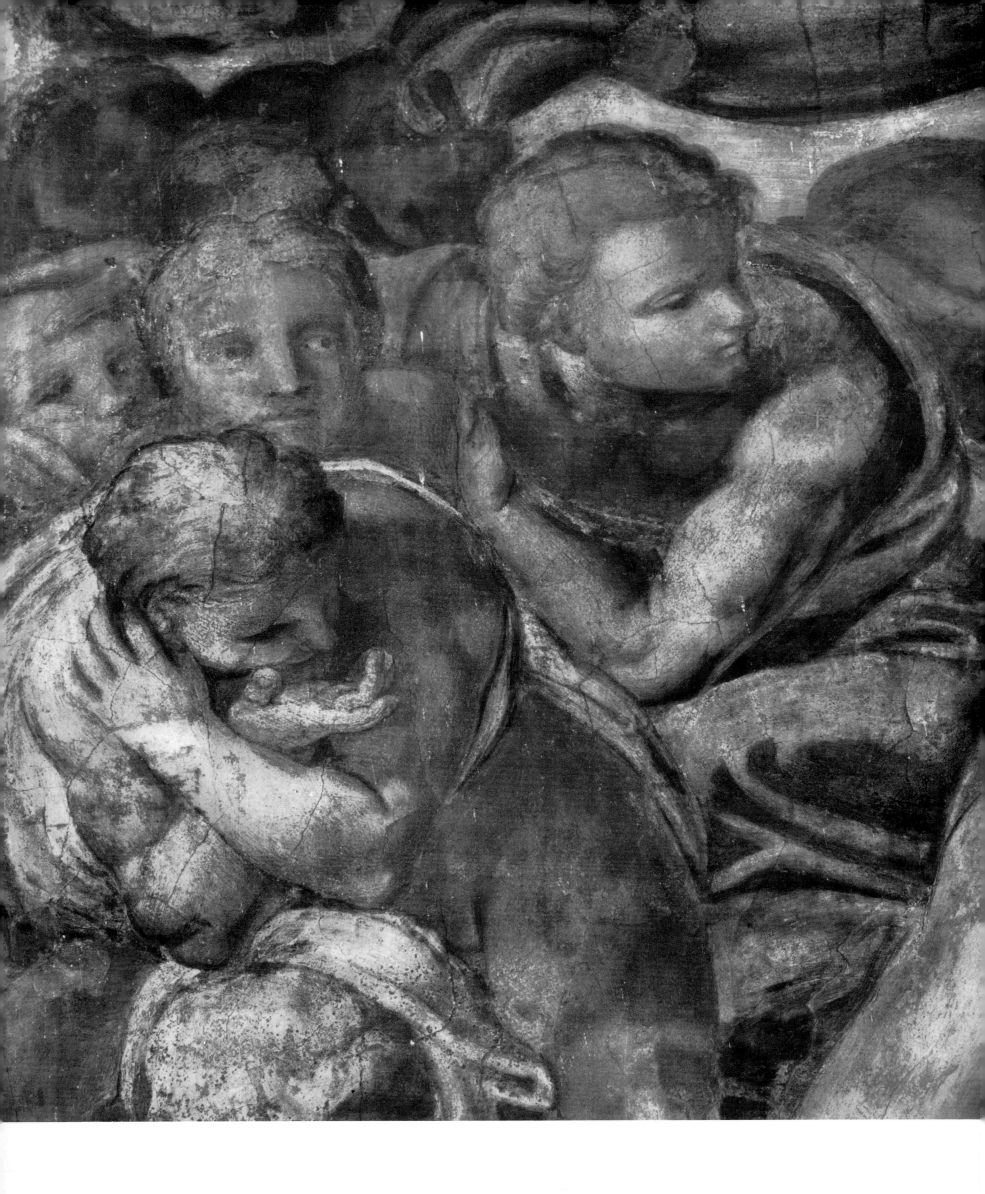

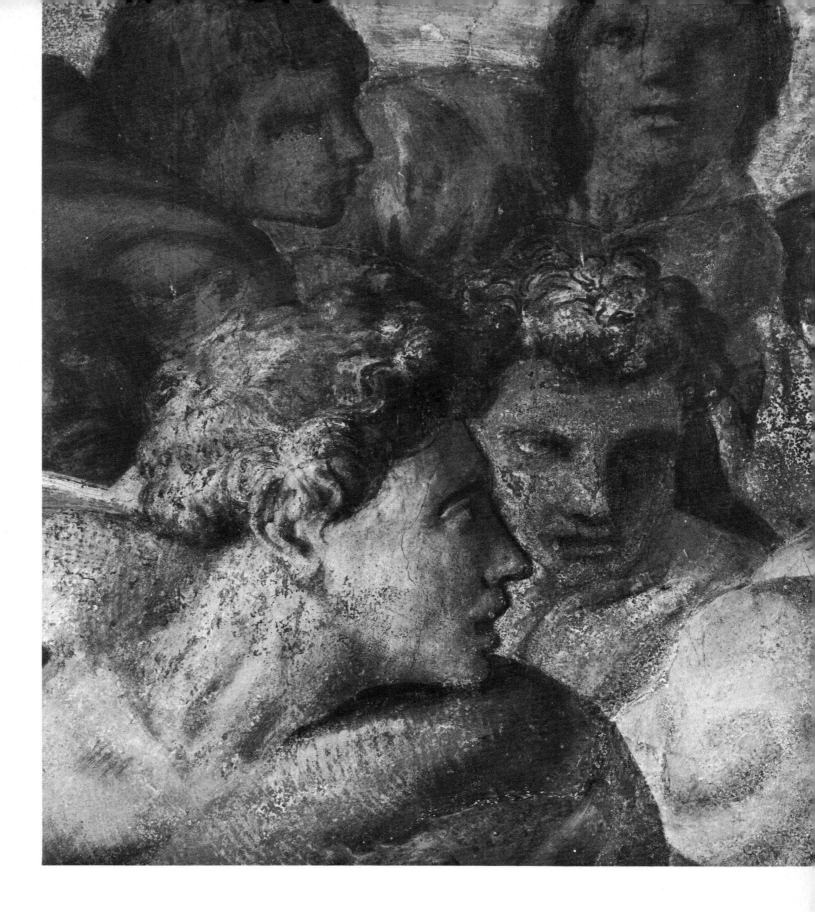

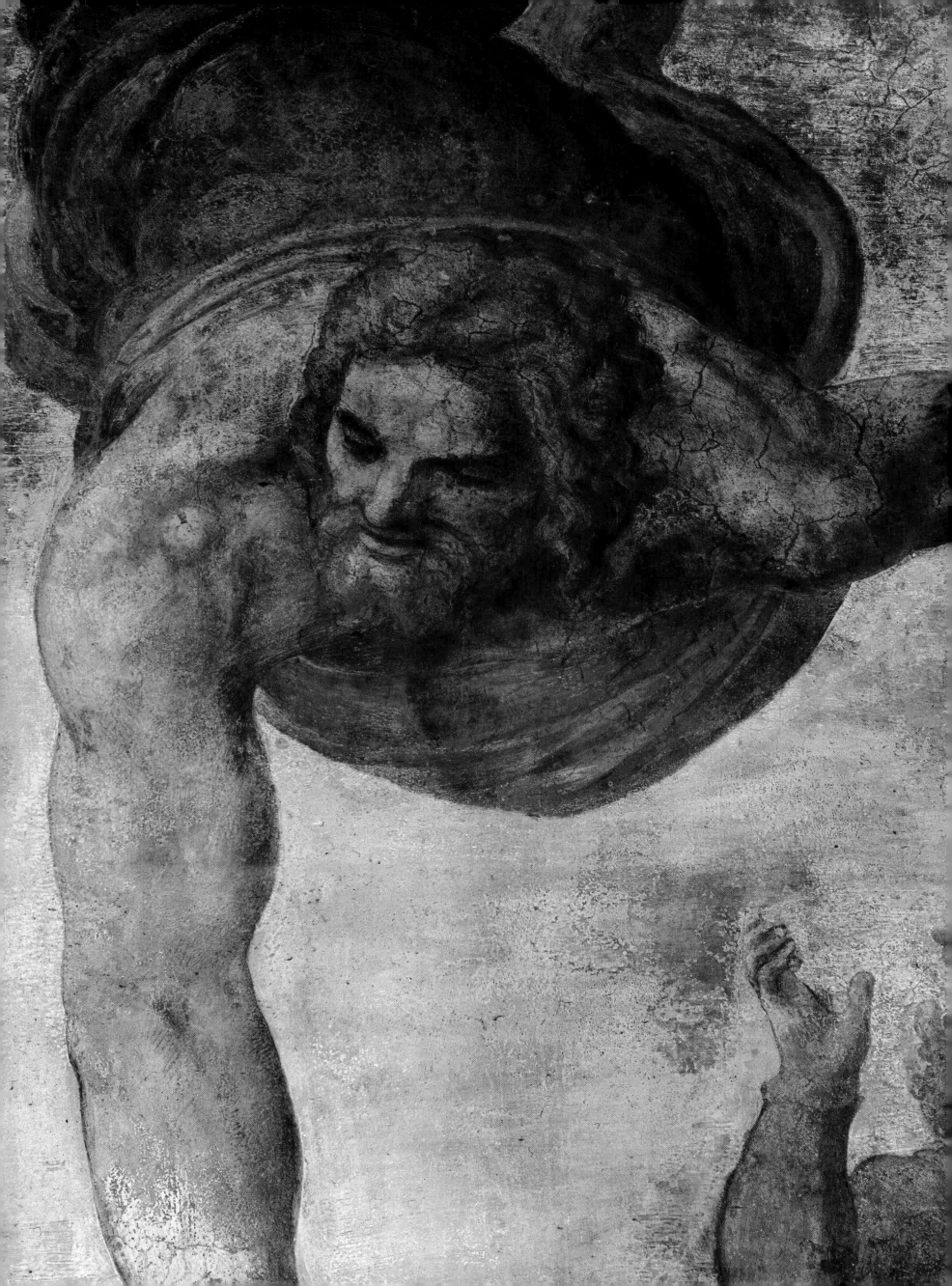

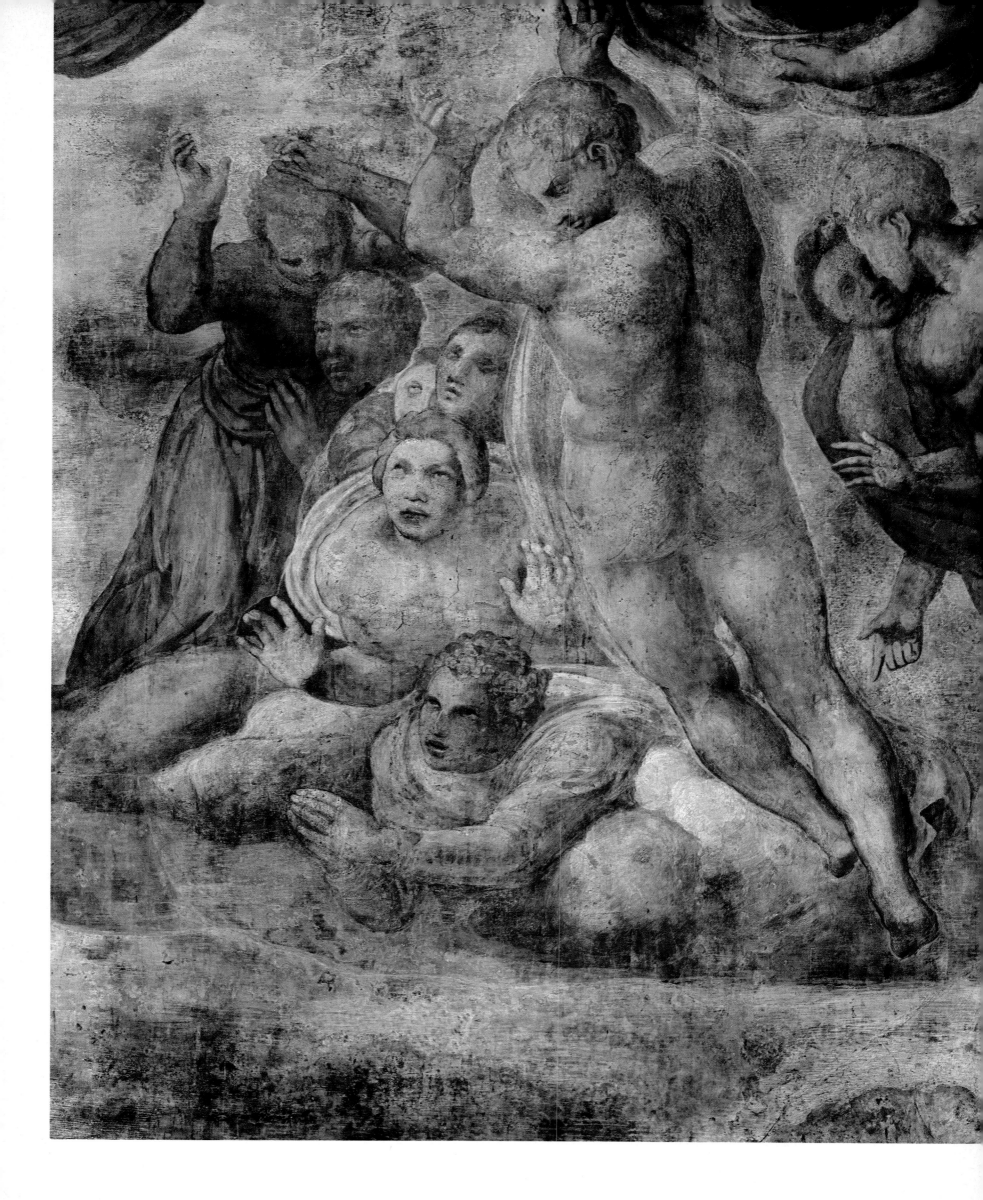

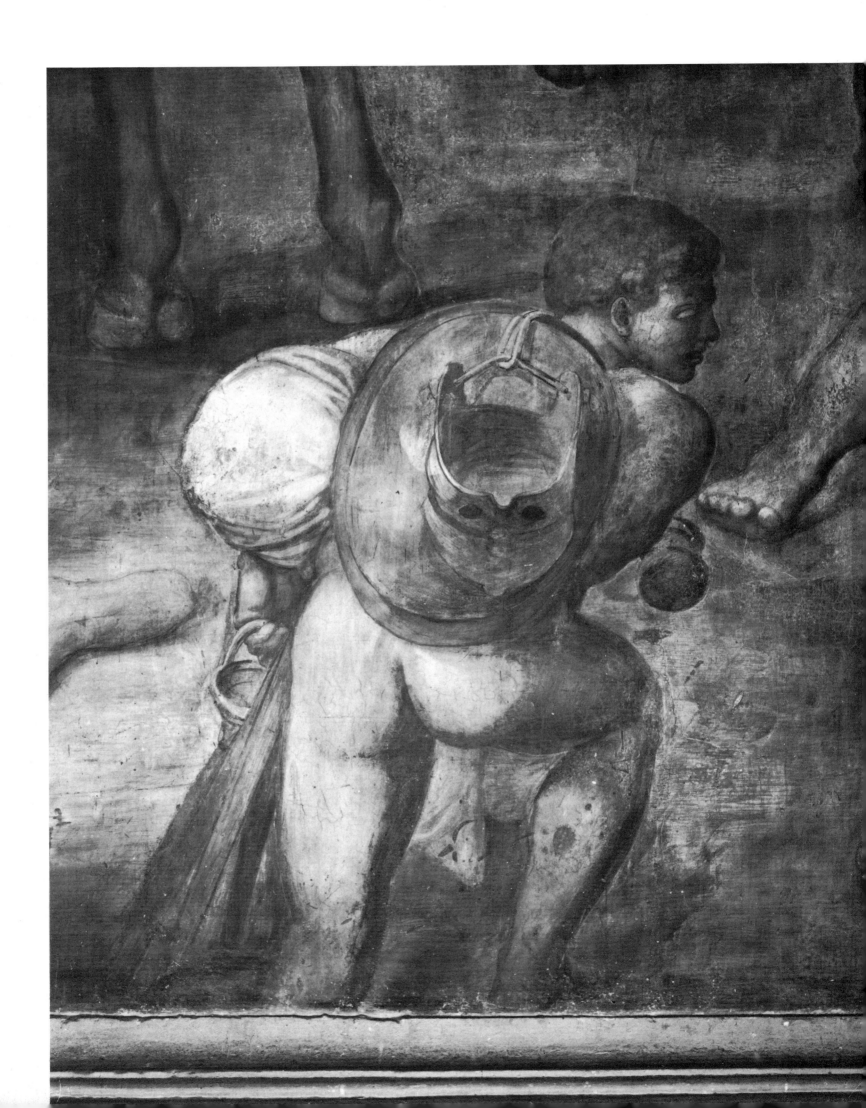

18

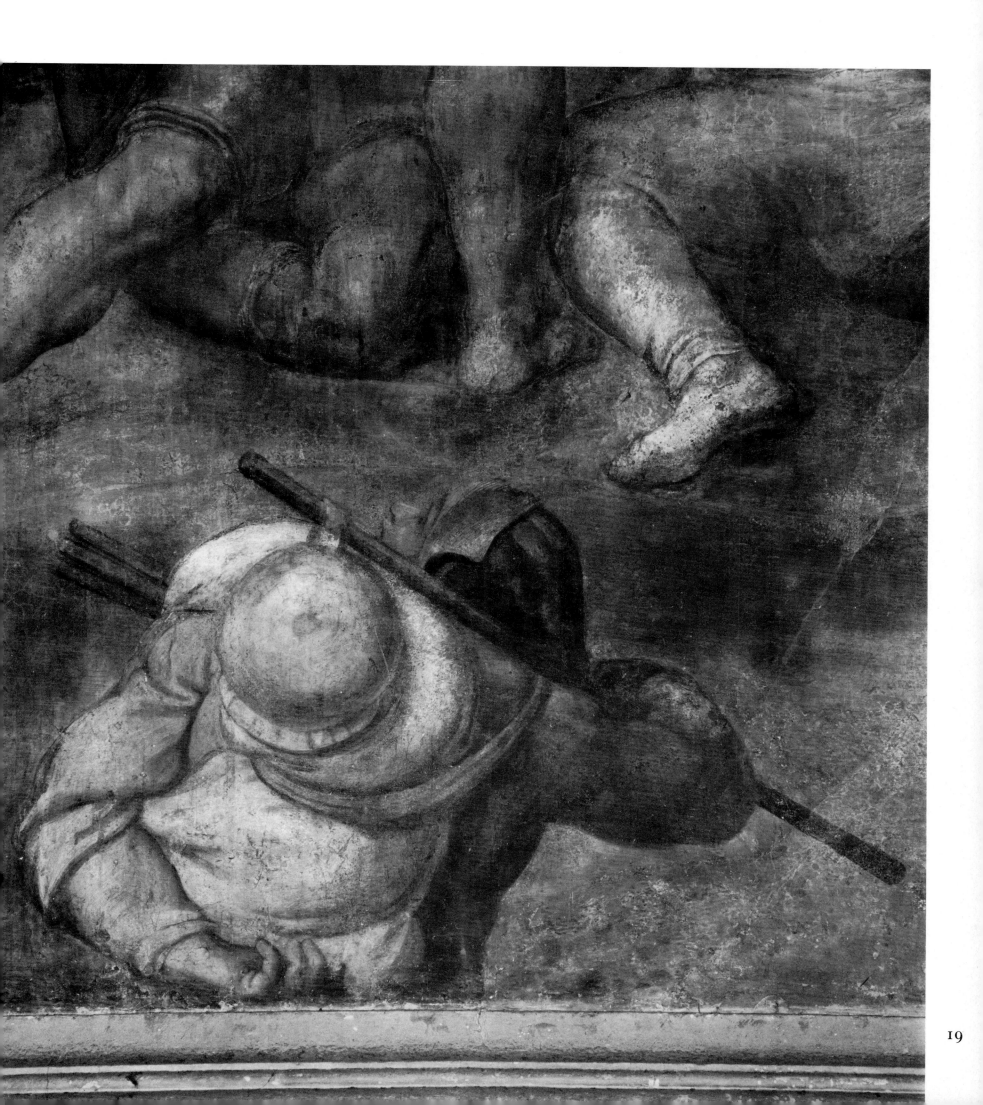

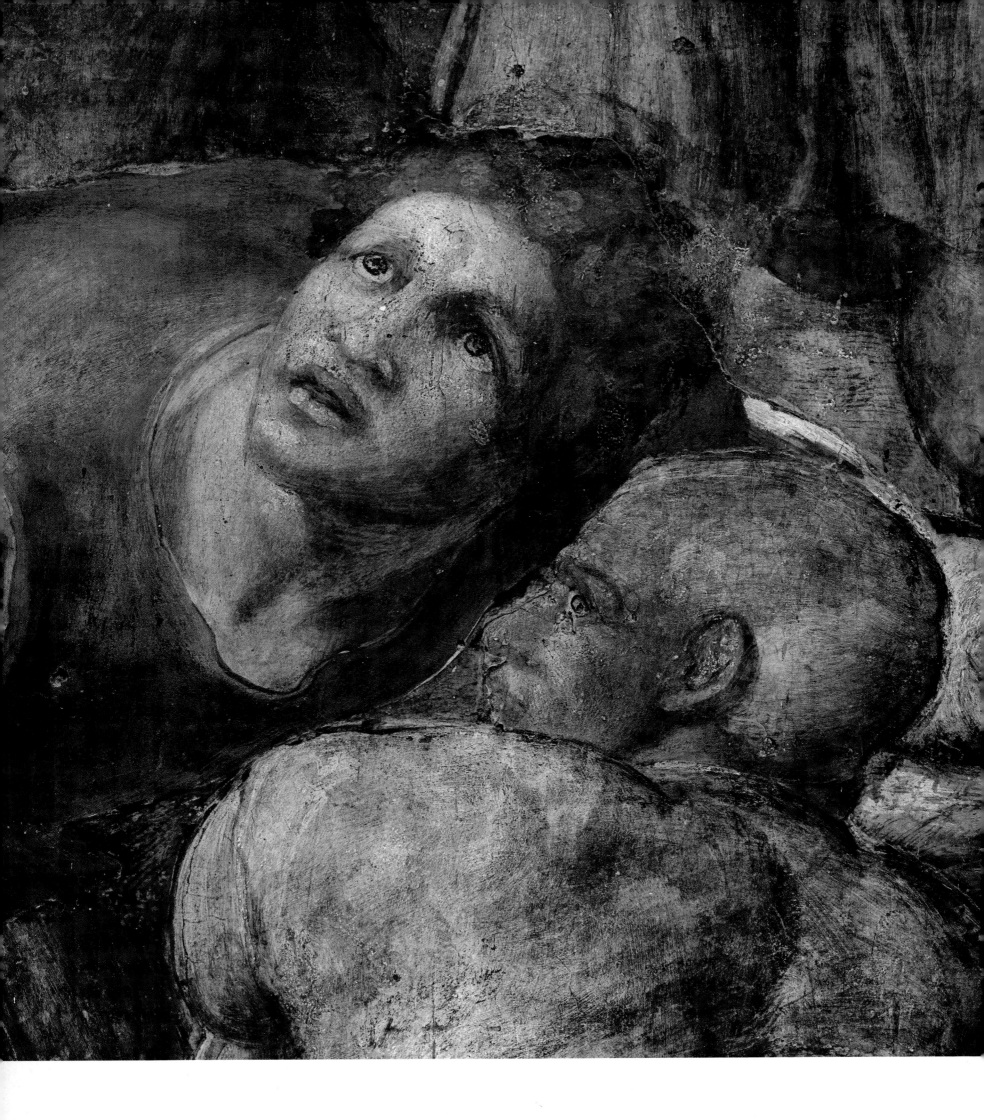

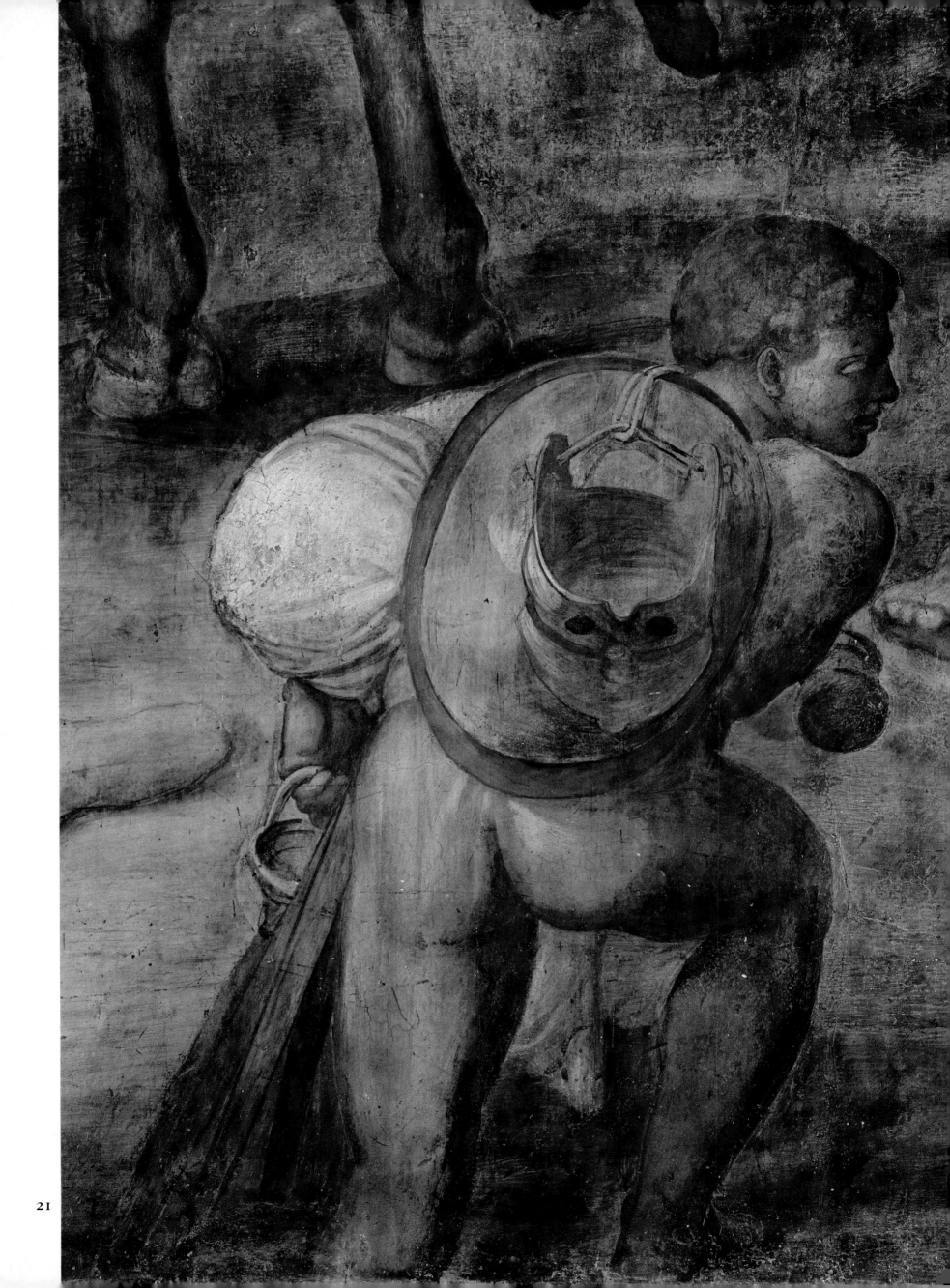

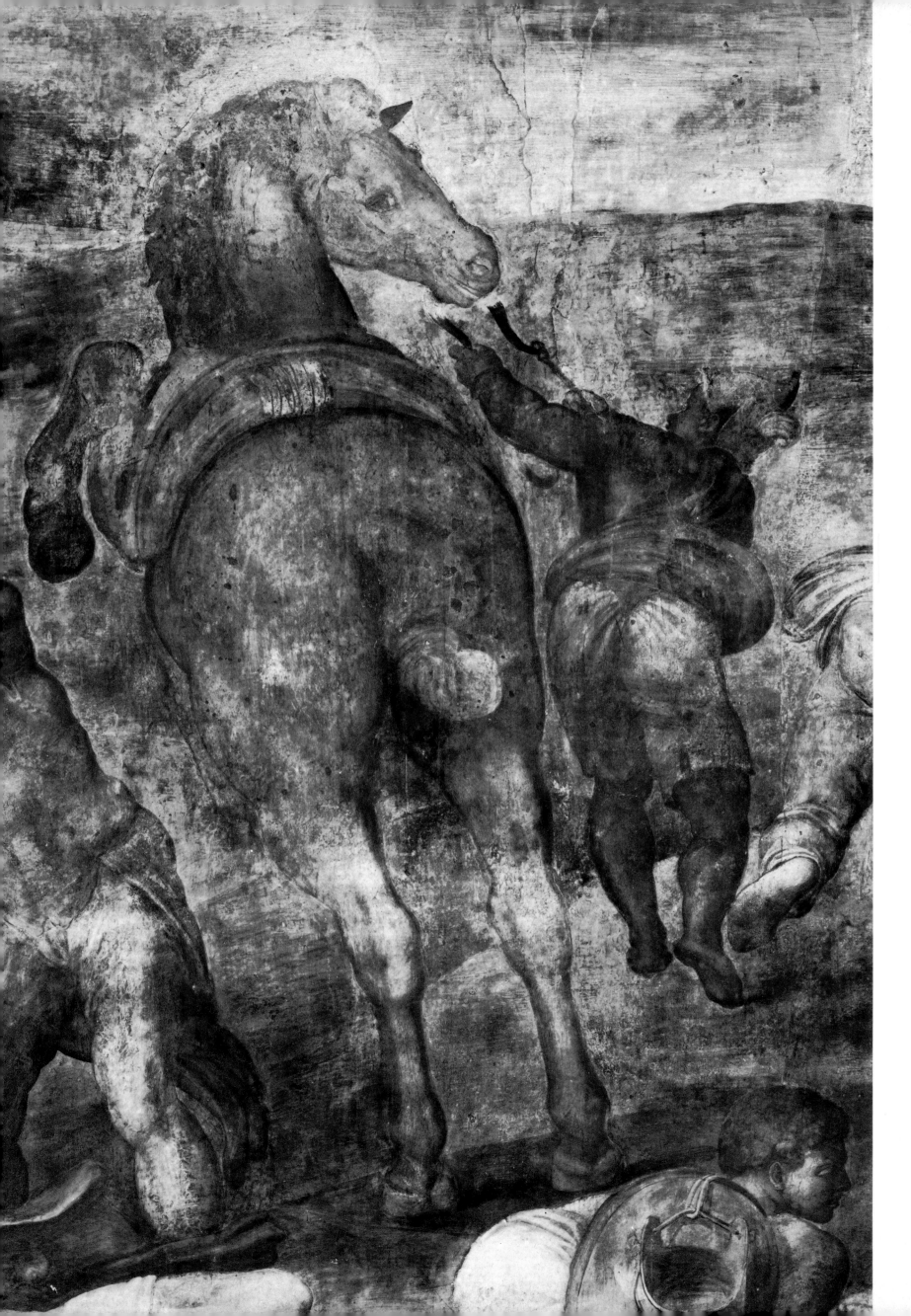

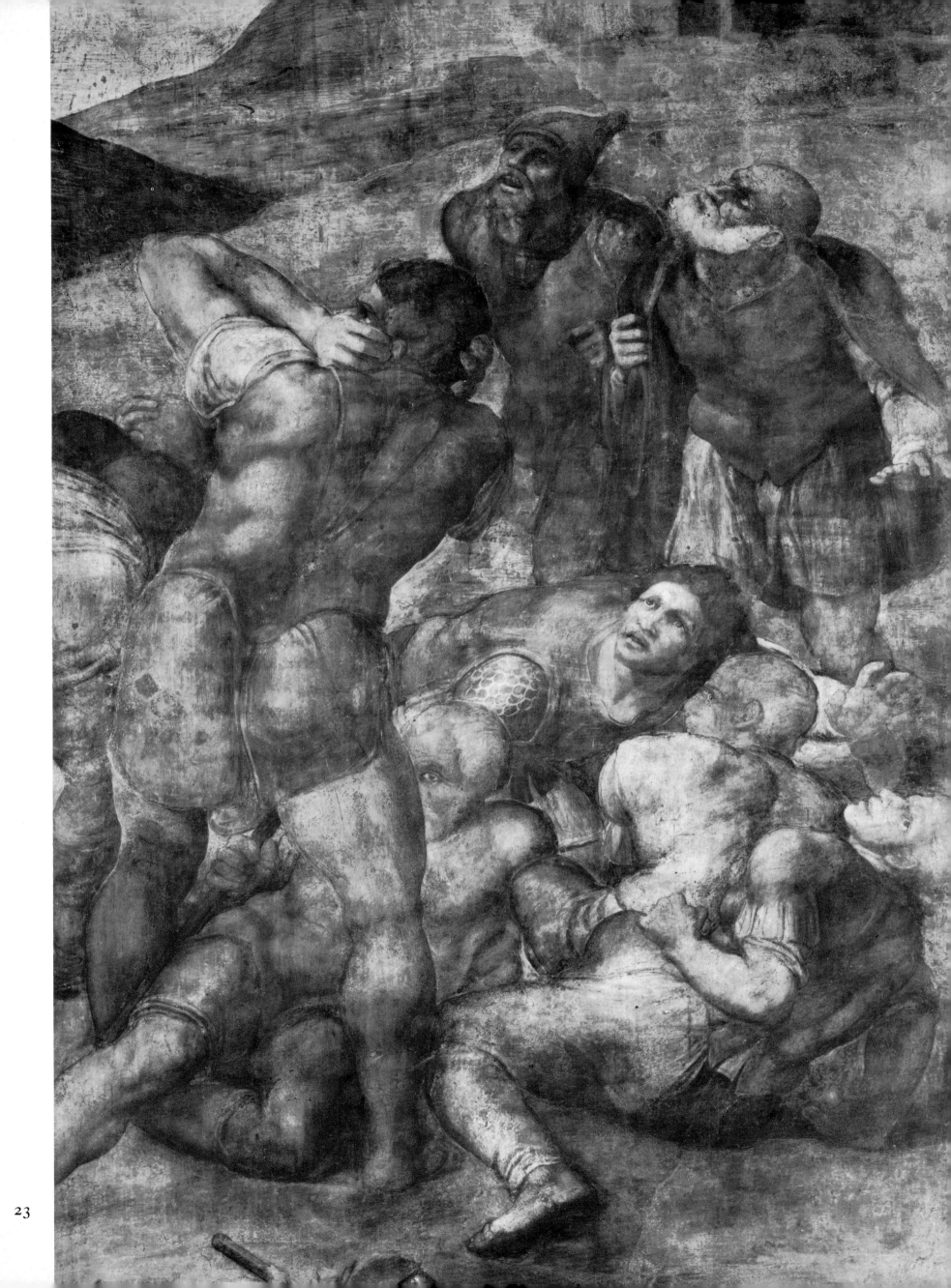

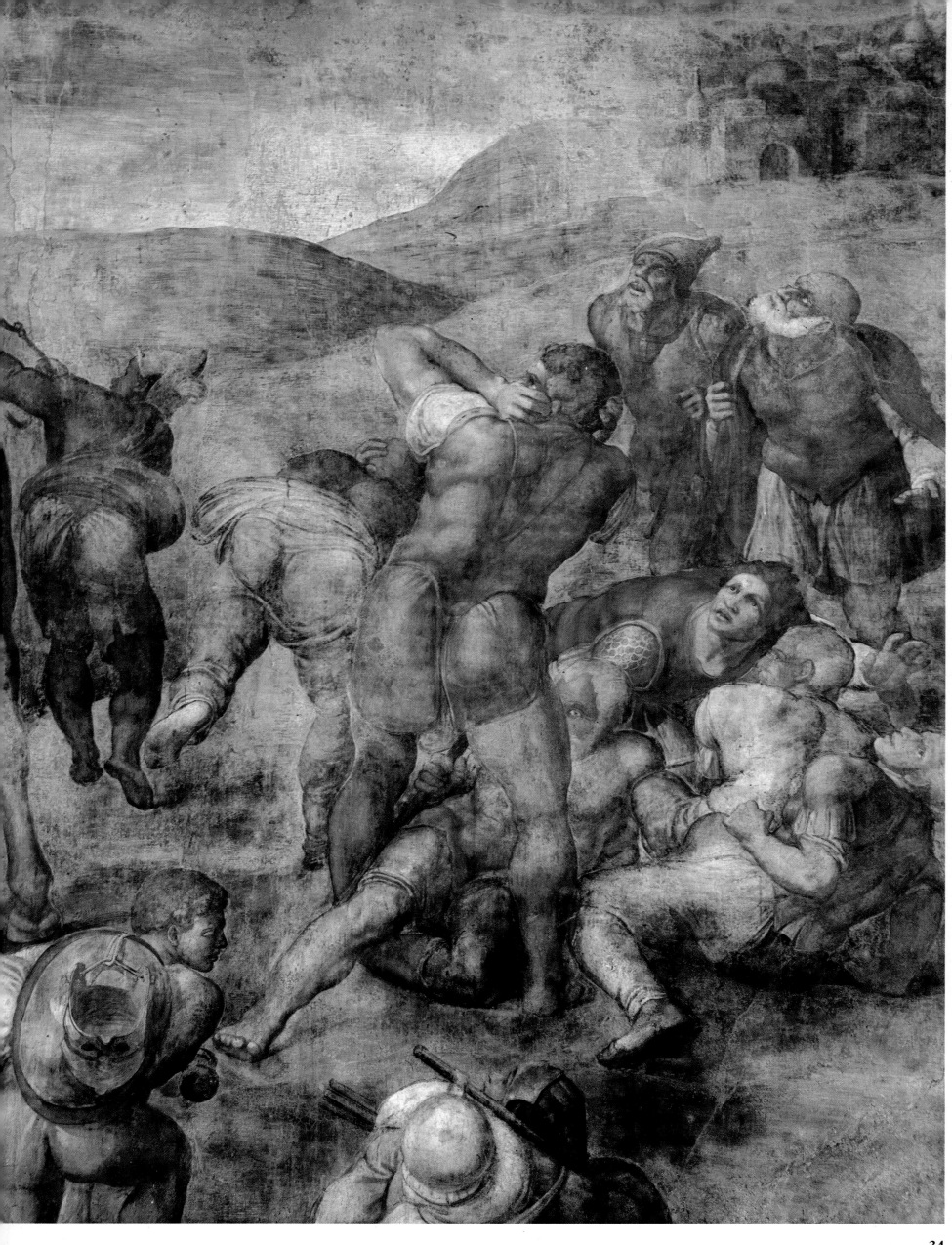

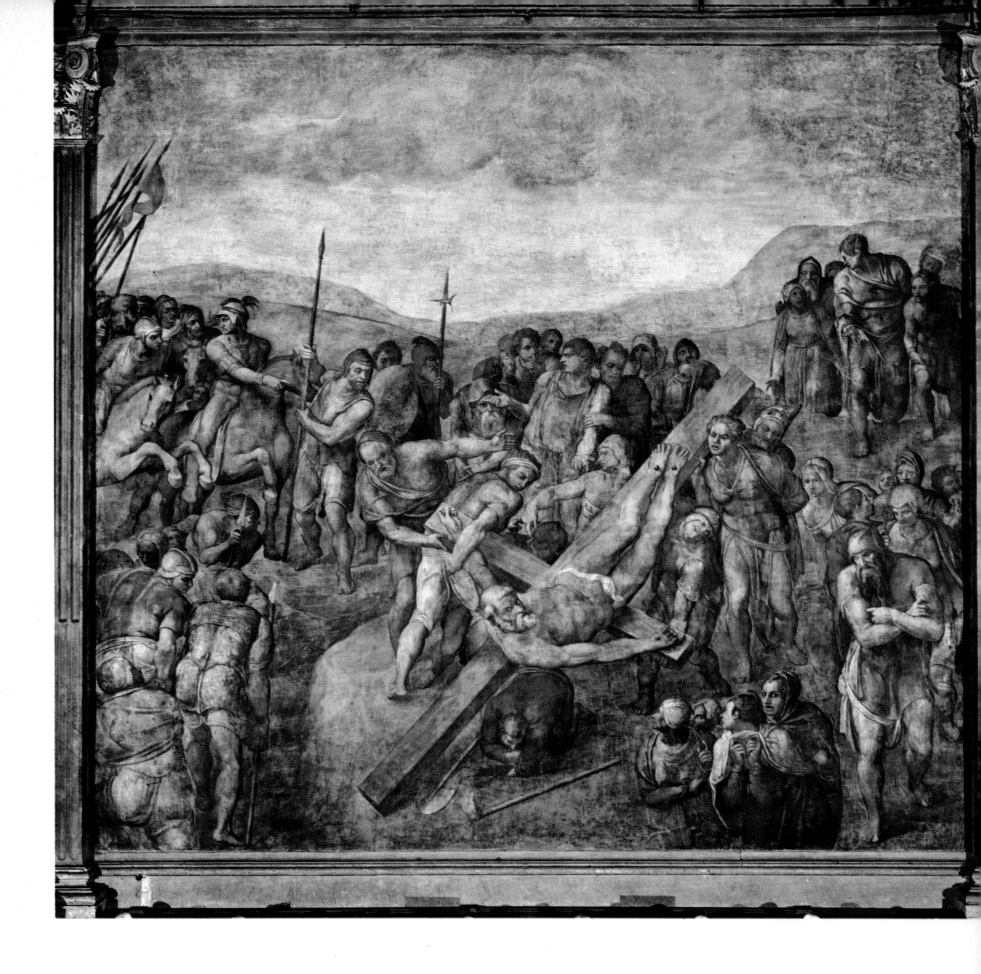

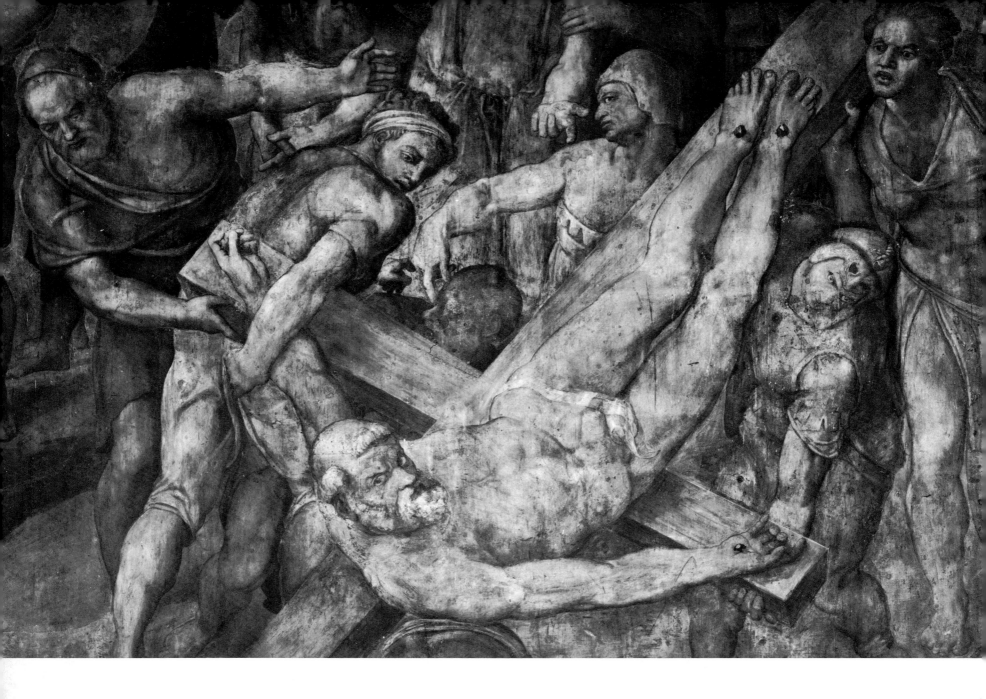

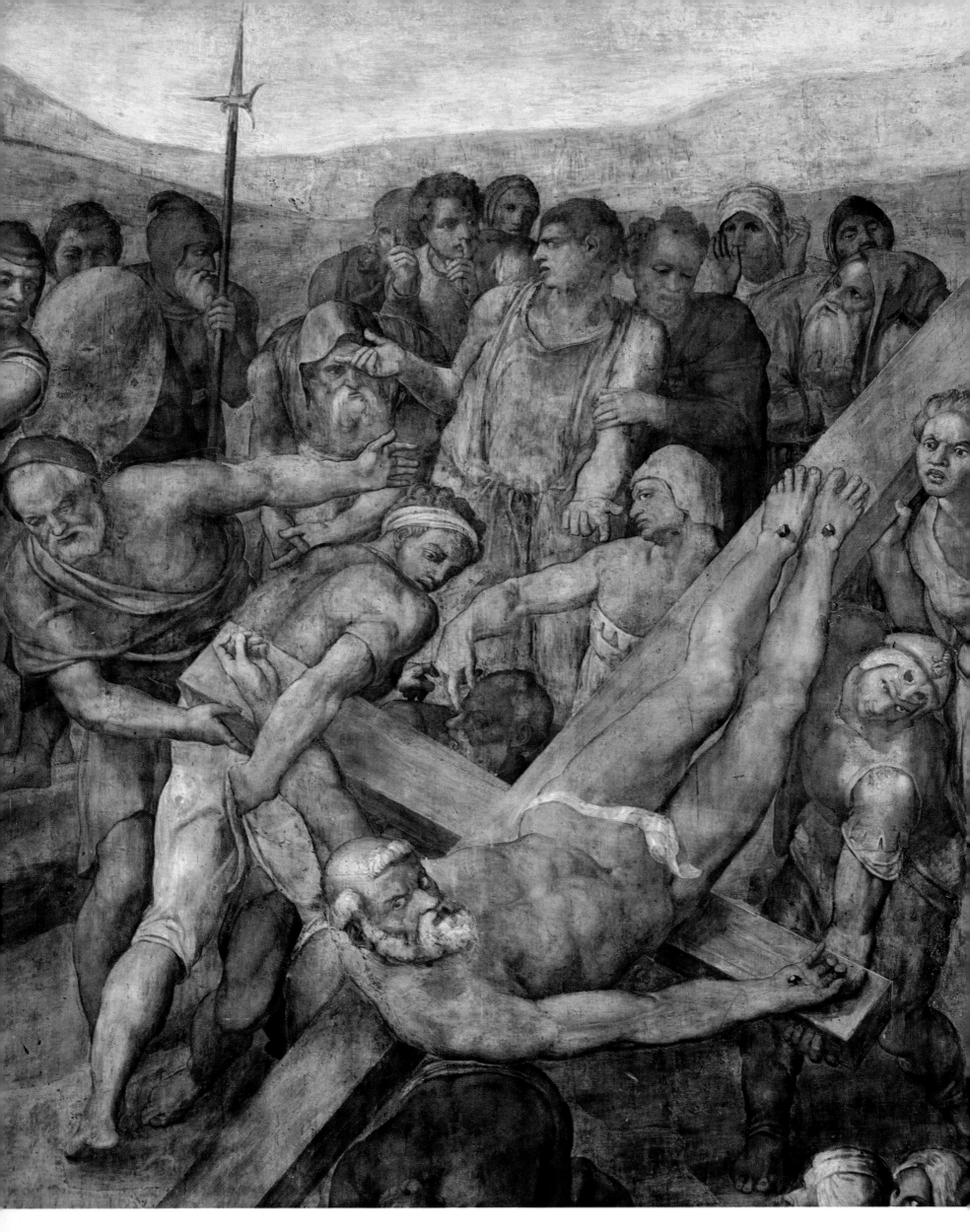

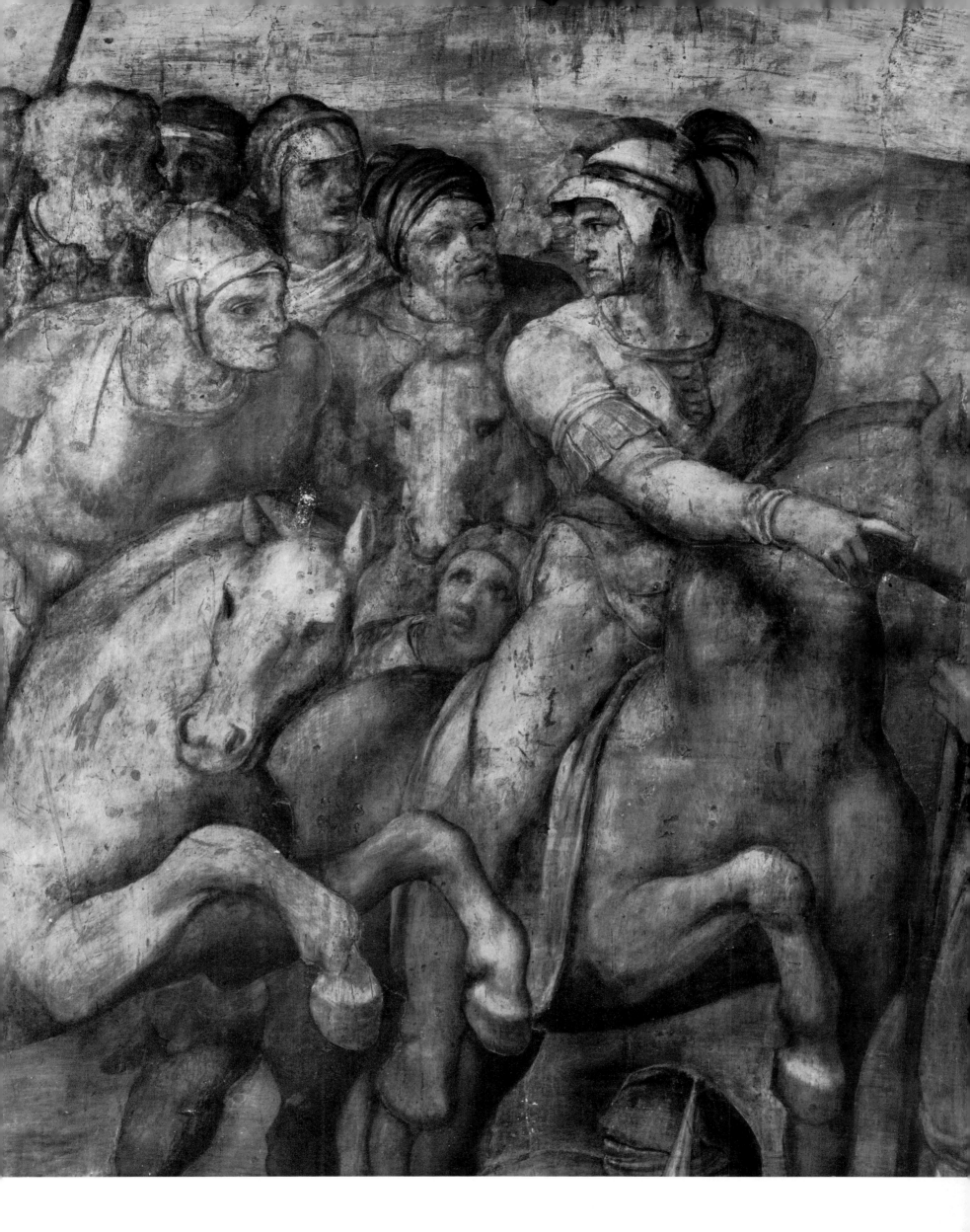

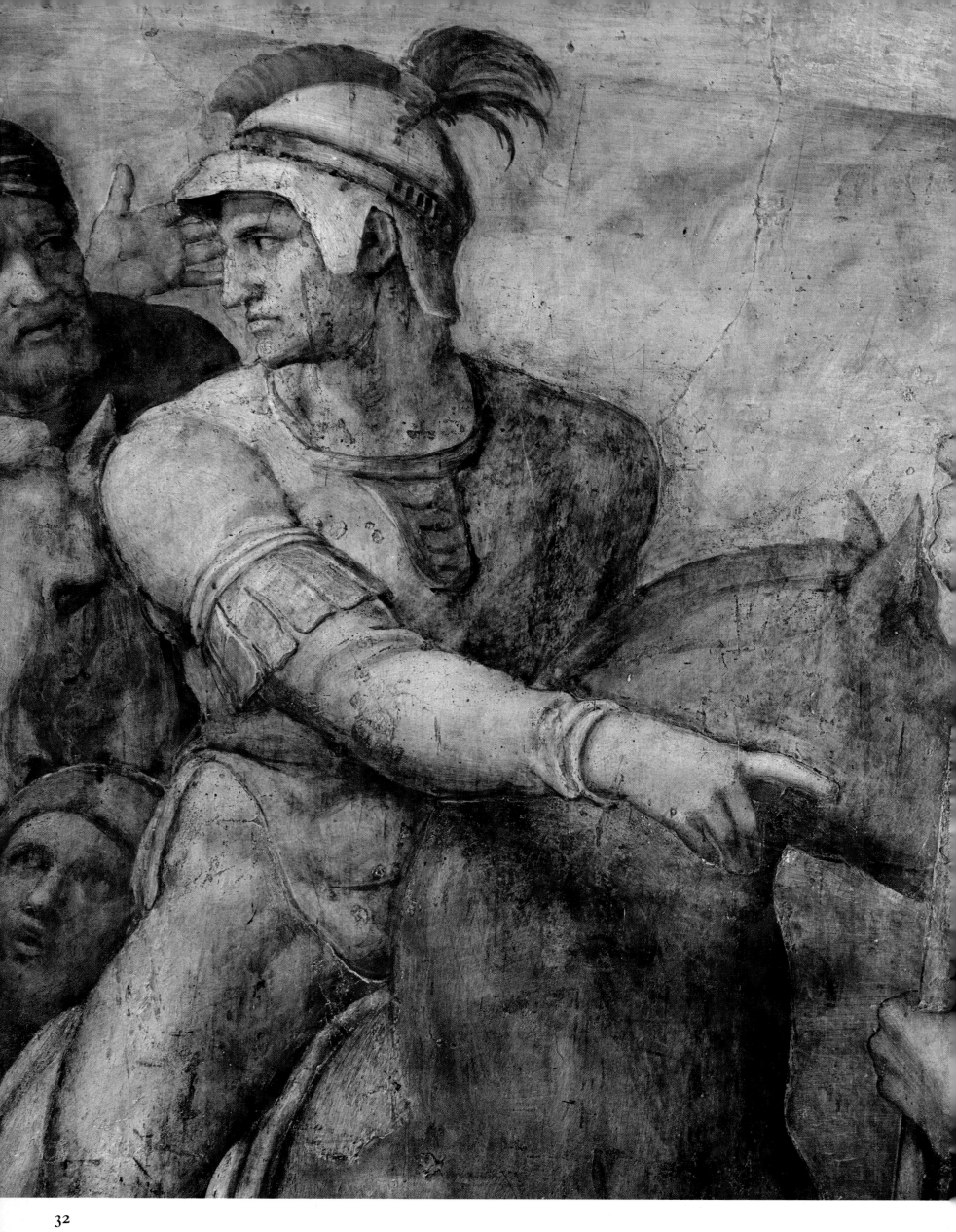

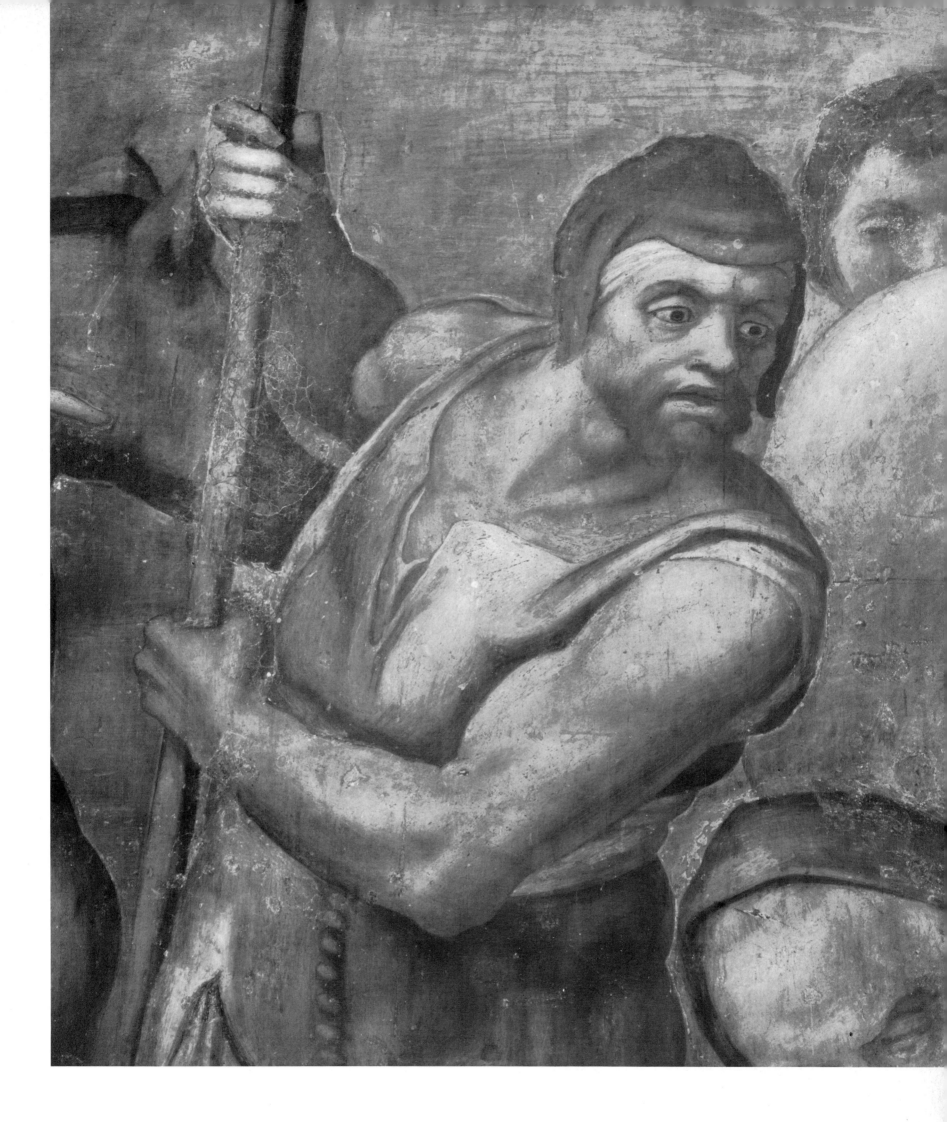

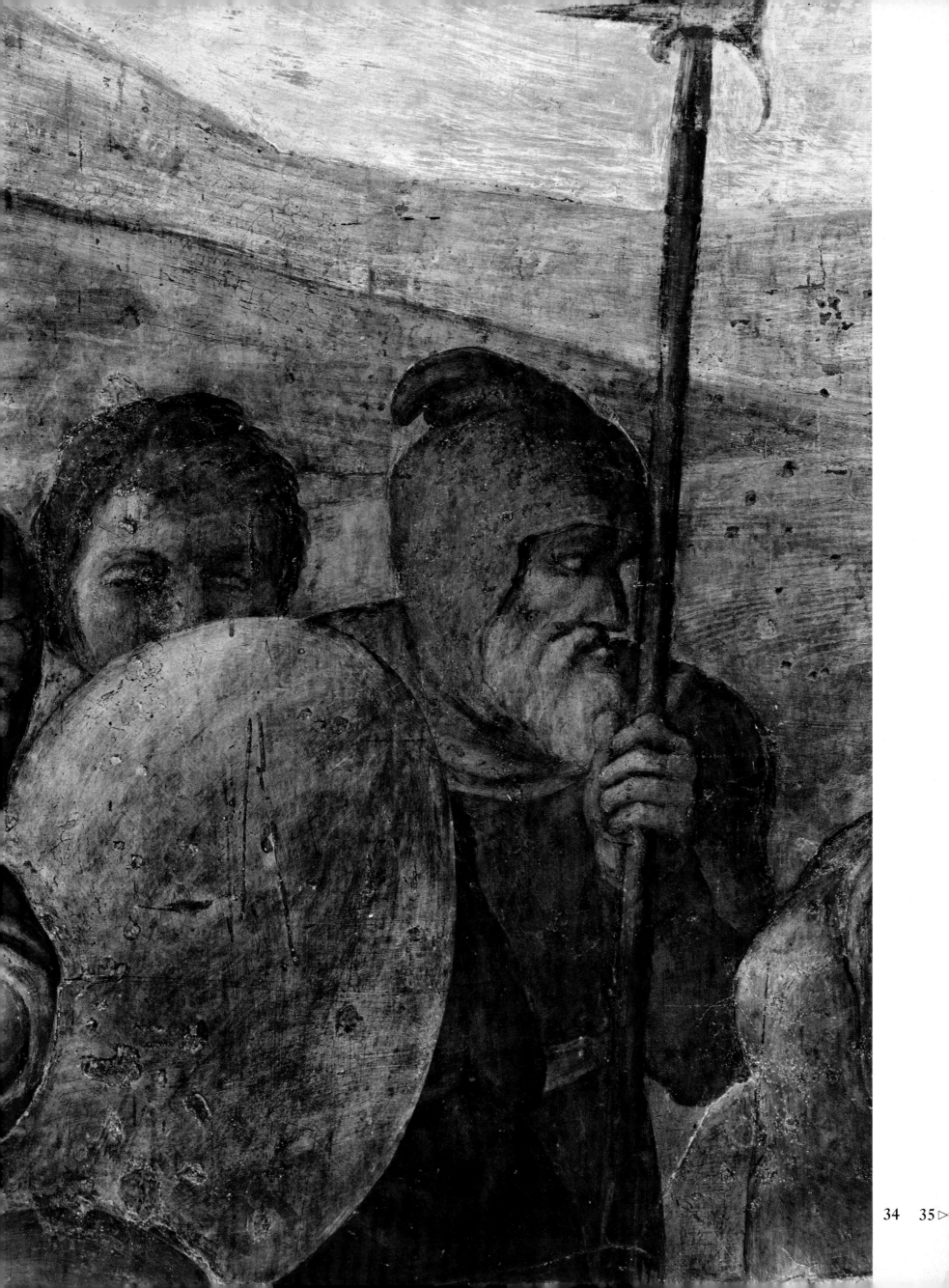

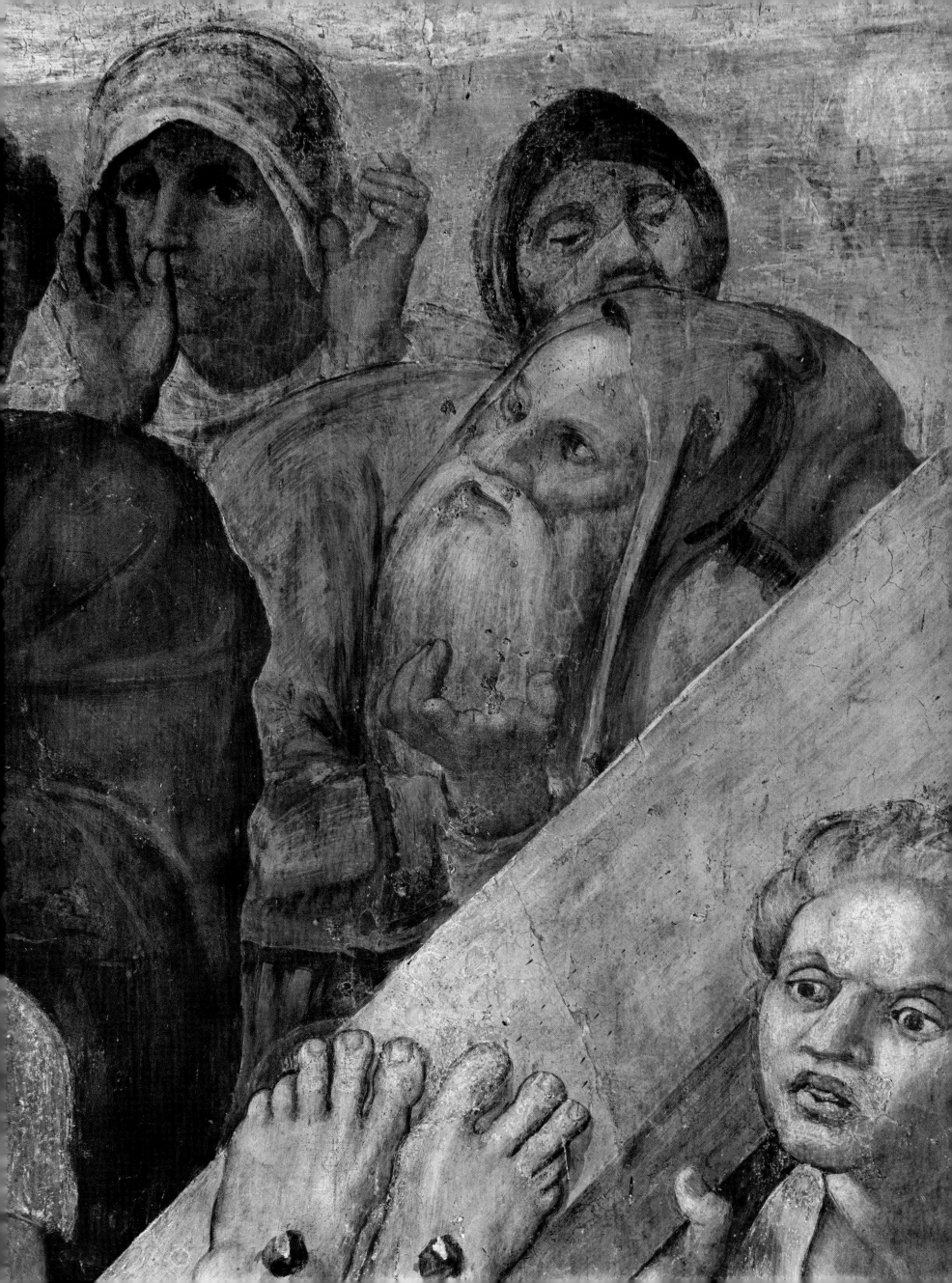

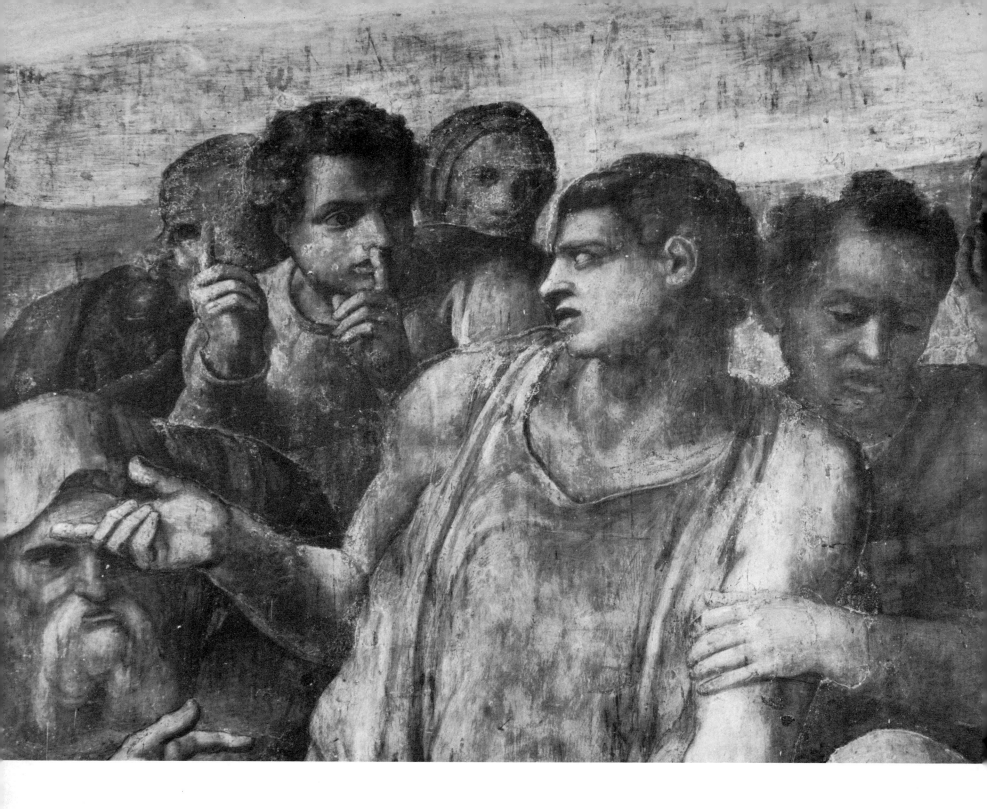

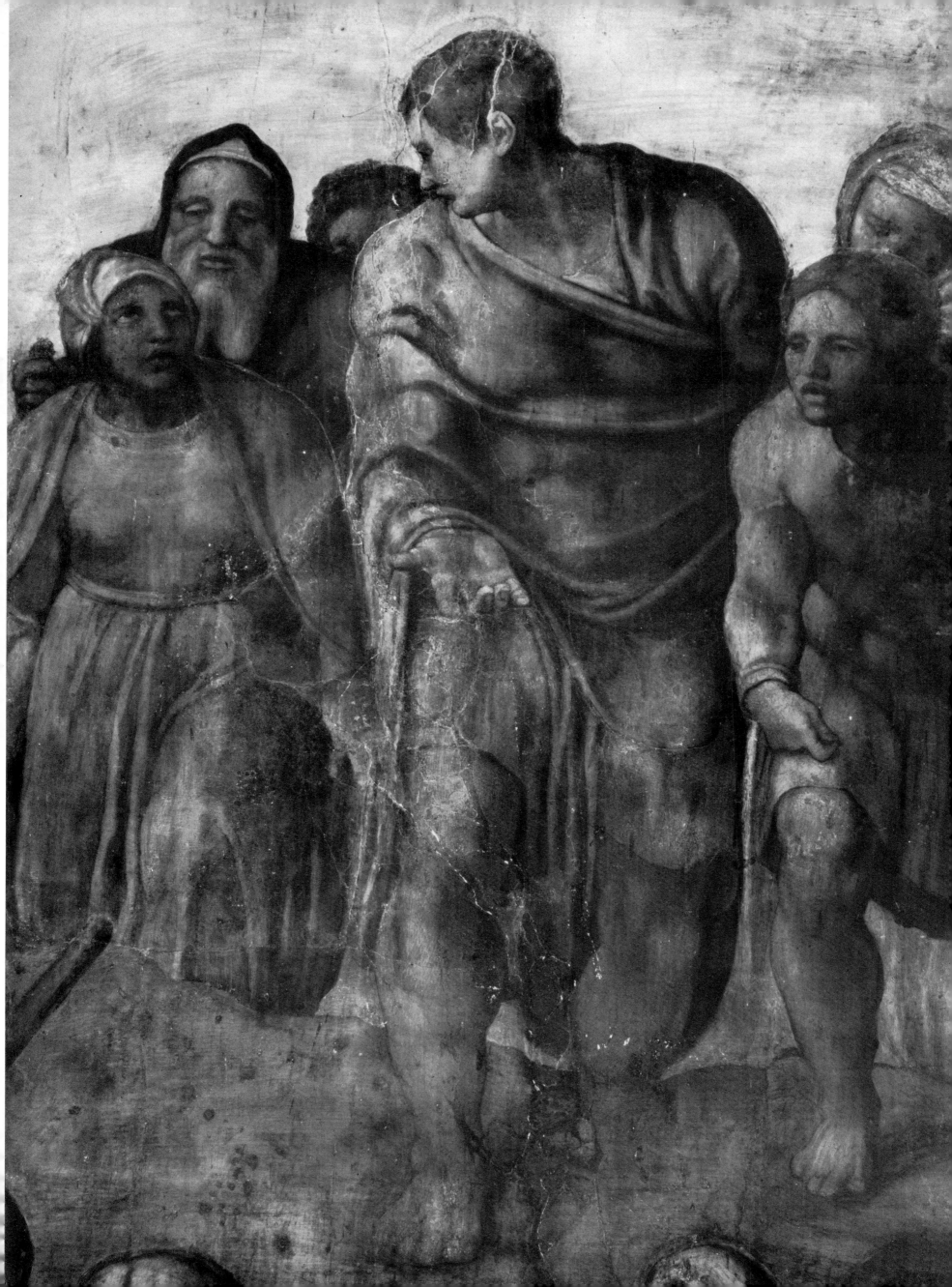

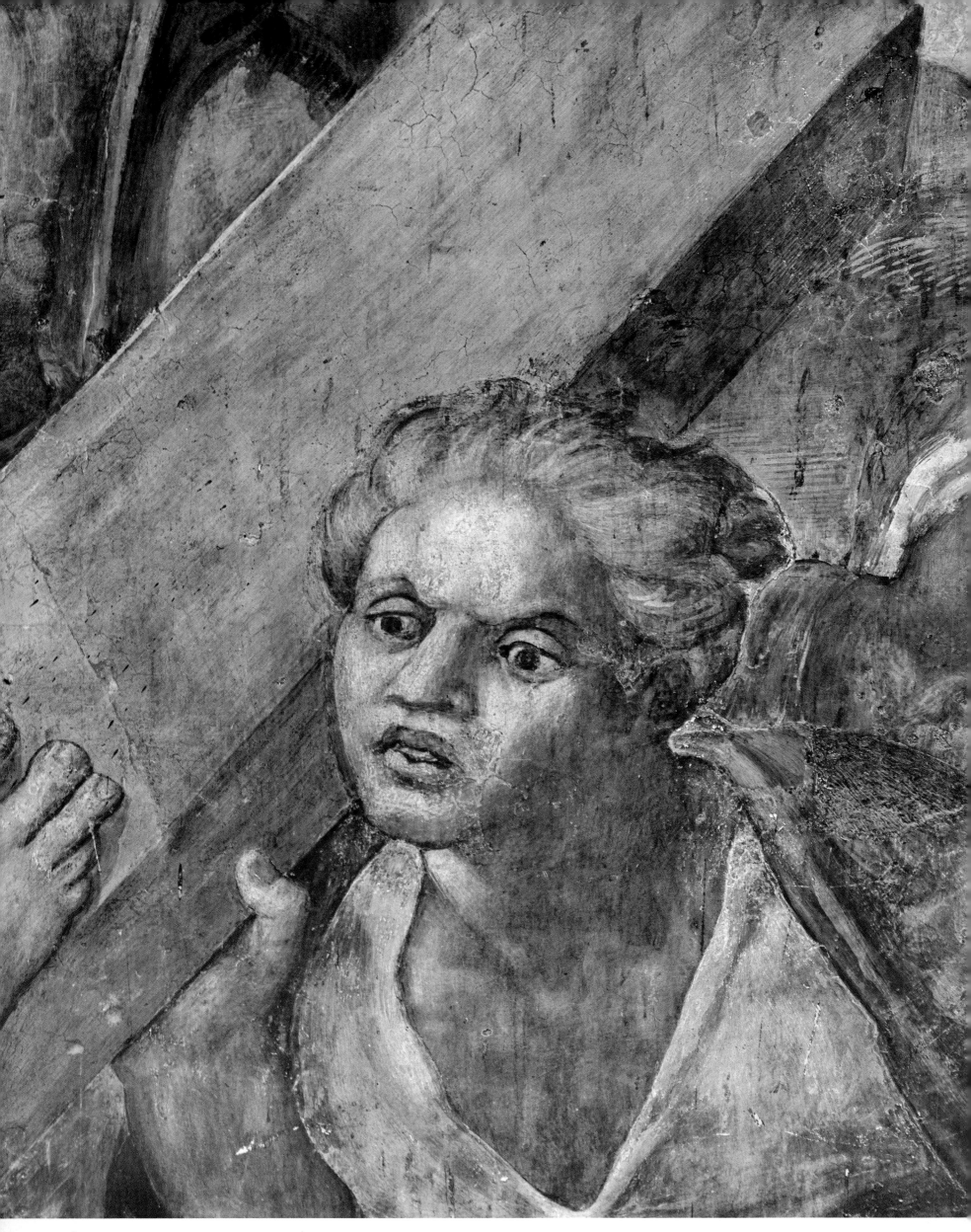

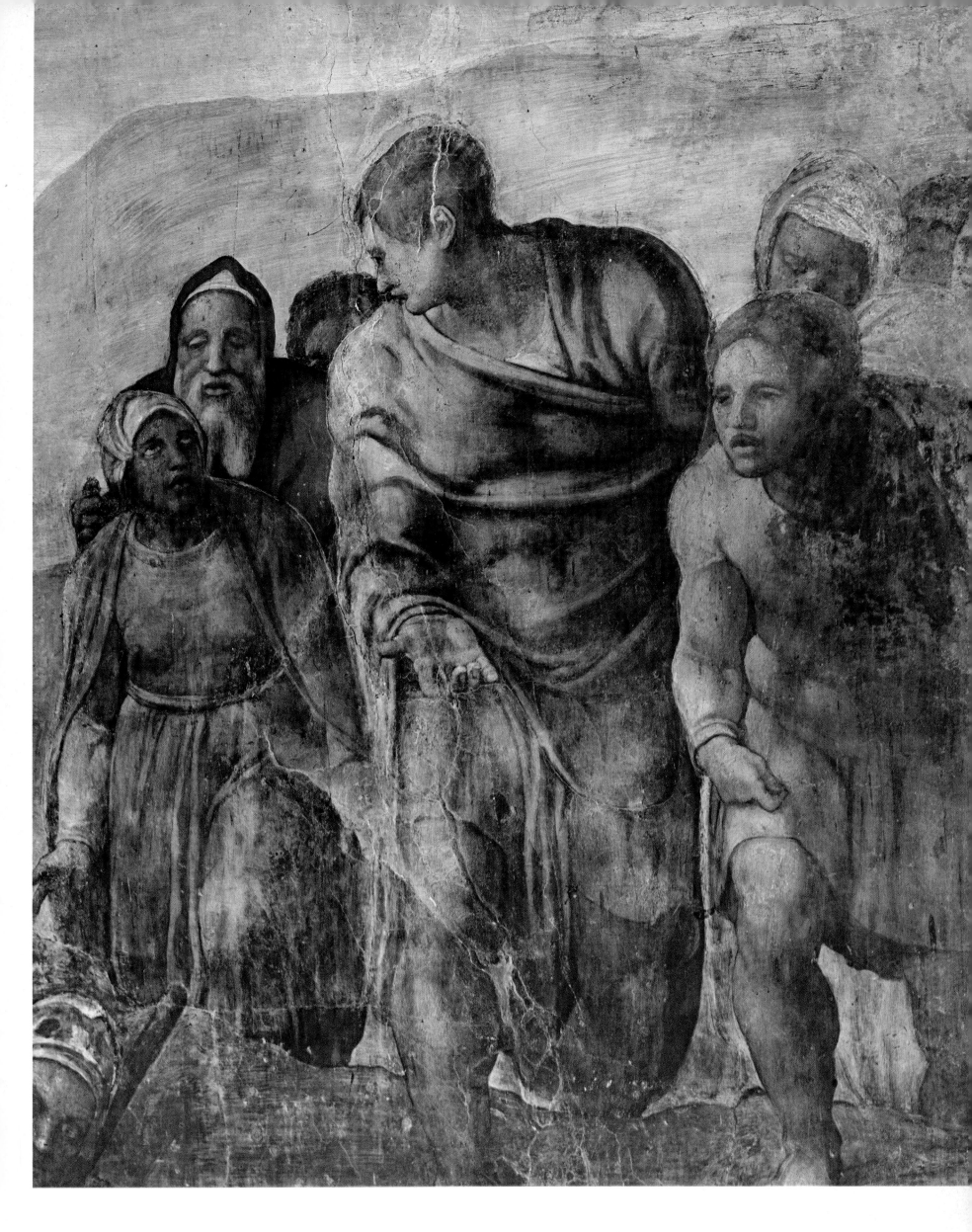

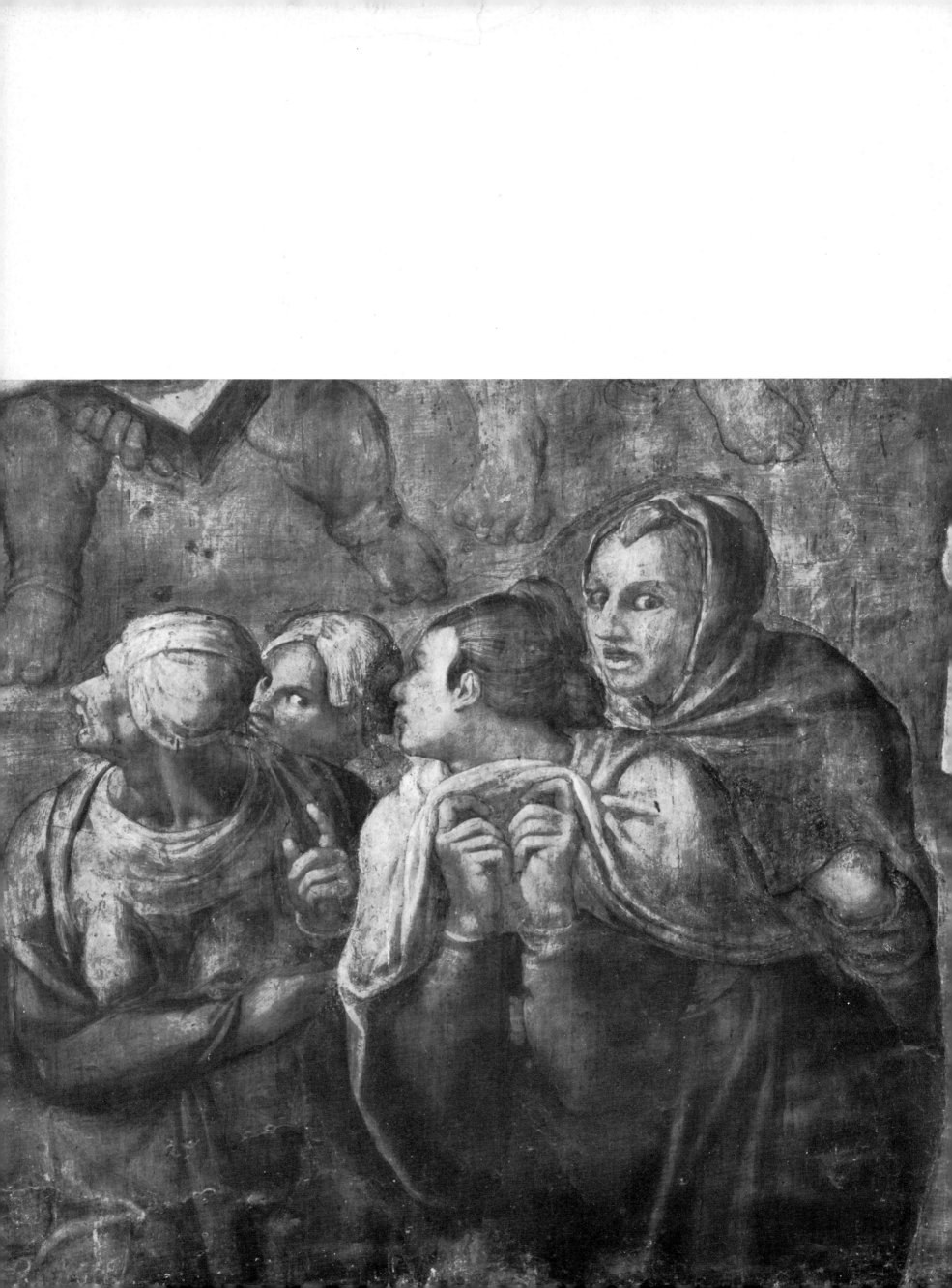

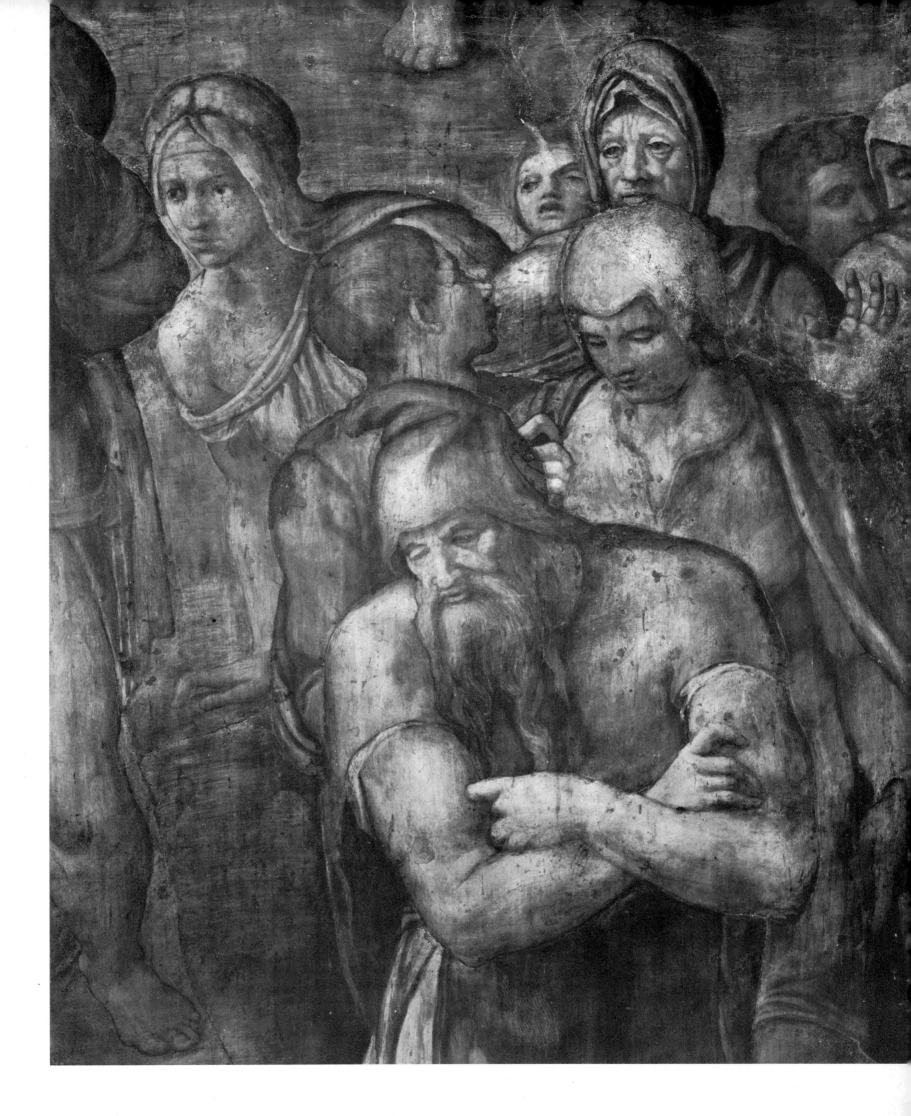

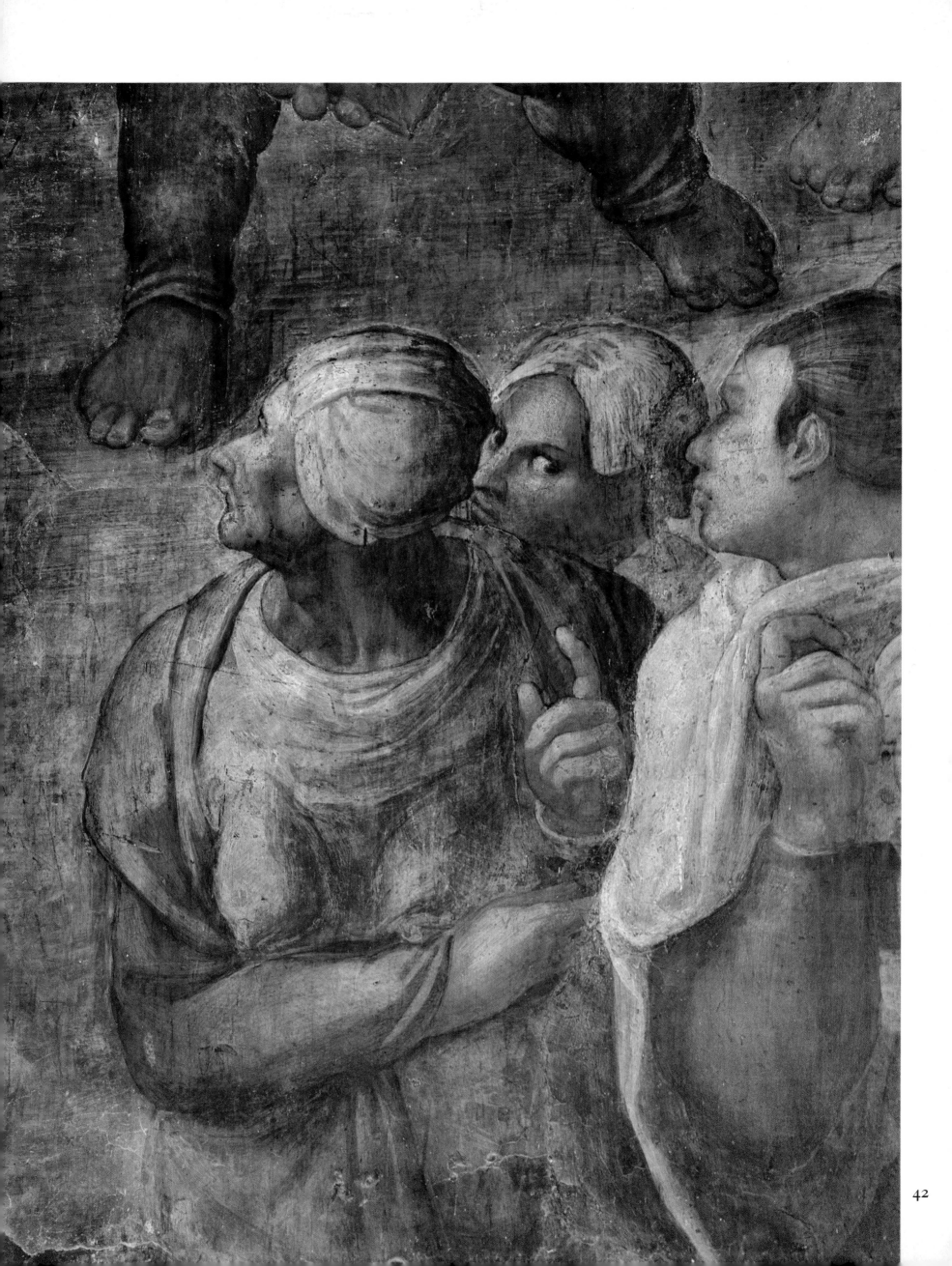

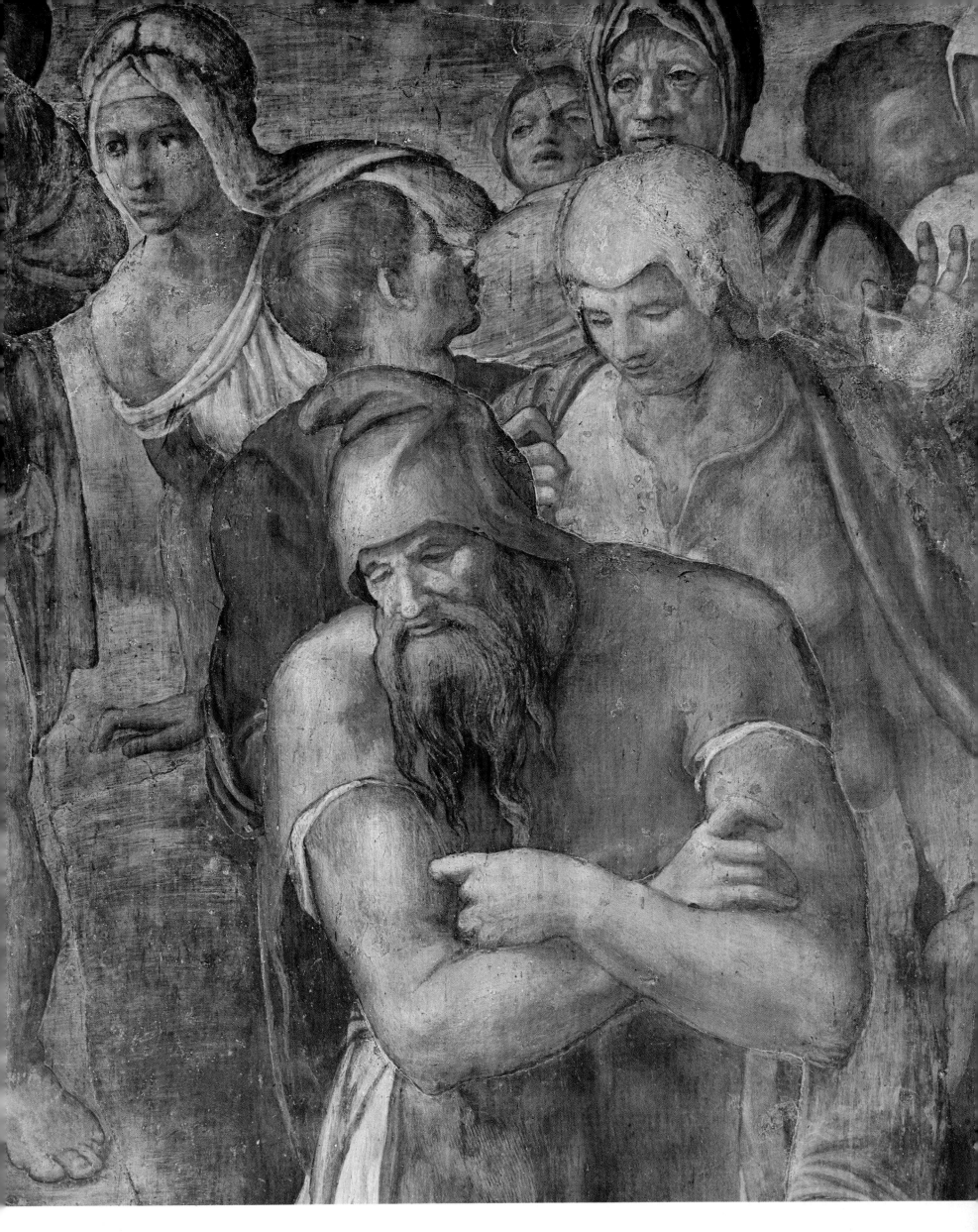

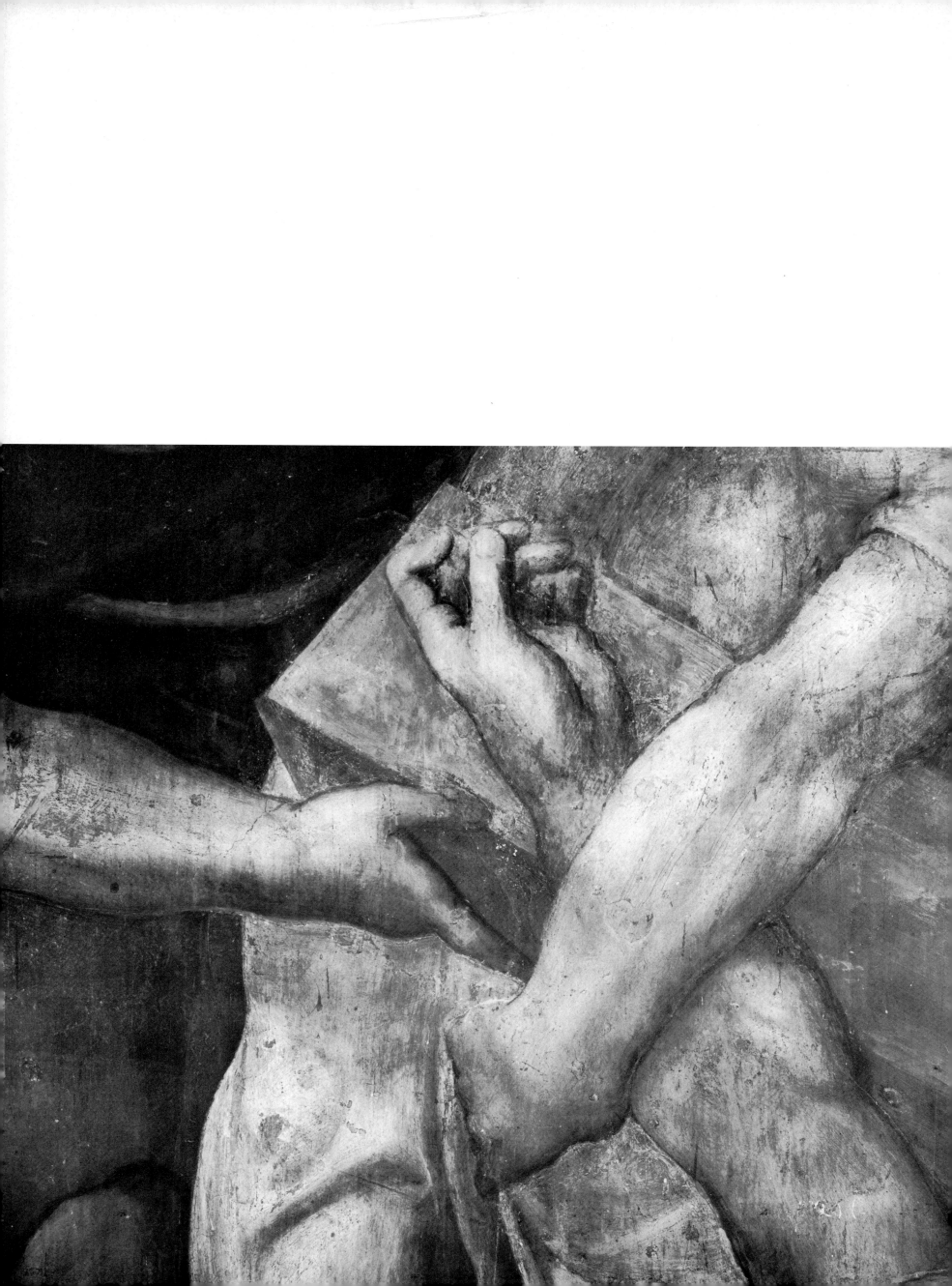

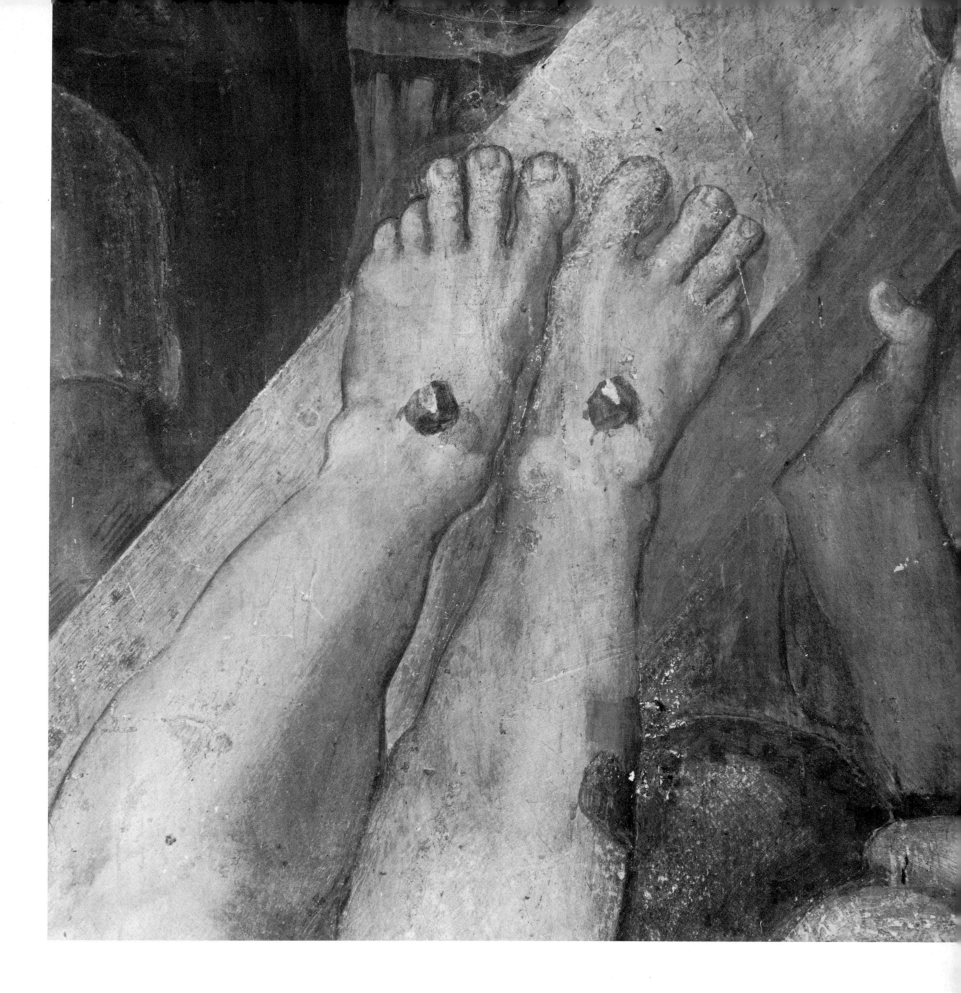

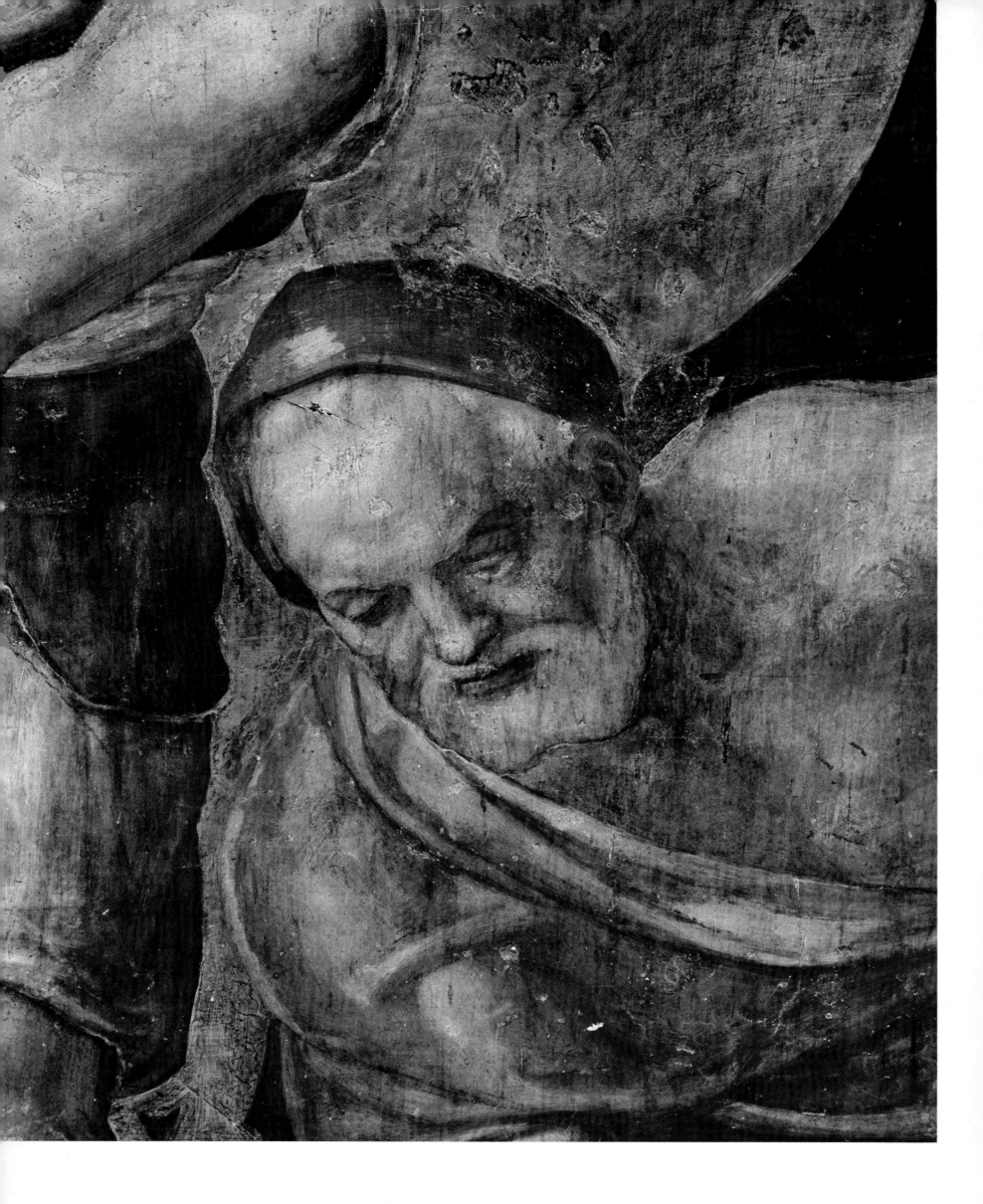

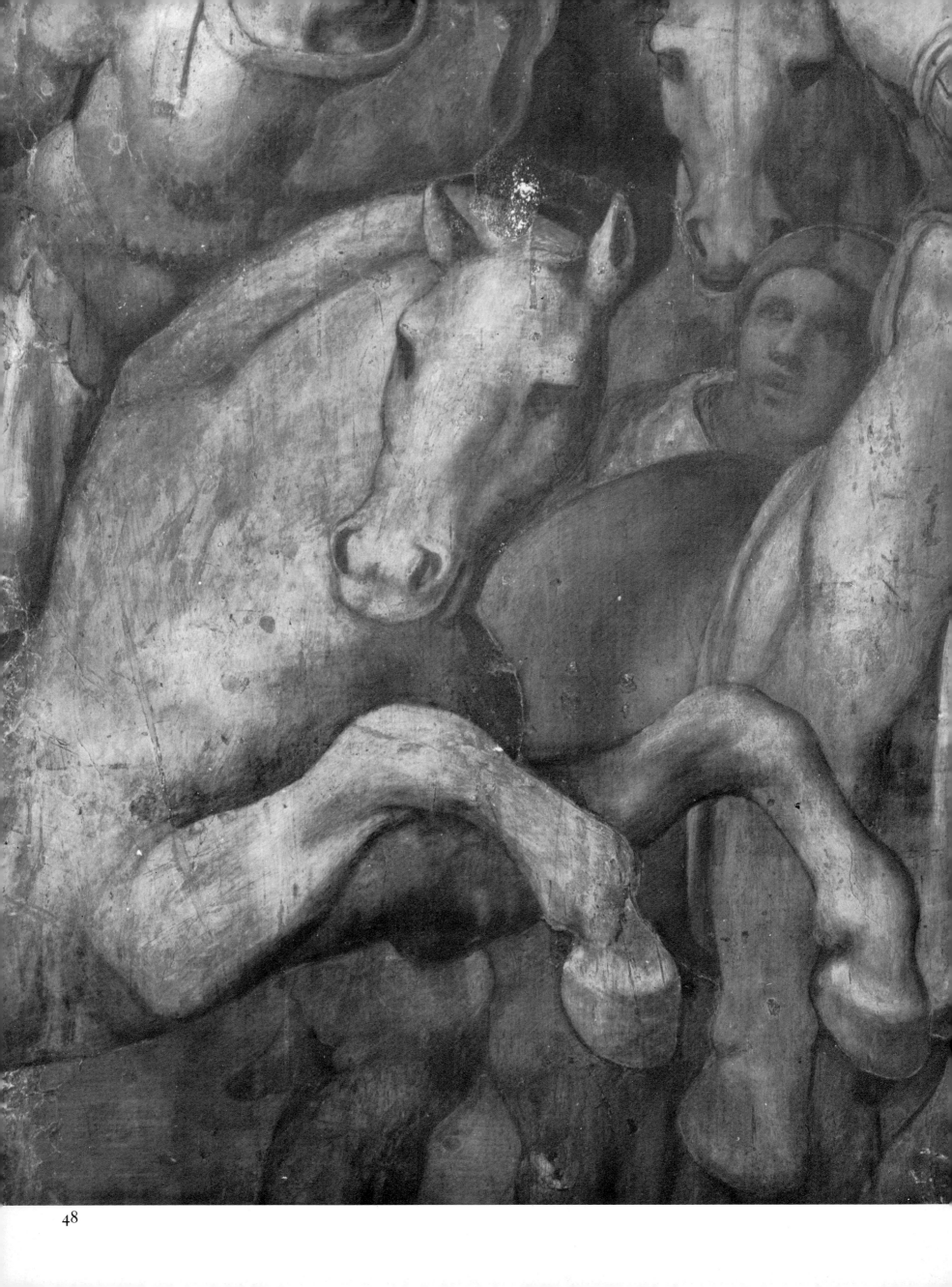

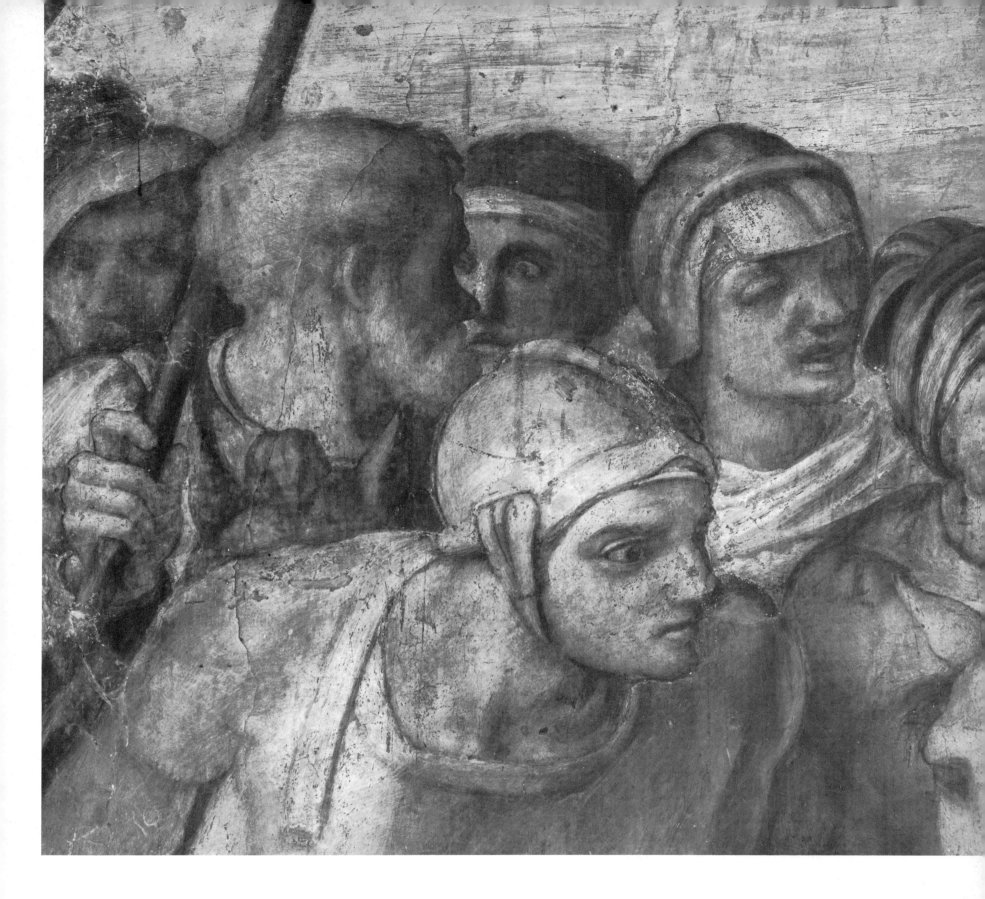

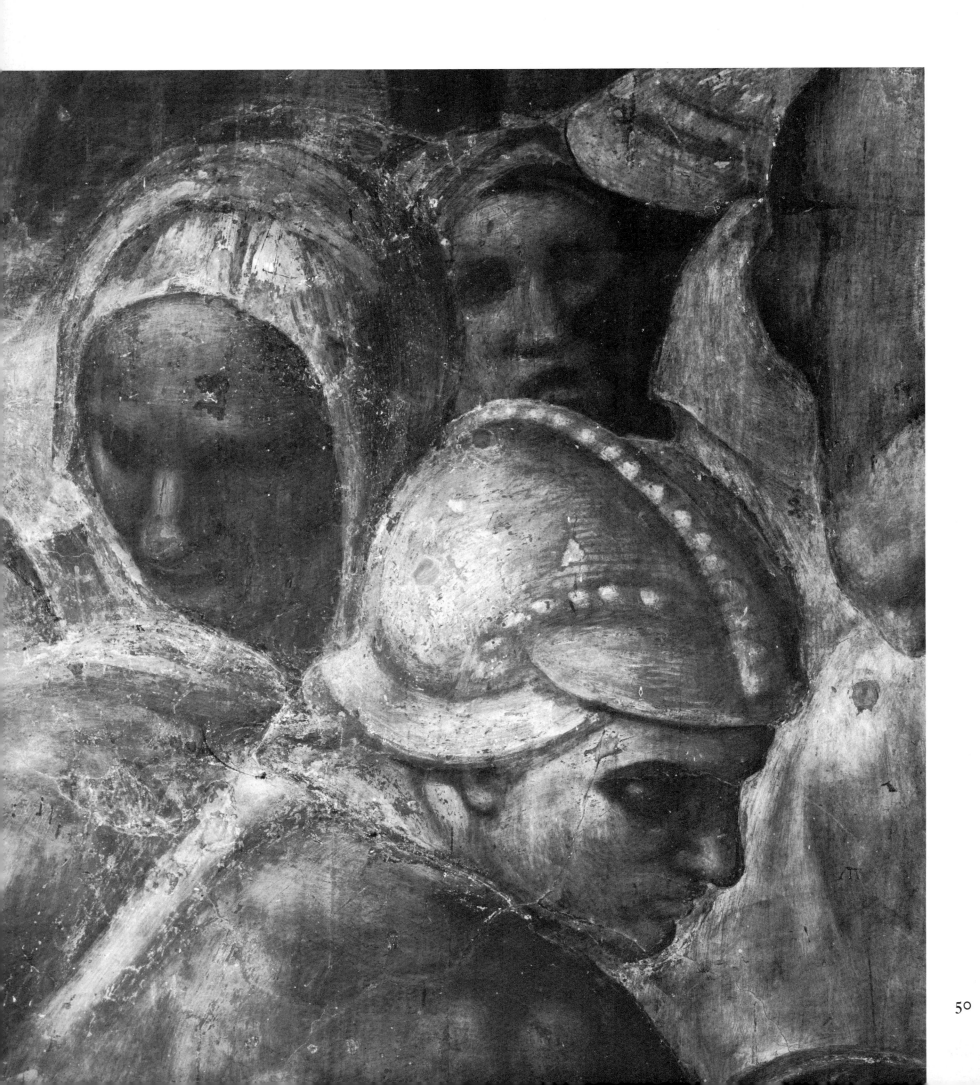

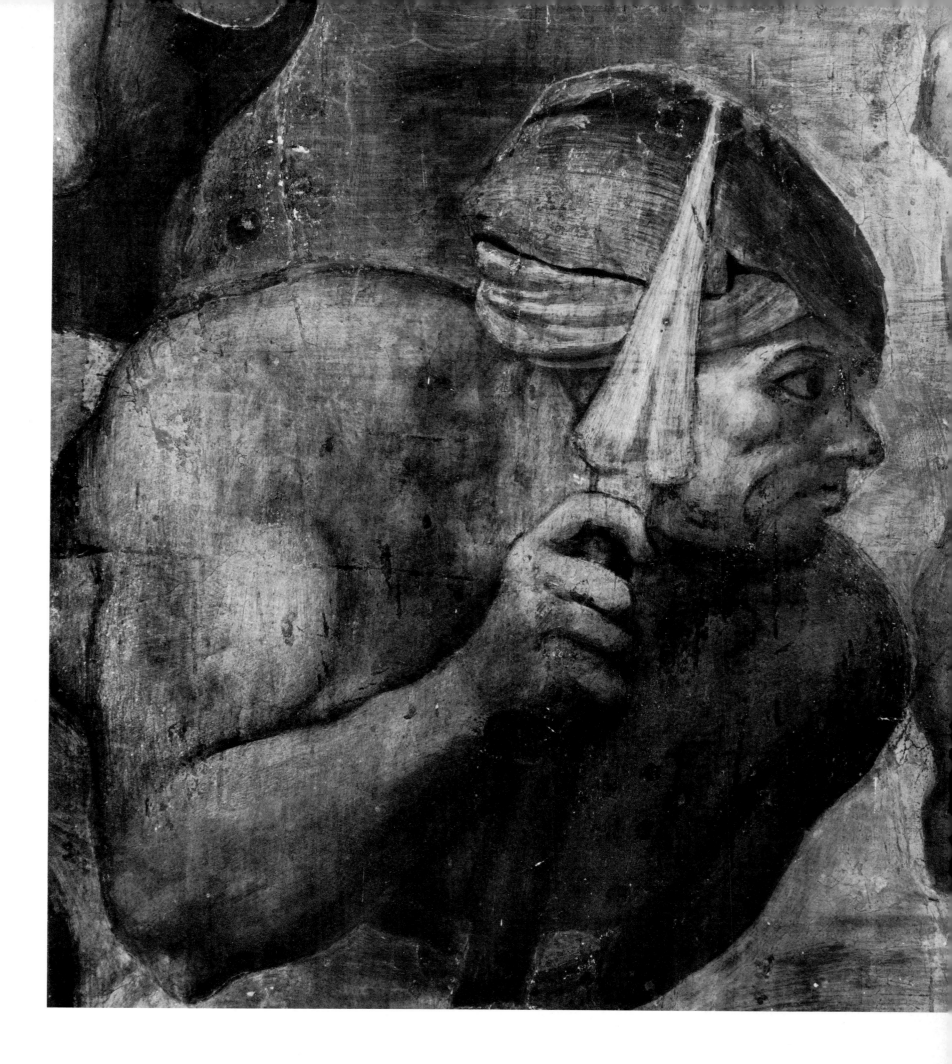

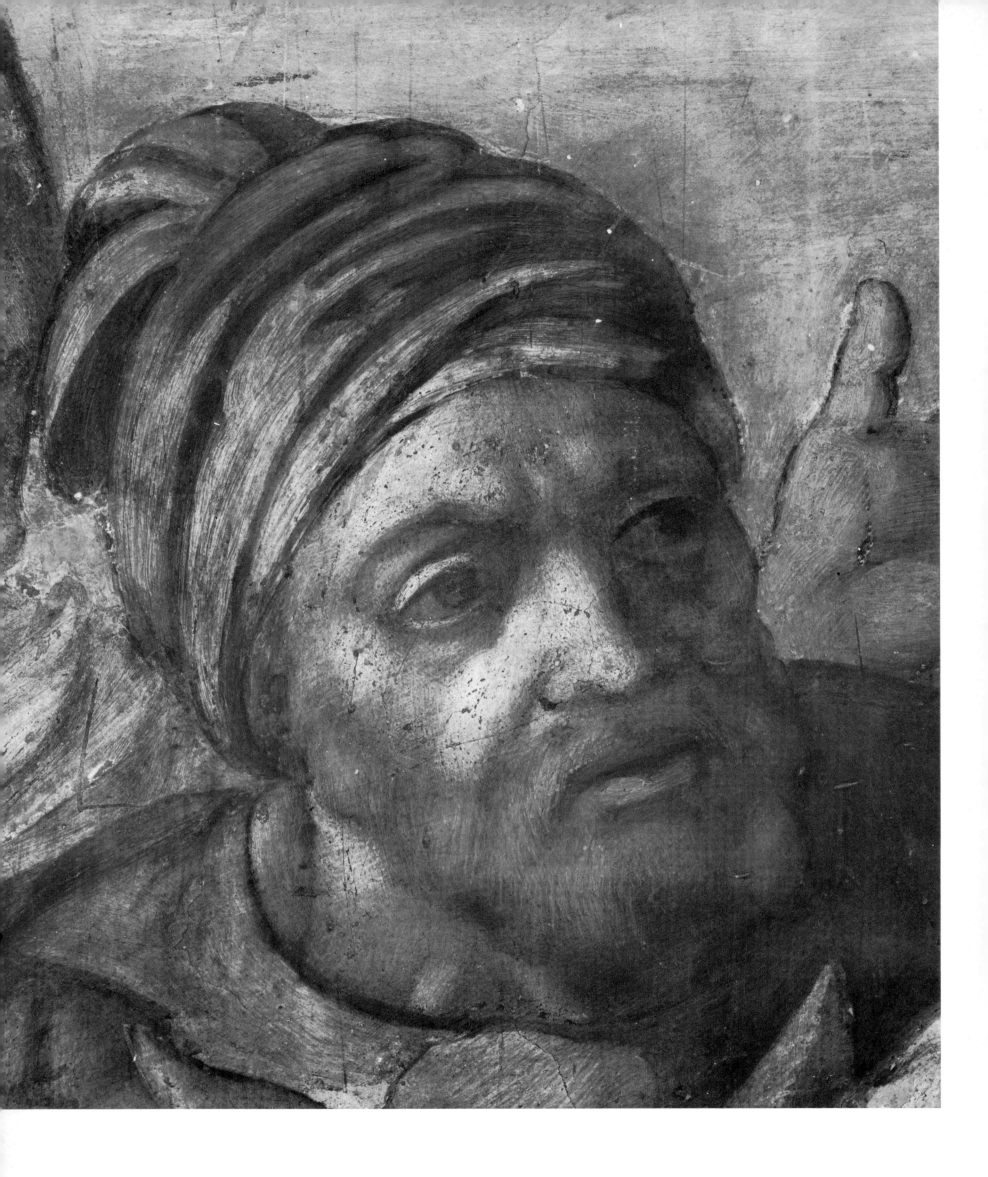

52

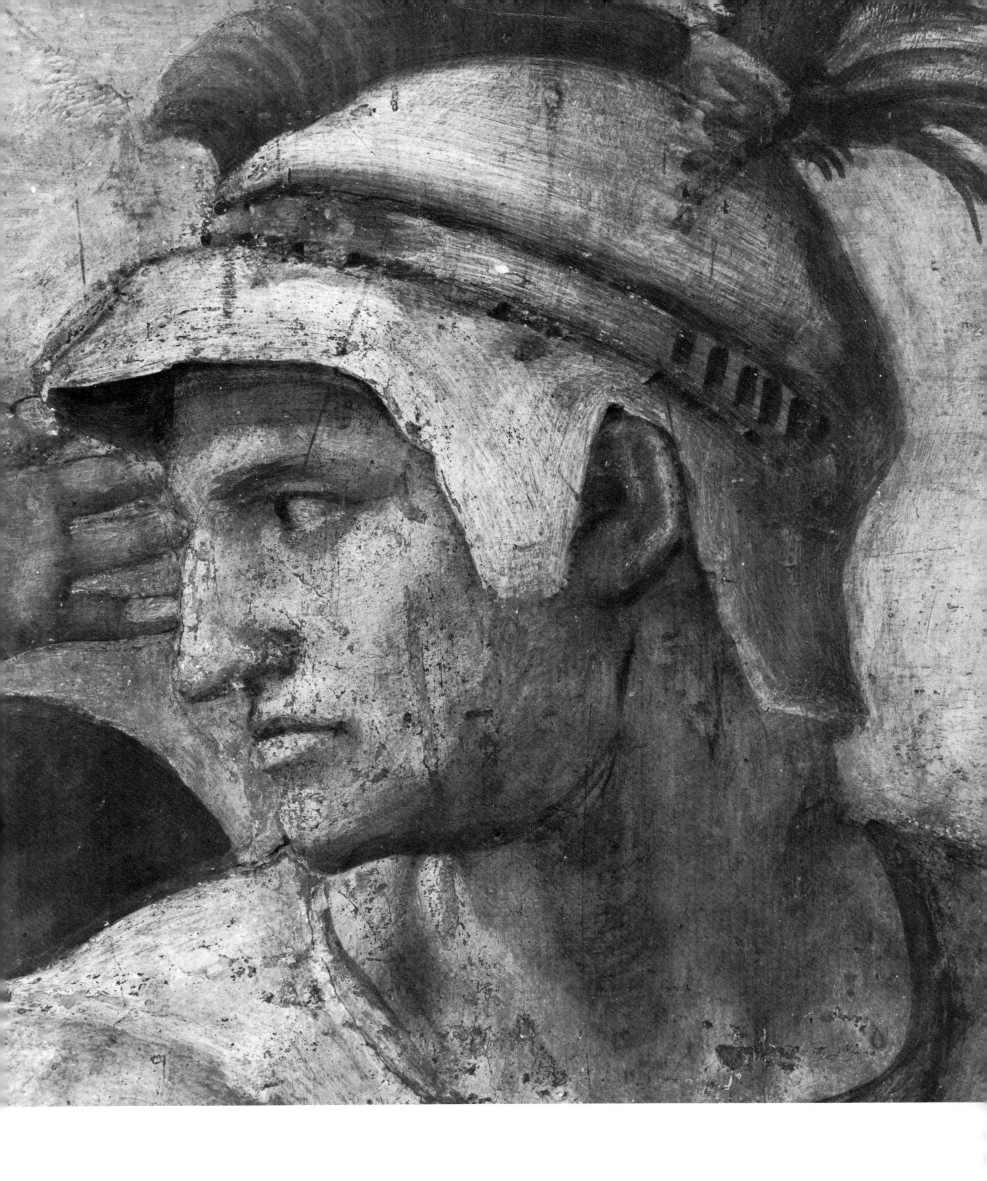

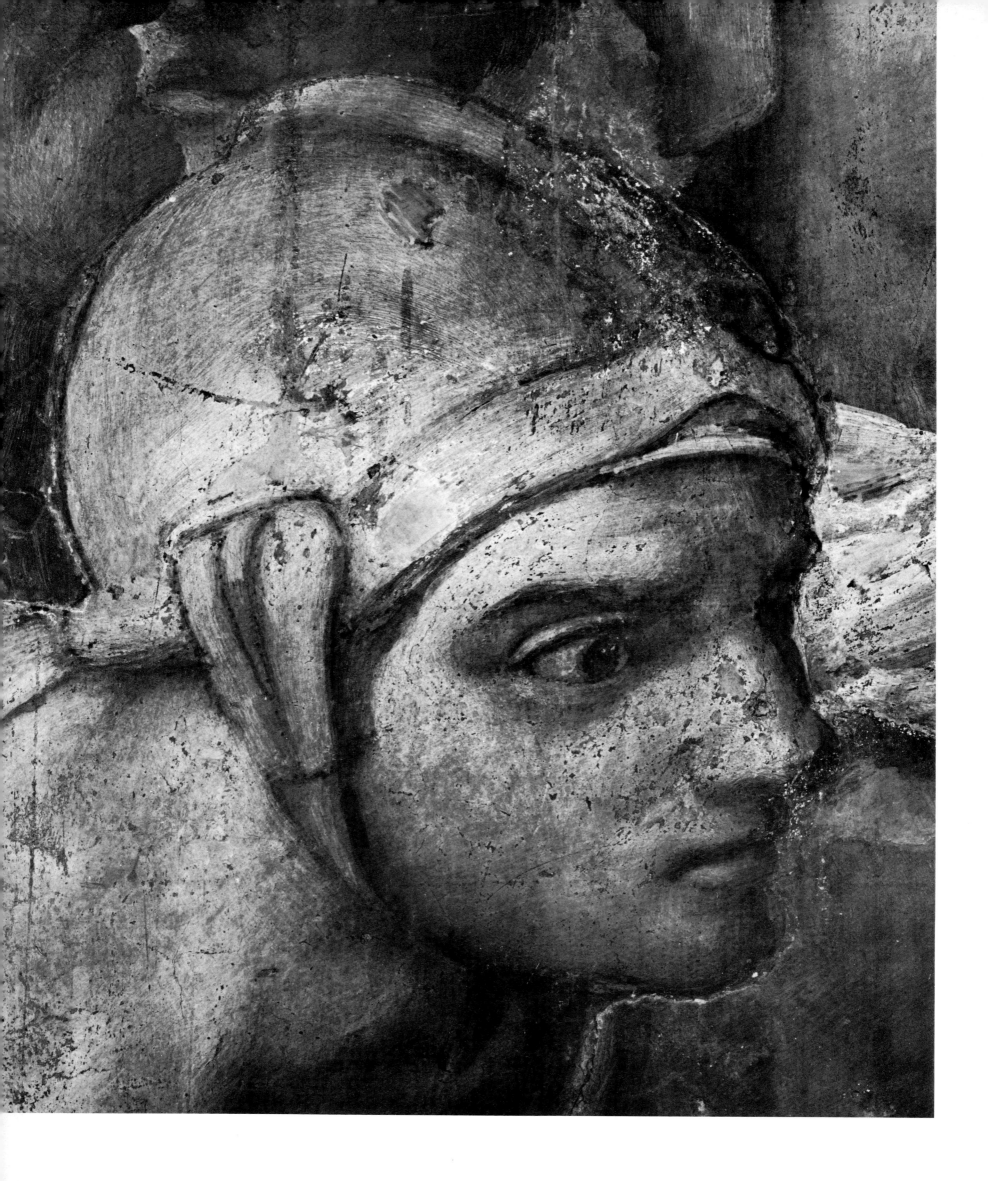

54

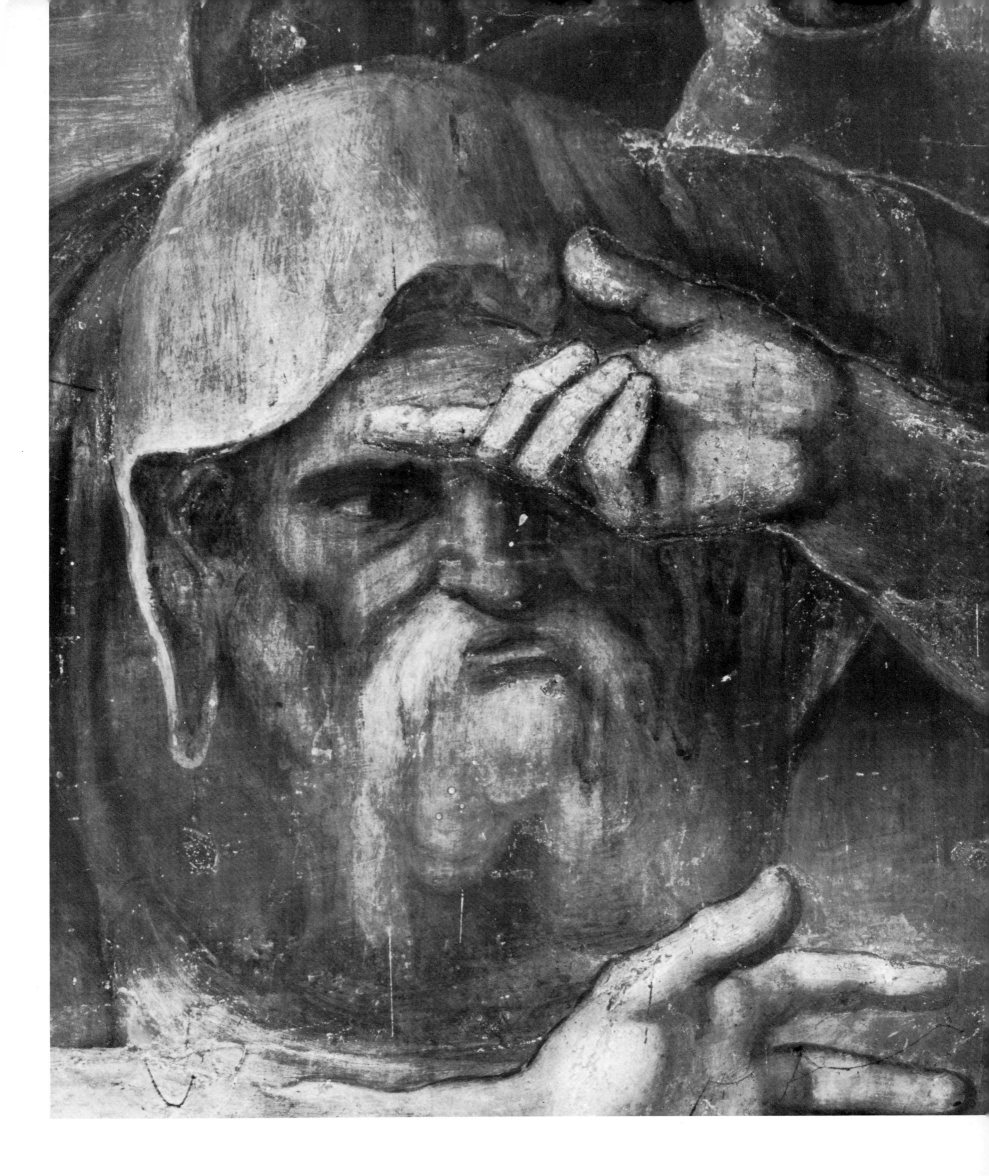

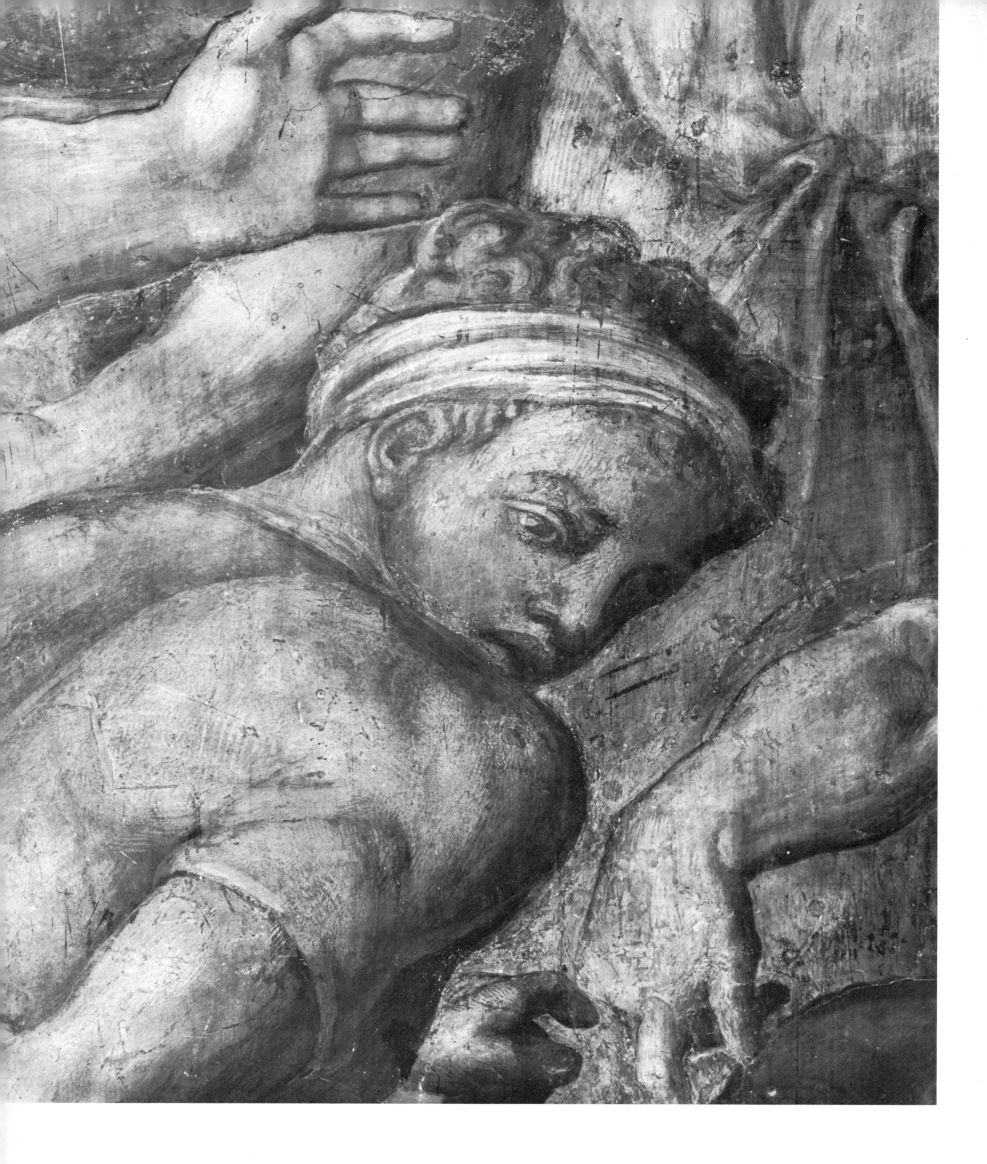

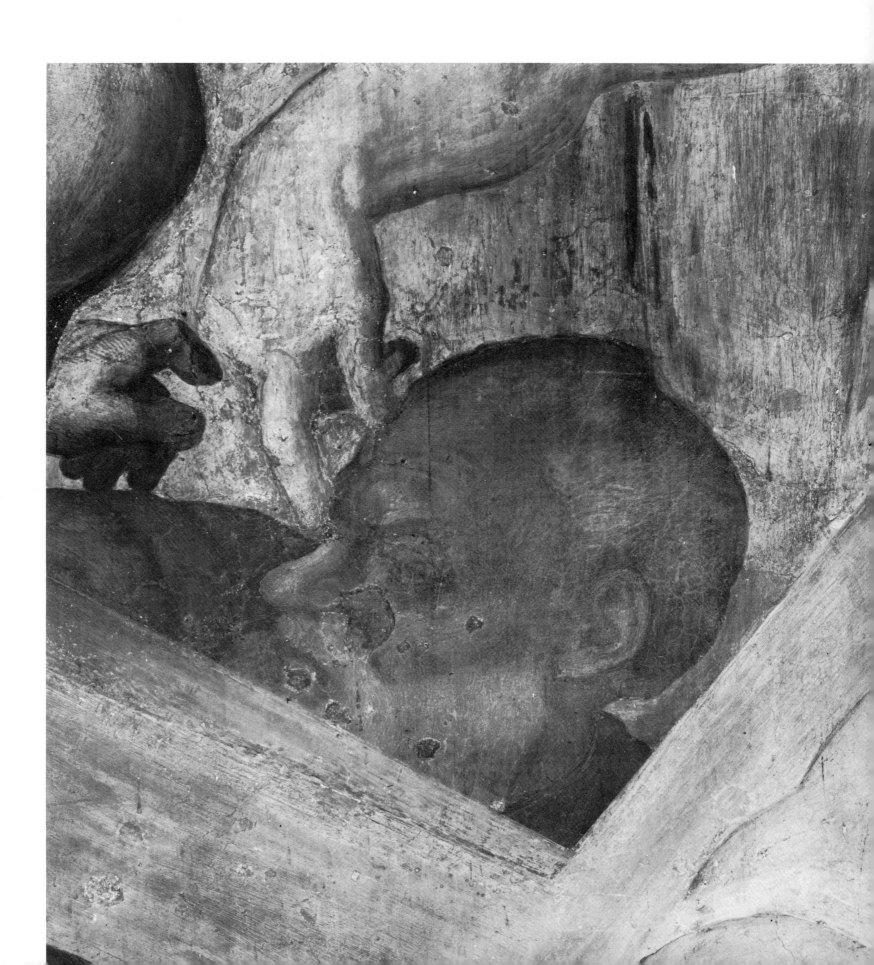

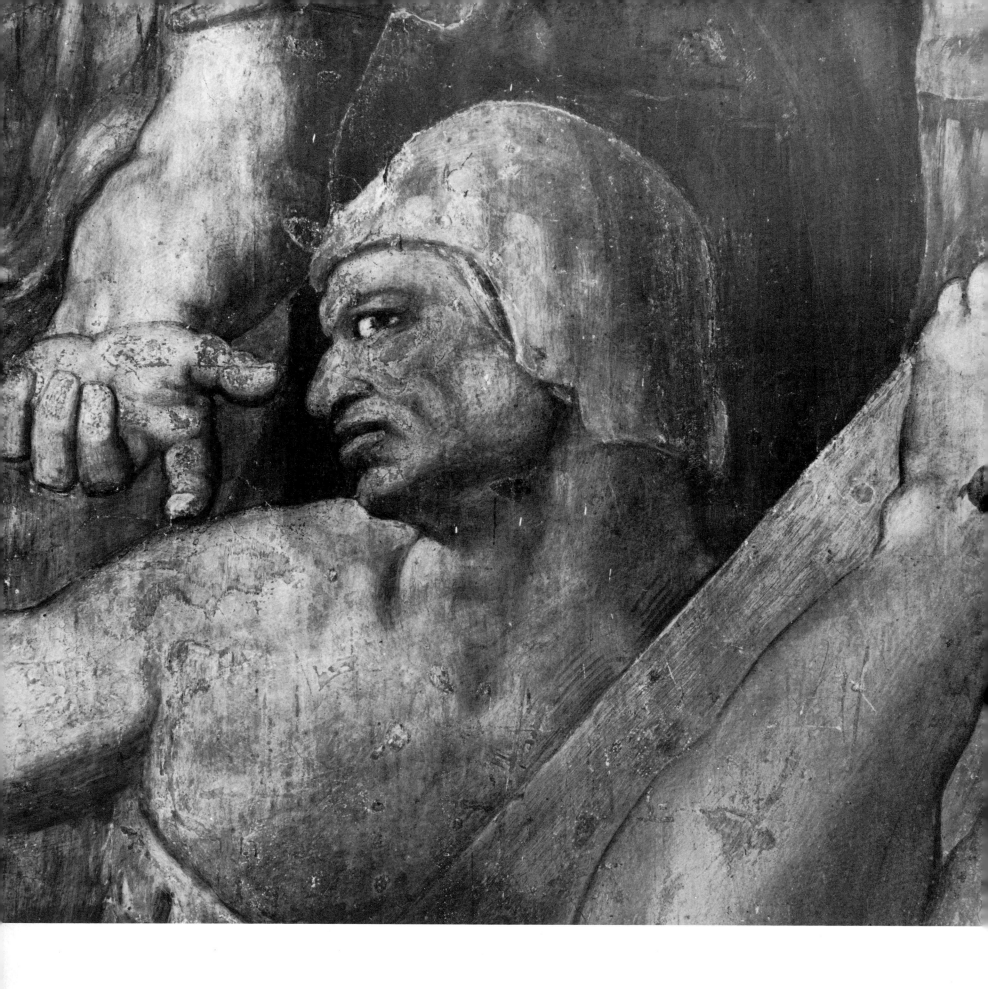

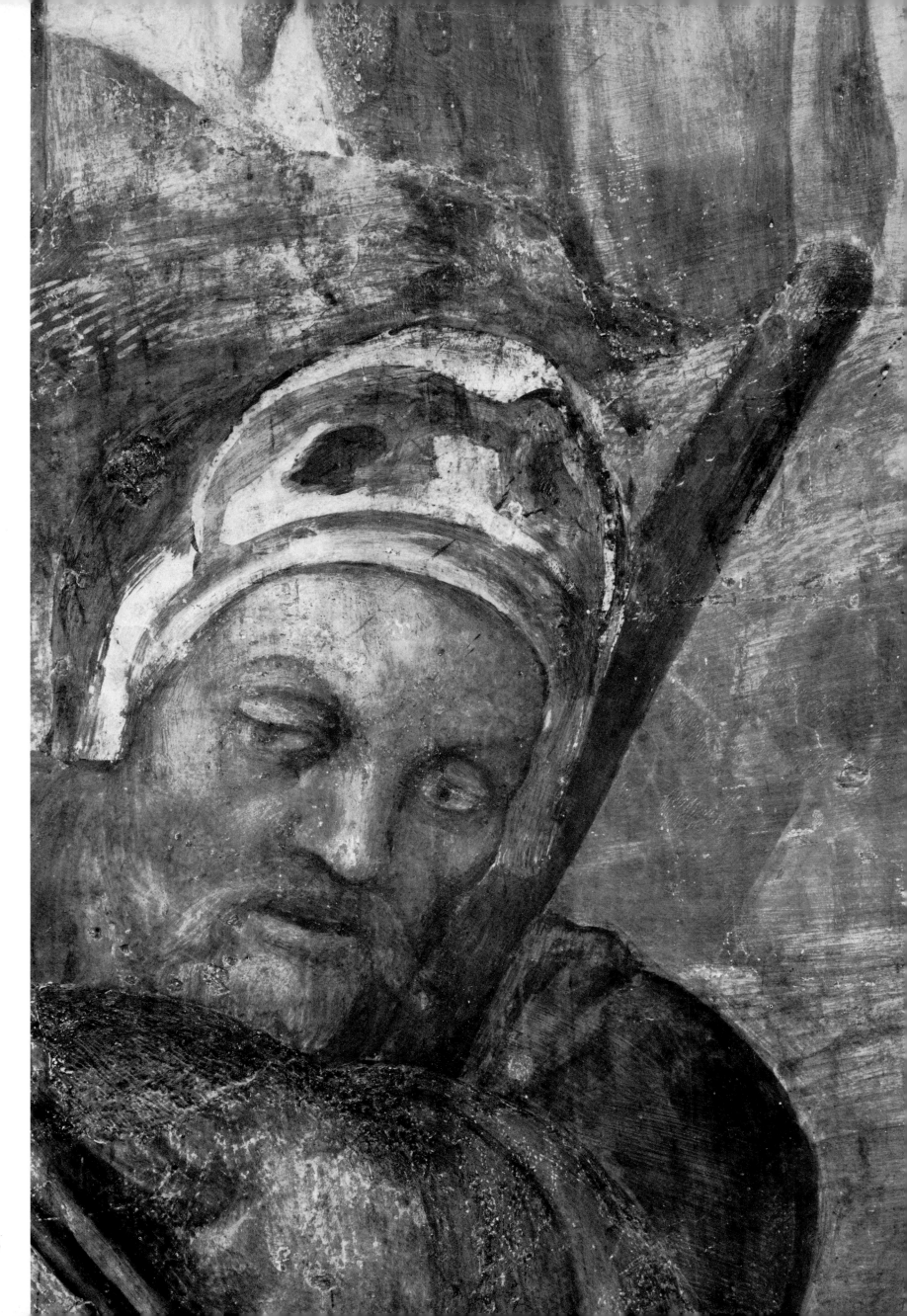

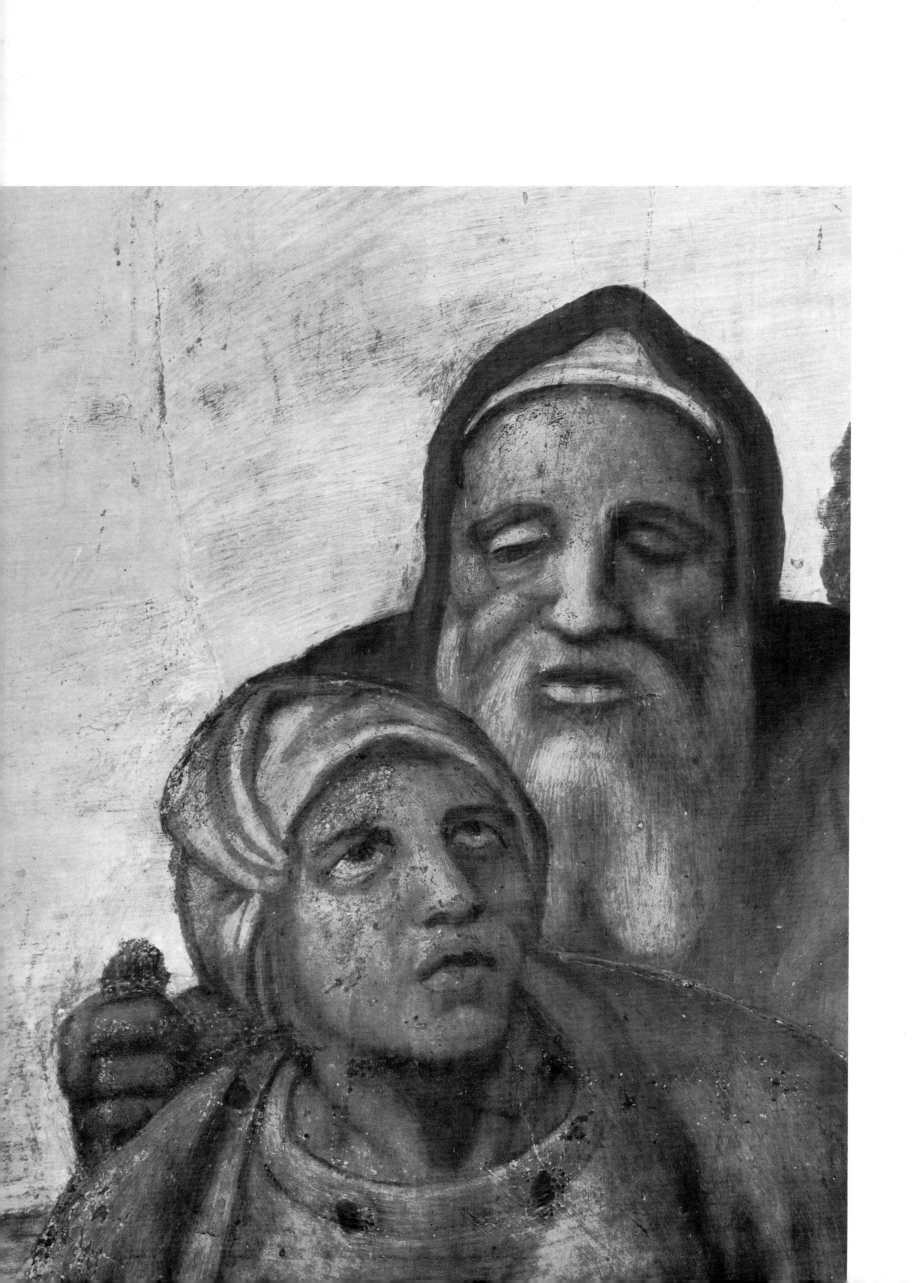

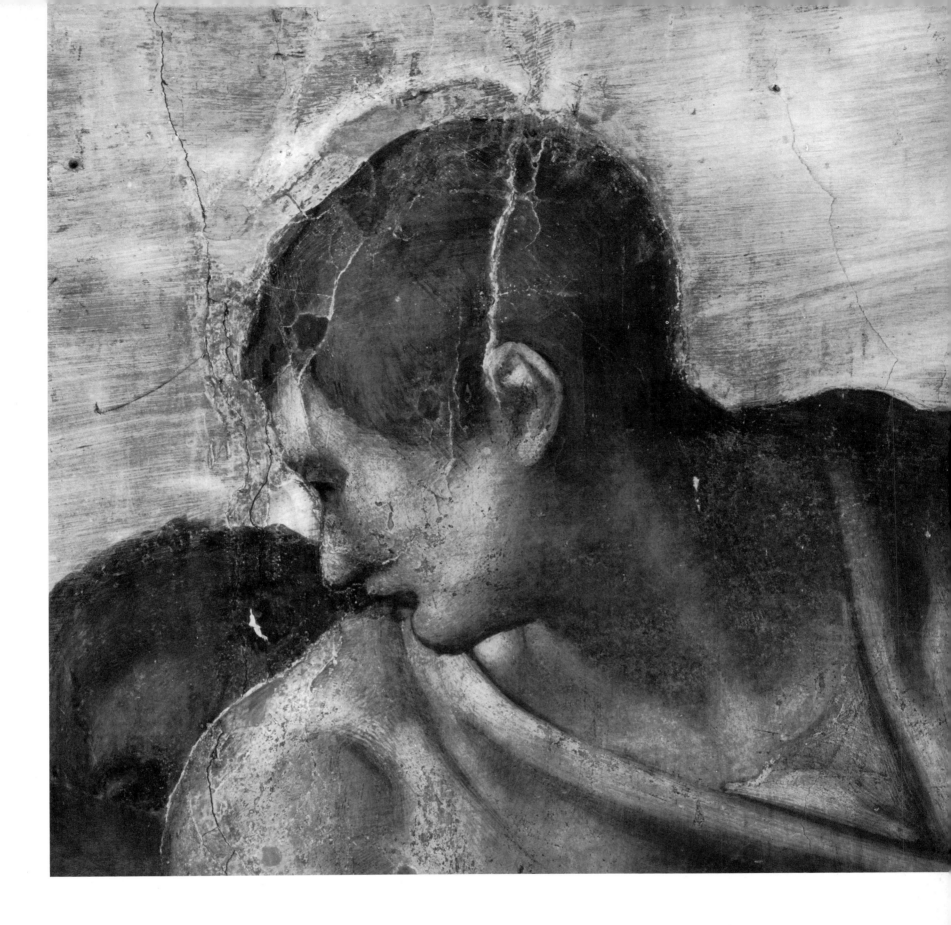

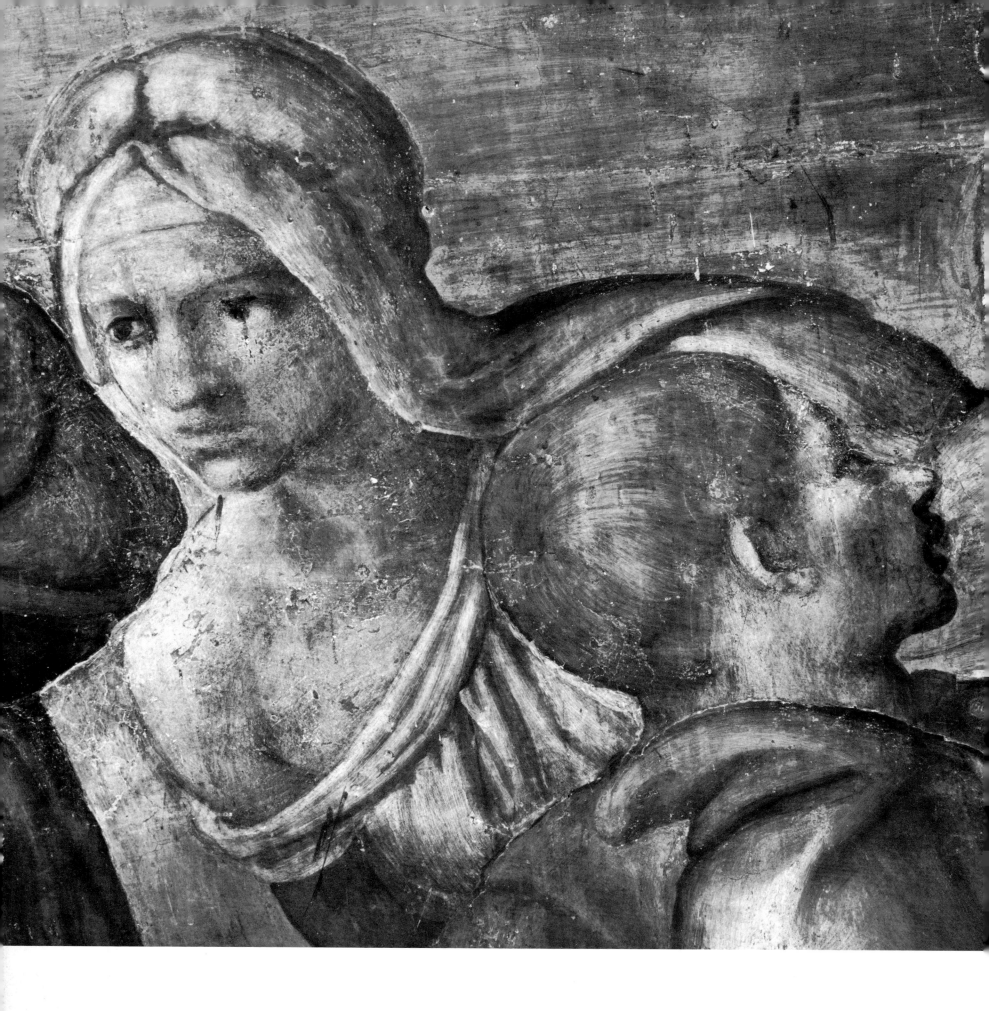

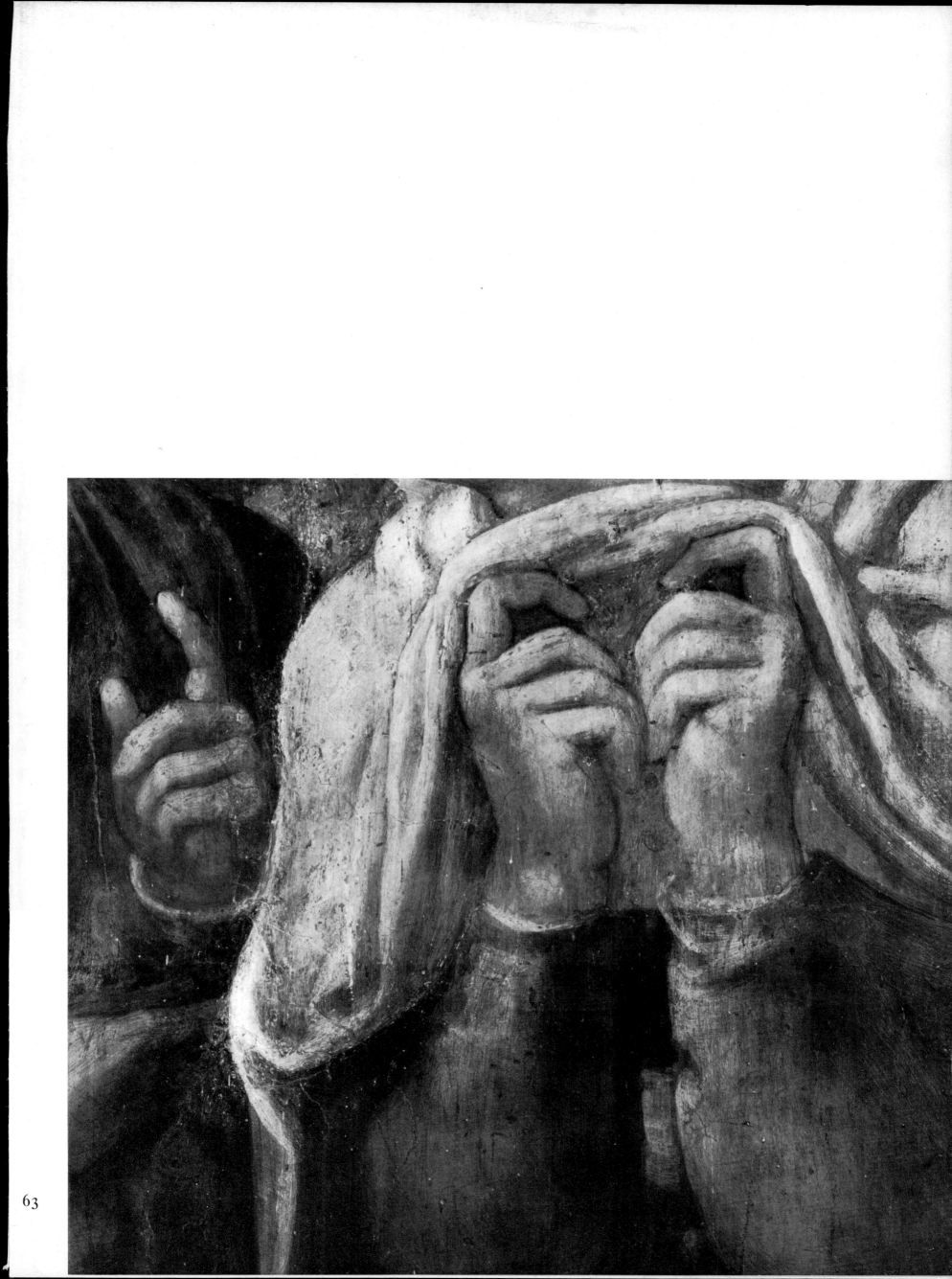

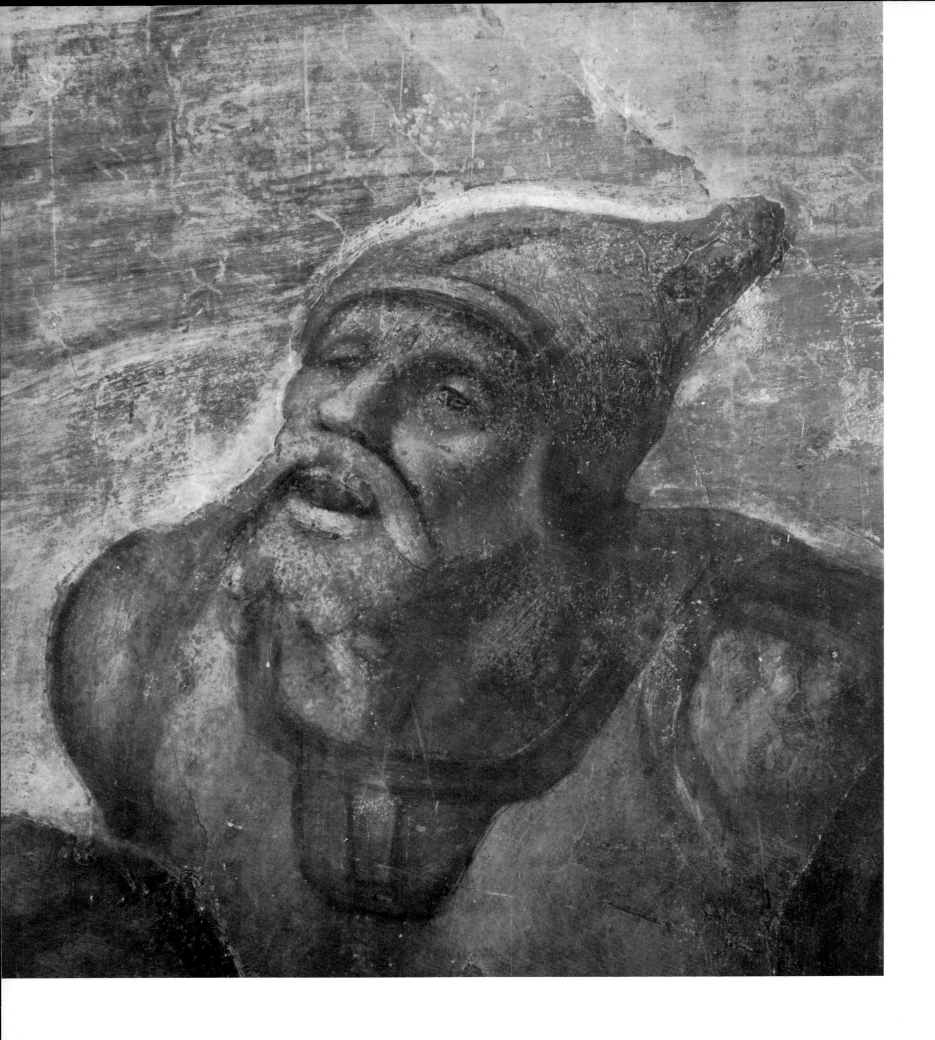